THIS WILL END IN TEARS

THIS WILL END IN TEARS

THE MISERABILIST GUIDE TO MUSIC

ADAM BRENT HOUGHTALING

!t

it **books**

AN *IMPRINT* OF HARPERCOLLINS*PUBLISHERS*

itbooks

HarperCollins books may be purchased for educational, business, or sales promotional use. For information please write: Special Markets Department, HarperCollins Publishers, 10 East 53rd Street, New York, NY 10022.

FIRST EDITION

Designed by Renato Stanisic

Library of Congress Cataloging-in-Publication Data is available upon request.

ISBN 978-0-06-171967-7

12 13 14 15 16 OV/RRD 10 9 8 7 6 5 4 3 2 1

CONTENTS

AUTHOR'S NOTE

I have learned to look on nature
Not as in the hour of thoughtless youth,
But hearing oftentimes
The still sad music of humanity . . .

<div align="right">

—WILLIAM WORDSWORTH

</div>

It's a perfectly gray winter Sunday in Brooklyn. The air is brisk but comfortable, and the streets are just shy of empty. Looking for a suitable soundtrack for my walk to the subway, I pull my phone out of my jacket pocket and scroll through the list of artists I had compiled (randomly, over time, as one does): David Ackles, American Music Club, Patsy Cline, Billie Holiday, Echo and the Bunnymen, Townes Van Zandt, Low, Joy Division, Johnny Cash, Portishead, Radiohead, Györgi Ligeti, James Carr, Tindersticks, David Sylvian, Robert Wyatt . . .

Looking over the list, I notice that almost every artist, regardless of genre or the decade in which they were active, has a natural affinity for melancholy, the dark stuff, an elemental leaning toward the shadowy side. Throughout my life, much of the music that has most affected me—certainly from my late teen years on—has come from artists with this defining attribute, this uncommon understanding of the varying shades of sorrow. They all manage to "own" misery, and

to infuse desperation, loneliness, heartbreak, grief, and ponderous wonder into their work in a manner that sets them apart.

Most of my favorite songs are sad songs, and I know I'm not alone. The devotees of Miserabilist music are not confined to any single genre but seek out the downcast heart of song no matter where it may lie. They lower the shades and listen reverentially in the half-light to Skip James, Nick Drake, and Morrissey. They wait anxiously for new albums from the Cure, Leonard Cohen, and the Blue Nile and buy up the deep catalogs of Nina Simone, George Jones, and Scott Walker.

I soon began to wonder, What is it about these artists that makes them more attuned to grief? What makes Billie Holiday's voice such a perfect vessel for sadness? How does a piece of music such as Samuel Barber's heartbreaking "Adagio for Strings" or Radiohead's "How to Disappear Completely" work on our brains to induce feelings of sadness? And how do those same songs somehow also contain the ability to make us happy?

This book was born partly of the struggle to comprehend what Winston Churchill infamously referred to as his Black Dog. It's an attempt to bridge that bitter, unpredictable purgatory of depression with song, an indisputable source of joy, and celebrate the mean between the two: melancholy, in a perhaps bygone sense of the word.

In the liner notes for the ECM recording of modern interpretations of lachrymose sixteenth-century composer John Dowland's songs, *In Darkness Let Me Dwell*, composer Robert White notes the connection between Dowland's fascination with the lachrimal, accompanied by the larger Elizabethan celebration of melancholy, and our current preoccupation with depression, saying, "What his age knew, and we sometimes lose sight of, is that meditating on a beautiful expression of sadness can help to provide a thoroughly uplifting sense of consolation." Sting, who recorded an album's worth of Dowland material on 2006's *Songs from the Labyrinth*, defined the vital difference between depression and melancholy while discussing Dowland's work, saying, "I think depression is different to melancholy. Depression is a clinical condition. Melancholy comes about through self-reflection. And it's not necessarily a bad thing to be melancholic."

In William Styron's *Darkness Visible*, the author suggests that depression lacks the artful command of "melancholia." To him, depression is "a noun with a bland tonality" and "a true wimp of a word for such a major illness." (Later in the book he chronicles a number of the artists who have spent their creative spurs giving shape and vocabulary to melancholy, including the "suffering that often touches the music of Beethoven, of Schumann, and Mahler, and permeates the darker cantatas of Bach.") But while melancholy can and should be celebrated as a natural part of life that allows our bodies to recover from traumas and disappointments and provides the opportunity to learn and grow, the knotty grip of true depression can be a great ruiner of lives and is to be treated as such. Unfortunately, the two have become entwined by a culture armed with abundant pharmacology and an honest-to-goodness "happiness industry."

Consider this book a small stone cast in the war against chasing the healthy aspects of gloom away—to do battle with that is to struggle against what it is to be human, to misunderstand happiness, and to dismiss the possible catharsis afforded by the artists and songs represented in this book.

This is not meant to be a comprehensive exercise in summing up the Western world's musical malaise, but rather an attempt to coalesce disparate artists separated by time and traditional genres into a new system based on emotional cues and to allow lovers of melancholy music the ability to discover new artists and to quickly immerse themselves in their work. The more I wrote, the more pervasive the theme became. So, heeding the story of Robert Burton (the author of *The Anatomy of Melancholy*, who spent the better part of a lifetime attempting to chase away his depression and define its scope), and in an attempt to find an ending line, I needed to pull back my scope and focus on only the most important artists and songs.

The book is broken into five distinct aspects: artist profiles, song essays, topic essays, "Miserable Lists," and a final list of the top 100 saddest songs of all time. The artist entries are arranged in alphabetical order to foster a sense of discovery, so that readers who may love the National might also chance on Mickey Newbury and a Bright Eyes fan might be tempted to listen to Jacques Brel. There are

a handful of song essays scattered throughout to tell the stories of some of the most important songs in the Miserabilist oeuvre, such as Joy Division's "Love Will Tear Us Apart" or Billie Holiday's "Strange Fruit," and topic essays provide coverage of larger umbrella subjects vital to the history and narrative of sad songs, while also serving to broaden the definition of those songs and their meaning to both our culture and our selves. A "Miserable List" accompanies many of the profiles and essays and are designed to spotlight the saddest material of a given artist or topic.

Finally, the book closes with a list of the top hundred saddest songs of all time. This list is the result of hundreds of hours of listening, contemplating, researching, second-guessing, crowdsourcing, more listening, and editing. Songs have been gathered from all genres across all time, from Josquin des Prez's "Mille Regretz" to Jóhann Jóhannsson's "The Sun's Gone Dim and the Sky's Turned Black." I have sidestepped full operas, symphonies, song cycles, and other lengthy works that could otherwise be considered—such as Sibelius's Fourth Symphony; Richard Strauss's *Metamorphosen, Study for 23 Strings*; and Górecki's Third Symphony (*Symphony of Sorrowful Songs*)—in favor of highlighting specific movements, songs, or arias. While performances in English are the focus some songs, such as Jacques Brel's "Ne Me Quitte Pas," have transcended language and felt appropriate to include. Most notably, to avoid a list overrun by the consistently melancholic catalogs of Cohen, Holiday, Jones, or Van Zandt, only one performance per artist has been included in the top 100 list (though that restriction does not hold with regards to songwriting). Some songs reflect important historical movements and moments, such as the Civil War, the civil rights movement, the residuum of the Vietnam War and, in the twenty-first century, the aftermath of the tragedies of September 11, 2001. Others carry a wider cultural import, such as "Taps," which is so tied to tragedy within the American cultural consciousness that it's impossible to hear it without also absorbing the historical scars—the funerals, memorials, and tragedies—that it shepherds. Whether you read the book cover to cover or open it at random, I hope you'll find a miserabilist journey as enlightening to interact with as I did in creating it.

INTRODUCTION

How good are the tears, how sweet the dirges, I would rather sing dirges than eat or drink.

—EURIPIDES

T here is an aching line that stretches from the grief of Orpheus, the lyre master of Greek myth who had the power to draw "iron tears down Pluto's cheeks," through sixteenth-century lutenist John Dowland—whose personal motto, *Semper Dowland, semper dolens* (Always Dowland, always doleful), gives a clear indication as to his creative nature—to saturnine rock saviors Radiohead, resounding along the way through the high-lonesome yearning of Hank Williams, the hardship-satin vocal of Billie Holiday, the retreating folk of Nick Drake, and the downbeat genre-clashing experimentalism of Portishead. The list of artists attuned to this sorrowful genealogy is impressive: Leonard Cohen, Patsy Cline, Jimmy Scott, Roy Orbison, Jean Sibelius, Frank Sinatra, Townes Van Zandt, Scott Walker, Joy Division, Henryk Górecki, Nick Cave, the Cure, Mark Eitzel, Tindersticks, Lambchop, Richard Hawley, Low, Bright Eyes, Cat Power, and the National all belong to this lineage that is now, in technology's echo of a Baroque vogue for emotional musical categorization, gelling into a new genre of miserabilist music.

What is a sad song? What is it that makes us want to cry when we listen to "Bridge Over Troubled Water" but not when we listen to

"Yellow Submarine"? Does music really move us emotionally or do we simply ascribe our own feelings to the music we hear? And what do we get out of listening to sad music anyway? Why is listening to Billie Holiday singing the painful antilynching song "Strange Fruit" or Notorious B.I.G. expressing his "Suicidal Thoughts" a pleasurable experience, one that we often seek out?

Our encounter with music begins before we're born. Roughly twenty weeks after conception, the auditory system of a developing fetus can register sounds. Studies have shown that by the age of twelve months, children prefer music they were exposed to in utero to new music, leading researchers to conclude that a still-developing fetus listens to, and registers in some way, the sounds of a world beyond the womb. A 2008 study published in the journal *Infant Behavior and Development* found that babies as young as nine months could distinguish happy music (Beethoven's "Ode to Joy") from sad (Edvard Grieg's "Aase's Death"), while other studies have found that babies show a preference for faster, upbeat music and that by two years of age they begin to show a cultural predilection for the music they have heard with regularity up to that point.

The sounds of the world around us are all composed of a series of waves, each one a fingerprint with peaks and whorls unique to its source. These waves are created by the displacement of air, which ripples out with its own unique signature, from your fingers clacking on a laptop keyboard to the quiet fizz of a freshly poured soda. As the soundwaves hit the ear they interact with a complex physical system that includes the three tiniest bones in the human body—the malleus (hammer), incus (anvil), and stapes (stirrup)—and mechano-receptors (cells with microscopic hairs) floating in fluid-filled tunnels in the inner ear. The waves crash into the microscopic hairs and transmit every minuscule jostling to the brain, where an even more complicated set of chain reactions occurs, beginning with the auditory nerve running to the auditory cortex, which processes the components of the sound. The basal ganglia and cerebellum continually light up to parse rhythmic information, while familiar musical cues

activate the hippocampus (the brain's memory center) and regions of the frontal lobe. (Other regions of the frontal lobe, along with parts of the temporal lobe, respond to the use of lyrics and language.) The mesolimbic system, which houses the brain's pleasure center, is activated, resulting in the production of dopamine—a neurotransmitter linked to the regulation of mood (and targeted by a number of antidepressants)—and hormones such as prolactin, a tranquilizing hormone released following a birth, after orgasm, during lactation, and, fittingly, when you're sad.

While the right hemisphere of the brain controls our appreciation and creation of music, along with spatial understanding, facial recognition, and visual imagery, the left hemisphere controls language, logic, and math. Interestingly, when words are tethered to an emotional context, rather than simply conveying information, they trigger a right-brain activity, and the emotional aspect of music is significant in shaping our reaction to it.

The amygdalae (two small, almond-shaped areas of the brain that process emotional response and memory) and neurotransmitters work together to flag emotionally charged memories as having greater import—in other words, the brain automatically gives a higher priority to your last breakup than to your last trip to the dry cleaner (unless, that is, your dry cleaner broke up with you the last time you picked up your shirts).

As we mature and grow, so do our brains. So although the mind of an average two-year-old isn't necessarily equipped to understand the complexities of a Mozart symphony but enjoys "Peggy Sue" well enough, a decade later it can handle everything it once struggled with or ignored. Music (along with the Warholian constructs that accompany it) can become central to forging teenagers' sense of identity as well as influencing attitudes and friendships, the clothes they wear, and the color of their hair.

Our brain views the act of listening to music as a positive experience and releases chemicals to reward us for our musical natures. Little wonder that music has been reported in every human culture, and that the oldest known instrument—a 40,000-year-old

vulture-bone flute—dates to a time when modern humans still shared the earth with Neanderthals.

The Western system of musical notation has its roots in antiquity and, without going too deeply into theory, it's generally understood that major scales and chords are considered happier sounding and less obtuse, while minor scales and chords are regarded as sad sounding and more complex. But whether "absolute music"— nonrepresentational music unaccompanied by lyrics, images, or dances—can hold within it the seed of emotional expression is the focus of a long-standing argument between what philosopher and author Peter Kivy describes as "musical cognitivists" and "musical emotivists." The cognitivists, says Kivy, cling to the belief that the sadness of any given piece of music is just an expressive cue, backed by years of cultural training, much like "the sadness as a quality of a dog's countenance or even of an abstract configuration of lines," while the emotivists believe that a sad piece of music is sad because it makes a listener feel that way when they hear it.

These philosophical notions, however, address only a few aspects of popular music, which is loaded with cultural cues. We see videos online or on television, we know how artists dress and cut their hair, we know their histories (and sometimes who they're dating), and most important, we know the names of songs and albums and we hear the lyrics. All of which led this discussion toward more representational ideas expressed in music.

"Worldes Bliss" ("Worldly Bliss") is one of few existing examples of early Middle English ballad form, dating from the thirteenth century, and it also happens to be a wonderful example of miserabilist song:

> Worldes blis ne last no throwe;
> it went and wit awey anon.
> The langer that ich hit iknowe,
> the lass ich finde pris tharon;
> for al it is imeind mid care,
> mid serwen and mid evel fare,
> and atte laste povre and bare
> it lat man, wan it ginth agon.

Al the blis this heer and thare
bilucth at ende weep and mon.

Worldly bliss lasts but a moment;
it is here then it disappears.
The longer that I experience it,
the less value I find in it.
For it is mingled with care,
with sorrow, and with failure;
and in the end it leaves man poor and naked when it
 departs.
All the bliss here and there amounts,
in the end, to weeping and moaning.

Concerns over death ("Farewell, this world! I take my leve for evere") and the sorrows of love ("Alas departynge is ground of woo / Other songe can I not synge") were plentiful leading up to the work of the first great songwriters that appeared during the Elizabethan age, when melancholy was au courant. Sixteenth-century Franco-Flemish composer Josquin des Prez was the first to truly color his compositions with a clear, personal style. Before des Prez, music was largely sacred in nature, but he blended the polyphonic ideas that bloomed in fifteenth-century medieval music with a secular emotional expressiveness formerly unheard of. Des Prez is often referred to as simply Josquin (appropriate for someone who might be viewed as the father of pop, with its lineage of one-name icons: Dylan, Cher, Madonna), but the first true member of the miserable tradition, "the epitome of the 'outsider,' the alienated singer-songwriter," as Sting said of him, was John Dowland, whose consistent exploration of life's melancholy can be found in compositions like his still popular *Lachrimae*, or *Seaven Teares Figured in Seaven Passionate Pavans.*

English folk songs and ballads such as those collected by scholar Francis James Child in the late nineteenth century provided an academic link to the first true folk music in America, as Appalachian porch strummers and Delta blues singers performed variations on English ballads like "Barbara Allen" and "The Unfortunate Rake,"

the latter of which eventually morphed into both "St. James Infirmary Blues" and "Streets of Laredo."

One of the most popular songs during the Civil War was the sorrowful "Lorena," a tune so mournful and ubiquitous that some attributed Confederate military losses to its lugubrious nature. And it was just twelve years after the war ended that "music began to become a thing," as Evan Eisenberg puts it in his book *The Recording Angel*. That was the year, 1877, that Thomas Edison invented the phonograph, which would rapidly increase the influence of music as it reached more people than ever before. An influx of sad songs came along for the ride, including one of the biggest hits of the final years of the nineteenth century, Charles K. Harris's 1891 weepie "After the Ball."

Murder ballads and tragedy songs were popular in the nineteenth century and remained so in the twentieth—the sinking of the *Titanic* becoming a particularly catastrophic source of inspiration—and one of the earliest blues songs to be recorded, Mamie Smith's "Crazy Blues," from 1920, lays out some of the same symptoms for depression we're familiar with today: "I can't sleep at night / I can't eat a bite" in the first verse, and "Sometime I sit and sigh / And then begin to cry" in the second. Bing Crosby's "Brother, Can You Spare a Dime?" became synonymous with the Great Depression (the singer's smooth, plaintive croon enabled by advancements in microphone technology), while Billie Holiday's 1939 performance of the devastating "Strange Fruit" at New York's first integrated nightclub, Café Society, gave birth to the protest song. Journalist Greil Marcus is among those who consider the Orioles' ode to longing "It's Too Soon to Know" (1948) to be "the very first rock 'n' roll record," writing that the song contained "a passion so plainly repressed it implied not revolt but suicide." And Hank Williams's "I'm So Lonesome I Could Cry" (1949) captured the dusty truths of despair decades before Leonard Cohen was called the Prince of Bummers or Morrissey was nicknamed the Pope of Mope.

One of the biggest musical acts of the early 1950s, and a critical bridge between Frank Sinatra's easy croon and the birth of rock 'n' roll, was the now largely ignored Johnnie Ray, whose string of grief-stricken hits included "Cry," "The Little White Cloud That Cried,"

and "Tell the Lady I Said Goodbye," and who started a rush for "sob ballads." Just a few years later, in 1956, Elvis Presley put more of a defining edge on rock music with his first number one hit, "Heartbreak Hotel," a song inspired by a suicide, or at least a suicide note, which simply read, "I walk a lonely street." The death of James Dean in an automobile accident in 1955 became a precursor to a flood of teen tragedy songs like Mark Dinning's "Teen Angel" (1959) and the Shangri-Las' "Leader of the Pack" (1964). Also at that point, the folk and blues revival was in full swing, and new artists such as the Beatles and Bob Dylan were just beginning to explore the kind of confessional, introspective songwriting that Hank Williams had been doing a decade earlier (and that Josquin had experimented with four centuries before that). Jackson Browne, Leonard Cohen, Joni Mitchell, and Lou Reed were all part of the new wave of singers who weren't afraid to tackle brutally difficult issues such as suicide and abuse, and soon acts like Bauhaus, the Church, the Cure, Echo and the Bunnymen, the Smiths, and other gloomy rock acts were turning out some of the best records of the 1980s and building careers at least partly on a celebration of melancholy. Just as Kurt Cobain's angst reclaimed rock from a glut of dance-pop, hip-hop artists such as Biggie Smalls, Tupac Shakur, and Eminem pushed the envelope with a raw poetry underpinned by unsettling trauma and grief.

There have been plenty of sad songs that speak to everything from addiction and assassination to clinical depression and suicide, but why do we listen? What makes these songs so appealing?

It's part of a trilogy. A musical trilogy that I'm doing in D minor, which I always find is really the saddest of all keys, really. I don't know why, but it makes people weep instantly.

—NIGEL TUFNEL, *THIS IS SPINAL TAP*

In 2006 a group of researchers led by Dr. Harry Witchel (and funded by Nokia UK) conducted a small study of UK chart songs to find the happiest, saddest, and most exhilarating songs. The sampling pool was small and the methods (measuring heart rate, respiratory

response, and skin temperature) were basic, but the results of the study became news around the world, with newspapers, magazines, and blogs picking up the "discovery" that the Verve's "The Drugs Don't Work" was the saddest song ever, beating out Robbie Williams's "Angels," which came in second. Witchel stated that, compared with most of the other songs, and even compared to white noise, "a slow-tempo song like the Verve's 'The Drugs Don't Work' slows down the heart—in other words, it works like the emotional state of sadness."

Studies have long shown that your heart rate will mirror rhythmic stimuli, so it stands to reason that listening to a song with a slow tempo will decrease the heart rate, yet tempo (like titles and lyrical content) is just one possible signpost on the shadowy road to melancholy.

A similar type of musical cue is the recurring theme for melancholy explored by Alex Ross in his essay collection *Listen to This*: a descending four-note bass line that can be heard in laments in the folk music of Romania, Russia, and Kazakhstan; songs from the Renaissance; Delta blues; jazz ballads; and rock.

Sometimes referred to as John Dowland's falling-tear motif—the descending figure that occurs at the outset of his celebrated "Flow My Tears"—this kind of musical cue has at its root the weeping human voice, and represents, in Ross's words, "a fate from which we cannot escape." Claudio Monteverdi employed the descending figure for his "Lamento della Ninfa" and it turned chromatic (alternating black and white keys on a piano) for Henry Purcell's "Dido's Lament" from the opera *Dido and Aeneas*. Bach, Beethoven, Tchaikovsky, and György Ligeti have all used some form of this lament motif, as have Skip James ("Devil Got My Woman"), Robert Johnson ("Walkin' Blues") and, later, the Beatles ("Michelle") and Dylan ("Simple Twist of Fate" and "Ballad of a Thin Man"). This descending bass line is an echo of a slow, muted sob that steps downward in pitch until a new breath is taken, returning the cycle to a higher pitch, only to descend again.

Meagan Curtis, of Tufts University's Music Cognition Lab, released a study in the June 2010 issue of the journal *Emotion* suggesting

that speech also shares with music another grim signifier in the minor third—a specific measurable distance between two pitches. During the study, a group of nine actresses read various two-syllable words and phrases ("OK," "let's go," "come here," etc.) portraying four separate emotional states (happy, sad, pleasant, and angry). Measuring the distance between the pitches of each syllable, Curtis found that the minor third was "the most reliable cue for identifying sadness." Whether this is true across cultures has yet to be determined, and whether it has been true throughout history is as impossible to establish as whether music preceded language or vice versa.

There are other, less tangible qualities to music that can make it seem sad, such as a lo-fi aesthetic (notable in part for celebrating flaws born of cheap and outdated recording equipment) or the timbre of an instrument or voice. The mid-nineties bubbled with stark and earnest lo-fi maestros such as Elliott Smith, Bill Callahan's Smog, F. M. Cornog's East River Pipe, Will Oldham's Palace Brothers, and dozens of others discovering their authentic voices in basements and bedrooms from Olympia to Auckland. Lo-fi announces itself—as a mumble wrapped in tape hiss or the buzz of an ungrounded cord—but this announcement breaks the fourth wall, so to speak, reminding us that all this sound is simply electricity vibrating through speaker cones. The buzzes, clicks, and showy distortions are all signifiers suggesting to the listener "authentic statement in progress," as if tape hiss alone could build a bridge to artistic truth (it helps, of course, if the songs are good).

Another side to this argument of greater authenticity that actually does contain some empirical truths is that analog recording equipment offers what's often referred to as a "warmer" listening experience than its digital counterpart. Just as some argue that film projection speaks to a different part of the brain than the now ubiquitous digital projection—the film creating what critic Roger Ebert referred to as an "alpha state of reverie" due to its nearly invisible flickering—so, too, do aspects of lo-fi and predigital recordings seem a more emotional expression of the author's original statement. If you buy into all this, then a sad song should sound even sadder if it's recorded on reel-to-reel and listened to on vinyl, as opposed to a

digitally recorded version condensed to an MP3 file and squeezed out through button-size headphones.

Neuroscientist and former record producer Daniel J. Levitin describes in his book *This Is Your Brain on Music* that "the lumbering, deep sounds of the tuba or double bass are often used to evoke solemnity, gravity, or weight." Although rubbing your thumb and forefinger together mockingly may be the universal signal for the world's littlest grief, the smallest violin ever, evoking the world's tiniest cello would be more appropriate. Cellist Janos Starker told *Time* magazine in 1964 that, to most listeners, "the sound of a cello means someone is slowly dying on the movie screen. It is a depressing, melancholy sound with a wailing tremolo. It cannot laugh, but it takes to agony perfectly." He goes on to describe the instrument as "the sad hero who faces life with resignation."

The same can be said for singers with deep vocal ranges and damaged or curious voices. In the jangly power-pop tradition of the Raspberries, Cheap Trick, and Fountains of Wayne, you don't run across too many singers with low, rumbling registers, but listen in to the darkest corners of rock and you'll find Leonard Cohen, Ian Curtis, Nick Cave, Tindersticks' Stuart Staples, Mark Eitzel, the National's Matt Berninger, Interpol's Paul Banks, and Editors' Tom Smith, all crowded beneath a little black cloud of gloom like smokers huddled together outside a bleak concrete office building on a subzero day. Yet an untrained or damaged voice can also seem deeply expressive in relation to other, more sonorous vocals. "If sandpaper could sing," was how Joyce Carol Oates once described Bob Dylan's vocals; and Robert Wyatt's thin, reedy delivery may not be to everyone's taste, but composer Ryuichi Sakamoto once called it "the saddest voice in the world."

Still, none of these signifiers alone are completely accurate. There are plenty of slow songs that are more sultry than sad, and there are plenty of seemingly lighthearted songs that, unbeknownst to most listeners, contain lyrics that display the deepest of sorrows, à la Terry Jacks's "Seasons in the Sun." Major chords can be used in sad songs (Hank Williams's "I'm So Lonesome I Could Cry") just as minor chords can be used in joyous songs, and dynamics aren't a surefire clue to the emotional quality of a song.

What it comes down to is that I feel something sad deeper than I feel something happy. And I write out of what I feel.

—CHARLIE RICH

The April 13, 1936, edition of *Time* magazine featured in its letters section a note written by Hungarian composer Rezső Seress, whose most famous composition, "Szomorú Vasárnap," had recently been translated into English and recorded by a number of artists in the United States. Marketed as "The Hungarian Suicide Song," due to a number of reported suicides attributed to the grim power of the work, the newly translated "Gloomy Sunday" was an instant success, and its mythology followed it from Hungary, prompting the letter from Seress, wherein he explains: "I cried all the disappointments of my heart into this song, and people with feelings akin found their own hurt in it. That is how I account for it becoming a 'deathly song'—because disappointment and suffering are felt by everyone alike. If the songs which burst from my heart will not be chosen by suicides as their 'death march' but by those who seek balm for their hearts, I shall feel happy if I can accomplish this." All Seress wanted to offer the world was a three-minute miniature catharsis.

Catharsis can be a complex issue and has assumed many forms over the centuries. In an essay on Nico's haunting 1969 album, *The Marble Index*, influential rock critic Lester Bangs pondered, "Why would you want to listen, all the time, to a song about someone dying from an overdose of heroin?" He continued to suggest that such a person must be "a junkie for the glimpses of the pit." What Bangs was getting at—why do we find pleasure in creations so dishearteningly bleak?—is the paradox of tragedy in a nutshell.

Scottish philosopher David Hume, in his essay "Of Tragedy," wrote that the more an audience is touched by a portrayal of tragedy, "the more they are delighted with the spectacle; and as soon as the uneasy passions cease to operate, the piece is at an end." It's a philosophy that was shared by master of suspense Alfred Hitchcock, whose common rule of thumb was "Always make the audience suffer as much as possible."

In ancient Greece the "healing power of music" meant far

more than just the joy one received from the experience of listening to a well-crafted song or symphony. Aristotle, in his *Poetics,* responded to Plato's earlier assertions that tragedy can provoke irrational emotional exuberances by linking emotions to the notion of *catharsis*—which comes from the ancient Greek for "cleansing," "purifying," or "purging." He reappropriated for dramatic purposes a word that had until that time been used expressly in terms of health and medicine, stating that humankind is cleansed of this madness by poetry and drama. We are, he indicated, released by our inner demons as we experience tragic performances that reveal the sufferings of others.

Aristotle suggested that we are drawn to the beauty of the tragedy and that we find excruciating pleasure in our experience of artfully constructed tragic creations—essentially when we swoon at the grace of a lyric or vocal performance and thrill to the intricate architecture of a symphony. Modern translators of Aristotle's work believe he may have meant to say that we feel nothing short of ecstasy during catharsis, and that audiences are comforted to see lives tragically unravel, to witness the artistic heights of schadenfreude, leaving the amphitheater after a performance of Sophocles's *Oedipus Rex,* feeling secure in the knowledge that their lives aren't really so bad after all.

By the turn of the thirteenth century, the power of music was apparent, as noted in *Summa Musice*, a plainchant teaching manual, which states that music "cures diseases, especially those which arise from melancholia and sadness" and that "through music one can be prevented from falling into the loneliness of pain and despair." This belief is later found in Robert Burton's landmark study *The Anatomy of Melancholy*, in which he writes, "Many men are melancholy by hearing Musicke, but it is a pleasing melancholy that it causeth, and therefore to such as are discontent, in woe, feare, sorrow, or dejected, it is a most pleasant remedy, it expels cares, alters their grieved mindes, and easeth in an instant."

Aaron Smuts, assistant professor of philosophy at Rhode Island College, wrote in his essay "Rubber Ring: Why do we listen to sad songs?" that we listen to these songs not for catharsis but rather "to

intensify negative emotions partly as a means of focusing our reflection on situations of great importance," and it may well be that wallowing is a natural, protective state. It's possible that we listen to sad music precisely so that we may crawl deeper into our sorrows, and that the more unfathomable the grief, the more likely our brains will respond to the distress by opening the dopamine taps and shaking loose protective hormones. As classical composer Stephen Johnson has noted, "There is something about seeing your own mood reflected that allows you to let go of that feeling." Similarly, singer and songwriter David Sylvian has said, "I guess I find comfort in music that's more in touch with the darker elements of human emotion. That allows me some cathartic release that brings about a sense of joy. If I wallow in negative feelings, it's to recognise them, share them, and ultimately be released from them." We may turn to gloomy music and sad songs to wade in our own sorrows, and the music we choose to listen to may drive us deeper into our despair, but, sooner or later, the hope is, all roads lead to catharsis.

"Right, let's put it bluntly. Does Thom suffer from depression?" This was posed to Radiohead singer Thom Yorke during a 2001 *Uncut* interview, to which the singer curtly called out the stigmatism of depression, pointing out, appropriately, that "it damages the people who suffer from it." Sorrow has purpose, but depression is in the unenviable spot of remaining stigmatized while being massively overdiagnosed. Depression—the world's fourth worst health problem, according to a 2007 study conducted by the World Health Organization—in its darkest, most crippling form as well as its more mild, recurrent articulation, remains a source of shame, while overdiagnosis and the chase to pathologize emotive states that most would not consider abnormal at all, such as shyness, has simultaneously led to the belief that it can be easily controlled.

Not only has science allowed for a better understanding of mental health diseases like depression, but follow the money behind those numbers and the growth becomes more understandable. In 2007 antidepressants were a $12 billion annual market, and psychotherapeutic drugs (a class that includes antidepressants, antipsychotics, and antianxiety medications) were a $37 billion market.

Antidepressants have been reportedly used for back pain, nerve disorders, fatigue, cooling hot flashes, and treating hypersexual disorder. Yorke confessed to the *Times* in 2005, "There are giant waves of self-doubt crashing over me, and if I could alleviate this with a simple pill I think I would." The "idea" of psychopharmacology is now so many-limbed and multifaceted in the general consciousness that, reports *U.S. News & World Report*, many people "also expected the medications could help people deal with day-to-day stresses, help them feel better about themselves, and make things easier with family and friends." This attitude runs concurrent with the media's release of studies finding that a placebo could duplicate 82 percent of the response to antidepressants, as well as seemingly casual statements like "psychoactive drugs are useless," made, in *The New York Review of Books*, by the former editor in chief of *The New England Journal of Medicine*.

In a July 2011 editorial in the *New York Times* psychiatrist and author of *Against Depression*, Peter D. Kramer, wrote, "It is dangerous for the press to hammer away at the theme that antidepressants are placebos. They're not. To give the impression that they are is to cause needless suffering." To this end it's worth noting that almost all psychiatric professionals make a clear distinction between mild and severe forms of depression, and the surprising placebo effect is largely present in more mild forms of the disease. (It's also worth noting that only a mental health care professional is equipped to judge the difference.)

Social anxiety disorder and the desire to hide from the world often go hand in hand with depression—a longing captured phenomenally on Radiohead's "How to Disappear Completely," when Yorke sings, "I'm not here / This isn't happening." The result is often immersion in solitary activities like reading or listening to music. Harry Nilsson astutely sang (in a few separate octaves), "One is the loneliest number that you'll ever do," and loneliness is becoming epidemic. The authors of *Loneliness: Human Nature and the Need for Social Connection* define the difference between loneliness and depression concisely by saying that "loneliness reflects how you feel about your relationships. Depression reflects how you feel, period."

In 2000 there were a reported 26 million people in the United States living completely alone, and those numbers have continued to rise to nearly 31 million in 2010, according to the US Census Bureau—that's more than the total population of the ten most populous cities in the United States combined. When we set out to listen to something like "I'm So Lonesome I Could Cry," it's often because we already feel as desolate as Hank Williams seems to have been and want to be reminded that we're not alone for feeling lonely. As Lee Hazlewood said on his 1971 breakup concept album *Requiem for an Almost Lady*, "Probably the only comforting thing about losing someone you love is when you discover there're so many others riding the same train as you."

A study conducted by the University of Pittsburgh School of Medicine found a correlation between a greater number of hours that teenagers listen to music and increased rates of depressed feelings. In an interview with rock critics Jim DeRogatis and Greg Kot of radio talk show *Sound Opinions*, one of the study's researchers noted that this still leaves open to interpretation the question hapless record-store owner Rob Fleming asks in Nick Hornby's *High Fidelity*, "What came first—the music or the misery?" Fleming notably goes on to ask, "Did I listen to music because I was miserable? Or was I miserable because I listened to music? Do all those records turn you into a melancholy person?"

One of the reasons for the confusion, and why these songs may continually speak to us, is the existence and function of mirror neurons. Originally discovered in macaque monkeys during the 1980s and early 1990s, mirror neurons—a class of cells that fire when an animal performs a specific action or when that action is replicated, by sight or sound, by another animal—are now thought to play a role in a number of species, and may be critical in everything from young birds learning to sing to basic human emotions such as empathy and creating sympathetic reactions. This all may help to explain the emotional power of sad songs with defined narrative elements, as we may simply be hardwired to sympathize with Sinatra's sense of 3 a.m. despair or the National's thrumming urban anxiety.

There aren't too many genres of popular song, and one of the things I think we all love is a sad song.

—LEONARD COHEN

Artists hate to be tagged something as droll as melancholic or, heaven forbid, mopey. With the exception of "twee," is there any genre coinage more deflating to rock's rebel stance than "mope rock"?

Mark Eitzel, interviewed in 2008 by website PopMatters, had this to say about being labeled a miserabilist:

> It's kind of remarkable because people who know me always wonder why the media would label me a "miserabilist." I made a mistake when I was younger because I should have sung everything with a smile. I find that a lot of music I surround myself with is much darker, yet no one calls the members of Slayer miserabilists. It's a fucked-up thing and I really don't like it and I don't understand it. I take it as a put-down. I've been reading this for years about me being miserable and I'm like "Fuck You!" You're just trying to kill me and kill my music by saying shit like that. I mean, who wants to buy music by a miserabilist? Not me.

Eitzel's proclamation aside (he did join up with fellow sad sacks Will Johnson, David Bazan, and Vic Chesnutt for the Undertow Orchestra Tour in 2006), categorization has "a clear evolutionary purpose," says Steven Pinker, Harvard psychology professor and author of *How the Mind Works*. During our development, the still-forming brain heard its first song, and from that moment we began to lay the brickwork for labeling and storing all the music we would hear throughout our lives. We certainly didn't know it at the time, but that first song was categorized somewhere in the back of our minds as "music." It was our singular experience of it, so there was no need to differentiate it from other music. Yet as we heard more we began to notice differences. By the time most of us are in our teens, we're familiar with basic genre categories (the ones you used to find at most record stores): Classical, Blues, Country, Folk, and so on. Certainly

to anyone with an interest in music, these basic categories don't cut it for very long. Sooner or later, as we invest time and energy into listening and learning, we need more categories to define our new experiences.

As the public conversation becomes decentralized with the decline of 800-pound tastemakers such as *Rolling Stone* and MTV, the disappearance of record stores, the postmodern cut-and-paste approach to the creation of new music, and the rise of blogs, niche websites, social networking, and Internet radio, genres are not solidified with the certainty that they once were. So listeners and fans are stuck with a web of overlapping labels: The term *witch house* (or drag, or haunted house, or screwgaze, etc.) became the basis of a number of articles in 2010, as the mystifying label seemed to throw critics and music lovers for a loop. At the time of this writing, Wikipedia is home to a list of approximately 1,500 musical styles, beginning with 2-step garage and ending with zydeco.

In the tsunami of technological advances that has washed over the music industry in recent years—and in the process leveled much of what once was—the act of classification has become simultaneously more and less relevant. The democratization of the industry—from the ease of recording to the radical changes in distribution—has made for glut, almost an auditory existentialism, as choices become stultifying. This exponential explosion of artists and distribution methods requires new and inventive ways for listeners to separate the worthwhile from the schlock.

With so many fresh technologies allowing new ways to discover and listen to music, and rather than deepening the already cavernous gorge of genre definitions, we've alighted on another dimension of music categorization: mood.

Melancholics have been filed together in the past, long before anyone knew what "gloom rock" was, notably during the miserabilism that flourished in Elizabethan England, when, according to author and early music revivalist Diana Poulton, "a vogue or fashion for melancholy grew up not only among writers and musicians but among the aristocracy as well." Other notable miserabilist movements included the short-lived Wertherism (so named for Johann

Wolfgang von Goethe's wildly successful 1774 book *The Sorrows of Young Werther*) and Byronism (after the stormy Romantic poet George Gordon, Lord Byron), during the late eighteenth and early nineteenth centuries.

Internet radio and streaming services such as Pandora—also known as The Music Genome Experiment—base their recommendation engines on classifications and the art of breaking every song down to roughly 250 touch points, or what the company refers to as "genes." AllMusic, which sells its content (album reviews, artist bios, and more) to such high-profile clients as iTunes and eMusic, has been using an adjective-driven classifying strategy—what they refer to as "Moods"—for years. It's the ultimate clash of music geek and data nerd, and it has historical precedence in the loose-knit theory of *Affektenlehre* that became popular among Baroque-era composers who wished to impose a rational through-line to the elements of a given work by its affect: joy, anger, hate, love, jealousy, and sadness. No one can prove that any particular artist's work is specifically "detached" or "circular," of course, to highlight two "moods" found on AllMusic, but when dozens of these labels are corralled it begins to create a data-rich map of each artist's emotional core. The classification of so many artists and the use of those classifiers to bridge one artist to similar artists is relevant and marks a precursor to Pandora, which is based on a comparable methodology and puts it in the service of streaming radio. Instead of returning a simple list of like artists, Pandora creates for the user a never-ending personalized playlist, based on moods and a map of identifiers attached to each song. You can start a Pandora station with one suggestion, and from that one suggestion, the seed of a playlist, it grows, culling from its library similar artists and songs to serve up to the listener. A user can rate each song, then Pandora will catalog that user's opinions and slowly curate a personal station that, over time, becomes more and more unique to an individual.

A series of other start-ups have clued into the "emotional genre" concept over the past few years, including Stereomood ("tuning my emotions"); Musicovery, which allows you to choose music via a mood pad with four poles (Energetic, Positive, Calm, and Dark);

Moody, which coordinates your music library via a color pad featuring sixteen colored squares; nexTUNE, which features "Mood-maker" playlists; and Hutke (an Indian radio player), which features a mood grid of expressive cartoon faces such as Speechless, Sleepy, and Heartbroken to guide your listening.

Music fans today are more likely to be exposed to and enjoy music across a variety of genres (in part simply because more artists are mixing and remixing disparate genres into more single slices of sweet auditory racket than ever before). It's not difficult to imagine a time when the evolving classification of music by mood creates a consumer experience with a user-generated mood rating alongside a star rating—Coldplay's *A Rush of Blood to the Head* gets four out of five stars and is 72 percent sad, and Frank Sinatra's "Only the Lonely" gets five out of five stars and is 89 percent bury-your-head-in-your-hands-and-cry sorrowful—and *sad* becomes the new *jazz*.

SONG ESSAY: "LUSH LIFE"

Composer Billy Strayhorn began writing "Lush Life"—easily among the most emotionally complex standards in the Great American Songbook—in 1931, when he was just sixteen years old. He revisited the song a number of times over the following five years, slowly nudging the poetry into place, performing it for friends, sharpening its bite, before revealing it publicly as a duet with singer Kay Davis during a November 13, 1948, Carnegie Hall concert with the Duke Ellington Orchestra.

It's an intricate torch song—Frank Sinatra attempted to record it but gave up, exclaiming that he would return to it at a later date (he never did)—and one Strayhorn didn't conceive of as anything more than a personal hymn and party favor. "You know, you have your private projects? Well, that was 'Lush Life,'" he once explained. "I never intended for it to be published." Strayhorn's diaristic approach may help to explain the song's profound emotional impact, as singer/pianist Andy Bey said, lightly jabbing Sinatra's spirit and underlining the song's maudlin aspect: "It's not about 'ring-a-ding-ding' when you

do 'Lush Life.'" David Hajdu, the author of *Lush Life: A Biography of Billy Strayhorn*, calls the song "a masterpiece of fatalist sophistication" and, ultimately, "a prayer" from a prodigious young talent who dreamed of escaping his working-class environs—Strayhorn was raised in the rough Homewood area of Pittsburgh—for "jazz and cocktails" in Paris. The composer could have also been giving poetic form to a homosexuality that he was still learning to embrace—he was openly gay the majority of his life—with some looking at the opening line, "I used to visit all the very gay places," as a double entendre that slyly referenced his orientation. However, most doubt that this was the case as *gay* as a synonym for homosexuality didn't enter the common lexicon until much later, and it's unlikely that a teenager from Homewood would have known of it in that context. But there are other coded indications that Strayhorn was exploring his sexuality in the song, including the fact that the lyrics dispense with identifying males or females (with the singular exception of the "girls with sad and sullen gray faces" who are little more than drab wallpaper in "come-what-may places"); the idea that a "poignant smile" would be "tinged with a sadness of a great love," which reveals unusual complications beneath an emotion usually represented as pure joy; and his heartache at reading, not for the first time, a smile incorrectly: "Ah yes, I was wrong / Again, I was wrong."

The young Strayhorn's head was stuffed in gray clouds, and his miraculous escape from Homewood contains nothing of the world-conquering teenagers often daydream of, but rather a mysteriously cultivated cynicism that imagines his fantasy as nothing more than another dark corner. In this stunning piece of music he joins the jet set in style but can't escape his overbearing sense of loneliness.

The first jump in time places the composer into the dizzying lifestyle he craves with only loneliness there to meet him. He's haunted these nightclubs and bars for so long that he now seems to do it only out of habit, when suddenly something different, someone new "with a siren song" appears. But the storm clouds break for only an instant, mere seconds, before quickly regathering ("I was wrong"). In a blink Strayhorn jumps from what could be yesterday or years ago, reminiscing about when—as the music leaps briefly to a more hopefully

key—"everything seemed so clear," but again optimism is short-lived as the language turns ugly ("life is awful again") and he declares that even a gutter full of hearts would do little to snap his melancholy. In order to move on he eventually fabricates a silver lining in the form of the old yarn that "Romance is mush / Stifling those who strive," before turning his future "lush life" as a drunk in "some small dive" into a bitter resignation, understanding that he'll have the jazz, and he'll have the cocktails, but he'll never have love: "There I'll be / While I rot with the rest of those whose lives are lonely, too."

Strayhorn originally titled the song "Life Is Lonely" before swapping it for the more evocative "Lush Life," saying, "When anyone wanted me to play it, they asked for 'that thing about lush life,'" and of course, that title stands as one of music's greatest as it both skillfully plays with the notion of a "lush life" brimming with romantic excess (all oxblood crushed velvet smoking jackets, spur-of-the-moment trips to Paris, etc.), but also betrays the alcoholism that would trouble the composer later in his life.

In 1938 Duke Ellington heard Strayhorn perform the song. Impressed, he asked the young composer to write up an arrangement for the Ellington band, which he did the very next day under the title "Lonely Again." It was never performed by Ellington's band, but the meeting did spark one of the most inventive collaborations in all of music history as Ellington and Strayhorn would go on to work closely for years (some even believe a brief romantic relationship existed between the two), resulting in a string of jazz classics including "Take the 'A' Train," "Chelsea Bridge," and "Satin Doll" (the latter of which Strayhorn was uncredited for), though they would never record Strayhorn's most popular composition. ("Lonely Again" can be found on the 2003 release *So This Is Love: More Newly Discovered Works of Billy Strayhorn* by the Dutch Jazz Orchestra.)

Ten years after Strayhorn scribbled his first arrangements for Ellington, Norman Granz, founder of the Clef, Norgran, and Verve labels, heard him perform "Lush Life" and insisted he record it for a compilation album Granz was putting together. Strayhorn evidently did record the song, and though it was ultimately left off the compilation (and seemingly lost to time), the studio was visited that day

by Nat King Cole, who was so impressed by the song he recorded it himself. His 1949 exotica-touched rendition, which took tiny liberties with the music and lyrics—skittering bongos here, swapping "stifling" for "strifling" there—upset the generally unflappable Strayhorn, and a friend of the composer recalled him screaming, "Why the fuck didn't they leave it alone?" But in a flash of serendipity, on their way to a one-day recording session on March 7, 1963, saxophonist John Coltrane and singer Johnny Hartman heard Cole's "Lush Life" on the radio and decided to include it in the day's lineup, Hartman remarking, "That is a fantastic song." Recorded in one take—as most of the material for 1963's *John Coltrane and Johnny Hartman* was—Coltrane's artful ballad style, coupled with Hartman's mature baritone and naturalistic approach, lends appropriate gravity to the song's sophisticated grief, and their recording stands as definitive. It is also said to have been Strayhorn's favored rendition of his best-known song.

DAVID ACKLES

In 1974, *Melody Maker* wrote that listening to a David Ackles album was "somewhat heavy going," and while it's true that his character-driven songs never shied from tackling dark topics such as mental illness ("Inmates of the Institution"), racism ("Blues for Billy Whitecloud"), addiction ("Main Street Saloon"), and child abuse ("Candy Man"), each of the four albums he released between 1968 and 1973 remain unique classics in the history of the American songbook. Having initially studied literature at the University of Southern California and Edinburgh University in Scotland, he graduated with a degree in film studies, and his roots in theater and film (he starred in a series of children's films in the late 1940s) mark his sweeping, theatrical songs. After a short stint as a songwriter for Elektra, the label signed him to a recording deal that allowed him to release three mid-seventies classics, beginning with his 1968 self-titled debut (rereleased in 1972 as *Road to Cairo*, also the name of the album's breakout

track), a work of remarkable maturity, more firmly rooted in singer-songwriter territory than anything that would come after. By the time of 1970's *Subway to the Country*, Ackles had acutely honed his dark style, as songs like the boozy show-tune opener "Main Line Saloon," the delicate "That's No Reason to Cry," and the eerie "Candy Man" (about a one-handed Vietnam veteran who gives pornography to children) demonstrate a marked growth in Ackles's confidence as a writer and performer. Named *Melody Maker*'s album of the year and produced by Elton John lyricist Bernie Taupin, 1972's *American Gothic* is his masterpiece. An album bursting with classic songs, including the Brechtian "American Gothic," which tackles a loveless marriage in painful detail, the plaintive and heartbreaking "Love's Enough," and the cynical "Oh, California!" ("Let's be happy until the sun goes out!"), it's the ten-minute-plus "Montana Song" that deserves a particularly close listen. Filled with moments of simple, hard-won beauty, reflective of the daily trials facing Montana's early settlers, it's a sprawling song that ignores traditional pop form as it slowly unfolds into golden Copland-esque vistas dotted with brief melodic cloudbursts. Each of Ackles's three albums for Elektra met with critical praise but poor sales, and the label decided not to renew his contract. Some reviewers compared *American Gothic* to the Beatles' *Sgt. Pepper's* and Ackles felt it impossible to keep up the ambitious scope he had set for himself. As such, his one-shot release with Columbia Records, 1973's *Five & Dime*, is a cautious step away from the grandeur of *Gothic*, though his power remains on songs such as "Run Pony Run" (concerning the hunting of horses for food during the beef shortage of the early 1970s), "I've Been Loved" (about the helplessness Ackles witnessed while visiting his aging grandmother), and "Surf's Down." The latter, a curious parody of the surfer music that ruled the California airwaves in the early and mid-sixties, features a guest vocal performance by Dean Torrence of Jan and Dean, and plays out as both a cracked celebration and a vicious attack, its sprightly electric organs propping up a world of severed toes and dirty old men. Ackles reentered the film and theater world after *Five & Dime* failed to find an audience, teaching theater at USC, writing for television, and eventually penning the score to the musical

Sister Aimee. He died of lung cancer in 1999, but songwriters such as Elton John (who dedicated *Tumbleweed Connection* to him), Phil Collins, Tom Waits, and Elvis Costello (who has written that Ackles was "perhaps the greatest unheralded songwriter of the late sixties") continue to acknowledge the tremendous power of his brief output.

THE MISERABLE LIST: DAVID ACKLES

1. "Sonny Come Home"—*David Ackles* (1968)
2. "Down River"—*David Ackles* (1968)
3. "His Name Is Andrew"—*David Ackles* (1968)
4. "That's No Reason to Cry"—*Subway to the Country* (1970)
5. "Candy Man"—*Subway to the Country* (1970)
6. "American Gothic"—*American Gothic* (1972)
7. "Waiting for the Moving Van"—*American Gothic* (1972)
8. "Surf's Down"—*Five & Dime* (1973)
9. "Run Pony Run"—*Five & Dime* (1973)
10. "Aberfan"—*Five & Dime* (1973)

AMERICAN MUSIC CLUB

San Francisco's American Music Club made their first unassuming appearance as a coffeehouse trio built around the post-punk infatuations of singer-songwriter Mark Eitzel—the singer screaming, ranting, and throwing spastic fits à la Ian Curtis, backed by acoustic guitar and an upright bass. It wasn't until 1983, when guitarist Vudi (Mark Pankler), bassist Dan Pearson, and drummer Matt Norelli approached Eitzel about working together, that American Music Club, as the world knows it, was born. Taking the name specifically for its nondescript qualities ("the worst band name in rock history," per Eitzel), the group began performing and sculpting Eitzel's songs into what would become its debut album, 1985's *The Restless Stranger*. Norelli and keyboardist Brad Johnson exited following the release,

and drummer Tim Mooney signed on. Eitzel's songwriting—packed with emotional intensity and threadbare honesty—found its stride on the group's third album, 1988's *California*, in songs like "Blue and Grey Shirt," about Eitzel's last visits with a friend dying of complications from HIV/AIDS, and "Western Sky," which touches on the songwriter's recurring theme of displacement, which became instant classics. Multi-instrumentalist Bruce Kaphan was brought in to play pedal steel on "Blue and Grey Shirt" and the album opener "Firefly," and soon became a full-time member of the group. The purest evocation of American Music Club can be found on 1991's *Everclear*, but it's their major label debut, 1993's *Mercury*, that best captures the bands eclecticism and a keen collection of Eitzel's darkest material, such as "Dallas, Airports, Bodybags," "Apology for an Accident" ("I'm an expert in all things that nature abhors"), and the Lazarus-as-doomed-romantic downer epic "I've Been a Mess." The group split shortly after the release of their fifth album, 1994's *San Francisco*, and Eitzel went on to release a handful of solo albums of varying quality. Then, in 2003, the band was resurrected by Eitzel, Vudi, Pearson, and Mooney, resulting in their first album in ten years, 2004's *Love Songs for Patriots*. It was a gentler AMC, or as Eitzel described the work, it's "kind of a Bread album." Only Eitzel and Vudi remained for 2008's *The Golden Age* (the pair rounded out by bassist Sean Hoffman and percussionist Steve Didelot), but the resulting album was worthy of the group at their peak. Eitzel has said, "I see transcendence through songs as a possibility, even though it sounds really stupid." It may be futile to try and assuage his fears with the knowledge that few bands have offered as many transcendent moments during their careers as American Music Club has, but it's worth noting.

See also: Mark Eitzel

THE MISERABLE LIST: AMERICAN MUSIC CLUB

1. "Room Above the Club"—*The Restless Stranger* (1986)
2. "Blue and Grey Shirt"—*California* (1988)
3. "Here They Roll Down"—*United Kingdom* (1989)
4. "Heaven of Your Hands"—*United Kingdom* (1989)
5. "Rise"—*Everclear* (1991)
6. "Why Won't You Stay"—*Everclear* (1991)
7. "I've Been a Mess"—*Mercury* (1993)
8. "Johnny Mathis' Feet"—*Mercury* (1993)
9. "Fearless"—*San Francisco* (1994)
10. "All the Lost Souls Welcome You to San Francisco"—*The Golden Age* (2008)

ANGELS OF LIGHT

Angels of Light grew from the ashes of singer/songwriter Michael Gira's brutal New York City No Wave group Swans, and was initially intended to go by the name the Pleasure Seekers, before Gira stumbled on an all-girl sixties garage-rock group with an established claim to that name. Gira's bleak-folk approach to traditional song forms results in a confrontational Americana, inspired by "old-time" music yet thoroughly modern in its avant-garde accoutrements and confessional poetry: He often sings of friends and family, fantasy and memory, with lyrics that are dark, painfully honest, or, as often as not, both. Although Gira's movement toward a more intimate setting was apparent on late Swans releases, like shimmers of moonlight on an otherwise pitch-black lake, with Angels of Light he stripped away the epic sheets of noise and industrial heartbeat that marked much of his earlier work and focused on crafting smaller settings for his dust-bowl growl and disarmingly personal lyrics. Which is not to say that Angels of Light doesn't pack a punch: "Palisades," from 2003's *Everything Is Good Here/Please Come Home*, hypnotically

pulsates before violently collapsing in on itself, while "My True Body," from 2001's *How I Loved You*, and "We Are Him," from the 2007 album of the same name, marry his Appalachian concerns with waterfalls of hissing drone. Repetitive, hypnotic passages—another trademark of Gira's compositions—add a transportive, dream-rock element to some songs, like "Song for Nico" (*How I Loved You*) and "Kosinski" (*Everything Is Good Here/Please Come Home*). But Gira's truest musical lineage (Lou Reed by way of Hank Williams) shines through on songs pared back to just the man and his guitar, which is how Gira usually performs these songs live. That said, throughout the career of Angels of Light he has worked with a number of incredible collaborators (no less than nineteen to produce 1999's debut, *New Mother*), including Phil Puleo, Christoph Hahn, Thor Harris, Kid Congo Powers, Bill Rieflin, the members of Akron/Family, and dozens of others. A self-taught musician, Gira comes from the "vessel" school of songwriting; that is, he views the act as simply picking up a guitar and waiting patiently for something to flow through him. "I don't think I personally write the songs," he said in a 2007 interview with junkmedia.org, "I feel like someone else does it. In a way, it's like I'm haunted." If only more artists were haunted by such radiant songs.

THE MISERABLE LIST: ANGELS OF LIGHT

1. "Praise Your Name"—*New Mother* (1999)
2. "The Man with the Silver Tongue"—*New Mother* (1999)
3. "Evangeline"—*How I Loved You* (2001)
4. "Song for Nico"—*How I Loved You* (2001)
5. "New York Girls"—*We Were Alive!* (2002)
6. "Palisades"—*Everything Is Good Here/Please Come Home* (2003)
7. "Kosinski"—*Everything Is Good Here/Please Come Home* (2003)
8. "Destroyer"—*Sing 'Other People'* (2005)
9. "Black River Song"—*We Are Him* (2007)
10. "The Man We Left Behind"—*We Are Him* (2007)

ANTONY AND THE JOHNSONS

Antony Hegarty is, in name and in practice, the focus of Antony and the Johnsons. The husky, porcelain-white transgender singer stands more than six feet tall and possesses an ethereal voice that shivers with unnatural vibrato—haunted by the spirits of Nina Simone and ghostly folkie John Jacob Niles. Hegarty created and performed as part of the cabaret act Blacklips in New York City before forming Antony and the Johnsons in 1997, the group performing as part of ambient artist William Basinski's Life on Mars installation. The group's self-titled debut was released to glowing reviews on David Tibet's (Current 93) Durtro label in 2000. The following year saw the release of the *I Fell In Love with a Dead Boy* EP and Antony's subsequent appearances on Lou Reed's *Raven* (2003) and *Animal Serenade* (2004) albums, as well as his time performing live with Reed, raised his profile dramatically. In 2003 Durtro released *Live at St. Olave's Church,* a limited-edition CD split single with Current 93, and in 2004, the band collaborated with conceptual video artist Charles Atlas on TURNING, a live concert performed with a series of video portraits presented as part of the Whitney Biennial. Also in 2004, the group released *The Lake* and *Hope There's Someone* EPs, setting the stage for the band's second full-length release, 2005's *I Am a Bird Now.* With the dramatic 1974 black-and-white photograph *Candy Darling on Her Deathbed* as a cover (by photographer Peter Hujar), announcing both mood and motif, the album features a string of devastating torch songs focusing on Hegarty's struggle to understand his transgender identity (Hegarty is self-identified as transgender, a definition of gender that defies fixed male or female roles). The appearance of high-profile guests such as Rufus Wainwright, Boy George, Devendra Banhart, and Lou Reed helped the album reach a wide audience, and it became one of the most talked about albums of the year, topping year-end lists in North America, Australia, and across Europe, and went on to win the prestigious Mercury Music Prize. Following the huge success of *I Am a Bird Now*, Hegarty recorded duets with Marc Almond,

Björk, Linda Thompson, and others; exhibited his artwork in Brussels, London, and Turin; and played a major part in the first album by gender-bending dance act Hercules and Love Affair—all while rigorously prepping material for a follow-up. The group returned in 2008 with the *Another World* EP, which preceded the 2009 release of their third album, *The Crying Light*. The group recorded more than twenty-five songs before settling on the eleven that make up the album, which is dedicated to famed Butoh dancer Kazuo Ohno (whose surreal image graces the cover). Featuring arrangements by Hegarty and avant-garde classical composer Nico Muhly, the album has themes that are, again, intensely personal and largely focus on the intersection between identity politics and environmentalism: "In the future, if there is one," Hegarty said during a 2009 interview, "people will spit on us for the reckless way we used up the earth." Speaking about what his next project may be, Hegarty mused that it would be nice to do a dance-oriented album, saying, "My music is totally morose, no one wants to dance to that." His next project turned out to be the *Thank You for Your Love* EP in the late summer of 2010, followed in the autumn by *Swanlights*, a successful continuation of his vanguard pop that was available packaged with a book of Hegarty's paintings and writings, which he closed with the thought, "I hope when I die, that I never return to your world. I will go where the trees go, I will go where the wind goes, where the birds go, I will leave you all to enjoy the world that you are creating for your children."

ARAB STRAP

Named after a popular men's sexual aid used to retain erections, the Scottish act Arab Strap found success in the wake of Belle and Sebastian's indie invasion in the late nineties (it certainly didn't hurt that B&S named their second album *The Boy with the Arab Strap*). But singer Aidan Moffat and multi-instrumentalist Malcolm Middleton carved out a decidedly less twee path. Known for their

unapologetically brusque lyrics about messy relationships, sloppy sex, drunken epiphanies, and the minutiae of the young and bored, there's a *Twin Peaks*–meets–*Prozac Nation* sagacity to what the Strap conceived: rejected, disinterested, confused, and angry—they were a musical manifestation of Gen-X inertia. Aidan Moffat's slurred, muttered vocals (picture a deeply inebriated Leonard Cohen with a thick Scottish brogue) are like an oil spill slowly spreading over a sea of sleepy lo-fi drum machine beats, acoustic guitars, and sheets of electronic hums. Their initial splash came with the 1996 single "The First Big Weekend"—a novelty song about the duo's first long and debauched weekend of the summer, which many people briefly believed to be a spoken-word track by novelist Irvine Welsh—which also appeared on their 1997 debut full-length, *The Week Never Starts Round Here*. *Philophobia* (also known as the fear of love) followed in 1998 and raised eyebrows with its opening line, "It was the biggest cock you'd ever seen, but you've no idea where that cock has been." The 2000 release of *Elephant Shoe* (a replacement phrase for those who find "I love you" a bit of a mouthful) proved a hesitant step forward in emotional maturity, while the release of *Mad for Sadness*, just weeks later, captured the band's lauded live show for posterity. It wasn't until 2001's *The Red Thread,* though, that the group hit its peak on the strength of songs such as the Morricone-meets-codeine march of "Last Orders" ("Always the last chance for you and me / First come apologies, then the plea") and the graceful, against-type "Haunt Me." Both Middleton and Moffat spun off their first solo albums after the release of *The Red Thread*: Moffat (under the name Lucky Pierre) recording immersive and cinematic instrumentals employing orchestral, hip-hop, and electronic elements, while Middleton took his turn at the microphone. The duo regrouped for 2003's *Monday at the Hug & Pint*, and later that same year they released their second live album, *The Cunted Circus*. Their final album, *The Last Romance*, landed in 2006 (as did the best-of compilation, *Ten Years of Tears*) and proved to be a mixed bag. Songs like "There Is No Ending" ("Now everything must end / Now every romance must descend") captured a marked maturity, while "Speed Date" and "(If There's) No Hope For Us," sounded like toss-away Dinosaur Jr., the

duo's unique properties all but disappearing behind a wall of fuzz and cymbals. Following the dissolution of Arab Strap, Middleton continued to record under his own name, while Moffat has released work as Lucky Pierre, Aidan John Moffat, and as the leader of Aidan Moffat and the Best-Ofs.

THE MISERABLE LIST: ARAB STRAP

1. "The First Big Weekend"—*The Week Never Starts Round Here* (1998)
2. "The Clearing"—*The Week Never Starts Round Here* (1998)
3. "Packs of Three"—*Philophobia* (1999)
4. "Cherubs"—*Elephant Shoe* (2000)
5. "Girls of Summer"—*Mad for Sadness* (2000)
6. "Last Orders"—*The Red Thread* (2001)
7. "The Love Detective"—*The Red Thread* (2001)
8. "Haunt Me"—*The Red Thread* (2001)
9. "The Shy Retirer"—*Monday at the Hug & Pint* (2003)
10. "There Is No Ending"—*The Last Romance* (2006)

SAMUEL BARBER

A self-described "living dead composer," Barber's adherence to long, melodic lines and the emotional heart of his compositions often consigned him to the role of anachronistic romantic in a classical world experimenting heavily with atonality, electronics, and conceptual acrobatics. It's likely, though, that Barber's ability to go his own way in the face of such institutional change was exactly what endeared him to prewar audiences perplexed by, or simply tired of, the tricks of modern composition, ultimately making him America's most well-known classical composer. Born in West Chester, Pennsylvania, on March 9, 1910, Samuel Barber was surrounded by music in his youth, with a celebrated contralto aunt and composer uncle. He wrote his first pieces of music—one a short solo piano composition

titled "Sadness"—at the age of seven, and attempted his first opera at ten. Possessed of an instinctual baritone, Barber trained early as a singer, but by the time he graduated from the Curtis Institute of Music, in Philadelphia, he had found solid footing as a composer, having completed Op. 1, Serenade for String Quartet; the Overture for *The School for Scandal* (1931); and the celebrated *Dover Beach*, which was set to a bleak poem by Matthew Arnold. He had also met his lifelong partner and collaborator, Gian Carlo Menotti. Confident in his style, he composed a number of outstanding pieces, including his String Quartet (1936), in which was embedded a mournful and especially moving adagio. While the success of "Adagio for Strings" has made it one of the most widely known American classical compositions, its success has also served to mute the historical import of Barber's other works. Like many great composers or songwriters, Barber exhibited a great expressive range in his work, but his propensity for pastoral melancholy led poet Robert Horan to observe that "almost everywhere in [his] work is the sensitive and penetrating design of melancholy." He completed *Let Down the Bars, O Death* (based on the poems of Emily Dickinson) in 1936 and wrote to his parents, "It will be all right for someone's funeral." The haunting *A Stopwatch and an Ordnance Map*, which Barber completed in 1940, is based on a poem by Stephen Spender, and makes grim study of the death of a soldier during the Spanish Civil War. His compositions of the early postwar years included *Hermit Songs* (1953) and *Prayers of Kierkegaard*, the latter based on the writings of the Danish existentialist and which he started in 1942 but did not complete until 1954. He finished his first opera, *Vanessa*, in 1957. The story of a woman forever awaiting the return of her lover who had disappeared twenty years earlier, *Vanessa* unfolds to reveal the cyclical nature of life, love, and heartbreak. Barber won the Pulitzer Prize for *Vanessa* in 1958 (he would win the Pulitzer again in 1962 for his Piano Concerto), and although it is largely considered to be a middling opera, it's also considered one of the best American contributions to the form. In 1959 he completed both the twelve-tone experiment *Nocturne* and a small second opera, *A Hand of Bridge*, which featured a light jazz influence. Where his first opera was a smashing success, and his second was roundly overlooked, his third, *Antony*

and Cleopatra, proved disastrous. Commissioned by the Metropolitan Opera and set to be the inaugural performance at the opening of its new opera house located in the Lincoln Center for the Performing Arts, the production experienced a great influx of money. It premiered on September 16, 1966, and was attacked viciously by critics for its staging and costumes. The opera was subsequently dropped from the repertory after its initial run, and Barber never fully recovered from the experience. He would continue to sporadically compose, even creating some compelling pieces, including *Fadograph of a Yestern Scene* (1971) and the *Third Essay for Orchestra* (1978). Informed in 1977 that he had terminal cancer, he died at home, Menotti by his side, on January 23, 1981. *Let Down the Bars, O Death* was performed at his memorial service.

THE MISERABLE LIST: SAMUEL BARBER

1. *Dover Beach* (1931)
2. *Let Down the Bars, O Death* (1936)
3. "Adagio for Strings" (1936)
4. *Essay for Orchestra,* Opus 12 (1937)
5. Four Songs, Opus 13, No. 1: "A Nun Takes the Veil" (1937)
6. *A Stopwatch and an Ordnance Map* (1940)
7. *Prayers of Kierkegaard* (1954)
8. *Vanessa* (1957)
9. *Nocturne* (1959)
10. *Fadograph of a Yestern Scene* (1971)

SONG ESSAY: "ADAGIO FOR STRINGS"

Samuel Barber wrote "Adagio for Strings" in 1936, at the age of twenty-six, as the third movement in his String Quartet, Opus 11, while summering in an Austrian chalet with his longtime partner and librettist Gian Carlo Menotti. Barber finished the piece toward the end of their stay, writing to friend and cellist Orlando Cole, "I

have just finished the slow movement of my quartet today—it is a knockout!" In January 1938, the composer mailed the score to conductor Arturo Toscanini, perhaps the most well-known classical musician in the country at the time, thanks to his popular weekly radio show conducting the NBC Symphony Orchestra. To Barber's dismay, Toscanini returned the score without comment, and it was only sometime later that the composer discovered that Toscanini, a preternaturally gifted conductor, had already memorized the score and planned to premiere it (which he did) on November 5, 1938, in New York, broadcast to millions of listeners.

Its first quiet tones slowly and mournfully emerged. Long notes betrayed a confident, unapologetic lyricism and an unfussy sincerity that billowed into the minds and hearts of the listeners before, finally, the great swelling suspensions of the third phrase—a piercing kaleidoscope held in a breathless climax—collapsed in on itself, leaving only a few stray elegiac embers smoldering. It remained unresolved as it drifted into silence.

The following morning, longtime *New York Times* classical-music critic Olin Downes wrote of the "Adagio," "we have here honest music, by a musician not striving for pretentious effect, not behaving as a writer would who, having a clear, short, popular word handy for his purpose, got the dictionary and fished out a long one." This was an auspicious beginning for a piece of music that a 2004 *BBC Today* radio audience voted as the single saddest piece of music ever, beating out other top nominated contenders "Gloomy Sunday," sung by Billie Holiday; Mahler's Symphony No. 5; Purcell's "Dido's Lament"; and Richard Strauss's *Metamorphosen*. But the "Adagio" was more or less instantly welcomed into the small cluster of compositions that can be called American masterworks. It was aired on the radio when presidents Franklin Delano Roosevelt and John F. Kennedy died, and it was played at the funerals for Albert Einstein and Princess Grace of Monaco. It was used by director David Lynch—who called the piece "pure magic"—in the tragic finale of his 1980 film *The Elephant Man*, and achieved even greater reach when director Oliver Stone used it in a pivotal scene of his tense 1986 Academy Award–winning Vietnam drama, *Platoon*. Menotti, however, believed the

composer "would not have been amused" by the music's success via Stone's antiwar film, and "might not even have allowed the 'Adagio' to be used." By the end of the 1990s it was so intertwined with tragedy that it became an easy target for parody on shows like *Seinfeld*, *The Simpsons*, and *South Park*. The "Adagio" has been arranged for organ, chorus, woodwinds, marimba, electric guitar, brass band, and clarinet choir, and has been reworked by techno artists William Orbit and Tiësto. Ferry Corsten's remix of Orbit's arrangement paraded into the British singles charts, peaking at number four (and leaving much of the music's forthright beauty behind). Sean Combs (then Puff Daddy, now Diddy) even used a recording of Barber's own vocal transcription of the song for extended versions of his 1997 hit "I'll Be Missing You," written in memory of Notorious B.I.G.

The song was ubiquitous following the events of September 11, 2001, and accompanied any number of memorials. Conductor Leonard Slatkin called it "the classical music world's sound of grief," and composer William Schuman said of it, "I think it works because it's so precise emotionally," adding, "it's never a warhorse; when I hear it played I'm always moved by it." The *New Yorker* critic Alex Ross summed it up astutely when he wrote, "Whenever the American dream suffers a catastrophic setback, Barber's 'Adagio for Strings' plays on the radio." Toscanini's premiere has since been selected for permanent preservation as part of the Library of Congress's National Recording Registry.

Some of the magic of the "Adagio" is the mystery behind its origins, as Barber never revealed what drove him to create such an awesome monument to sorrow. More of its magic is rooted in Barber's populist leanings, the composer saying that he wished to "write good music that will be comprehensible to as many people as possible." To achieve that aim he looked to agitate the heart, saying, "The universal basis of artistic spiritual communication by means of art is through the emotions." Though Barber pocketed the Pulitzer Prize twice in his lifetime and was responsible for a rich and complete catalog that ranked him among the most important classical composers to come out of the US, his legacy remains largely caged by the enormity of the "Adagio."

WILLIAM BASINSKI

A prolific sound artist best known for his four-volume *Disintegration Loops*—a series of physically degenerative tape loops that form a moving statement about the frailty of memory, the insistence of time, and a heap of other metaphorical readings—William Basinski was born in Houston, Texas, in 1958. Classically trained as a clarinetist and saxophonist, he discovered the minimalist, ambient works of Steve Reich and Brian Eno in the late 1970s and began experimenting with prepared pianos, feedback, tape loops, and the sounds of dying appliances ("Our freezer has a great sound," he once said). He moved to downtown Brooklyn in the early 1980s, and would spend time as a member of a handful of New York ensembles (Life on Mars, House Afire) while continuing to experiment with tape loops, creating a massive cache of material that would, in time, become the marrow of his work. He would tour briefly with David Bowie and open the club Arcadia in Williamsburg, Brooklyn (which he now calls "far too hip"), in the 1990s, providing a stage for a number of New York City's underground artists, including Antony Hegarty, Rasputina, and Diamanda Galás. His first album, *Shortwave Music*, appeared on the influential Raster-Noton label in 1998, and set Basinski on a more public path, using his tape archives as the foundation for time-stretched, emotionally devastating compositions. He launched his own label, 2062 Records, in 2000, to release his second album, *Watermusic*, but it wasn't until the 2002 release of the first *Disintegration Loops* material that Basinski's work received wide attention. In the fall of 2001, while in the process of digitally archiving reel-to-reel loops made in the early 1980s, Basinski found that the glue holding the iron oxide (which is then magnetized to capture sound) to the tapes had begun to lose its integrity and that they were literally disintegrating as they played. Treating this organic decay as the wilting heart of the composition, Basinski chanced upon a titanic piece of ambient beauty—glacial, haunting, and disconsolate—and the fact that these experiments unfolded during the events of September 11, 2001, which Basinski witnessed from his Brooklyn rooftop,

gave the music unfathomably deep meaning. Basinski has remained prolific since that time, releasing multiple albums every year, including: *The River*, in 2002; *Melancholia* and three additions to the *Disintegration Loops* series, in 2003; and *92982* and *Vivian & Ondine*, in 2009—all of which are based on material from his extensive loop archive.

ANDY BEY

A truly iconoclastic talent, Andy Bey began performing in front of audiences at eight and recorded his first record, *Mama's Little Boy's Got the Blues*, when he was just thirteen. In 1956, at seventeen, he formed Andy and the Bey Sisters with siblings Geraldine and Salome, and the trio went on to record three albums during the early and mid-1960s before breaking up in 1967. During the sixties, and into the 1970s, Bey sang with Max Roach, Pharoah Sanders, and the politically charged Gary Bartz's Ntu Troop, and began a lengthy association with pianist Horace Silver, the two recording what Silver called "metaphysical self-help music." *Experience and Judgment*, Bey's 1974 solo release, is an overlooked jazz-funk gem—worthy of mention with the best of other 1970s crate-digger classics from Roy Ayers (specifically the Roy Ayers Ubiquity releases) and Gil Scott-Heron—but the album didn't click with audiences, and it would be the last the world heard from Bey for more than twenty years. During his time away from the music industry he studied with vocal coaches, expanding his range to four octaves and mastering his falsetto and the use of the soft palate to create a unique style that led the the *New York Times* to call him "one of the most distinctive singers in jazz." It's hard to argue the point. His breathy, blues-based approach and unconventional phrasing give his performances velvet tactility, while his range—a rich, worn-leather baritone and a falsetto that would give Antony Hegarty a run for his money—and shivering vibrato make them near celestial. Bey's late-career revitalization is built on nothing if not his belief that "slow can be very suspenseful," and his

best songs reveal themselves at a deliberate pace that allows the singer to wring drama from the shortest of phrases. Bey was diagnosed as HIV-positive in 1994, but didn't let the news slow him down. In 1996 *Ballads, Blues & Bey*—an intimate album featuring only Bey's supernatural croon and studied piano—rejuvenated his career. The follow-up, 1998's *Shades of Bey*, continued his winning streak and featured covers of Billy Strayhorn's "Pretty Girls (The Starcrossed Lovers)" and Nick Drake's moody "River Man." *Tuesdays in Chinatown*, released in 2001, included heartfelt takes on Nina Simone's "Little Girl Blue" and Big Bill Broonzy's "Feelin' Lowdown," as well as the spectacular title track—a noirish narrative of a long-running love affair. *American Song* followed in 2004, and in 2008 a 1997 concert was released under the title *Ain't Necessarily So*. In 2010 Bey appeared on the Roots release *How I Got Over*, performing on a cover of his own "Celestial Blues" from *Experience and Judgment*.

Are You Ready to Be Heartbroken?

Heartbeats, Heartbreaks, and Artificial Hearts

All human musical investigation begins before birth with the steady, thumping march of a pulse—our mother's and our own. The cardiovascular system surrounds us with rhythm before we take our first breath, and music, in kind, has the power to affect cardiovascular changes, increasing or decreasing blood pressure and heart rate based on its properties. The heart beats roughly 100,000 times a day (35 million times a year), as blue, oxygen-poor blood is received in the right atrium and ventricle, and becomes oxygenated as it moves through the lungs. Pumped into the left atrium and powerful left ventricle, the now bright-red oxygenated blood is pushed out to the entire body, each beat conducted by a tiny bundle of nerves located on the right atrium called the sinoatrial (SA) node. It's the body's natural TR–808—the iconic drum machine that provided Kanye West with the 808 half of *808s & Heartbreaks* and that Ke$ha references in her song "Your Love Is My Drug" when she asks, "Do I make your heart beat like an 808 drum?" With the exception of the brain, no organ is as worthy of our awe as the heart, and though its function seems so bluntly, and necessarily, straightforward, the system's complexity is

evidenced by the numerous classifications of heart sounds, murmur grades, rubs, pulses, and clicks that exist in medical dictionaries.

The iconic heart-shape silhouette has been found to exist in many cultures through time, beginning with simple drawings by Cro-Magnon man dated to 10,000–8,000 B.C.E., though what it meant to our ancestors is unknown. Early Egyptians believed the heart to be the center of intelligence and emotion—it was the only organ left in the body during the mummification process—but its symbolic power began to truly take form in the Middle Ages with the Christians' use of the Sacred Heart, often inflamed or otherwise wounded, as a symbol of Christ's love, and the more secular use as an emblem of virtue and chivalry. The heart shape turned crimson in the twelfth or thirteenth century, became standardized on playing cards near the end of the fifteenth century, and the icon eventually became a poetic hook for composers and singers from Handel ("Thy Rebuke Hath Broken His Heart") to Lindsay Lohan ("Confessions of a Broken Heart").

In the shock-and-awe world of popular music, nothing takes a walloping like the heart, which is broken, shattered, split, ripped, torn, shot through, and burnt black with alarming regularity. Even if your feet continue to step and walk, and your lips can still move and talk, at any time your heart could simply . . . stop (see: Rodgers and Hart's "My Heart Stood Still"). And if you're wearing a pacemaker, it's possible the unseen magnetic field surrounding your headphones holds the grim power to disrupt the beat box that is keeping you alive.

Every so often it leaps.

The heart has been reimagined as being made of things as fragile as glass (Blondie's "Heart of Glass") and as prickly as cacti (Magnetic Fields' "The Cactus Where Your Heart Should Be") to being nonexistent (the tragedy of the Tin Man is scrutinized in the Hollies' "Man Without a Heart," Frank Zappa's "I Ain't Got No Heart," and the Subways' "No Heart, No Soul"). And even though it's been found that sexual activity is a contributing factor in less than one percent of all heart attacks, the facts didn't stop Olivia Newton-John from turning the notion of *la grande mort* into a hit with 1982's "Heart Attack" ("Must have died and gone to heaven / What a way to go").

Any simple, 4/4 methodic rhythm will bear some passing

resemblance to a heartbeat (the bass drum is often referred to as "the heartbeat" of a group's sound), but some sound more cardiovascular than others. "The Heart of Rock and Roll" by Huey Lewis and the News is obvious; less so is Ultravox's 1981 hit "Vienna," which features an electronic rhythm that echoes both the thud of a heartbeat as well as the "swishing" of blood being pushed through the ventricles. And it's decidedly more distressing when heartlike sounds are presented as wildly irregular, as heard in the opening minute of Four Tet's "Hands."

When in the early seventies pioneering free-jazz drummer Milford Graves came across an album created for cardiologists called *Normal and Abnormal Heart Beats*, he was set on an idiosyncratic course to blend hard science, music, and therapy ("It blew my mind . . . here were the secret rhythms, man," he recalled): Using a number of lab tools, some specially designed for his use, Graves records the microrhythms of the heart—he says a healthy heart sparks in triplets (1–2–3, 1–2–3)—and either attempts to correct heartbeats that are purring out eighth notes by sending corrected rhythms back into the body via acupuncture needles or headphones, or experiments with turning the heart sounds into music itself. And he often talks jazz luminaries into his workshop to riff on rhythms built from their own pulse. Graves told *New York* magazine in 2001, "People vibrate, and they vibrate differently. There's a true personal music." But it's when the vibrations stop that the real trouble begins.

Free of poetic metaphor, diseases and failures of the cardiovascular system are the world's leading cause of death (the World Health Organization estimates that nearly 17 million people die yearly of cardiovascular diseases, particularly heart attacks and strokes). Composer and organist Louis Vierne died of a heart attack while seated at the organ of Notre Dame Cathedral during a performance in 1937, tenor Richard Versalle passed in a similar manner in 1996 while onstage at the Metropolitan Opera, and Morphine singer and bassist Mark Sandman's heart gave out during a live show in Palestrina, Italy, in 1999. If these diseases strike but don't claim their musically inclined victims, they're likely to cast a pall over any ensuing work: Shostakovich, following his 1966 heart attack, notably turned dark and inward, composing *Seven*

Romances on Verses by Alexander Blok, and Mark Linkous (a.k.a. Sparklehorse), already attuned to a somewhat bleak worldview, focused all his energies on songs with more than a passing fascination with death (1999's *Good Morning Spider*) after his nearly fatal 1996 heart attack.

"'Broken Heart' Syndrome: Real, Potentially Deadly but Recovery Quick" was the headline of a Johns Hopkins University press release dated February 9, 2005. The study, published in *The New England Journal of Medicine* that same month, confirmed what folk tales and pop songs have been saying for generations, as researchers at the university had discovered what news organizations labeled "credibility to the idea of a real-life broken heart." Two years later, in April 2007, a team of researchers at the Wellcome Trust Centre for Neuroimaging at University College London and the Brighton and Sussex Medical School discovered that, in times of stress, the higher regions of the brain responsible for memory and emotions can destabilize the cardiac muscle of someone who has already suffered from heart disease, resulting in harmful rhythms in the heart.

Researchers found that catecholamines (epinephrine [adrenaline], norepinephrine [noradrenaline], and dopamine—more commonly known as the fight-or-flight hormones), which are released in varying amounts to help us deal with stress—from the noise of heavy construction to the low blood sugar brought on by skipping lunch—may flood into the bloodstream as a response to prolonged emotional stress. They found that under extreme distress some patients could face symptoms that "mimic a classic heart attack," a fact that often leads the disease to be misdiagnosed as a massive heart attack when, in actuality, "[the patients] have suffered from a days-long surge in adrenaline (epinephrine) and other stress hormones that temporarily 'stun' the heart."

The long love affair of Johnny Cash and June Carter Cash was immortalized in the 2005 film *Walk the Line*. June died of complications from heart surgery on May 15, 2003. Her husband would pass 120 days later, and although his official cause of death was complications from diabetes and respiratory failure, many people believe that he died from a broken heart. Cash's longtime friend Kris Kristofferson said, following his death, "After June died, life was a struggle for him. His daughter told me he cried every night." Producer and

architect of Cash's late-career comeback Rick Rubin recalled the singer telling him the day after June passed, "I need to have something to do every day. Otherwise, there's no reason for me to be here," suggesting that he didn't pass sooner after the death of his wife because he was able to channel his grief into the massive, ongoing recording sessions that produced upward of fifty songs—many of which were among the most strikingly sorrowful of his career. The last song he reportedly ever wrote, "Like the 309," paints a portrait of the train that is carrying his own casket back home. The song shares thematic elements with a Hank Williams classic that Cash recorded during these sessions, "On the Evening Train," which tells the story of a man grieving the loss of his wife, whose "long white casket" is being loaded onto the train for one last ride, as she's returned to her family. Cash sings, "It's hard to know she's gone forever" in the final verse, and it's difficult to deny that he's plumbing new depths, and his 1960 hit "The Story of a Broken Heart"—which he recorded while still at Sun Records—seals the mythology in poetic fashion: "Now we're two lovers drifted apart / The story of a broken heart."

Of course, there are many kinds of broken hearts, some more metaphorical than others.

A December 3, 1982, *St. Petersburg Times* report from the first successful temporary artificial-heart-transplant surgery began by identifying the polyurethane pump's "softly clicking" sound, with the headline, "Click . . . Click . . . Click . . . the sound of an artificial heart adds new beat to the music of life." The story described the long surgery and how Ravel's *Bolero* "filled the operating room." Postsurgery, people who stood near the patient—a sixty-one-year-old retired dentist—said that they could hear a faint "click . . . click . . . click" emanating from the Jarvik 7 in his chest.

Since that time, the artificial heart has, understandably, been an inspiring metaphor for musicians including Yo La Tengo, the Fever, Ricky Skaggs, Cherrelle, and Soul Asylum.

Subsequent artificial-heart recipients, such as Robert Tools, who lived for 151 days after receiving the first self-contained artificial heart, the AbioCor, in 2001, have bemoaned a conspicuous change in the body's rhythm. Following his operation, Tools said that "the

biggest thing is getting used to not having a heartbeat." Peter Hough-
ton, who lived for a record-breaking 1,513 days after receiving the
Jarvik 2000 left-ventricular assist device in 2000, said the pump
whirred "like a washing machine" and left him feeling cold, removed,
distant, and distressingly concerned that he had lost a piece of his
soul. Designers of prosthetic hearts took note, and newer versions
seek to restore the heartbeat sound. It would seem that the "lub-lub"
rhythm of the heart is so essential to our being that we need to re-
create it even when it's unnecessary to do so.

Roger Waters decided to bookend Pink Floyd's massive (in every
sense of the word) *Dark Side of the Moon*—a loose-concept album
about life, death, and the choices we make in between—with the
sound of a lumbering heartbeat (actually a bass drum), suggesting
the sound's centrality to our organic being, that it grounds us in exis-
tence, as our first and final tether to life. Is it really a stretch to imag-
ine that life without the warm, essential rhythm that has surrounded
you since before birth would be somehow cruel and unusual? That it
would lead one to feel something less than human?

When the NASA commission chaired by Dr. Carl Sagan compiled
a twelve-inch, gold-plated copper record—a message for alien life
forms to tell the most complete story possible of life on Earth—and
launched it with the *Voyager 1* space probe in 1977, it contained the
first movement of Bach's Brandenburg Concerto No. 2 in F, Chuck
Berry's "Johnnie B. Goode," the sounds of birds and thunder, and
Louis Armstrong's "Melancholy Blues." It also contained the warm,
round thudding of a human heartbeat.

THE MISERABLE LIST: WELCOME TO HEARTBREAK

1. "Thy Rebuke Hath Broken His Heart" (*Messiah*) — George
 Frideric Handel (1741)
2. "Breakin' In a Brand New Broken Heart" — Connie Francis (1961)
3. "Only a Fool (Breaks His Own Heart)" — Mighty Sparrow with
 Byron Lee and the Dragonaires (1966)

4. "Only Love Can Break Your Heart"—Neil Young (1970)

5. "How Can You Mend a Broken Heart"—Al Green (1972)

6. "Broken Heart"—Spiritualized (1992)

7. "The Game of Broken Hearts"—Tarnation (1995)

8. "Somebody Already Broke My Heart"—Sade (2000)

9. "This Is What Happens When the Heart Just Stops"—The Frames (2001)

10. "Welcome to Heartbreak"—Kanye West featuring Kid Cudi (2008)

BLACK TAPE FOR A BLUE GIRL

Not as esoteric as their predecessors Dead Can Dance, or as sweetly blissed-out as Cocteau Twins, Black Tape for a Blue Girl (BTFABG) created a mixture of floating synths, chamber music, and ethereal vocals that, for many fans, was the definition of dark ambient. The brainchild of songwriter, keyboardist, and producer Sam Rosenthal—an entrepreneurial goth who launched the influential Projekt label, in 1983, as an outlet for his own electronic releases—BTFABG was cobbled together from a handful of key collaborators (notably vocalist Oscar Herrera of Florida group the Sleep of Reason) to record songs for their 1986 debut, *The Rope*. The album framed not just the group's future releases, but, much like 4AD's Ivo Watts-Russell and his collaborative This Mortal Coil, the group also largely defined the Projekt sound during the late 1980s and early 1990s, the label becoming associated with darkwave and ethereal goth music through its acts Lycia and Love Spirals Downwards as well as BTFABG. The song titles found on *The Rope*—"Memory, Uncaring Friend," "The Few Remaining Threads," "The Floor Was Hard But Home"—give a good indication of what's waiting for the listener. Though 1987's *Mesmerized by the Sirens* and 1989's *Ashes in a Brittle Air* featured brief rockist moments—usually built around the work of drummer Allan Kraut—the group moved confidently deeper into the dark ambient world with 1991's *A Chaos of Desire*.

Rosenthal released *Terrace of Memories*, an ambient collaboration with Vidna Obmana in 1992, and the following year released the fourth BTFABG album, *This Lush Garden Within*, which featured performances from a number of Projekt label musicians. Around this time Rosenthal explained that each of the groups albums is linked by a concept of "unfulfilled desire and obsession." A fifth album, *Remnants of a Deeper Purity*, appeared in 1996 and also formed the bulk of the group's first live show that year, at Projektfest '96 in Chicago. The 1999 album *As One Aflame Laid Bare By Desire* turned out to be something of a transitional statement for the group as Herrera, with one foot out the door, sang only two songs, and Juliana Towns—who had appeared on previous efforts—took over the majority of the vocal work, only to be removed from the band following a brief tour before the album's release. Elysabeth Grant joined the band as a violinist, then quickly took over vocal duties and stayed on with the group to record. In 2002 the conceptual *The Scavenger Bride* unfolds as the story of a woman and her past lovers and includes a cover of Sonic Youth's "Shadow of a Doubt." With the pastoral 2006 album *Halo Star*, Rosenthal infused a newfound lightness to the proceedings, including a gothic twist on Tony Orlando's bubblegum hit "Knock Three Times." Rosenthal collaborated with singer Nicki Jaine for the dark cabaret project Revue Noir, which set the stage for 2009's BTFABG release, *10 Neurotics*, an album infused with both the decadent Weimar sound of Revue Noir and the most potently goth-rock elements in the BTFABG catalog. The album deals with everything from anorexia to furries, and found the group bathed in critical praise for their new direction.

THE MISERABLE LIST: BLACK TAPE FOR A BLUE GIRL

1. "Hide in Yourself"—*The Rope* (1986)
2. "Kathryn"—*Before the Buildings Fell* (1986)
3. "Ashes in the Brittle Air"—*Ashes in the Brittle Air* (1989)
4. "The Hypocrite Is Me"—*A Chaos of Desire* (1991)

THE BLUE NILE

The Swiss have Patek Philippe, the Italians have Ferrari, and the Scots have the Blue Nile. Formed in 1981, the contemplative group have released only four albums in the three decades since—provided you don't count the two albums' worth of recorded material the band has either burned or erased during that time. Clock watchers they are not. But they are a reminder that even in a world of instant everything and constant hunger for something new to appropriate, absorb, criticize, and forget, there truly are some things worth waiting for. Or, as singer and songwriter Paul Buchanan rhetorically asked during a 1996 interview, "Why do people make so many records?" The Blue Nile came together when singer and guitarist Paul Buchanan, keyboardist Paul Joseph Moore, and bassist Robert Bell—all recent Glasgow University graduates—began to slowly pare back Motown standards and Beatles hits, drawn to the silences that appeared when Smokey wasn't singing. They took their name from the second of Alan Moorehead's two-part history of the Nile River and released their first single, "I Love This Life," on their own Peppermint label to little fanfare. Then, an unlikely savior appeared: Linn, makers of high-fidelity stereo equipment, wanted to cut their own records to showcase the superiority of their flagship turntable. The Blue Nile signed to the newly minted Linn Records and released their debut full-length, *A Walk Across the Rooftops*, in 1984 (it was later released by A&M Records in the United States),

which established their distinct sonic template: glacial tempos propelled by sparse percussion, billowing synths, plaintive guitars, and roomy piano, all falling into the service of Buchanan's emotive vocals that whisper, ache, and soar, often within the same song. Despite not touring, and a limited promotional budget, the album found an audience and reaped its share of critical praise. The group's cinematic approach solidified on 1989's *Hats*, their unquestionable masterpiece—one critic going so far as to call it "music's answer to Venice." The impressionistic vision of the album—the music polished to reflect Buchanan's lyrical motifs: rainy nights and early mornings, cityscapes and hillsides, cars and trains, love and loss—is so focused it nearly has its own gravity, and issues its own timeless currency. Directed by a happenstance collision with sixty minutes of techno music, Buchanan steered their next release, 1996's *Peace at Last*, into a more organic direction. As he said at the time of the release, "Dylan goes electric, Blue Nile goes sloppy." This step away from the controlled atmospherics of their earlier work resulted in their least successful album, but eight years later, with the release of *High* in 2004, the group returned to the warm precision that made their first two releases such jewels.

THE MISERABLE LIST: THE BLUE NILE

1. "Second Act"—Single (1982)
2. "Tinseltown in the Rain"—*A Walk Across the Rooftops* (1984)
3. "Easter Parade"—*A Walk Across the Rooftops* (1984)
4. "The Downtown Lights"—*Hats* (1989)
5. "From a Late Night Train"—*Hats* (1989)
6. "Seven A.M. (Live)"—B-side, *Saturday Night* (1990)
7. "Tomorrow Morning"—*Peace at Last* (1996)
8. "Let's Go Out Tonight"—Craig Armstrong: *The Space Between Us* (1998)
9. "Because of Toledo"—*High* (2004)
10. "I Would Never"—*High* (2004)

JACQUES BREL

Born in Brussels on April 8, 1929, Jacques Romain Georges Brel came dangerously close to whiling away his days in the family cardboard business before releasing a debut single and, against the wishes of his family, assaulting the clubs of Paris with his brash, sweaty performances and dark, uniquely narrative chansons influenced by the prevailing existential bohemianism that radiated from the Left Bank during the postwar years. He toured France, released his debut album, *Jacques Brel et Ses Chansons*, and in 1956 achieved his first French hit with "Quand on N'a Que l'Amour." Brel's first US release, 1960's *American Début*, was a compilation of previously recorded material, and his first US appearance came three years later at Carnegie Hall. Singer Rod McKuen translated a number of Brel's songs into English, and it was his take on Brel's "Le Moribond" ("The Dying Man"), which he titled "Seasons in the Sun," that became a monster hit for the Kingston Trio in 1964. Two years later, Damita Jo had a hit with "If You Go Away" (McKuen's take on Brel's "Ne Me Quitte Pas"), which would go on to become a pop standard recorded by Frank Sinatra, Scott Walker, Neil Diamond, Dusty Springfield, and others. Still a youthful thirty-eight-years old, Brel retired from performing with a final concert on May 16, 1967, and although he would continue to write and record music, he largely turned his attention to acting in films and onstage. Meanwhile, in America, songwriter Mort Shuman and writer Eric Blau transcribed a number of Brel's songs into English with a source reverence McKuen's earlier translations lacked, and cobbled them into the off-Broadway hit *Jacques Brel Is Alive and Well and Living in Paris*, which opened in January 1968. (The show has been restaged multiple times and was turned into a film—complete with a Brel cameo—in 1975.) At the same time in England, American expat Scott Walker, then a member of chart-topping trio the Walker Brothers (who famously had a fan club list to rival the Beatles), heard early recordings of the Shuman/Blau translations, fell under Brel's spell, and quickly recorded a hit version

of "Jackie" ("La Chanson de Jacky"). (Importantly, Walker didn't just record a number of Brel's songs throughout the late sixties; the Belgian's realist poetry and dark subject matter became benchmarks for his own work, which in turn proved vastly influential to artists such as David Bowie, Julian Cope, Jarvis Cocker, and Radiohead.) In 1973 folk-pop singer Terry Jacks hit number one in the US, the UK, and Germany with an edited, largely defanged "Seasons in the Sun" (his follow-up, a version of "If You Go Away," was a more modest hit). In the final years of his life Brel devoted much of his time to sailing, and in July 1974 set off in his yacht on what he intended to be a circumnavigation of the globe. The death of a close friend, however, brought him back to France, where he stayed on for the wedding of one of his three daughters. In November of that year, he was rushed to the hospital and informed he had late-stage lung cancer. An operation removed portions of his left lung and Brel, understanding his days were numbered, announced his intentions to die in peace. The singer and his second wife, Madly, left France, settled on the island of Hiva-Oa, in the Marquesas, and lived quietly. But Brel continued to write, and in 1977 recorded twelve new songs that would make up his final album, *Brel*. On the day of its release, Brel stubbornly ignored doctor's orders and returned to the Marquesas. His health then deteriorated quickly, and, after being rushed back to France in July 1978, he died three months later. One of the greatest songwriters of the twentieth century, Brel leaves a legacy of poetic, deeply personal songs that influenced and anticipated the work of Bowie, Cohen, Dylan, and countless others.

THE MISERABLE LIST: JACQUES BREL

1. "Sur la Place"—*Jacques Brel et Ses Chansons* (1955)
2. "Heureux"—*Brel 2* (1957)
3. "Dites, Si C'etait Vrai"—*Brel 3* (1958)
4. "Seul"—*Brel 4* (1959)

5. "Ne Me Quitte Pas"—*Brel 4* (1959)

6. "Amsterdam"—*Olympia '64* (1964)

7. "Jef"—*Brel 6* (1964)

8. "Au Suivant"—*Brel 6* (1964)

9. "La Chanson des Vieux Amants"—*67* (1967)

10. "La Ville S'Endormait"—*Brel* (1977)

BRIGHT EYES

Wiry, Nebraskan, indie-rock wunderkind Conor Oberst began performing in Omaha in 1992, when he was just thirteen years old, and by the following year he and his older brother, Justin, had started Lumberjack Records (later Saddle Creek) to release his first album, the cassette-only *Water*. In 1994 he formed Norman Bailer (later known as the Faint), but left the group to form Commander Venus with future Cursive frontman Tim Kasher. While finding some success with Commander Venus, Oberst proved spectacularly prolific, and he began writing and recording more personal material that didn't work for the band: Enter Bright Eyes. He released twenty of these scratchy gems on *A Collection of Songs Written and Recorded 1995–1997*, in 1998, followed the same year by *Letting Off the Happiness*, an album that instantly made Oberst the new darling of the national indie-rock scene. His cracked, unsteady, and hesitant vocals; interest in emotionally honest moments; and intimate recordings combined to create remarkably mature, frangible songs like "The Awful Sweetness of Escaping Sweat" and "Padraic My Prince," which opens with the stunningly dark line, "I had a brother once / He drowned in a bathtub." As leader of Bright Eyes and founder of Saddle Creek Records, Oberst was the prime mover in what became known as the Omaha scene, which also spawned Cursive and the Faint. With 2000's *Fevers and Mirrors*, Oberst's song craft tightened while the fidelity sharpened, and the inescapable Dylan comparisons

began to circle the young songwriter. His kitchen-sink tunes blended Neil Young, the Cure, Pavement, Radiohead, and Elliott Smith into nervous rock for the new millennium—his panic attacks and battle with depression spilling into the record. Following the success of *Fevers and Mirrors*, Oberst funneled his musical energies toward the short-lived punk group the Desaparecidos, which released its debut album, *Read Music/Speak Spanish*, in 2002. Later that year Oberst was back attending to Bright Eyes business with the release of the mini-epic *Lifted, or The Story Is In the Soil, Keep Your Ear to the Ground*, the album that broke the shy singer into the mainstream. Two years later, when he released the singles "Lua" and "Take It Easy (Love Nothing)," the songs climbed into the top two spots of the *Billboard 100*. Also in 2004 Oberst started a second label, Team Love Records, with Nate Krenkel, formerly of Sony Records. With all this unfettered success, perhaps a bit of a backlash was inevitable, and with the 2005 simultaneous releases of the country-rock influenced *I'm Wide Awake It's Morning* and the electronically informed *Digital Ash in a Digital Urn*, Oberst took his first major misstep(s). *I'm Wide Awake* was the more celebrated of the two albums, featuring a handful of fantastic, stripped-down seventies-inspired folk songs—"Land Locked Blues" and "We Are Nowhere and It's Now," one of three tracks that featured a guest turn from Emmylou Harris—alongside a number of empty tunes that seemed to struggle to find their footing. *Digital Ash* was even more unfocused, Oberst's wordy lyrics and quivering vocals out of sorts in a sea of skittering electronics. In the spring of 2005, he lit up the blogosphere with the release of the anti-Bush protest single "When the President Talks to God," and in 2006, he released the compilation album *Noise Floor (Rarities 1998–2005)*. Though the Bright Eyes ecosphere had seen talented musicians come and go, it was always acknowledged to be Oberst's show until 2007's *Cassadaga*, when longtime collaborators Mike Mogis and Nate Walcott became official members of the band. The trio produced a mature and full roots-rock sound that shirked the melancholy gloom and hesitant naïveté that had surrounded much of his earlier work. Oberst's voice was more confident, his songs more

polished, and his youthful angst replaced by a more laid-back classicist's sensibility. Later the same year, the rich sound was applied to the group's first official live release, *Motion Sickness*. With Bright Eyes now rolling forward as a collaborative effort, Oberst indulged in anachronistic country rock with a collection of friends he corralled together as the Mystic Valley Band and recorded a self-titled solo album in Mexico. As the decade came to a close, Oberst seemed more than happy to let go of the writing process along with the spotlight, joining M. Ward, My Morning Jacket's Jim James, and longtime Bright Eyes accomplice Mike Mogis in the indie-rock supergroup Monsters of Folk for a self-titled 2009 release. He also reunited with the Mystic Valley Band for *Outer South* (also 2009)—half of which was either written or cowritten by no fewer than four other members of the band, many of them taking lead on their own songs. In early 2011, Bright Eyes was back with the monologue-heavy, sci-fi-influenced *The People's Key*, which combined Oberst's recent classicism kick with a heavy dose of eighties synths and the dynamic crunch of the Pixies.

THE MISERABLE LIST: BRIGHT EYES

1. "If Winter Ends"—*Letting Off the Happiness* (1998)
2. "Padraic My Prince"—*Letting Off the Happiness* (1998)
3. "A Spindle, a Darkness, a Fever and a Necklace"—*Fevers and Mirrors* (2000)
4. "A Song to Pass the Time"—*Fevers and Mirrors* (2000)
5. "Lover I Don't Have to Love"—*Lifted* (2002)
6. "Lua"—Single (2004)
7. "Land Locked Blues"—*I'm Wide Awake It's Morning* (2005)
8. "Weather Reports"—*Noise Floor (Rarities 1998–2005)* (2006)
9. "Lime Tree"—*Cassadaga* (2007)
10. "Ladder Song"—*The People's Key* (2011)

JAMES CARR

Blessed with a deep and pure Southern-soul voice that puts him at the front of the line in any discussion about the greatest singers, James Carr lived a troubled life that produced, in a brief stretch of grit, the definitive performance of one of the greatest songs of the twentieth century. Carr was born on June 13, 1942, near Clarksdale, Mississippi. His father, a minister, moved the family to Memphis when the singer was young, and by the age of nine he was performing in his father's church. As a teenager, he became a member of a number of gospel groups, including the Redemption Harmonizers and the Harmony Echoes, but Carr and his Harmonizers bandmate O. V. Wright had been eyeing a shift to secular music, prompting the two to sign with manager Roosevelt Jamison. Carr never truly learned to read or write and was married with children by the time he met Jamison, who said his first impression of the man was "childlike." In 1964 Carr's impressive baritone—described by author Peter Guralnick as "a more muscular Otis Redding or a more explosive Percy Sledge"—caught the ear of Hi Records cofounder Quinton Claunch, who signed the singer to his Goldwax label, releasing his first single, "The Word Is Out (You Don't Want Me)." It wasn't until 1966, with the release of "You Got My Mind Messed Up," that Carr's expressive talent would reach the charts. Soon after, Carr would cut his unequivocal masterpiece, Penn and Moman's "Dark End of the Street." Though the song has since been performed by a number of artists—including Aretha Franklin, Clarence Carter, Linda Ronstadt, and Percy Sledge—Carr was there first, and his definitive recording has yet to be eclipsed. The singer's understated approach to the song belies his impact: "It's really a simple song. . . . Just sing it the way you talk." Despite the chart noise of a handful of subsequent recordings, Carr dropped longtime manager Jamison in favor of signing with Otis Redding's manager, Phil Walden. Unfortunately, this marked the beginning of a decline in Carr's personal life. The emotional power he brought to his performances, that juxtaposition of rough pain and effortless control, had at its root tumultuous waves of depression that kept Carr from pursuing

a mainstream career. It turned out that Jamison had not only served as a manager but also as a caretaker—he would later recall telling the singer when to go to sleep and when to wake up—and Carr struggled with the stresses of touring by often wandering off and getting lost in new cities. Without personal attention—which Walden either couldn't, wouldn't, or didn't know to provide—Carr's depression tightened around him. He struggled to record his second LP for Goldwax, 1968's *A Man Needs a Woman*, and by 1969, at a Muscle Shoals recording session for his third Goldwax album, he simply sat in front of a microphone and stared into space (Claunch recalled that the singer "just sat up there and looked"), mustering the strength to record only one track, a cover of the Bee Gees hit "To Love Somebody." Goldwax was soon bankrupt, and Carr signed with Atlantic, but only released one single, 1971's "Hold On (To What We've Got)." After disappearing for a handful of years—leaving a number of people to believe he had died—Carr reemerged in 1977 with the single, "Let Me Be Right (I Don't Want to Be Wrong)," which he recorded for his former manager Roosevelt Jamison's label, River City. A 1979 tour of Japan started well but ended in chilling fashion as Carr, purportedly having downed too many antidepressants, took the stage in Tokyo and simply stood catatonic at the microphone. For the remainder of the 1970s, and throughout the 1980s, Carr would split time between living with his sister (in Memphis) and in various psychiatric institutions. As he began to get his depression under control he would record for a revived Goldwax in 1991 and return to touring. In 1994 he cut his final album, *Soul Survivor*, for Claunch's Soultrax label, but was soon diagnosed with lung cancer, a disease that he would succumb to on January 7, 2001.

JOHNNY CASH

Rumbling out of the small Sun Studios in 1955, the Tennessee Two at his back, Johnny Cash was a blazing original right from the start. Born on February 26, 1932, in Kingsland, Arkansas, Cash was writing songs by age twelve and sang on local radio while in

high school. It wasn't until after the outbreak of the Korean War, though, while as an Air Force cryptographer in Germany, that he bought his first guitar, taught himself a few chords, and wrote what would become his first classic, "Folsom Prison Blues." Cash left the Air Force in 1954, married, had four children (including singer/songwriter Rosanne Cash), and settled in Memphis, where he sold kitchen appliances door-to-door for a time while playing nights with guitarist Luther Perkins, bassist Marshall Grant, and steel-guitar player A. W. "Red" Kernodle. He labored for an audition with Sun Records founder Sam Phillips, which finally came in 1955, but the bullish Cash was billing himself as a gospel singer, and Phillips was looking for another secular sensation to equal the success of his biggest star, Elvis Presley. The producer ordered Cash to write a hit, and when the singer returned with "Hey Porter," Phillips set to work on creating a single, "Cry Cry Cry" b/w "Hey Porter." Phillips renamed Cash's backing band the Tennessee Two (Kernodle never made it to the audition) and christened him with the nickname "Johnny," which the singer disliked, believing that it sounded too young. A success right out of the gate, Cash, in 1957, became the first performer to release a full-length album on Sun Records with *Johnny Cash and His Hot and Blue Guitar*, though disputes with the label over royalties and the singer's continuing desire to release a gospel album dissolved the relationship. In 1958 Cash signed with Columbia Records, where he continued his success and finally cut his gospel album, 1959's *Hymns by Johnny Cash*, which would be the first of many themed albums he would release. In 1960 the Tennessee Two brought on drummer W. S. Holland and became the Tennessee Three. Cash played the first of his legendary prison concerts at San Quentin—with a young Merle Haggard, jailed for burglary, cheering from the audience—and the hits kept coming. At this point, though, he had already turned to amphetamines to keep up with his relentless schedule—Cash released multiple albums every year and performed more than three hundred concerts some years between the late fifties and late sixties. Although 1963 proved tumultuous as the singer fled for New York, leaving his family and

legal matters behind, the following year saw the release of two classic albums, *Bitter Tears: Ballads of the American Indian* and *I Walk the Line*. Then a song cowritten by a young singer named June Carter (with Merle Kilgore) would return Cash to the top of the charts. But as "Ring of Fire" lit up the charts, the troubles that plagued the singer were continuing to mount. In 1965 he spent three days in jail after attempting to smuggle amphetamines into the United States in his guitar case, and he famously exploded at the Grand Ole Opry, destroying the footlights of the legendary stage after fumbling for his microphone during a performance—the Opry asked that he not return. His wife filed for divorce in 1966, and Cash moved to Nashville, where his relationship with June Carter, herself recently divorced, blossomed. Carter—country royalty as a member of the Carter Family—was able to stanch the addictions that plagued Cash, and during a concert in 1968 the embattled beast proposed to the pacifying beauty onstage. The two were married on March 1, 1968, and later that year Cash released *Johnny Cash at Folsom Prison*, which went on to become his bestselling album. He followed it up the next year with *Johnny Cash at San Quentin*, appeared on Bob Dylan's *Nashville Skyline*, and launched the weekly variety program *The Johnny Cash Show*. During the seventies Cash would see a slow decline in his popularity as he became more politically and religiously active, in evidence on his 1971 album, *Man in Black*, which features both a duet with Billy Graham ("The Preacher Said, 'Jesus Said'") and the antiwar song "Singing in Vietnam Talking Blues." In the titular song, he explains the philosophy behind his infamous wardrobe: "I wear the black for the poor and the beaten down, living in the hopeless, hungry side of town. I wear it for the prisoner who has long paid for his crime . . ." His classic autobiography, *Man in Black*, which appeared in 1975, may have been his most important release during the disco decade. The 1980s proved to be difficult for the rebellious singer, and he took comfort working with old friends—first with Carl Perkins and Jerry Lee Lewis as The Survivors; then with Waylon Jennings, Willie Nelson, and Kris Kristofferson as the Highwaymen—but his profile would remain

relatively low throughout the decade. In 1988 he underwent preventive double-bypass heart surgery—a "soul-searching experience," he said—and his career began to pick up as he was inducted into the Rock and Roll Hall of Fame in 1992 and lent his husky baritone to "The Wanderer" on U2's massive 1993 album *Zooropa*. Enter enigmatic, Zen-steeped hip-hop and rock producer Rick Rubin, who would refashion the career of the aging country star by combining bleak contemporary rock covers from acts such as Nine Inch Nails and Danzig with Cash originals and traditional songs. The string of radio-produced albums cemented Cash as a dark poet of the American soul and crafted a compelling third act for the iconic artist. *American Recordings* appeared in 1994 and opened with one of Cash's most graphic and austere murder ballads, "Delia's Gone," his deep, gravelly baritone patient with menace. *Unchained* (1996), *American III: Solitary Man* (2000), and *American IV: The Man Comes Around* (2003) followed the same formula with varying degrees of success, but in May 2003 June Carter, center of his universe and wife of thirty-five years, passed away. Cash, both ill and heartbroken, threw himself into recording before complications from diabetes claimed him on September 13, 2003. Rubin continued to work on the material after Cash's death, releasing the *American Unearthed* box in 2003, *American V: A Hundred Highways* in 2006, and *American VI: Ain't No Grave* in 2010.

THE MISERABLE LIST: JOHNNY CASH

1. "Give My Love to Rose"—B-side, *Home of the Blues* (1957)
2. "I Still Miss Someone"—*The Fabulous Johnny Cash* (1958)
3. "The Caretaker"—*Songs of Our Soil* (1959)
4. "Another Man Done Gone"—*Blood, Sweat and Tears* (1962)
5. "Dark as a Dungeon (Alternate Take)"—*At Folsom Prison (Legacy Edition)* (1968; Legacy Edition released 2008)

6. "The Ballad of Ira Hayes"—*Bitter Tears: (Ballads of the American Indian)* (1964)

7. "Route No. 1, Box 144"—*Hello, I'm Johnny Cash* (1969)

8. "Highway Patrolman"—*Johnny 99* (1983)

9. "Unchained"—*Unchained* (1996)

10. "Hurt"—*American IV: The Man Comes Around* (2003)

This Will End in Tears

Teardrops, Sob Songs, and Crying in the Rain

I do not know how to make a distinction between tears and music.

—FRIEDRICH NIETZSCHE

I thought my world had ended when you said good-bye
'til I found three ways to ease the pain: cry, cry, cry

—"CRY, CRY, CRY" BY CONNIE SMITH (1968)

Like the heart, the teardrop possesses a towering iconic magnitude in popular culture. First the heart breaks, then the tears flow—or so the story goes. When Orpheus lost Eurydice to Hades's dark underworld he sang songs that made the gods cry. And when Elizabethan composer John Dowland graphed the falling of tears into his greatest song, and Johnnie Ray—the sadly overlooked cultural bridge between Frank Sinatra and Elvis Presley—scored a monstrous hit with his 1951 song "Cry" and led the recording industry on a rabid hunt for "sob ballads," they joined Orpheus to become integral parts of music's lugubrious past, part of a long-running musical tradition of glamorizing tears. The connection between music, melancholy, and tears is so strong that philosopher and novelist E. M. Cioran suggested in his 1937 book *Tears and Saints* that tears are an art form unto themselves, similar to music in that "melancholy is the

unconscious music of the soul" and, in turn, "tears are music in material form." But where do tears come from and why do they flow in the first place? How has the cultural currency of tears affected music? And is weeping to a sad song—or just crying in general—really as cathartic as we've long held it to be?

The cultural heft of tears has never wavered, even if their meaning changes. Over time, tears have been read as *lacrimaeque decorae*, or decorative tears (a view held by Virgil and Ovid that many goth kids enamored of thick, runny mascara would recognize), and the early Christian church divided tears into four distinct categories: tears of contrition, tears of gladness, tears of grace, and tears of sorrow. The Romantics of the eighteenth and nineteenth centuries were enamored of the joy and pleasure of tears (see: Schubert's "Lob der Tränen," or, "In Praise of Tears"), which is just a short leap to the eroticized tears that Williams James described in his landmark *Principles of Psychology* (1891), writing of "an excitement during a crying fit which is not without a certain pungent pleasure of its own," complete with rising heart rate, quivering muscles, and release of bodily fluids.

Hippocratic physicians in the sixth century B.C. believed that tears were developed in the brain. Medical minds during the Renaissance believed they were a fundamental way that the body purged humoral imbalances. Galen, a physician who lived from 130 to 200 A.D., was the first to promote the notion that tears were created by glands rather than the brain. And in the late seventeenth century Nicolas Steno (a.k.a. Steno of Denmark) discovered the lacrimal glands as a primary component in the production of tears, after dissecting sheep heads. Yet it was more than a hundred years later that the lacrimal pathways would be correctly outlined, and it wasn't until the twentieth century, with the advancement of endocrinology, that the origins of tears began to be rightly understood.

All tears are the work of the lacrimal system, which is composed of a series of glands along with multiple ducts and sacs, and broken into two parts: the secretory and excretory systems—the former producing the tears, the latter draining them away.

Though they may all appear the same, there are actually different types of tears. Basal, or continuous, tears function to lubricate and protect the eyes, washing away dust with every blink and delivering vital nutrients to cells in the cornea, the outer layer of the eye, which has no blood vessels. Reflex tears well up in the eyes when a foreign bit of dust finds its way past the eyelashes, or when onions are cut. And the third tear type, psychic (or emotional) tears, are the tears that fill poems, songs, films, and stories, the result of a complex web of cognitive, verbal, and motor activity; neural systems; and psychology, all of which are engaged during moments of heightened emotional agitation. (Though other creatures, most specifically elephants, have been reported to shed tears, emotional weeping remains, for the time being, a uniquely human trait—Charles Darwin once referring to it as one of the "special expressions of man.") Another Charlie, singer Charlie Rich, attempted to analyze emotional tears in the song "H2O" (from his phenomenal 1968 album *Set Me Free*) and broke it down as "two parts H," which is "for hurtin'," and "one part O" for "love that's over"—though he freely admits, "I'm no expert." Disguising emotional tears behind a reflex origin is a tried-and-true pop maneuver that has resulted in amazingly fine songs like the Platters' "Smoke Gets in Your Eyes" and clunkers like Alice Cooper's "I Never Cry," which features the spectacular excuse, "It's just a heartache that got caught in my eye."

When a rush of strong emotions overtakes you, the brain releases chemicals that lead to waterlogged eyes, the secretion of those tears providing our bodies with a shot of endorphins and protective hormones (like prolactin, which is present in tears of sadness but not in tears of joy or in the everyday tears that lubricate and flush irritants from the eye). They help relieve stress and flush away toxins: a process long considered to be big-time catharsis, endorsed by grandmothers and psychologists alike. In that, tears and sad music would seem an ideal coupling. But a paper entitled "Is Crying Beneficial?," published in the December 2008 issue of *Current Directions in Psychological Science*, found that there is little empirical evidence to support the

theory that crying is the majestically cathartic experience it is widely held to be.

Writing for *Psychology Today*, one of the paper's coauthors, Jonathan Rottenberg (director of the Mood and Emotion Laboratory at the University of South Florida), notes, "Not all crying episodes are created equally." Rottenberg and his colleagues found that you're more likely to view a crying episode as cathartic in retrospect—a belief exhibited between sixty and seventy percent of survey participants—than you are while you're actually wiping tears from your cheeks. When the researchers tried to induce tears—via sad films like *The Champ* or *Steel Magnolias*—they found that "people rarely report that their tears provide any immediate mood benefits." They also notably found that "in most laboratory studies, people who cry to an eliciting stimulus actually report feeling worse (e.g., increased sadness and distress) than do people who view the same stimulus without crying."

Much of the lachrimal research that exists suggests that numerous factors come into play when looking at the benefits of crying: Whether you're a man or a woman, whether you suffer from anxiety or depression, and social context can all color the emotional response of a crying episode. It's also possible that the emotional outcome of crying may be cemented in the psychology of your early life, dependent on parents' (or caregivers') reaction to your cries as a child.

The researchers also found that criers reported more physiological arousal than noncriers, while a study published in the January 14, 2011, edition of *Science* found that women's tears reduced testosterone and sexual feelings in men (the tears were captured in vials and given to men to smell at a later time). These kinds of contradictions underscore the large gaps in knowledge about both the psychological and the physiological realities of crying and tears.

In a poetic twist, those who suffer from severe depression—a symptom of which can be mysterious weeping fits—can actually be immune to crying. A 2007 article published in the journal *Acta Psychiatrica Scandinavica* found that severe depression flattens emotional response to such a degree that the circuitry required to kickstart the crying process simply doesn't respond to stimuli. Max Hamilton, a psychologist who created the Hamilton Depression Rating

Scale, wrote in a later paper that severely depressed patients seem to "go beyond weeping," eventually settling into a blank emotional state that supercedes emotional tears. In effect, the attempt to blunt the depression winds up blunting everything (à la Lisa Lisa and Cult Jam's "All Cried Out" or the Rolling Stones' *Voodoo Lounge* single "Out of Tears"—"I can't feel / Feel a thing").

In the melodramatic world of popular music, having your lachrimal tank run dry (see also: Kansas's overstuffed power ballad "Can't Cry Anymore") may happen more often than it does in real life, but it's a downright novel concept compared with what is arguably the most overpolished lyrical trope in the history of song: crying in the rain. It goes all the way back to Zeus, Lord of Olympus, as the Greeks believed the falling rain to be a mortal manifestation of the lightning god's grief. Artists have mined the poetic similitude between rain and tears ever since (see: "The Sky Is Crying" by Elmore James; Godley and Creme's 1985 hit, "Cry"; and David Cassidy's "[It Must Be] Raindrops"—"It must be raindrops . . . falling from my eyes, eyes").

The Everly Brothers' 1962 hit "Crying in the Rain" ("I know how to hide all my sorrow and pain"), subsequently climbed the charts for Tammy Wynette in 1981, and charted a third time for surprisingly resilient Norwegian group A-ha in 1990. David Coverdale penned his own "Crying in the Rain" in the early eighties for Whitesnake's 1982 album, *Saints & Sinners,* which was rerecorded—along with monumental hit "Here I Go Again"—for the group's self-titled breakthrough 1987 album. Willie Nelson had an enormous crossover hit with the Fred Rose song "Blue Eyes Crying in the Rain," on his 1975 album *The Red Headed Stranger,* and it continues to be one of his most beloved songs. It was originally recorded by Rose in 1945, and Hank Williams even performed it during the *Mother's Best Flour Hour* recordings, which finally saw the light of day on *The Unreleased Recordings* box set in 2008. Gerry and the Pacemakers twisted the idea a bit for their 1964 hit, "Don't Let the Sun Catch You Crying," and musical comedy group Flight of the Conchords skewered the cliché in the very first episode of their HBO series with the song "Not Cryin' "—"I'm not cryin'/It's just been raining . . . on my face."

According to artists across genres "Big Girls Don't Cry" (Frankie Valli and the Four Seasons), "Boys Don't Cry" (the Cure), "Gangsters Don't Cry" (Just-Ice), "Cowgirls Don't Cry" (Brooks and Dunn), "Grown Men Don't Cry" (Tim McGraw), and "Pimps Don't Cry" (Cee-Lo Green and Eva Mendes)—except, of course, when they do. Smokey Robinson and the Miracles spun two huge lachrimal hits with "The Tracks of My Tears" and "Tears of a Clown," and Jackie Wilson attempted to recapture some of the magic of his 1958 hit, "Lonely Teardrops," by recording "The Tear of the Year" in 1961 and "Teardrop Avenue" in 1965. But no artist has ever been as obsessed with the metaphorical power of tears as John Dowland, the Sobfather himself, who titled many of his compositions accordingly, including "Go Crystal Tears," "I Saw My Lady Weep," "Weep You No More, Sad Fountains," and "Flow My Tears," variations of which form his most famous book of pavanes (slow courtly dances), *Lachrimae (Seaven Teares)*, which features titles such as "Lachrimae Antiquae" ("Old Tears"), "Lachrimæ Tristes" ("Sad Tears"), and "Lachrimæ Veræ" ("True Tears"). "Flow My Tears" (and the pavanes of the *Lachrimae*) even begin with Dowland's hallmark "falling tear" motif—descending notes strung together that step in time to the opening lyric, "Flow my tears."

Though crying and tears have been a constant theme in popular music, actual sobbing in song is something more rare. Though a singer's voice will often quiver with woe or plead so strongly as to be on the verge of tears, seldom does it actually happen. There are instances, though, despite Voltaire's belief that tears are a "silent language of grief." One of Johnnie Ray's numerous nicknames, the Crying Crooner, mythologized his tendency for breaking into tears during performances—a trait coal-eyed indie chanteuse Chan Marshall (Cat Power) and teen sensation Justin Bieber also have in common. R&B singer Chris Brown caused a "lite" controversy when he was accused of shedding crocodile tears during his comeback performance—after a 2009 felony assault charge brought by singer Rihanna nearly derailed his career—at the BET Michael Jackson tribute concert in 2010. Sinéad O'Connor's version of Prince's

"Nothing Compares 2 U" is a devastating song, but how much did the single serendipitous tear that ran down O'Connor's face in the iconic video help the song achieve its success? Bob Miller's "Ohio Prison Fire" is particularly gruesome as a mother of one of the convicts visits following the conflagration and "all atremble she looks on his charred remains." The song gives way to a brief dialogue between a state official ("Can you identify this body?") and the weeping mother who cries out, "Who's to blame for this awful, awful thing? Who's to blame? Oh . . . bodies . . . bodies . . . bodies. I can't stand it! I can't stand it! I can't stand it!" Lauryn Hill is barely able to sing through her tears during an overlong performance of "I Gotta Find Peace of Mind," during her 2001 MTV *Unplugged* appearance. And in a bit of dizzying metagrief, one of history's greatest tenors, Enrico Caruso, admitted that he wept genuine tears thinking of his own wife's betrayal while portraying Canio, the cuckolded actor (who is in turn portraying Pagliaccio, a cuckolded clown), in Ruggero Leoncavallo's *Pagliacci*.

As dramatic as these sobbing spells may be, they pale in comparison to the field recordings of sung-weeping by the Kaluli from Papua New Guinea's Mount Bosavi region, which, though anthropologically fascinating, is as much a torture to listen to as Lou Reed's *Metal Machine Music* ever was—it's nearly impossible to hear their captured husky moans and protracted shudderings without a lump forming in your throat. (For more on the Kaluli and sung weeping, see pages 314–16.)

Though many aspects of weeping and tears and their psychological and physiological effects may remain a mystery, unraveling that mystery in the future is unlikely to stop the natural marriage of crying and song. As Oscar Wilde once wrote, "Music is the art which is most nigh to tears and memory," and it's this connection between music, our emotional imaginations, and cultural history that ensures music will continue to provoke oceans of tears. And just as surely, some of those tears will go on to inspire even more songs that make us cry.

THE MISERABLE LIST: THIS WILL END IN TEARS

1. "Flow My Tears"—John Dowland (1596)
2. "Golden Teardrops"—The Flamingos (1953)
3. "Drown in My Own Tears"—Ray Charles (1956)
4. "Guess I'll Hang My Tears Out to Dry"—Frank Sinatra (1958)
5. "As Tears Go By"—The Rolling Stones (1965)
6. "Tears Don't Fall No More"—Lonnie Johnson (1967)
7. "Tears"—Force M.D.'s (1984)
8. "Levi Stubbs' Tears"—Billy Bragg (1986)
9. "Tiny Tears"—Tindersticks (1995)
10. "Tears All Over Town"—A Girl Called Eddy (2004)

THE MISERABLE LIST: CRY, CRY, CRY

1. "I'm So Lonesome I Could Cry"—Hank Williams (1949)
2. "Cry"—Johnnie Ray (1951)
3. "Crying in the Chapel"—The Orioles (1953)
4. "Cry Baby"—Garnet Mimms and the Enchanters (1963)
5. "The Crying Game"—Dave Berry (1964)
6. "I Cry In the Morning"—Dennis Olivieri (1968)
7. "Blue Eyes Crying in the Rain"—Willie Nelson (1975)
8. "Never Make Me Cry"—Fleetwood Mac (1979)
9. "Cry"—Godley and Creme (1985)
10. "Llorando"—Rebekah Del Rio (2003)

CAT POWER

Born on January 21, 1972, Chan (short for Charlyn) Marshall, the daughter of a traveling piano player, spent her youth (which she prefers not to talk about), relocating throughout the South,

eventually dropping out of high school and winding up in Atlanta, where she met guitarist Glen Thrasher, with whom she would form Cat Power (the name inspired by a stranger's Cat Diesel Power hat). The two moved to New York City in September 1992 (though Thrasher's stay was short-lived) and two years later Marshall began playing solo shows, her dramatically shy demeanor, arty sensibilities, and emotionally revealing songs making waves overnight. Her first two releases were recorded on the same day in 1995 but released by two separate labels: *Dear Sir* by Plain Recordings in 1995, and *Myra Lee* (named after her mother) by Steve Shelley's Smells Like Records in 1996. Impressed with her first recordings, Matador Records swooped in and released Marshall's next six releases, beginning with *What Would the Community Think* in 1996. These earliest releases were marked by a lo-fi, art-rock aesthetic and wiry performances that kept Marshall's cathartic songs from finding a mainstream audience, but by 1998's *Moon Pix* her style had cemented into a more confident mix of throaty torch blues and smart indie rock. She told Greil Marcus in a 2007 interview that she isn't a "learned musician" and that her writing style is to "just kind of mess with the notes," which may be one reason why her early music focuses so adroitly on emotional exorcism and a tottering sleight-of-hand. The first of her covers albums, aptly titled *The Covers Record*, appeared in 2000 and featured her renditions of a song by Velvet Underground ("I Found a Reason"), her second Smog cover, "Red Apples" (her first being "Bathysphere" from *WWTCT*), and the Rolling Stones classic "(Can't Get No) Satisfaction," which she slowed to a narcoleptic pace, trapping it in amber and alchemically turning its nervous energy—the aspect amped by Devo in their classic take on the song—into tender woe. As 2003's *You Are Free* featured the most confident set of songs and a confident merger of her indie-rock past and newfound comfort as a smoldering piano balladeer, her alcoholism, recreational drug use, and personal demons caught up with her in a well-publicized downward spiral that ended with her stay in a Miami psychiatric ward. After release from the hospital, she recorded what is arguably her best work, 2006's *The*

Greatest, a dusky and bold collection of songs built in collaboration with veteran Memphis soul musicians. *The Greatest* features some of Marshall's most beautifully bleak material: the title track, a gently mournful ballad that finds the singer coming to terms with the passage of time and perhaps with her well-documented sense of perfectionism ("Once I wanted to be the greatest"), while "Lived in Bars" is an alcoholic's lament ("There's nothing like living in a bottle and nothing like ending it all for the world") with a jumpy third act that suggests a triumph over her personal demons. Following *The Greatest* she became the celebrity spokesperson for Chanel jewelry (among other advertising work); appeared as a New York City postal worker in artist Doug Aitken's 2007 MOMA installation *Sleepwalkers*; and costarred alongside Jude Law and Norah Jones in Wong Kar-wai's 2007 film *My Blueberry Nights.* A projected 2008 release of new songs never materialized, but her second album of covers, *Jukebox,* did. Featuring interpretations of the Highwaymen's 1990 hit "Silver Stallion," Bob Dylan's "I Believe in You" (from his largely ignored Christian album, *Slow Train Coming*), and Joni Mitchell's mesmeric classic, "Blue," *Jukebox* went on to become her biggest-selling album to date. As 2008 came to a close, the release of the *Dark End of the Street* EP appeared, featuring six new cover songs, including the title song, Otis Redding's "I've Been Loving You Too Long (To Stop Now)," and Sandy Denny's heartbreaking "Who Knows Where the Time Goes."

THE MISERABLE LIST: CAT POWER

1. "Rockets"—*Dear Sir* (1995)
2. "Ice Water"—*Myra Lee* (1996)
3. "What Would the Community Think"—*What Would the Community Think* (1996)
4. "Say"—*Moon Pix* (1998)
5. "Colors and the Kids"—*Moon Pix* (1998)
6. "Good Woman"—*You Are Free* (2003)

NICK CAVE AND THE BAD SEEDS

Nicholas Edward Cave was born on September 22, 1957, in Wangaratta, Victoria, Australia. The death of his father while he was a teenager deeply affected Cave, who sought solace in literature and music. In his late teens, along with future Bad Seed Mick Harvey, Cave started Australia's Birthday Party—they began life as the Boys Next Door, changing their name after a move to London—which would provide the framework for Cave's first frenzied salvos into the pop landscape, and by rights should be cataloged as one of the best groups of the post-punk era. Threading together punk, goth, and new wave, the Birthday Party excelled at a suffocating mixture of feedback, stark tribal rhythms, and the biblical howls, sexual perversity, and dark character studies that would prove to be a stock-in-trade for this singer-songwriter. For an expat Australian living in England, Cave developed a geographically removed obsession with Southern-Gothic America and the Old West—early rock 'n' roll, dusty blues, religion, sex, and violence, violence, violence. In a December 1982 concert review, *NME* suggested they "may be the Greatest Rock 'n' Roll Band in the World," but the group wouldn't get to capitalize on such grandiose praise for long—by 1983 the Birthday Party had fizzled. Following the band's dissolution, Cave formed the Cavemen, and, later, the Bad Seeds—which included former Birthday Party cohorts Mick Harvey and Blixa Bargeld, along with Hugo Race and former Magazine bassist Barry Adamson. They released 1984's *From Her to Eternity*, the first step in Cave's fusing of his frenzied gothic howlers with loftier notions, turning in a relatively straitlaced cover of Elvis Presley's "In the

Ghetto" and morphing Leonard Cohen's "Avalanche" into a seething dirge. In many ways his sound was already established: the heat of passion on a dark night and the chill of regret on a rainy morning; one part glorious and two parts guttural. *The Firstborn Is Dead* (1985), the covers album *Kicking Against the Pricks* (1986)—which produced the minor hit "The Singer" in the UK—and *Your Funeral . . . My Trail* (1986) followed, as Cave gradually began turning from his raucous punk roots into something of a goth balladeer. He kicked a heroin habit and had a startlingly productive string of years: appearing in director Wim Wenders's 1987 independent film hit *Wings of Desire*—the first of what would become many sojourns into the film world for Cave—and publishing a book of poetry (*King Ink*) and his first novel (*And the Ass Saw the Angel*) before recording 1988's *Tender Prey* with new guitarist Kid Congo Powers (the Cramps, the Gun Club) signing on for the first of two albums. Cave starred in the Australian prison flick *Ghosts . . . of the Civil Dead* in 1989 and composed its haunting score, and released *The Good Son* (1990) and *Henry's Dream* (1992)—the first album to feature long-standing Bad Seeds Martyn Casey and Conway Savage. The controlled fury of the group's live presence was captured on 1993's *Live Seeds*. Cave explored his romantic side on 1994's *Let Love In*, which featured gripping heartbreakers like "Nobody's Baby Now" and breathtaking chillers like "Red Right Hand," a song that presaged the group's next release, 1996's *Murder Ballads*, which produced the dark hit "Where the Wild Roses Grow," a duet between Cave and Australian pop sensation Kylie Minogue. Perhaps it was the influence of violinist Warren Ellis, who joined the Bad Seeds around this time (as did drummer Jim Sclavunos), but with 1997's melancholy *The Boatman's Call* Cave recast himself as the introspective balladeer who had been quietly but steadily searching for air. Discussing the affect of his mood on writing bleak material in a 2005 interview, Cave said, "I can be real happy and write a sad song. I only have to sit down and play an A minor chord. It just puts you in that kind of frame of mind; musically, that chord suggests all the sorrow in the world." In 1999 he released the spoken-word

album *The Secret Life of the Love Song/The Flesh Made Word*, which featured two monologues, one regarding his approach to the love song in which he stated that the ubiquitous form, whether it addresses religious or secular love, "is the noise of sorrow itself." He continued in this subdued vein over the course of 2001's *No More Shall We Part* and 2003's *Nocturama*, with Bargeld exiting the Bad Seeds shortly after the album's release (replaced by Gallon Drunk's James Johnston). This was a move that somehow spurred Cave and Co. to the best, most ambitious album of their career, the two-disc *Abattoir Blues/The Lyre of Orpheus* in 2004. *Abattoir Blues* filled with the kind of slinky, slow-burning fuses and bluesy conflagrations that Cave had been largely ignoring since *Let Love In*, while *The Lyre of Orpheus* is elegiac—"Breathless," "Babe, You Turn Me On"—yet still spiked with something dark—"O Children." Just as he created his most diverse album, containing the most beautiful, carefully crafted work of his career, he turned his back on it and formed the grimy, loud, and blissfully abrasive Grinderman with the Bad Seeds' Warren Ellis, Martyn Casey, and Jim Sclavunos, releasing a self-titled debut in 2007 (and a follow-up, *Grinderman 2*, which Cave referred to as "a mammoth midlife crisis," in 2010). Cave wrote the script and, with Ellis, the score for 2007 Aussie Western *The Proposition*—the two also collaborated on the music for 2007's moody *The Assassination of Jesse James by the Coward Robert Ford*. In 2008 the group released *Dig!!! Lazarus Dig!!!* and in 2009 Cave released the black comedy novel (also available in musical audiobook) *The Death of Bunny Munro*.

THE MISERABLE LIST: NICK CAVE AND THE BAD SEEDS

1. "Knockin' on Joe"—*The Firstborn Is Dead* (1985)
2. "Sad Waters"—*Your Funeral . . . My Trial* (1986)
3. "The Weeping Song"—*The Good Son* (1990)
4. "Nobody's Baby Now"—*Let Love In* (1994)

5. "Lay Me Low"—*Let Love In* (1994)

6. "People Ain't No Good"—*The Boatman's Call* (1997)

7. "Where Do We Go Now But Nowhere?"—*The Boatman's Call* (1997)

8. "As I Sat Sadly by Her Side"—*No More Shall We Part* (2001)

9. "O Children"—*Abattoir Blues/The Lyre of Orpheus* (2004)

10. "The Ship Song"—*The Abattoir Blues Tour* (2007)

VIC CHESNUTT

Vic Chesnutt had the pulse of authentic Americana that other artists can only struggle to find, and for two solid decades he created some of the most beguiling, troubling, and enchanting music in the country. Born James Victor Chesnutt on November 12, 1965, a drunken car crash at eighteen left him paralyzed and, as he would later explain, focused: "It was only after I broke my neck," he told NPR in 2009, "that I really started realizing that I had something to say." Created in one day at a cost of $100 and produced by R.E.M.'s Michael Stipe (who once described Chesnutt as "an acerbic reporter"), 1990's *Little* preserves Chesnutt's choppy, gothic gems by capturing him in a bare setting with only a nylon-string guitar and intermittent washes of cheap keyboard, his wobbly, misfit-stuffed poetry and peculiar phrasing already in evidence. Stipe also produced the 1991 follow-up, *West of Rome*, which framed Chesnutt's songs in a more fleshed-out band setting and showed a marked increase in confidence in Chesnutt's reedy vocals. A three-day party in a rural farmhouse resulted in 1993's *Drunk*, and in 1995 *Is the Actor Happy?*, arguably Chesnutt's finest recording from his first decade of work, appeared, featuring the cracked Southern rock of opener "Gravity of the Situation" and the ethereal "Betty Lonely" ("Her maidenhood was lost beneath the Spanish moss"). Following the success of 1993's *Sweet Relief* benefit album for Victoria Williams, a fantastically talented singer/songwriter who had been

diagnosed with multiple sclerosis, the Sweet Relief Fund gathered artists that included Garbage, R.E.M., Hootie and the Blowfish, Sparklehorse, Smashing Pumpkins, Williams, and, recording with her brother-in-law Joe Henry, Madonna, for 1996's *Sweet Relief II: Gravity of the Situation,* as a benefit for Chesnutt. *About to Choke* was released within weeks of the *Sweet Relief II* album and garnered a fair share of attention for the singer/songwriter. Two years later he released *The Salesman and Bernadette,* a song cycle created with Nashville chamber-country group Lambchop. Chesnutt shines in the loose chamber-pop setting, re-appropriating some older material in the service of a loose-concept album about the thoughts and deeds of two wayfaring lovers. Three solid recordings would follow: 2000's *Merriment,* recorded in collaboration with husband-and-wife musicians Kelly and Nikki Keneipp; 2003's *Silver Lake,* which paints Chesnutt's songs with confident seventies-styled production; and 2005's *Ghetto Bells,* which was recorded with luminaries such as guitarist Bill Frisell and Van Dyke Parks. Working with Thee Silver Mt. Zion Memorial Orchestra, Guy Picciotto of Fugazi, Bruce Cawdron of Godspeed You! Black Emperor, and Chad Jones and Nadia Moss of Frankie Sparo, Chesnutt's *North Star Deserter* (2007) takes his small, homespun material and explodes it into vast expanses of bleak symphonic rock. He then worked with Athens psych-rock outfit Elf Power for another surprise with 2008's *Dark Developments,* and for 2009's *At the Cut,* he returned to work with a number of the collaborators who made *North Star Deserter* so sublime. Chesnutt drilled deeper into his own life than he had before, notably exploring his own depression on "Flirted with You All My Life," which the singer described as "a suicide's breakup song with death." Just months later he released the sparse, acoustic *Skitter on Take-Off.* Howe Gelb of Giant Sand once called Chesnutt the country's "best, most indestructible songwriter"; the former may remain an apt descriptor even as the latter proved to be sadly unsound, as Chesnutt succumbed to the depression he had always given voice to, taking his own life on Christmas Day in 2009.

THE MISERABLE LIST: VIC CHESNUTT

1. "Isadora Duncan"—*Little* (1990)

2. "When I Ran Off and Left Her"—*Drunk* (1993)

3. "Gravity of the Situation"—*Is the Actor Happy?* (1995)

4. "God Is Good"—*Sweet Relief II: Gravity of the Situation* (1996)

5. "New Town"—*About to Choke* (1996)

6. "Maiden"—*The Salesman and Bernadette* (1998)

7. "Glossolalia"—*North Star Deserter* (2007)

8. "Mystery"—*Dark Developments* (2008)

9. "Flirted with You All My Life"—*At the Cut* (2009)

10. "Grim Augury"—*Danger Mouse and Sparklehorse Present: Dark Night of the Soul* (2010)

GENE CLARK

Best remembered as the handsome, introspective leader of the Byrds during their mid-sixties moment as folk-rock lords of the Sunset Strip, Gene Clark had a way with both lonesome, keening melodies and self-sabotage. Born on November 17, 1944, Harold Eugene Clark, the second of thirteen children, spent his youth in rural Missouri and Kansas, and his singing career took off in his late teens, when he became a member of the button-down folk family the New Christy Minstrels. Clark proved too shy for success in the Minstrels and made a run for the Hollywood Hills, where he formed a duo with Roger McGuinn. The two soon added David Crosby, and the Byrds were born. Besides the songs plucked from the Bob Dylan songbook, Clark was responsible for the lion's share of the Byrds' earliest classics, including "I Knew I'd Want You," "Set You Free This Time," and the gun-shy optimism of "I'll Feel a Whole Lot Better." Infighting and Clark's (ironic, but true) fear of flying led to his exit from the Byrds in April 1966. His short-lived Gene Clark Group cemented Clark's place as a country-rock pioneer, but his first solo release,

1967's orchestral-pop classic *Gene Clark with the Gosdin Brothers*, hit stores the same week as the Byrds' fourth album, *Younger Than Yesterday*, and unfortunately sold poorly in its shadow. When Crosby exited the Byrds later that year, Clark returned to the group for a mere three weeks before realizing why he'd left in the first place. He doubled down on his roots influences for 1968's *The Fantastic Expedition of Dillard and Clark* and 1969's *Through the Morning, Through the Night*. The calming effect of the singer's move from Los Angeles to Mendocino can be heard throughout 1971's *White Light* and 1973's *Roadmaster* (originally available in America only as a Dutch import), two more solid spotlights for Clark's shy talents that did little to improve his fortunes. He rejoined the Byrds yet again for a short-lived reunion that culminated in the 1973 album *Byrds*. Impressed by his two original contributions to the album ("Full Circle" and "Changing Heart")—easily the strongest tracks—Asylum Records head David Geffen signed Clark and provided a long leash for his next release. The infamous *No Other* (1974) was an expensive (for the time) psych-country-bluegrass-rock album inspired by the awe of the Pacific Ocean, and is now considered by many to be Clark's masterpiece and the summit of Gram Parsons's Cosmic American Music. It tanked and made the singer's name a four-letter word in the mind of Geffen, who, upset that his $100,000 budget bought only eight songs, smothered promotion for the album and the singer's hope for a resurgence along with it. Always short on self-confidence and still suffering from stage fright, Clark struggled, falling into an abusive cycle of drugs and alcohol. His final major-label release, 1977's *Two Sides to Every Story*, has largely disappeared (*Rolling Stone* called it "a heartbreaker—in the worst way"), but a late-career comeback of sorts was waiting in the wings in the form of a fruitful collaboration with former Textones member Carla Olson. The duo's 1987 album, *So Rebellious a Lover*, clicked with a small group of L.A. cowpunks and became an influence on the burgeoning alt-country scene. The following year, stricken with ulcers from years of heavy drinking, Clark had much of his stomach and a portion of his intestines removed. His last shot of fame came when Tom Petty covered "I'll Feel a Whole Lot Better" on his wildly popular 1989 album *Full Moon*

Fever. A comeback tour of the UK was arranged, but Clark canceled at the last minute. He spent his final years battling his considerably strong demons and died suddenly of a heart attack at forty-six on May 24, 1991.

THE MISERABLE LIST: GENE CLARK

1. "I'll Feel a Whole Lot Better"—*Mr. Tambourine Man* (1965)
2. "Set You Free This Time"—*Turn! Turn! Turn!* (1965)
3. "Tried So Hard"—*Gene Clark with the Gosdin Brothers* (1967)
4. "Echoes"—*Gene Clark with the Gosdin Brothers* (1967)
5. "Train Leaves Here This Mornin'"—*The Fantastic Expedition of Dillard & Clark* (1968)
6. "With Tomorrow"—*White Light* (1971)
7. "She's the Kind of Girl"—*Roadmaster* (1973)
8. "Some Misunderstanding"—*No Other* (1974)
9. "Give My Love to Marie"—*Two Sides to Every Story* (1977)
10. "Why Not Your Baby"—*The Fantastic Expedition of Dillard and Clark/Through the Morning, Through the Night* (2011)

PATSY CLINE

The most popular female singer in the history of country music, Patsy Cline—born Virginia Patterson Hensley on September 8, 1932, in Gore, Virginia—pined for stardom from an early age. By fifteen she had dropped out of high school and was working various day jobs while performing at night in colorful fringed outfits she designed herself. She cut seventeen singles between 1955 and 1960, which produced only one hit in the creeping ballad "Walkin' After Midnight," a crossover success she struggled to repeat in the grips of a suffocating contract with Four Star records. When her contract expired, in 1960, she began working with legendary producer Owen Bradley (who had crafted hits for Brenda Lee and Loretta Lynn), the

two choosing material tailored to Cline's balladic strengths. The first track cut with her newfound freedom, "I Fall to Pieces," proved to be the spark that would send her career into orbit. A crossover hit that ruled the country charts and climbed to number twelve on the pop charts, the song also serves as a historical waterline between country music's largely traditional period and the flood of crossover-country that followed its massive success. Owens's use of crying strings and back-up vocals by the Jordanaires in the recording make it an important link in the creation of "the Nashville sound." Cline fulfilled a dream when, on January 9, 1960, she became a member of the Grand Ole Opry—her first appearance on the Opry stage had taken place on July 1, 1955, when she sang "A Church, a Courtroom, and Then Goodbye." She reveled in her place in the Nashville scene, befriending and encouraging numerous singers and musicians, whom she referred to as "Hoss," while she referred to herself as "the Cline." She was injured in a car accident in June 1961 and received, among other injuries, a deep, jagged cut across her forehead that required plastic surgery and forced the singer into a series of wigs for subsequent performances. But the accident barely slowed her, and she returned to the road while still on crutches. (Recordings of her first show following the accident were discovered in 1997 and released shortly thereafter as *Patsy Cline: Live at the Cimarron Ballroom*.) Following the success of "I Fall to Pieces," Cline attempted to record Willie Nelson's "Crazy," a song she initially disliked. Still recovering from the accident, she had trouble controlling her breath and claimed the high notes were too difficult to hit. Thankfully, Cline gave the song another shot the following week—reportedly nailing it in one take—and it went on to become her signature song and another crossover hit. Though Cline could belt out country-and-western stompers and flat-out rockabilly, it was her ability to completely embody the brokenhearted protagonists of teardrop ballads that made her a star—or as she plainly put it, "Oh, I just sing like I hurt inside." The maturation of her public persona as a countrified torch singer brought about a change in appearance, and she gave up her fringed jackets and cowboy boots for cocktail dresses and high heels. On March 3, 1963, she performed three benefit concerts in Kansas City for the

family of a local DJ who had recently died in an automobile accident, closing the final show with her last recorded song, "I'll Sail My Ship Alone." Anxious to get home to see her family, she boarded a Piper Comanche piloted by her manager Randy Hughes. The plane hit severe weather and crashed in a forest just outside Camden, Tennessee. Cline's watch, later found at the scene, was frozen at 6:20 P.M. She continued to have posthumous success with the singles "Sweet Dreams," "Leavin' on Your Mind," and "Faded Love," all cracking the country top ten. Cline's simple tombstone has a gold plaque that reads: "Death Can Not Kill What Never Dies."

THE MISERABLE LIST: PATSY CLINE

1. "Walkin' After Midnight"—*Patsy Cline* (1957)
2. "I Fall to Pieces"—*Showcase* (1961)
3. "Crazy"—Single (1961)
4. "She's Got You"—Single (1962)
5. "I Can't Help It (If I'm Still In Love With You)"—*Sentimentally Yours* (1962)
6. "You're Stronger Than Me"— B-side, *So Wrong* (1962)
7. "Leavin' on Your Mind"—Single (1963)
8. "Faded Love"—Single (1963)
9. "I'll Sail My Ship Alone"—B-side, *When You Need a Laugh* (1963)
10. "You Took Him Off My Hands"—*A Portrait of Patsy Cline* (1964)

LEONARD COHEN

Given many suggestive names throughout his career—Godfather of Gloom, Prince of Bummers, to mention a few—Leonard Norman Cohen was born on September 21, 1934, in Montreal, Quebec, Canada—just a few months before Elvis Presley. His father died when he was nine, and his mother encouraged her son's interest in literature,

specifically poetry, but it wasn't until the young Cohen was thirteen that he tentatively picked up the guitar in the hopes of impressing a girl—what else would you expect from the Bard of the Boudoir? An average student, Cohen managed to waltz away from McGill University in 1955 with the McNaughton Prize in creative writing under his belt. He wasted no time in pursuit of literary fame, publishing two books of poetry (*Let Us Compare Mythologies* in 1956, and *The Spice Box of Earth* in 1961) before scraping together enough money to live throughout his twenties as a globe-hopping bon vivant, eventually settling for a period on the small island of Hydra, in the Aegean Sea. Two novels (most notably 1966's *Beautiful Losers*) and more volumes of poetry followed, while his isolation on Hydra led him to explore songwriting. These songs may have existed in a vacuum and disappeared without a trace had it not been for folksinger Judy Collins, who befriended Cohen and included both "Suzanne" and "Dress Rehearsal Rag" on her 1967 album *In My Life*. "Suzanne" became a minor hit and Cohen soon debuted as a live performer at the 1967 Newport Folk Festival. In the crowd was legendary producer John Hammond Sr.—who had produced Billie Holiday, Benny Goodman, and Bob Dylan—and it wasn't long before he found a home for Cohen at Columbia Records, stealing the swarthy Canadian songwriter into the studio to create 1967's stark and masterful *Songs of Leonard Cohen*. The production perfectly matched Cohen's ambered baritone and the romantic melancholy of his songs; it didn't take long for the poet and singer to build a rapt audience. He holed up in Manhattan's Chelsea Hotel for a time, flirted with Warhol's Factory crowd, struck up an infamous friendship with Janis Joplin, which would be immortalized in his "Chelsea Hotel No. 2," and wrote material for his next release, 1970's *Songs from a Room*, a collection that revealed an even darker nature than his debut. *Songs of Love and Hate* followed in 1971, another poetry collection in '72, and his first live release, appropriately titled, *Live Songs*, in '73. *New Skin for the Old Ceremony* appeared in 1974, furthering a creep toward pop territory, a trend Cohen would continue to investigate through the ill-fated Phil Spector experiment, 1977's *Death of a Ladies' Man*. Although it is now

celebrated by some as a misunderstood work of some subtle genius, most (including Cohen, who has called the album "grotesque") are willing to concede that Spector's kitchen sink production manhandled the introspective songwriter's gifts. Sprinting from the miscalculation of *Death of a Ladies' Man*, Cohen made 1979's *Recent Songs*, a return to the spare production of his earliest works. Recorded with singer/songwriter Jennifer Warnes, 1984's *Various Positions* included the first recording of what would become his most widely known song, "Hallelujah." Though the album didn't perform well, Warnes's 1987 release of Cohen covers, *Famous Blue Raincoat,* did, introducing his talents to a new generation of fans. It spurred the success of his next release, 1989's *I'm Your Man*, which became his bestselling record in years. In 1991 the all-star covers album *I'm Your Fan: The Songs of Leonard Cohen* appeared, featuring R.E.M., Nick Cave, the Pixies, and John Cale's notable version of "Hallelujah." Pushing sixty years of age, his voice a deep, radiant growl, Cohen released *The Future* in 1992, and though a handful of recordings would follow, none would match its bitter energy and craftsmanship. "You sing from a kind of thorn in your side," Cohen once revealed, "which may just be the human heart aching in its particular predicament," adding, "All art is an effort to address that aching."

THE MISERABLE LIST: LEONARD COHEN

1. "Suzanne"—*Songs of Leonard Cohen* (1968)
2. "Sisters of Mercy"—*Songs of Leonard Cohen* (1968)
3. "Story of Isaac"—*Songs from a Room* (1969)
4. "Last Year's Man"—*Songs of Love and Hate* (1971)
5. "Famous Blue Raincoat"—*Songs of Love and Hate* (1971)
6. "Bird on a Wire"—*Live Songs* (1973)
7. "Chelsea Hotel No. 2"—*New Skin for an Old Ceremony* (1974)
8. "Hallelujah"—*Various Positions* (1985)
9. "Everybody Knows"—*I'm Your Man* (1989)
10. "The Future"—*The Future* (1992)

SONG ESSAY: "HALLELUJAH"

First appearing at the heart of his 1985 album *Various Positions*, Leonard Cohen's "Hallelujah" slowly burned itself into the public's imagination, eventually becoming the default sound of sadness. *Rolling Stone* didn't even mention the song in its 1985 review of *Various Positions*, and when the *New York Times* wrote in anticipation of Cohen's Carnegie Hall appearance in May of that year, it also neglected to single out "Hallelujah" for even faint praise. In fact, Cohen's label bosses at Columbia initially deemed *Various Positions* unfit for release in the US, citing its disconnect with contemporary music, but eighteen years later "Hallelujah" had become—via a poll of fifty songwriters that included John Legend, Chris Martin (Coldplay), and Peter Hook (New Order), and in the British music press tradition of no light hyperbole—what *Q Magazine* named "The Most Perfect Song Ever."

But the song's perfection hasn't stopped it from being "papped, drivelled, exploited, and massacred," as noted in a January 2005 article devoted to the song in London's *Sunday Times*. In December 2008 singer Alexandra Burke won the British reality talent-search show *X Factor* with her rendition of Leonard Cohen's "Hallelujah," and her version of the song became the fastest-selling download ever across Europe. It also strayed into the magnetic and culturally officious orbit of *American Idol* when, during its seventh season, it was performed by contestant Jason Castro. Following the performance, *Idol* ringleader Simon Cowell said, "The Jeff Buckley version of that song is one of my favorite songs of all time," an off-handed mention that subsequently sent Buckley's "Hallelujah" to the top of iTunes most-downloaded list.

Buckley's performance, from his 1993 debut, *Grace*, is generally acknowledged as the song's zenith, and *Rolling Stone* placed it at number 259 in their 2004 list "The 500 Greatest Songs of All Time." It's hard to imagine a performer embodying the spirit (in a very celestial sense) of the song more than Buckley, and in a 1994 *New York Times* review of *Grace,* Stephen Holden even suggested that the performance "may be the single most powerful performance of a Cohen song outside of Mr. Cohen's own versions." Cohen's original, for its part, is weighed down by outmoded synths and an overproduced chorus, giving it a

terribly dated sound—far from definitive, subsequent live versions did little to improve upon his studio take. But Cohen was never touched with a true performer's prowess: his vocal often little more than a fanciful narration and his stage presence something akin to uncomfortable concentration. No one can argue, however, that as a writer he possesses a direct line to some fragile and miserable muse.

Cohen famously told Bob Dylan that it took two years to write "Hallelujah." (When Cohen asked Dylan how long it took to write "I and I," Dylan quipped, "Fifteen minutes.") Through the years Cohen, a songwriter's songwriter, has claimed that "Hallelujah" percolated for anywhere from three to more than five years. In a 1988 interview with *Musician* magazine he recalled the process, saying, "I filled two notebooks with the song, and I remember being on the floor of the Royalton Hotel, on the carpet in my underwear, banging my head on the floor and saying, 'I can't finish this song.'" Known to live with his material over extended periods, Cohen steeps his verses and melodies in reflection, as if they were endowed with the ability to learn from their missteps and false starts. U2's Bono, who mumbled through an unfortunate take on "Hallelujah" for the heavyweight 1995 tribute album *Tower of Song: The Songs of Leonard Cohen*, has said of Cohen's songwriting, "You get the sense that he will wait for God to walk through the room. He'll wait for the right phrase, the right rhyme, the right and rigorous thought." And coming to songwriting from literature, "the right phrase" is often threaded with allusion and myth. The lyric of "Hallelujah" is certainly no exception.

His deconstruction of the word *hallelujah* redirects its root religious meaning—the highest exultation of the Lord—into a prismatic array of erotic destruction, artistic compromise, and spiritual collapse, but rather than give in to the imperfections of life, and more specifically, the fallibility of romantic love, Cohen suggests we search for the fleeting moments of beauty and comfort that randomly flicker into being throughout our lives, and acknowledge those instances before they vanish. In his words: "This is a broken world and we live with broken hearts and broken lives, but that is still no alibi for anything. On the contrary, you have to stand up and say 'Hallelujah' under those circumstances."

There is a third man that stands between Cohen's pen and Buckley's voice in the story of "Hallelujah" and its rise from deep cut to contemporary classic. It would have likely remained just another softly radiant chapter in Cohen's songbook if not for early drone pro and former Velvet Underground member turned producer and pop practitioner John Cale. It wasn't until Cale got hold of the song for the 1992 Cohen tribute album *I'm Your Fan* that it truly took root in a larger cultural consciousness. Cale could have easily attacked the song with washes of atonal strings or an experimental collision of samples and synths, but instead chose a minimalist piano arrangement, simply slowing the tempo a hair and allowing the poetry and magnetic melody of the verses to rise through his plaintive Welsh baritone. Cohen, who filled notebooks with more than eighty verses for the song during its genesis, even provided Cale, in a tsunami of faxes, with some of those unused verses for his new interpretation. This was the arrangement Jeff Buckley transcribed to guitar for inclusion on *Grace*. Buckley's performance laces the song with an ethereal presence that neither Cohen's fanciful narration nor Cale's workmanlike vocals could attain. If Cale's version is beautiful, Buckley's take is majestic. Most people familiar with the song have discovered it through one of these two artists, likely via its prominent use on the soundtracks to multiple films and television shows such as *Basquiat* (Cale), *Shrek* (Cale), *The West Wing* (Buckley), *Scrubs* (Cale) and *The O.C.*, which used both Buckley's version of the song (to end season 1) and a ghostly a cappella version performed by Imogen Heap (to end season 3). It was also one of a handful of songs played in heavy rotation on VH1 following the events of September 11, 2001.

The song has since become a modular melancholy masterwork, with artists as diverse as Bettie Serveert, Willie Nelson, Starsailor, Rufus Wainwright, Chris Botti, and the Dresden Dolls offering interpretations—k.d. lang performed it at the opening ceremonies to the 2010 Vancouver Winter Olympics, and the performance propelled the song once again into the iTunes top-twenty singles charts. Each artist casts away and rearranges the verses as they see fit, yet, as open to interpretation as the song currently is, there's still the lingering question of all those notebooks stuffed with verse resting in

Cohen's watchful care. If the mood strikes the deliberate poet and a notebook or two worth of verses enters the cosmos, it's hard to tell how many interpretations of the song will spring into being.ⓗ

THE CURE

As punk's DIY aesthetic merged with art-school intellectualism in the mid-1970s and early 1980s, the Cure were at the head of the charge, along with Bauhaus, the Birthday Party, and Siouxsie and the Banshees. The group was formed in 1976 by seventeen-year-old guitarist and vocalist Robert Smith—pop-depressive par excellence with a wiry tangle of black hair, smudge of red lipstick, and permanent drag of black eyeliner—with bassist Michael Dempsey, drummer Laurence "Lol" Tolhurst, and guitarist Porl Thompson. At first calling the band the Easy Cure, Smith soon shortened the name to the Cure ("less hippieish," he believed), as well as ditching Thompson, marking the first in a long and blurry succession of lineup changes. The group's stark and nervous post-punk demo found its way into the hands of Polydor Records' Chris Parry, who arranged for another recording session and the release of the group's first single, "Killing an Arab," in December 1978 via the independent Small Wonder label. Parry soon left Polydor to start his own label, Fiction, snapping up the Cure, reissuing "Killing an Arab" in February 1979, and sending the boys back into the studio and on to their first tour of England. In March, *Melody Maker* would call them a "no-image band," an auspicious remark about a group that would quickly come to define goth's woe-is-me theatricality in the public consciousness. The Cure's first full-length, *Three Imaginary Boys*, was released in May, and the group soon joined Siouxsie and the Banshees for a successful tour. By the end of the year the singles "Jumping Someone Else's Train," the classic "Boys Don't Cry," and the inexplicable "I'm a Cult Hero," which they released under the name the Cult Heroes, with postal worker Frank Bell on vocals, would hit stores. Dempsey exited and was replaced by Simon Gallup, and the group added its first keyboardist, Matthieu Hartley, who would quickly exit during the

group's first world tour, before finishing work on 1980's sparse *Seventeen Seconds*. Carrying on as a trio, they recorded and released 1981's *Faith*. Though the Cure's doom-laden personas were well established, it was 1982's *Pornography* that marked them as mope-rock royalty. Gallup quit and Tolhurst jumped from drums to keyboards while Smith became lost in a whirlwind of Banshee-related projects, performing on their 1984 album *Hyaena*, and forming the Glove with Banshees bassist Steven Severin. (The Glove's one and only album, 1983's *Blue Sunshine*, is considered by many a lost Cure album, though label complications kept Smith's vocals off all but two songs. Smith recorded new vocals for the 2006 reissue of the album.) The group reconvened in 1983 with Tolhurst and Smith joined by new bassist Phil Thornalley and drummer Andy Anderson. The playful "Love Cats" soon appeared and proved to be the Cure's biggest hit to date, but was not exactly the best indicator of the psychedelic miserabilism that blossomed on 1984's *The Top*. Spawning the hit singles "In Between Days" and "Close to Me," 1985's *Head on the Door* marked the beginning of the group's formidable run of alt-rock classics, matched during the period only by Smith's tabloid nemesis, Morrissey, and his group, the Smiths. The two bands became the Beatles and the Stones of the alternative era as Smith's spider-web-in-a-windstorm mess of black hair and crimson slash of lipstick ("I'm completely featureless without it") made him a poster boy for outcasts and wallflowers everywhere. A compilation of the Cure's earliest singles, *Standing on a Beach: The Singles*, was released in 1986, followed later that year by one of the greatest double albums in rock history, *Kiss Me, Kiss Me, Kiss Me*, which featured, among other classics, their first American top-forty hit, "Just Like Heaven." Before recording began on the next release, Smith was pressured into firing Tolhurst, the remainder of the group claiming that their relations with him had become irreparably damaged. Following Tolhurst in dismissal, Smith's bleak streak came roaring back for 1989's gauzy and gray *Disintegration*, a masterstroke. It marked the end of the band's lush creative zenith. Smith was just thirty years old. In 1991, Tolhurst reappeared and unsuccessfully attempted to sue the group, claiming his contributions were larger than stated in his contract and that he co-owned rights, with Smith, to the name the Cure. The fizzy and light *Wish* appeared in 1992 and featured

the hits "Friday I'm in Love" and "High." *Show* and *Paris*—two live albums—were released in 1993, and *Wild Mood Swings* appeared in early 1996. The group reemerged in the new millennium with their last album for Fiction Records, 2000's *Bloodflowers*, completing a theoretical trilogy of the group's darkest material (with *Pornography* and *Disintegration*). Though not a return to form, it certainly stands as the best of their later material. The Cure's first self-titled release followed in 2004 to little fanfare, and if *Bloodflowers* looked back to the grim mile markers in their catalog, 2008's hook-heavy album *4:13 Dream* looked back to *Kiss Me, Kiss Me, Kiss Me* and *Wish*.

THE MISERABLE LIST: THE CURE

1. "Killing an Arab"—Single (1979)
2. "Faith"—*Faith* (1981)
3. "The Hanging Garden"—*Pornography* (1982)
4. "Cold"—*Pornography* (1982)
5. "The Caterpillar"—*The Top* (1984)
6. "Kyoto Song"—*The Head on the Door* (1985)
7. "Just Like Heaven"—*Kiss Me, Kiss Me, Kiss Me* (1986)
8. "The Same Deep Water as You"—*Disintegration* (1989)
9. "Pictures of You (Live)"—*Entreat* (1991)
10. "Watching Me Fall"—*Bloodflowers* (2000)

SONG ESSAY: "KILLING AN ARAB"

It's unsurprising that the Cure's first single, "Killing an Arab," sparked controversy. The splashy and nervous post-punk cut that lasts just more than two minutes—and that *NME* named Single of the Week in January 1979, calling Smith's performance "full of eerie promise"—introduced the world to one of the biggest rock bands of the 1980s. And its lightning-rod title, which *Village Voice* critic Robert Christgau chalked up to "typical punk provocation," made sure people were listening.

One of the first songs recorded by the trio then known as the Easy Cure, "Killing an Arab" captured the attention of Polydor A&R rep Chris Parry and quickly became the group's first single. Recorded at the same time as their debut album, *Three Imaginary Boys*, but released beforehand to drum up interest in the band, the single's initial run of 15,000 copies, in December 1978, came via the Small Wonder label. (Polydor, which had signed the band, refused to release any records so near to the winter holidays.) Shortly thereafter, it was reissued by Chris Parry's newly formed Fiction Records in February 1979—Parry, having left Polydor, purchased the Cure's contract on his way out. The following year the song hit American shores as part of the band's first US release, *Boys Don't Cry*.

Smith wrote the song in celebration of one of his favorite books, the trim existentialist classic *The Stranger*, by Albert Camus. When Fiction rereleased the single, they even mailed out copies of the book with the record as a marketing gimmick.

The novel centers around the emotionally detached Meursault, who deals with the death of his mother ("Maman died today") before helping his friend Raymond lure an unfaithful girlfriend to his apartment, where she is beaten. After the beating, the woman's brother and several Arab friends begin to trail Raymond, who is stabbed during the eventual altercation. Later, as Meursault walks along a hot beach, carrying a pistol he had taken from Raymond, he encounters the Arab man who had stabbed Raymond. The world blurring before him, on the verge of heatstroke, and distracted by the "dazzling spear" of light reflected off the man's knife, he shoots the Arab man: "And it was like knocking four quick times on the door of unhappiness." Smith's song was, in his own words, "a short poetic attempt at condensing my impression of the key moments" in the book. It's worth mentioning, though, that Smith's take on the events in the novel differ from the source material in a couple of notable ways: First, following the murder, Smith recognizes "the Arab" as a "man," whereas Camus dehumanizes the character and refers to him only as "the motionless body." Second, the unnamed narrator of the song sees himself "reflected in the eyes of the dead man," suggesting an underlying universality missing from Camus's bleak novel.

The trouble began almost as soon as the song was released, as British skinheads adopted it as a call to arms against Arab immigrants. Cure bassist Michael Dempsey, though, defended the group's decision to . . . well, *not* defend the song, saying, "There's no reason why we should have to. If people aren't bothered to listen to it properly we don't really care about them anyway." Then, in 1986, as the Cure was reigning over college radio and on the eve of the release of *Standing on a Beach: The Singles*, a student DJ at Princeton's WPRB reportedly introduced the song by saying, "Now, here's a song about killing A-Rabs." After reading a review of *Standing on the Beach* and hearing of the DJ's remark, the American-Arab Anti-Discrimination Committee worked to enact a nationwide protest of the song on the grounds that it was offensive and could promote anti-Arab sentiment. If not for the strength of the Cure's contract with Elektra (their US label), the protest would have successfully seen the song excised from the album. As it was, the protests restricted its radio play and Elektra released a statement to eight hundred student and album-oriented rock stations that requested the song "be given no further airplay at your station" on the grounds that it "has been, and could continue to be, interpreted in such a way as to further anti-Arab sentiment and threaten the well-being of Arab-Americans." Elektra and the band also agreed to sticker all copies of the album with a short statement from Smith condemning any racist or violent readings of the track: "The song KILLING AN ARAB has absolutely no racist overtones whatsoever. It is a song which decries the existence of all prejudice and consequent violence. The Cure condemn its use in furthering anti-Arab feeling." Finally, Smith released a longer statement, explaining the song's origins, and the group played a benefit concert, with proceeds donated to organizations aiding Lebanese, Palestinian, and American orphans.

Though Smith was willing to comply with these measures, the political message of the song still rings out in that some view Meursault's murder of an Arab in the novel as colonialism and racial dominance rather than an exercise in the futility of choice. As Ellie M. Hisama notes in her essay "From l'Étranger to 'Killing an Arab': Representing the Other in a Cure Song": "No longer able to claim cultural superiority,

dominance, and authority over the Arab, the Meursault who is portrayed in the song becomes, to himself, a stranger, just another 'Other,' surely a terrifying thought to someone who has always enjoyed a position of privilege because of his unmarked ethnic identity." But Smith didn't see it that way, and in his statement about the song he claimed it "was designed to illustrate the utter futility of the actual act of killing," adding, "the fact that it was an Arab who was shot seemed, to me, totally immaterial, as I imagine it did to Albert Camus."

Unsurprisingly, the controversy surrounding the song returned following both the escalation of the Gulf War and the events of September 11, 2001. In John Sack's *Company C: The Real War in Iraq*, the author recalls a moment when a colonel tells his soldiers that the best way to get over nerves "is to fire one round," something many of the soldiers had not yet done: "One boy played on his Walkman his *Killing an Arab*, by The Cure, *I'm starin' down the barrel, At the Arab on the ground*, the boy now thinking, *I wish*."

In a 2001 interview Smith stated, "If there's one thing I would change, it's the title." And so he did. When the group resurrected the song during their 2005 tour he had changed the title to "Kissing an Arab" before writing a new verse and changing the name yet again to "Killing Another," for the group's 2007–2008 tour. Ultimately Smith stands by the work: "One of the themes of the song is that everyone's existence is pretty much the same. Everyone lives, everyone dies, our existences are the same. It's as far from a racist song as you can write." Even so, Smith has had it written into his contract that his record labels cannot use the song for any purpose without his expressed permission, and it's conspicuously absent from the group's 2001 *Greatest Hits* collection.

When *Trouser Press* asked Robert Smith in 1980 if he regretted recording and releasing the song, he replied, "No, because the good that came from it far outweighed the bad. We came to public attention really quick on the strength of a single that wasn't a hit." Years later, however, Smith would refer to the song as an "albatross," and in 2004 he said that it "has at times overshadowed everything we've ever done." It's a fact he would find more patience for dealing with but for his belief that it's just "not that good a song."

Breaking Up, Breaking Down, Cheating, and Divorce

Tammy Wynette was already a country and crossover star in 1968, having topped the charts with the amatorially opposed singles "D-I-V-O-R-C-E" and "Stand by Your Man" that year: In the former she spells out "the hurtin' words" for the benefit of her young son, and in the latter she implores womankind to stick by their men through thick and thin. The following year Wynette married another of country music's biggest stars, George Jones, and the music they collaborated on during their uneasy union—Tammy once said that Jones was "the only person who could get me so mad I could scream one minute and then sing me a song that was so sad I'd cry my eyes out"—offers a surprisingly complete musical picture of the rapture and tragedy of a modern relationship, the duo capturing every simple joy, quivering lip, stolen glance, and falling teardrop of their time together in song.

It began in 1969 with Jones's "I'll Share My World with You," which was written by a Florida seashell artist after reading about the marriage of country's first couple, and would have gone to number one on the country charts if not for the continued success of Wynette's "Stand by Your Man." The duo's chemistry is palpable on their first album of duets, 1971's *We Go Together*, which is stacked with songs

that celebrate their new union ("Something to Brag About," "Never Grow Cold," "Lifetime Left Together"), but by their next album, 1972's *Me and the First Lady*, the cracks were beginning to show in material like Wynette's "Lovely Place to Cry," "Great Divide," and "We're Gonna Try to Get Along," even as they reenacted their wedding vows in "Ceremony." By 1973's "We're Gonna Hold On"—who are they trying to convince?—things were headed south largely due to Jones's drinking and violent behavior. The following year witnessed a string of heartbreak singles from Jones, including "The Grand Tour"; "The Door," which compares "earthquakes" and "a thousand bombs exploding" to "the closing of the door"; and "These Days (I Barely Get By)." By early 1975 Wynette—whose own diaristic solo recordings during this period included "One Final Stand," "Another Lonely Song," and "Woman to Woman"—had filed for divorce, while Jones charted with "Memories of Us" and "I Just Don't Give a Damn" ("I've done everything I can to make you happy").

But for all the previously mentioned melodrama, the best place to start with country's first couple may be the duo's postdivorce 1976 classic, *Golden Ring*. Produced by legendary countrypolitan architect Billy Sherrill during the final days of the rocky public relationship between Jones and Wynette, the album captures the entire arc of their relationship with a heartbreaking series of songs in which both artists turn in some of the best performances of their career. It's highlighted by the title track, a duet that follows a young couple from "a pawn shop in Chicago" where they look at wedding rings, to a chapel, then "a small two-room apartment" where the listener soon catches them fighting their "final round" before the woman walks out, exclaiming, "I don't love you anymore." The song's plainspoken lyrics insist that the ring, the symbol of their love, is little more than a "cold, metallic thing" until their emotional bond alchemically transforms it into something enchanted, a "golden wedding ring," only to find that love can be so fleeting that the leap from marriage certificate to divorce papers fits majestically, concisely into four short bars.

Songs about cheating and leaving, straying and breaking up, are as constant as song itself. It's like Newton's third law of motion: For every love song that rings into existence from a baby grand in London

there's a breakup song thrumming to life from an acoustic guitar in Nashville. But to remain Newtonian it's worth remembering the scientist's first law of physics: A body at rest remains at rest until put into motion by an outside force—or to quote Waylon Jennings, "What makes me want to roam / When I have so much love at home?"

The unexpected, whiplash kind of heartbreak that infidelity can bring about has long been a bitter muse. For many years it was widely held that only wives could be said to be "cheating" on their husbands, and in keeping with that double standard, there are a number of early dances and ballads that play on the cuckold's shame, such as "A Cuckold by Consent"; Samuel Pepys's collected "Love, Pleasant" broadside ballads include "The Innocent Shepherd and the Crafty Wife" and "The Country Cozen, or The Crafty City Dame," both of which feature witty philandering women outsmarting their somewhat dim husbands, while the *Child Ballads* include notable works that touch on mythology, such as "The Daemon Lover" (also known as "James Harris" or "The House Carpenter") and "Clerk Colvill," which features a man who dies after a dalliance with a mermaid.

Unfaithful men and women are ubiquitious in the blues, the most notable figure being the "backdoor man" who slips out of the back of the house as a husband returns home through the front. But the backdoor man didn't originate with the blues; he has a long-standing history, as evidenced by English proverbs like "A nice wife and a back door, do often make a rich man poor," which dates to 1678. Willie Dixon's "Back Door Man" as performed by Howlin' Wolf (1966) is perhaps the best-known blues evocation of this slippery character, but the notion appears in Seth Richard's 1928 recording of "Skoodledum Doo" and soon after in recordings by Scrapper Blackwell, Kokomo Arnold, Casey Bill Weldon, and Emery Glen, all of whom recorded songs titled "Back Door Blues." Jimmy Rogers recorded "Back Door Friend" in 1952, and Lightnin' Hopkins, who claimed to be the song's true author, recorded his first version as "Letter to My Back Door Friend" in 1963.

Ma Rainey and Bessie Smith both specialized in blues about cheating men, and the line "Trust no man no further than your eyes can see," from Rainey's "Trust No Man," summed up their

approach to the battle of the sexes. Also worth digging up are Blind Joe Reynolds's "Cold Woman Blues," "Third Street Woman Blues" (recorded as Blind Willie Reynolds), and "Outside Woman Blues," which was covered by Cream on their classic 1967 album *Disraeli Gears*. "Outside Woman Blues" was changed slightly and again recorded by Reynolds as "Married Man Blues," which ends with the cynically sage lyric "Man's a fool if he thinks he got a whole woman to himself." More modern blues recordings that expertly hark back to these wandering ways can be found in cuts like Little Milton's "Who's Cheating Who?" and Robert Cray's *Strong Persuader* album from 1986, a loose-concept record that deals with the ramifications of cheating.

Willie Nelson wrote in his autobiography that "after Daddy Nelson died, I started writing cheating songs." He was no doubt influenced by songs like Floyd Tillman's slack 1949 single "Slippin' Around" (which Nick Tosches has referred to as "the granddaddy of all country cheating songs"), Ray Price's "Heartaches by the Number," Jim Reeves's "He'll Have to Go," and Kitty Wells's "It Wasn't God Who Made Honky Tonk Angels." A historically relevant answer song to Hank Thompson's cheating classic, "The Wild Side of Life," Wells's "Angels" was banned from radio yet still became the first *Billboard* country-chart number one for a solo female artist. Of course, any conversation about country music's greatest cheating songs is incomplete without Hank Williams's "Your Cheatin' Heart." Written in 1952, the song remained unreleased until after Williams died, in 1953, and even then it appeared as the B side to the strange novelty song "Kaw-Liga." "Your Cheatin' Heart" remained atop the country charts for six weeks and has since become synonymous with the legacy of Williams as a confessional "Drifting Cowboy" and poet of the people.

"Sad Movies (Make Me Cry)," a top-ten hit in 1961, by Sue Thompson (the Lennon Sisters' version, recorded the same year, didn't fare quite as well), and Kenny Rogers and the First Edition's "Ruby, Don't Take Your Love to Town" (1969) neatly bookend country cheating songs of the 1960s, yet they couldn't be more different. Thompson's twee country vocal and innocent heartbreak seem

a world away from the darkness of "Ruby." Kenny Rogers, before he became a bona fide country star and rotisserie-chicken entrepreneur, led the country-psych-rock outfit First Edition and had a tremendous hit with the Mel Tillis song. First recorded in a straightforward acoustic reading two years previous by country singer Johnny Darrell (who rode the bleak song to number nine on the country charts), the First Edition pumped up the tempo and turned in an inexplicably jaunty song about a Vietnam veteran who returns from the war a shell of his former self. Bedridden, unable to move ("It's hard to love a man whose legs are bent and paralyzed"), and on the verge of death ("But it won't be long, I've heard them say, until I'm not around"), the man discerns the time of day by watching shadows move across the wall, while his lover emasculates him by dressing up and going out on the town night after night. His anger and jealousy drive him to wish he could move, if only to grab his gun and "put her in the ground," and the muffled delivery Rogers brings to the song echoes the exhaustion of the cuckolded veteran. As compact and viciously miserable as "Ruby" may be, it seems surgical compared with the heap of cheat that unfolded during the 1970s.

Country singer Moe Bandy released his debut album, *I Just Started Hatin' Cheatin' Songs Today* (the cover featuring a doughy, mutton-chopped Bandy seated with the neck of a broken Jack Daniel's bottle in his hand) in 1974, and had his biggest hit in 1979, with Curly Putman and Sonny Throckmorton's "It's a Cheating Situation." Street, an ace songwriter who committed suicide by shooting himself in the head just months after signing a deal with Mercury Records, wrote more than his share of classic country cheatin' songs during the seventies, including "Lovin' on Back Streets," "Forbidden Angel," "(This Ain't Just Another) Lust Affair," "I Met a Friend of Yours Today," and "Daylight Strangers, Midnight Friends."

The best cheating songs of all time, however, seem to come from the R&B world. "I guess 'Dark End of the Street' was the culmination of two or three years of thinkin' about cheatin,'" confessed songwriter Dan Penn, and there's little doubt that the hit he cowrote with Chips Moman and Spooner Oldham lands near the top of any discussion about the greatest cheating songs. The song's most perfect incarnation

was captured by troubled singer James Carr, who managed to imbue his performance with steamy anxiety and remorseful exhaustion, the lyric framing an affair as a self-destructive addiction. Elsewhere on the R&B landscape, Marvin Gaye's "I Heard It Through the Grapevine" is a sprightly infidelity tune effectively used to sell raisins during the 1980s; Otis Redding's "Dreams to Remember" is gut-wrenching in its grim power; Ann Peebles's "Breaking Up Somebody's Home" is a graceful slice of Hi Records soul from 1972; and Doris Duke's "To the Other Woman (I'm the Other Woman)" turns the idea on its ear by approaching the topic from the view of . . . well, the other woman, happy to know with certainty she's number two, while echoing Rainey and Smith, while brazenly asking, "What number are you?" A similar idea was explored on Millie Jackson's fantastic 1974 love-triangle concept album *Caught Up*, which dedicated the A-side to the other woman and the flip to the wronged wife. The album opened with the steamy smash "(If Loving You Is Wrong) I Don't Want to Be Right" ("Am I wrong to fall so deeply in love with you / Knowin' you've got a wife and two little children dependin' on you too?") and ran through incredible cuts like "The Rap," "It's All Over but the Shouting," and Bobby Womack's "I'm Through Trying to Prove My Love to You." The album proved so popular that Jackson returned to the scene of the affair the following year for *Still Caught Up*.

More recently, Usher's "Confessions, Part II" ("Just when I thought I said all I could say / My chick on the side said she got one on the way") was a number-one R&B hit during 2004, and Rihanna's "Unfaithful," a song that equates cheating with murder ("I might as well take a gun and hold it to his head"), just missed the top spot two years later. But as far as cheating songs go, they don't come more ridiculously epic than R. Kelly's twenty-two-part (with a "To Be Continued . . ." tease) stream-of-consciousness cheater's tale, "Trapped in the Closet." Given a staggered release between 2005 and 2007 (with more chapters possibly on the horizon), "Trapped" begins with Kelly (as Sylvester) waking up in a strange woman's bed, quickly devolves into a grand and absurd soap opera of straying spouses and their bemused lovers, and ends (for now) with a desperate game of telephone (literally) that finds many of the characters confronting the

notion that they may be connected through their dalliances to another character that (spoiler alert!) is in the hospital with "the package" (HIV/AIDS). It's ambitious in scope, but just as epically flawed, and listening to too much of it at once is a grind, yet it's a bold move that Kelly concisely described as "a ghetto *Desperate Housewives*."

In the indie landscape, few lo-fi poets have been so touched with bitter gifts as Arab Strap's Aidan Moffat. The group's "(If There's) No Hope for Us" is a great example of his interpersonal cartography, as he plots the course of another contented relationship that dissolves into "grunts and sighs and shrugs"—she cheats without remorse and he wonders how there can be hope for anyone, anywhere, if they can't work it out. The lovelorn reportage of indie stalwart David Gedge (Wedding Present, Cinerama) features three's-a-crowd material like "Everyone Thinks He Looks Daft" and "Dalliance." Nebraska native Tim Kasher (Cursive, the Good Life) writes brusque songs about unsteady relationships that include the pained "Excerpts from Various Notes Strewn Around the Bedroom of April Connolly, February 24, 1997" and peak with Cursive's 2000 concept album, *Domestica*, which includes "A Red So Deep" and "A Game of Who Needs Who the Worst" ("What did that prick whisper to you? Was it playful and flirty or degrading and dirty?"). And while the metal world is full of power ballads and jackhammer screeds laced with infidelity, it's easy to start and stop the conversation with Type O Negative's forthright "I Know You're Fucking Someone Else."

Despite the pleading and begging that follows being discovered straying from a relationship, the next step is usually off the cliff. The distressed, dark sibling to the effusive glow of the love song, the breakup song, while ubiquitous, is nearly always more complicated. As Scott Walker crooned so elegantly on the Walker Brothers' 1965 smash "Make It Easy on Yourself," "Breaking up is so very hard to do."

The world's composers have created an encyclopedic variety of breakups, splits, and dissolutions, but the majority of these songs can fit neatly into the well-worn Kübler-Ross grief cycle, also known as the Five Stages of Grief. The cycle, first introduced by Dr. Elisabeth Kübler-Ross in her 1969 book *On Death and Dying*, was initially created to outline the shifting mental states of those dealing with terminal

illnesses, but was later expanded upon to cover any traumatic personal event, including the loss of a job or the end of a relationship.

DENIAL

Esther Phillips's "We Are Through," the Cure's "Apart," the Modern Lovers' "Hospital," Boyz II Men's "End of the Road," Jennifer Hudson's "And I Am Telling You."

ANGER

Edith Wilson's "I'll Get Even with You," Ben Folds Five's "Song for the Dumped," Marianne Faithfull's "Why'd Ya Do It?," Descendents' "Clean Sheets," Alanis Morissette's "You Oughta Know."

BARGAINING

Chicago's "If You Leave Me Now," Nilsson's "Without You," Thelma Houston's "Don't Leave Me This Way," No Doubt's "Don't Speak," Air Supply's "All Out of Love."

DEPRESSION

Mamie Smith's "Crazy Blues," Frank Sinatra's "One for My Baby," Eric Carmen's "All By Myself," Nine Inch Nails' "Something I Can Never Have," Pedro the Lion's "The Poison."

ACCEPTANCE

Dolly Parton's "I Will Always Love You," Elvis Presley's "Separate Ways," Stars' "Your Ex-Lover Is Dead," Blur's "No Distance Left to Run," the Mountain Goats' "Woke Up New."

To this list we can add one self-abusive theme that constantly occurs in breakup songs: regret. Hank Williams's "They'll Never Take Her Love from Me," George Michael's "Careless Whisper," Death Cab for Cutie's "A Lack of Color," or Elvis Presley's "I'm Leavin'"—possibly the saddest song to feature so damn many "la la las"—all reflect on missed opportunities and "what if?" moments that, in retrospect, make letting go that much more difficult.

When Frank Sinatra entered the studio to craft his 1955 album *In*

the Wee Small Hours, he wound up creating not just one of the first concept albums, but also the first breakup album. Overspilling with delicate late-night brooding and boozy heartbreak fueled by the singer's split from actress Ava Gardner, selections from the album include "When Your Lover Has Gone," the hopelessly self-abusive "I'll Be Around," "I Get Along Without You Very Well (Except Sometimes)," and the swooning melancholy of the Hilliard and Mann title track. Consistently placed in lists of the greatest recordings ever made, it also sparked the beginning of an intermittent string of fantastically glum barroom albums by the Chairman, such as *Where Are You?* (1957), *Only the Lonely* (1958), and *No One Cares* (1959).

Since that time, the breakup album has become a sort of rite of passage: Trembling Blue Stars' *Her Handwriting,* Weezer's *Pinkerton,* Ryan Adams's *Heartbreaker,* Beck's *Sea Change,* Blur's *13,* Prefuse 73's *One Word Extinguisher,* Amy Winehouse's *Back to Black,* Kanye West's *808s & Heartbreak,* and Adele's humongous 2011 album, *21,* were all painfully informed by partings.

These album-length odes to ruined relations are as frequently reserved for full-out divorce—which comes with all the heartache but can also be subject to legally messy gravitational forces, pulling love, money, property, and children into its orbit.

With the advent of "no fault" divorce in the United States, first passed into law with the Family Law Act of 1969, in California (by then Governor Ronald Reagan), before spreading to other states (as of 2010 it is legal in all fifty states and the District of Columbia), the 1970s became the golden age of divorce. The rate of divorce doubled during the disco decade in the US and tripled between 1962 and 1981—from 400,000 to 1.2 million. Before the no-fault divorce many unhappy couples with means popularized the "Mexican divorce," a practice bronzed by the Drifters in a 1962 song written by Bob Hilliard and Burt Bacharach, "Mexican Divorce"—"Cross the Rio Grande and you will find / An old adobe house where you leave your past behind."

Though divorce was considered a dirty word until the 1970s, it's now as commonly accepted as the microprocessor, and recent figures show marriage itself experiencing a downward trend. According to

numbers compiled by the National Center for Health Statistics 8.2 per thousand adults (2,315,000) in the US were married in 2000. By 2007 that figure had dropped almost 10 percent to 7.3 per thousand (2,197,000), despite an increase in population from 281.4 million to 302.2 million. Meanwhile the divorce and annulment rate has also slowed, if at a less perceptible rate, from 4 per thousand in 2000 to 3.6 per thousand in 2007.

Whether you believe that divorce is a necessary evil or plain sin there's little denying that it held conceptual sway over some very fine musical moments during the 1970s.

Where R&B owns the cheating song, its stiffest competition, country and western, seems to own the divorce song: Hank Snow's "Married by the Bible (Divorced by the Law)" ("Divorces by the thousands, is this human race insane?"), Patsy Cline's "A Church, a Courtroom, and Then Goodbye" ("Where man-made laws push God's laws aside"), George Jones's "Brown to Blue" ("They changed your name from Brown to Jones and mine from Brown to blue"), Loretta Lynn's "Rated X," "(Pay Me) Alimony" by the Maddox Brothers and Rose, Merle Travis's "Divorce Me C.O.D.," Jerry Reed's "She Got the Goldmine (I Got the Shaft)," and "Single Again" by Gary Stewart ("Now he's got you and I've got two divorce lawyers on my back") are just a few examples.

Cher, while working closely with her then-husband Sonny Bono, climbed the charts in 1972 with the divorce ballad "Living in a House Divided" ("Look at us / The king and queen of emptiness"), which peaked at twenty-two on the charts and came five years after another divorce-themed hit for the duo, "You Better Sit Down Kids," which peaked at number nine in 1967. ABBA—the Swedish quartet made up of two married couples, both of which divorced during the band's run—twined their separations into their effervescent Swedish pop on songs like "The Winner Takes It All," from their 1980 album *Super Trouper,* and "One of Us" and "When All Is Said and Done," from their eighth and final album, 1981's *Visitors.* But during the 1970s no group so personified the bloom-is-gone resignation, defeat, despair, and anger of love and divorce as Fleetwood Mac, who somehow turned the infamous tangle of emotional intrigue that flared

during the recording of 1977's *Rumours*—drummer Mick Fleetwood divorced his wife Jenny Boyd, singer and keyboardist Christine McVie divorced bassist John McVie, and the long-term relationship between Lindsey Buckingham and Stevie Nicks came to a halt—into one of the biggest-selling albums ever.

Though the majority of songs that deal with divorce focus on romantic ruptures, there are a number that deal with the minutiae of legal separation—Millie Jackson's "House for Sale" and Sinéad O'Connor's "The Last Day of Our Acquaintance" ("we will meet later to finalize the details")—squaring religious concerns with earthly realities. Collateral damage, primarily children, is addressed in the aforementioned Sonny and Cher song "You Better Sit Down Kids," the painful honesty of the Loudon Wainwright song "Your Mother and I" (for which both his son, Rufus Wainwright, and daughter, Martha Wainwright, wrote responses in the former's "Dinner at Eight" and "Two Gold Rings," and the latter's "Bloody Mother Fucking Asshole"), and more recently Eminem's "Mockingbird," from his 2004 album *Encore*, and, from Glasvegas's 2008 self-titled debut, "Daddy's Gone." But few album-length statements have ever been as forthright about the complications of divorce as Marvin Gaye's 1978 *Here, My Dear*, a controversial and epic concept album devoted entirely to the breakup of his first marriage, to Anna Gordy—elder sister of Motown founder Berry Gordy—who had received half of Gaye's royalties from the as-yet-unrecorded album during their divorce proceedings, hence, the needling title. Though considered a flop when it first appeared, it had an intimate, confessional nature featuring Gaye's silky delivery laying out lines like "Somebody tell me please / Why do I have to pay attorney fees?"

Many of the greatest breakup albums are technically divorce albums: Bob Dylan's *Blood on the Tracks*, Elvis Costello's *Blood and Chocolate*; Bruce Springsteen's *Tunnel of Love*, Richard Buckner's *Devotion & Doubt*, Kirsty MacColl's *Titanic Days*, Tom Petty's *Wildflowers*, Smog's *The Doctor Came at Dawn*, David Sylvian's *Blemish*, Cursive's *Domestica*, and Usher's *Raymond v. Raymond* are all strong contenders for the greatest in this category.

John Martyn's *Grace and Danger* featured percussion work by Genesis member Phil Collins, who pulled plenty of inspiration from the

sessions for his own divorce album—also his solo debut—*Face Value*, which appeared the following year. The heavily compressed drums get most of the attention in Collins's 1981 hit, "In the Air Tonight," but listen to the lyrics, most of which were improvised, and you'll find a bitter, vitriolic kiss-off to his first wife: "If you told me you were drowning / I would not lend a hand." "The lyrics you hear are what I wrote spontaneously. That frightens me a bit, but I'm quite proud of the fact that I sang 99.9 percent of those lyrics spontaneously," Collins told *Mix* magazine in 1999. (The drowning metaphor he used became the basis for an urban legend regarding Collins witnessing a similar tragedy, a legend that became so persistent it even popped up in the lyrics to Eminem's "Stan.")

Henry Wadsworth Longfellow wrote, "Great is the art of beginning, but greater is the art of ending," which holds as true for writing a song about breaking up as it does for actually breaking up. Love songs may be the prettier, more confident, less complicated cousins, but it's the dagger-in-the-chest songs of splitting up, breaking down, and learning to move on that succor us when we need it most.

THE MISERABLE LIST: GUILTY FEET HAVE GOT NO RHYTHM

1. "It Wasn't God Who Made Honky Tonk Angels"—Kitty Wells (1952)
2. "Your Cheatin' Heart"—Hank Williams (1953)
3. "The Dark End of the Street"—James Carr (1967)
4. "Borrowed Angel"—Mel Street (1972)
5. "I Was Checkin' Out (She Was Checkin' In)"—Don Covay (1973)
6. "(If Loving You Is Wrong) I Don't Want to Be Right"—Millie Jackson (1974)
7. "Careless Whisper"—George Michael (1984)
8. "The Rain"—Oran "Juice" Jones (1986)
9. "(If There's) No Hope for Us"—Arab Strap (2005)
10. "Take a Bow"—Rihanna (2008)

THE MISERABLE LIST: BREAKING UP IS SO VERY HARD TO DO

1. "One for My Baby (And One More for the Road)"—Frank Sinatra (1958)
2. "It's Over"—Roy Orbison (1964)
3. "Make It Easy on Yourself"—The Walker Brothers (1965)
4. "Stay with Me Baby"—Lorraine Ellison (1966)
5. "Without You"—Badfinger (1970)
6. "I Know It's Over"—The Smiths (1986)
7. "Something I Can Never Have"—Nine Inch Nails (1989)
8. "Nothing Compares 2 U"—Sinéad O'Connor (1990)
9. "You're the One"—Kate Bush (1993)
10. "No Distance Left to Run"—Blur (1999)

THE MISERABLE LIST: D-I-V-O-R-C-E

1. "Married by the Bible (Divorced By the Law)"—Hank Snow (1952)
2. "A Church, a Courtroom, and Then Goodbye"—Patsy Cline (1955)
3. "Separate Ways"—Elvis Presley (1972)
4. "The Grand Tour"—George Jones (1974)
5. "Sail On"—The Commodores (1979)
6. "The Winner Takes It All"—ABBA (1980)
7. "Your Mother and I"—Loudon Wainwright III (1986)
8. "The Last Day of Our Acquaintance"—Sinéad O'Connor (1990)
9. "Oh, the Divorces!"—Tracey Thorn (2010)
10. "A Line in the Dirt"—Eels (2010)

DEAD CAN DANCE

Combining elements of Renaissance music, European folk, goth, ambient, and African polyrhythm with dark songs of loss, mystery, and sorrow, the duo of Brendan Perry and Lisa Gerrard found

a unique and successful niche in the art-rock market with the group Dead Can Dance (DCD). Perry came from Auckland punk band the Scavengers, where he served first as bassist, then as vocalist. The band relocated to Melbourne in 1979 and changed its name to the Marching Girls, which didn't help its fortunes, and by the following year Perry, influenced by the growing experimental post-punk "Little Band" scene, left the group and began to experiment with tape loops and electronic music. After meeting Gerrard, the two formed DCD in 1981 with bassist Paul Erikson and former Marching Girls drummer Simon Monroe. In 1982 Perry and Gerrard— now involved romantically—decided to relocate to London, while Erikson and Monroe decided to stay in Australia. It didn't take long for the relocation to prove fruitful; by the end of 1983 the duo had signed to 4AD. The following year they contributed two tracks to This Mortal Coil's debut, *It'll End in Tears,* and released their self-titled debut. Still steeped in the post-punk aesthetic, the album shares much with the raw, early works of fellow 4AD act Cocteau Twins and the gloom-pop of the Cure, even if songs like "Frontier," "Ocean," and "Musica Eternal" point to their more empyreal future. In 1985 the duo released the *Garden of the Arcane Delights* EP and their second full-length, *Spleen and Ideal,* which shed much of their post-punk past and embraced the ethereal chiaroscuro they would become known for: a foreboding mixture of Gregorian chant, ambient textures, polyrhythm, European folk traditions, Perry's crooning baritone, and Gerrard's slippery, keening glossolalia. In 1986 the group released the album *Within the Realm of a Dying Sun.* As DCD was always cinematic in scope, it was only a matter of time before they became involved in film—in 1988 they scored the music to *El Niño de la Luna,* which provided Gerrard's acting debut as well. Also in 1988 they released their fourth album, *The Serpent's Egg,* which opened with the epic "The Host of Seraphim"—which itself would in time come to fill a handful of soundtracks. Following the release of *The Serpent's Egg* the romantic relationship between Perry and Gerrard dissolved; Gerrard returned to Australia, while Perry relocated to Ireland, though they would continue to work together,

releasing their fifth album, *Aion*, in 1990. In 1991, after DCD had mounted their first successful small tour of America, Rykodisc released the compilation album *A Passage in Time*, making it the first domestically available DCD album in the US. Their first proper US release came in 1994 with *Into the Labyrinth*, and the successful tour that followed was documented for the 1995 film and live album *Toward the Within*. Lisa Gerrard released her first solo album, *The Mirror Pool*, in 1995. Unsurprisingly it sounded like a chip off the DCD block. The next year the group released their final album, *Spiritchaser*, though Perry and Gerrard didn't officially call it quits until 1999. Gerrard recorded the 1998 album *Duality* with Pieter Bourke, and scored the 1999 Michael Mann film *The Insider* (she previously scored Mann's 1995 heist film *Heat*) and Ridley Scott's 2000 film *Gladiator*. Perry released his first solo album, the gloomy folk-rock *Eye of the Hunter*, in 1999. In 2005, rumors swirling, Perry and Gerrard mounted a limited Dead Can Dance tour. Two songs debuted on the tour were recorded for Perry's 2010 album, *Ark*.

THE MISERABLE LIST: DEAD CAN DANCE

1. "Musica Eternal"—*Dead Can Dance* (1984)
2. "De Profundis (Out of the Depths of Sorrow)"—*Spleen and Ideal* (1985)
3. "The Cardinal Sin"—*Spleen and Ideal* (1985)
4. "Anywhere Out of the World"—*Within the Realm of a Dying Sun* (1987)
5. "The Host of Seraphim"—*The Serpent's Egg* (1988)
6. "In the Kingdom of the Blind, the One-Eyed Are Kings"—*The Serpent's Egg* (1989)
7. "Black Sun"—*Aion* (1990)
8. "The Wind That Shakes the Barley"—*Into the Labyrinth* (1993)
9. "I Am Stretched on Your Grave"—*Toward the Within* (1994)
10. "Sanvean"—*Toward the Within* (1994)

DEPECHE MODE

Depeche Mode began life as a bubbly synth-pop band before becoming one of the gloomiest hit-making machines of the eighties and nineties. Keyboardists Andrew Fletcher, Vince Clarke, and Martin L. Gore played together in various combinations, under a handful of names, before the three collided in Composition of Sound, with Clarke handling vocal duties. The trio soon signed on David Gahan as full-time vocalist, changed their name one last time to Depeche Mode (culled from a French fashion magazine), and dumped every instrument that wasn't a synthesizer. The group's first few singles failed to find an audience, but their fourth attempt, 1981's "Just Can't Get Enough," became a top-ten hit in the UK and is now a synth-pop staple. In fact, their debut album, *Speak & Spell* (released the same year), went a long way to establishing the attributes of the synth-pop sound, inspiring an explosion of imitators during the 1980s. *Speak & Spell* was largely Clarke's baby, and he would carry his fizzy sensibilities ("Vince doesn't write gloomy songs," said David Gahan in 1981) with him when he left the group to form Yazoo soon after the debut album's release (Clarke was replaced by Alan Wilder). Gore stepped up to become the group's primary songwriter, and though it took him a few albums to find his footing, by 1984's *Some Great Reward*, Gore and company had fully realized their transition from bubbly dance-pop to gloomy, introspective synth-rock. The lead single, "People Are People," became their first hit to trouble the charts in both the US and the UK As they honed their sound and experimented with industrial notions and sampling, Gore's lyrics found their sweet spot in themes of alienation, loneliness, uncertainty, faith, truth, and politics, often expressed via romantic and S&M imagery (he has joked that he uses the word "knees" more than any other lyricist). Featuring songs like the Gore-sung ballads "Sometimes," "World Full of Nothing," and the desperately bleak "Fly on the Windscreen," 1986's *Black Celebration* stands as perhaps their most completely miserable statement. "Strangelove" was released as a preamble to 1997's *Music for the Masses*, which is filled with dreary pop diamonds such as "The Things You Said," "I Want You Now,"

and "Nothing." Then came 1991's mainstream breakthrough, *Violator*, which spawned a trio of huge hits in "Enjoy the Silence," "Policy of Truth," and "Personal Jesus." The group became one of the biggest in the world and their next release, 1993's rockist *Songs of Faith and Devotion*—likely a nod to Gahan's discovery of grunge—was a huge seller. Unfortunately, in an oft-repeated storyline, the group began to fall apart at the height of its success, with Wilder exiting in 1995 and Gahan imploding; he attempted suicide and ultimately flatlined (his heart reportedly stopped for two full minutes) in a Los Angeles hospital, after which he entered rehab for a longtime heroin addiction. The group took a four-year break, Gahan cleaned himself up, and Depeche Mode returned as a trio to release 1997's lackluster *Ultra* and 2001's *Exciter* before finding their groove again on 2005's *Playing the Angel* and 2009's *Sounds of the Universe*. Gore and Gahan both invested themselves in solo releases between albums, while Fletcher dabbled as a restaurateur. So attached in the popular consciousness is Depeche Mode to the themes of sadness and loneliness that makers of the popular video game *World of Warcraft* subpoenaed Gore's presence in a court case: An avid player was suing the video-game maker, claiming the game was alienating him from real life. Gore, *The Guardian* reported, appeared to be "an expert witness on melancholy."

THE MISERABLE LIST: DEPECHE MODE

1. "I Sometimes Wish I Was Dead"—*Speak & Spell* (1981)
2. "Leave in Silence"—*A Broken Frame* (1982)
3. "Somebody"—*Some Great Reward* (1983)
4. "Blasphemous Rumours"—*Some Great Reward* (1983)
5. "Black Celebration"—*Black Celebration* (1986)
6. "The Things You Said"—*Music for the Masses* (1989)
7. "Enjoy the Silence"—*Violator* (1990)
8. "The Love Thieves"—*Ultra* (1997)
9. "Precious"—*Playing the Angel* (2005)
10. "Come Back"—*Sounds of the Universe* (2009)

JOHN DOWLAND

It all starts with John Dowland: The first English-speaking pop star just happened to be a self-proclaimed miserabilist living in a time when melancholy was all the rage. He published songbooks for the masses, he toured—as well as a musician seeking patronage could in the sixteenth century—and, as Sting writes in the liner notes to his 2006 bestselling album of Dowland songs, *Songs from the Labyrinth*, he "was the epitome of the 'outsider,' the alienated singer-songwriter." It's no stretch to draw a line from Dowland straight to Nick Drake and Elliott Smith. His influence even pops up in unlikely places such as the Rolling Stones classic "Ruby Tuesday," which Brian Jones imagined as a cross between Dowland and Skip James. What we know about the earliest parts of his life amounts to little more than educated guesswork. In two of his own writings he places his birth year at 1563, and Dowland scholars, including Diana Poulton, author of *John Dowland: His Life and Works*, have determined that he likely came from an English family of well-to-do artisans. He had a wife and a son, of whom he barely spoke, and in Poulton's estimation was likely "self-centered and highly emotional, with a just appreciation of his own powers, but with an almost childishly irritable reaction to criticism." We know just as little about his early musical life, but we do know that he received his first bachelor's from Oxford in 1588. Dowland left England in 1594 after his failure to gain an appointment as lutenist in the court of Elizabeth I—which, following the English Reformation, may or may not have been due to his Catholicism. He made his way to Germany, to Italy, then back to England, where he obtained another bachelor's degree from Cambridge in 1597. In *The First Booke of Songes,* containing his "hits" "Come, Heavy Sleep," "If My Complaints Could Passions Move," "Can She Excuse My Wrongs," and "Come Again"—published in 1597, the same year that he would again be denied an English court post—he stated that he was "sundry

times leaving me native country, the better to attain so excellent a science." In 1598 he entered the service of Christian IV of Denmark and during another trip back to England during 1603–1604—made primarily to lobby for the post he had twice failed to obtain at the English court—he published his most well-known work, *Lachrimae, or Seaven Teares Figured in Seaven Passionate Pavans* (a series of variations on his popular song, "Flow My Tears"). In 1605, following a string of salary advances and extended leaves, he was dismissed from his position in Christian's court and once again made his way back to England. With little reason to suggest why, on October 28, 1612, Dowland finally achieved the appointment that had eluded him his entire career—he became one of the King's Lutes at the court of James I (Elizabeth I died in 1603). At the same time, his compositional skills began to abandon him. To truly understand Dowland, the Elizabethan vogue for melancholy needs to be understood. The ardor of the age wasn't simply the desire of an entire generation to bury its head in its hands, and it wasn't the modern form of depression that was being celebrated; rather, this melancholy—and, more to the point, "inspired" melancholy—was a combining of the arts, largely music and poetry, used to lift introspection itself to an art form. And no one embodied this vision more than Dowland. Although his chosen instrument hasn't held up well against the passage of time—the lute fell out of favor by the eighteenth century—Dowland's reputation is larger now than it has been at any time since he was performing in the courts of Europe. His work is strikingly modern, and something like "Come Again" not only scans like an early Smiths song—"I sit, I sigh, I weep, I faint, I die / In deadly pain and endless misery"—but the melody is also reflective of one as well. The precise date of Dowland's death is unknown, but we do know from existing records that he was buried on February 20, 1626. His music has been recorded countless times, but ECM's brilliant 1999 album *John Dowland: In Darkness Let Me Dwell*, which *Jazz Times* called "one long ode to the joys of depression," is a good place to get acquainted with the ever-doleful Dowland.

THE MISERABLE LIST: JOHN DOWLAND

1. "Come, Heavy Sleep" (c. 1597)
2. "Go Crystal Tears" (c. 1597)
3. "If My Complaints Could Passios Move" (c. 1597)
4. "Flow My Tears" (c. 1600)
5. "I Saw My Lady Weep" (c. 1600)
6. "Sorrow, Come!" (c. 1600)
7. "Weep You No More, Sad Fountains" (c. 1603)
8. "Lachrimae Antiquae" (c. 1604)
9. "Semper Dowland, semper dolans" (c. 1604)
10. "In Darkness Let Me Dwell" (c. 1610)

NICK DRAKE

Born Nicholas Rodney Drake, on June 19, 1948, in Rangoon, Burma, two years before his family returned to their native England, Drake was already adept at playing the piano, clarinet, and saxophone when he picked up the guitar in 1965. He slowly began to piece together songs, recorded demos as early as 1967, and did a bit of hustling in hopes of scoring a record deal, but it wasn't until Ashley Hutchings, bass player for the Fairport Convention, heard Drake's hypnotic songs and contacted her manager Joe Boyd that the shy young singer got his break. Boyd would remain a constant in Drake's life from that point forward and would oversee all of his recordings, beginning with 1969's *Five Leaves Left*. The world's first exposure to the twenty-year-old's impressionistic folk preceded Donovan and John Martyn and, due to the orchestral arrangements of Robert Kirby, were sprinkled with allusions to Ravel and Handel. Though his mournful lyrics drifted throughout the album, the songs rang with gilded beauty, the essence of a perpetually autumnal English countryside: "River Man" and "Way to Blue" are soft, baroque, and poignant, "Cello Song" skates by quickly yet remains clouded

by melancholy, while "Fruit Tree" strikes the listener as eerily pre-
scient, Drake's voice sighing as he sings, "Safe in your place deep in
the earth / That's when they'll know what you were really worth."
Due to his gripping shyness, live performances were never comfort-
able for Drake. Brian Cullman, who opened for the timid singer one
night in early 1970, recalled Drake's halting performance in touch-
ing detail for *Pynk Moon* fanzine, saying that Drake sat on a stool,
clutched his guitar, and "mumbled and whispered, all with a sense of
precariousness and doom," and added that the experience was "like
being at the bedside of a dying man who wants to tell you a secret,
but who keeps changing his mind at the last minute." Drake headed
back into the studio for 1970's comparatively upbeat *Bryter Layter*,
which featured a touch of jazz influence along with Kirby's longing
string arrangements and contributions from John Cale and Richard
Thompson. Unfortunately neither *Five Leaves Left* nor *Bryter Layter*
found much of an audience, and Drake plummeted into serious de-
spair. He continued writing, however, and returned to the studio with
eleven brief songs for 1972's tender and stark *Pink Moon*. This time
around Drake recorded alone, just his guitar, a bit of piano, and a more
hesitant voice, his songs unadorned by outside elements. Boyd believed
Drake's songs became "less about other people and more about him-
self as time went on" an introspection that's evident on the delicate
and mournful "Place to Be" when he sings that he's both "darker than
the deepest sea" and "weaker than the palest blue," and in "Parasite"
when he mumbles, "I am the parasite of this town." The title track, of
course, was famously used in a 1999 Volkswagen commercial, which
brought a wave of renewed interest in Drake's music, but when it was
originally released, *Pink Moon* was met with a flurry of indifference,
which led the singer to an eventual breakdown and hospitalization. By
1974 he was twisting in the wind. He tried to record a fourth album,
but had neither the material nor the strength; Boyd recalled that he
couldn't even simultaneously play and sing anymore. After a brief trip
to Paris he attempted to get a job in the burgeoning computer industry
and even considered joining the army. To his friends, Drake was disin-
tegrated before their eyes. Linda Thompson said that before his death,
"he looked like Howard Hughes. There was this beautiful boy with the

milky white, almost see-through skin, who always took great care of his hands and his fingernails, and now he was dirty and unkempt and his nails were too long to play the guitar." On November 26, 1974, he was found dead in his parent's home. By his mother's count she believed he may have taken as many as thirty bright orange Tryptizol tricyclic antidepressant capsules in the night, and, according to accounts of the aftermath, little was done to inspect a cause of death beyond linking it to a half-empty pill bottle. An inquest was held more than two weeks after the body had been cremated and, with only the family doctor's testimony as evidence, a death certificate was issued on Christmas Eve, stating the cause of death as "Acute Amitriptyline Poisoning—self-administered when suffering from a depressive illness" followed, in brackets, by the word "suicide," a declaration some of Drake's friends and family dispute to this day. The rarities and outtakes collection *Time of No Reply* was released in 1986, and included the four songs he was able to record during his final sessions. More songs and additional versions found their way out of the vaults on 2004's *Made to Love Magic* and 2007's touching look at his earliest recordings, *Family Tree*. His simple tombstone rests at the foot of a large oak overlooking the Warwickshire countryside; an inscription carved into the reverse of the stone reads, "Now we rise and we are everywhere."

THE MISERABLE LIST: NICK DRAKE

1. "River Man"—*Five Leaves Left* (1969)
2. "Way to Blue"—*Five Leaves Left* (1969)
3. "Fruit Tree"—*Five Leaves Left* (1969)
4. "Fly"—*Bryter Layter* (1970)
5. "Pink Moon"—*Pink Moon* (1972)
6. "Place to Be"—*Pink Moon* (1972)
7. "Parasite"—*Pink Moon* (1972)
8. "Time of No Reply"—*Time of No Reply* (1986)
9. "Black Eyed Dog"—*Time of No Reply* (1986)
10. "They're Leaving Me Behind"—*Family Tree* (2007)

EAST RIVER PIPE

A 2006 profile in the *New York Times* painted F. M. Cornog (a.k.a. East River Pipe) as a contented family man—linoleum salesman at Home Depot during the day, bedroom Brian Wilson by night: "There's something to be said for humbly and quietly living your life . . . going to work, doing your job, taking care of your family." It wasn't always that simple for Cornog, and there to here is nothing short of a modern fairy tale: A troubled young adult walks off the job at a New Jersey lightbulb factory before a bout with alcoholism leaves him homeless and spending his nights in a Hoboken train station until a bighearted woman who has heard some of his old recordings takes him in, buys him some recording equipment, supports the man and his music, and the two eventually fall in love, marry, and bring a daughter into the world. But Cornog's music doesn't glitter with the fairy dust it has been brushed with. Take the name he stumbled upon for his recording career, which came to him in the belief that his music was no better than the raw sewage flowing into the East River. His songs are wounded, shy, bittersweet, and brilliant creations that gently pull listeners into their orbit with cascading waves of synths and shimmering guitar. It's only once inside the songs that you begin to see a glimmer of hope hanging around. Recording his initial demos onto cassette, Cornog eventually pressed his first single, "Helmet On," which would become *Melody Maker*'s single of the week and led to a deal with Sarah Records. The legendary indie label compiled all of his home recordings and released them in 1994 as *Shining Hours in a Can,* letting the world in on such downcast gems as "Made a Deal with the City," "Times Square Go-Go Boy," and "She's a Real Good Time." The collection received critical praise, but Cornog didn't hit his stride until 1995's *Poor Fricky*, a slow and steady album of breathtaking, deceptively simple beauty. The *New York Times* and the UK's *Independent* named 1999's *The Gasoline Age*—a collection of songs loosely based on US car culture—the "album of the year" and prompted *Rolling Stone* to call Cornog "one of our generation's great eccentric songwriters." *What Are You*

On? followed in 2006, focusing on the pervasive drug use in modern culture, from dime bags to Zoloft. His songs have been reinterpreted by David Byrne, Okkervil River, the Mountain Goats, and, most notably, Lambchop, who recorded versions of no fewer than five of Cornog's subtle masterpieces between their 1997 release, *Thriller*, and its follow-up, 1998's *What Another Man Spills*. None of it seems to faze Cornog though: "I'm just like a plumber or a sanitation worker or a salesman. I'm just doing my job . . . trying to get by."

THE MISERABLE LIST: EAST RIVER PIPE

1. "Helmet On"—Single (1992); *Shining Hours in a Can* (1994)
2. "Make a Deal with the City"—*Shining Hours in a Can* (1994)
3. "Bring on the Loser"—*Poor Fricky* (1995)
4. "Keep All Your Windows Tight Tonight"—*Poor Fricky* (1995)
5. "Beautiful Worn-Out Love"—*Mel* (1996)
6. "Kill the Action"—*Mel* (1996)
7. "Shiny, Shiny Pimpmobile"—*The Gasoline Age* (1999)
8. "King of Nothing Never"—*The Gasoline Age* (1999)
9. "Where Does All the Money Go?"—*Garbageheads on Endless Stun* (2003)
10. "What Does T. S. Eliot Know About You?"—*What Are You On?* (2006)

ECHO AND THE BUNNYMEN

Led by guitarist Will Sergeant, with his psychedelic flourishes, and singer Ian "Mac" McCulloch, whose pile of dark shaggy hair, predilection for baggy overcoats, and brooding vocals (not to mention a penchant for laughable hyperbole) made him an instantaneous star in the British music press, Echo and the Bunnymen may not be as resolutely grim as Joy Division or the Cure, but there's no doubt that they draw strength from the shadows. McCulloch's journey began when he formed the Crucial Three in 1977, with Pete Wylie and Julian

Cope. By the following year Wylie had exited to form Wah!, leaving Cope and McCulloch to continue on briefly (with Dave Pickett) as Uh? and then A Shallow Madness, until Cope sacked the moody Mc-Culloch and went on to form the Teardrop Explodes. McCulloch laid low until bonding with guitarist Will Sergeant (whose own Industrial Domestic project had run out of steam) over a shared love of Bowie, Television, and the Velvets. It led to a fruitful round of writing with the duo's notorious drum machine, "Echo"—an alias that came only after McCulloch's roommate had provided the group's gloriously odd name (other suggestions had included the Daz Men, Mona Lisa and the Grease Guns, and Glisserol and the Fan Extractors). They soon added boatbuilder/bassist Les Pattinson and made their live debut as Echo and the Bunnymen at the Liverpool club Eric's on November 15, 1978. Early the following year the Zoo label released the group's debut single, "The Pictures on My Wall"/"Read It in Books," which became Single of the Week in both *NME* and *Sounds* and introduced the foreboding image of the "Bunny Creature" (or "Bunnygod") that would lend itself to the band's dark, mysterious mythology. The trio toured, turned in an impressively raucous Peel Session, and recorded their final track as a trio, "Monkeys," for a compilation album. (A second single, "Happy Death Men," was slated for release by Zoo, though it mysteriously fizzled before appearing.) Shortly afterward they signed to Sire subsidiary Korova Records and, at the label's behest, shelved their trusted "Echo" for flesh-and-blood drummer Pete de Freitas (despite their initial pleas to simply "get a more expensive drum machine"), then set to work infusing the live beats into their sound. The first song created by the newly composed foursome was the self-deprecating "Rescue," which was released as a single in May 1980 and paved the way for their full-length debut, 1980's *Crocodiles*, which met with nearly universal acclaim and firmly established the group as a gloomy, majestic force of nature. Not content to lose momentum, the group toured (dressed in full camouflage), released the live *Shine So Hard* EP culled from tracks recorded for a short concert film of the same name, and prepped their second album. Released in 1981, *Heaven Up Here* is where the new group truly gelled. Mining a darker vein than before the album cracked the UK top ten,

it featured the saturnine pop hit that wasn't, "A Promise." which Mc-Culloch later recalled as "the saddest song ever." Their third album, 1983's *Porcupine*, peaked at number two on the UK album charts thanks to the momentum of top-ten single "The Cutter," and in 1984 they released their undisputed classic, *Ocean Rain*, which, despite being marketed as "the Greatest Album Ever Made" only peaked at number four in the UK (though it did become the group's entry to the US charts). They followed up with the 1985 compilation *Songs to Learn & Sing*, which included only one new recording, "Bring on the Dancing Horses." Thanks to that song's inclusion in the classic John Hughes film *Pretty in Pink*, it may well be their single most well-known recording. De Freitas exited the group briefly during 1986 but rejoined within a matter of months, and when the group returned in 1987 with a self-titled album they had their biggest chart success in the US (number fifty-one). By the end of 1988 McCulloch had left the group to focus on a solo career, but the remaining members of Echo chose to carry on, hiring singer Noel Burke to replace McCulloch and making keyboardist Jake Brockman—who had become affectionately known to fans as the "Fifth Bunnyman"—an official member of the group. Tragedy struck before the new group entered the studio, however, when De Freitas died in a motorcycle accident in June 1989. (In a bizarre coincidence, Brockman would also die in a motorcycle accident twenty years later, in September 2009.) Drummer Damon Reece was hired, and the new Bunnymen created 1990's *Reverberation*, a strange, if not nearly necessary, detour that failed to chart and proved the end of the Bunnymen for a time. McCulloch released two solid if uneventful solo albums, his bleak songs and ocean-bottom poetry losing some of their dangerous appeal with the loss of Sergeant's guitar. In 1994 McCulloch and Sergeant committed to working together again, but rather than resurrect the Echo name, they christened their new project Electrafixion. The resulting single, "Zephyr," and album, 1995's *Burned*, modernized the classic Echo sound with cynical touches of grunge and radio-ready alternative—Sergeant working out his more experimental aspirations in his ambient-psych side-project, Glide. *Burned* failed to connect, and Echo and the Bunnymen returned with Pattinson on

bass and new drummer Michael Lee, releasing the string-drenched, fan-favorite return to form *Evergreen* in 1997. A series of solid if straightforward Echo albums followed, showcasing flashes of the brilliance that the group displayed with such ease during their eighties heyday, including *What Are You Going to Do with Your Life?* (1999), *Flowers* (2001), *Siberia* (2005), and *The Fountain* (2009), along with a series of live album releases, most notably the two-disc *Live in Liverpool* (2002).

THE MISERABLE LIST: ECHO AND THE BUNNYMEN

1. "Stars Are Stars"—*Crocodiles* (1980)
2. "A Promise"—*Heaven Up Here* (1981)
3. "The Disease"—*Heaven Up Here* (1981)
4. "Porcupine"—*Porcupine* (1983)
5. "Ocean Rain"—*Ocean Rain* (1984)
6. "Bring on the Dancing Horses"—*Songs to Learn & Sing* (1985)
7. "All My Life"—*Echo & The Bunnymen* (1987)
8. "Lost and Found"—*Echo & The Bunnymen* (1987)
9. "Just a Touch Away"—*Evergreen* (1998)
10. "Rust"—*What Are You Going to Do with Your Life?* (1999)

EELS

Mark Oliver Everett began life in the public eye as E with his 1992 debut *A Man Called E,* which established the basic musical recipe he would fine-tune for the next two decades—boxy hip-hop beats and somber pop melodies paired with lyrics composed of equal parts intimate personal reflection, "grotesque" character studies, and childlike whimsy. The release had some small success behind good reviews and the miserable manifesto single "Hello Cruel World"—"Hello cruel world / So this is you / A broken heart / A withered view." But after the unjustly overlooked 1993 follow-up, *Broken Toy Shop*, failed to

find an audience, Everett split from his label and formed Eels with bassist Tommy Walter and drummer Butch Norton, scoring a minor hit right out of the gate with "Novocaine for the Soul" from their 1996 debut, *Beautiful Freak*. Then the rug was pulled out from under Everett, as both his sister and mother passed away within two years of each other, followed by Walter's exit from the group. Everett found catharsis in the Eels' troubled second release, 1998's *Electro-Shock Blues*, his pain rippling through the recording from the opening track, "Elizabeth on the Bathroom Floor," which recounts his sister's suicide, to "Cancer for the Cure," which delves into his mother's diagnosis of terminal cancer (E would later refer to the album as "cancer rock"). In 2000 the group released the lighter *Daisies of the Galaxy* and a limited-edition live album, *Oh What a Beautiful Morning*, and in 2001 Everett cowrote *Souljacker* with John Parish, introducing the world to another cavalcade of his unconventional character studies, including fan and Everett favorite "Dog Faced Boy." Another live album, *Electro-Shock Blues Show*, was released soon after. In a 2002 interview Everett said that the "two things that kept me from blowing my brains out" were Lenny Waronker, the DreamWorks executive who stood by the group through the difficult journey of making their second album, and the support of his wife. Norton left the band in 2003 after the release of *Shootenanny!*, which ultimately mattered little, as by this time Eels *was* Everett. The haphazard double-disc *Blinking Lights and Other Revelations* appeared in 2005, capturing a slew of Everett's most intimate, personal songs alongside the group's most adventurous sonic sketches. A third live album, *With Strings: Live at Town Hall*, appeared in early 2006; following its release, Everett spent time on two personal and deeply introspective projects dedicated to understanding his emotionally distant father, physicist Hugh Everett III, who died suddenly in 1982, when Mark was in his late teens. The memoir *Things the Grandchildren Should Know* appeared in early 2009 along with a BBC documentary that followed Everett on his journey of self-discovery. Eels' 2009 release was titled *Hombre Lobo: 12 Songs of Desire*, a self-deprecating joke at the expense of Everett's intense beard, which at times seemed to receive as much attention as his music (*hombre lobo* translates as

wolf man). He was questioned by London police in 2010 as a possible terrorist suspect, a mistake he defused with dry wit saying, "Not every guy with short hair and a long beard is a terrorist. Some of us just want to rock." *End Times* appeared the following year, on the heels of a global economic collapse and the dissolution of Everett's marriage. It is, not surprisingly, a bleak entry into the Eels catalog, personified in the delicate and brief ballad "Little Bird," which turns a bird that hops across Everett's porch into an existential confessional: "Know it sounds kinda sad, but what's it all for?" Later in 2010, demons momentarily quelled and spirits buoyed, Eels released *Tomorrow Morning*, which Everett described as the final installment in a trilogy that began with *Hombre Lobo* and *End Times*, and that explored the themes of desire, loss, and redemption.

THE MISERABLE LIST: EELS

1. "Hello Cruel World"—*A Man Called E* (1992)
2. "Your Lucky Day in Hell"—*Beautiful Freak* (1996)
3. "Elizabeth on the Bathroom Floor"—*Electro-Shock Blues* (1998)
4. "Dead of Winter"—*Electro-Shock Blues* (1998)
5. "The Medication Is Wearing Off"—*Electro-Shock Blues Show* (2002)
6. "Last Time We Spoke"—*Blinking Lights and Other Revelations* (2005)
7. "I'm Going to Stop Pretending That I Didn't Break Your Heart"—*Blinking Lights and Other Revelations* (2005)
8. "Bad News"—*Useless Trinkets: B-Sides, Soundtracks, Rarities, and Unreleased 1996–2006* (2008)
9. "That Look You Give That Guy"—*Hombre Lobo: 12 Songs of Desire* (2009)
10. "Little Bird"—*End Times* (2010)

Born to Be Blue
The True Color of Misery?

The connection between *blue* (the color of sparkling seas and open sky) and *blue* (a metaphor for melancholic teenagers and brokenhearted cowboys) has been recorded for more than four centuries and is the most persistent crease in meaning to a word that is among the English language's most versatile homographs. The *Oxford English Dictionary*, the first stop in all things etymological, traces the word's connection to low spirits—to when *blue* became *blue*—to the mid-sixteenth century and the malicious blue devils that troubled those touched with melancholy.

It also ties the meaning to anxiety, fear, discomfort, extreme nervousness, and "tremulous dread," but the term has endured primarily as a cloud of woe. It has survived the Jazz Age, the birth of rock 'n' roll, free love, the "Me" Decade, and limped through the rise of hip-hop and the grunge era as an acceptable—if ineffably twee—way of expressing everything from an anomalous gloomy afternoon to the effects of a deeper, much more serious illness.

Being "blue" long predates "the blues," but the two have become inextricably linked in the public consciousness, a not completely unfair commingling that seemed to be seeded in the first published true "blues," Hart Wand's "Dallas Blues" from 1912. And that's just the beginning of blue's pop history, which is a nice way of saying

that blue has some baggage. Or as Victoria Finlay sums it up in her book *Color: A Natural History of the Palette*, "It is curious that in English the word *blue* should represent depressing as well as transcendent things; that it should be the most holy hue"—The Virgin Mary is draped in cerulean cloth in paintings by Da Vinci and Michelangelo—"and the color of pornography." Leonard Cohen's "Famous Blue Raincoat" calls upon this religiously informed meaning of the word, while Shorty Long's "Devil with a Blue Dress On" (a 1966 hit for Mitch Ryder and the Detroit Wheels) turns the Virgin Mary association on its head. Blue not only represents the color of the sky ("Blue Skies") and the heavenly realm beyond it ("My Blue Heaven"), but it's also the color that best reflects, depending on how you define it, the soul.

Postimpressionist painter Wassily Kandinsky wrote in his influential essay "Concerning the Spiritual in Art," "The power of profound meaning is found in blue, and first in its physical movements of retreat from the spectator, of turning in upon its center. The inclination of blue to depth is so strong that its inner appeal is stronger when its shade is deeper." Kandinsky goes on to describe the dichotomy at work within blue as both "the typical heavenly color," which creates a "feeling of rest" and a color that, as it darkens, recalls "a grief that is hardly human." Kandinsky also felt that the spectrum of blue suggests specific orchestral elements: the lightest blue reminiscent of flutes, a darker blue would be cellos, and the darkest hue the organ.

American writer and philosopher William Gass devoted his short book *On Being Blue: A Philosophical Inquiry* to the exploration of the slippery color. In it he writes, "Of the colors, blue and green have the most emotional range. Sad reds and melancholy yellows are difficult to turn up. Among the ancient elements, blue occurs everywhere: in ice and water, in the flame as purely as in the flower, overhead and inside caves, covering fruit and oozing out of clay." Gass goes on to define the theoretical limits of other colors and concludes that blue is "most suitable as the color of interior life."

Pablo Picasso's Blue Period is the defining artistic example of the power of the moody hue. Referring to a number of paintings made by the artist between 1901 and 1904—an unbelievably short period

of time considering the influence that reverberated from it—the Blue Period is marked by a haunting melancholy that enveloped all of the painter's people and scenes. The art critic Laszlo Glozer, author of *Picasso: Masterpieces of the Blue Period*, describes the works as portraying a "mysterious, ethereal grief" populated with figures that "stand out unambiguously as monuments of a world of poverty, sickness, and despair." Perhaps the most famous of the Blue Period paintings—and certainly the piece with the most obvious connection to melancholic music—is his 1903 masterpiece *The Old Guitarist*. The portrait features a bent and bony man with chalk-white hair and torn clothing strumming an old classical guitar that looks as though it's made of worn leather rather than wood. The long fingers of his right hand hang motionless mid-strum while his left hand stiffly forms an indistinguishable chord. Paul McCartney, upon viewing a print of *The Old Guitarist* (which was hung in the hospital where his second daughter, Mary, was born), wondered which chord the forlorn fictional guitarist was playing, and was inspired to write his "Two Finger Song" (also sometimes referred to as "Two Fingers")—though it's hard to imagine that the sunken blue figure in the painting would play anything as pastoral as the song McCartney came up with. (No one ever accused Macca of being too glum.) And jazz pianist Gil Evans's dramatically rueful "Blues for Pablo," which first appeared on Miles Davis's, *Miles Ahead*, was inspired by the works of the painter's lugubrious period.

A raft of standards such as "Blue Moon," "Little Girl Blue," "Am I Blue?" and "Born to Be Blue" turn on the term. Jimmie Rodgers—also known as the the Father of Country Music, the Singing Brakeman, and notably the Blue Yodeler—recorded a series of thirteen "blue yodels" that merged folk and blues and helped to define country music. And the "blue note" (or "worried note")—a note played at a slightly lower pitch from a major scale, often falling on the third, fifth, or seventh note of the scale—is integral to blues and jazz and all the genres that have spun out from them.

One beautifully cerulean song from the pre–British Invasion era that deserves special attention is "Mr. Blue" by the Fleetwoods, a genteel doo-wop trio that at times sounded like they were devising a

blueprint for twee-pop long before the Shaggs teetered into a studio (cue up "I Care So Much"). Originally written for the Platters, the brief "Mr. Blue"—the group's third single, which charted at number one on the pop charts for one week in mid-November 1959, and even managed to hit number five on the R&B charts—floats by in such a dreamy, polite manner that the bold indiscretions of the protagonist's lover seem jarring. Neil Young, who has been known to lay down a heartache or two, spoke in his biography, *Shakey*, about his experiences of listening to "Mr. Blue" when he was young: "I related to the story. That feeling—if Mr. Blue was more aggressive, he probably wouldn't be Mr. Blue. He probably would've found out either yes or no and would've been able to move on—but he wasn't. He was Mr. Blue. I think I was a little like Mr. Blue." (The Fleetwoods cataloged a number of other crisp heartbreakers worth tracking down, including a haunting a cappella version of "Unchained Melody," a sweet piece of arithmetic misery in "Ten Times Blue" ["Just like five times two equals ten, ten times blue equals me"], and "Tragedy," which went to number ten in 1961 and was a favorite of a young Brian Eno.)

Elvis Presley struggled to understand "a complicated lady" in "Moody Blue," suffered through a lonely "Blue Christmas," and continually rhapsodized about the color of the moon ("Blue Moon," "Blue Moon of Kentucky," "When My Blue Moon Turns to Gold Again"). And, of course, there have been a number of influential songs and albums that were stoic in the face of the colors' blanket of gloom, among them "Almost Blue" by George Jones (also the name of Elvis Costello's 1981 Nashville excursion album) and Miles Davis's landmark album *Kind of Blue*. The list of artists that have named an album simply *Blue* is itself long and varied—it even includes the album *Blue* by 1970s power pop group Blue, which, though not particularly melancholy, is worth seeking out. None, however, will likely ever live up to Joni Mitchell's expressive, introverted, and influential 1971 breakthrough album.

Influenced in part by Miles Davis, and recorded during an intensely turbulent period of her life that included a difficult split with fellow singer/songwriter Graham Nash, relationships with Leonard

Cohen and James Taylor, and her decision to give up a daughter for adoption, Mitchell's *Blue* became *the* confessional album of the 1970s ("I was absolutely transparent, like cellophane," Mitchell has said of her own *Blue* period). It continues to rank high on lists of the greatest albums ever made, with songs like "Little Green," "Blue," and "River" showcasing a fragile artist precisely attuned to her shifting emotional state. Having let the world into the darker corners of her turmoil, Mitchell changed the landscape for singer-songwriters in the process.

Oddly, in contradiction to this raft of cultural evidence, studies conducted to determine color-mood associations have repeatedly singled out blue as a color representative of comfort, peace, calm, and quiet, while grays and blacks are more often tied to troubling and negative emotions such as sadness and resignation. Swiss psychologist Dr. Max Lüscher developed the Lüscher color test as a way to use color to gain insight into an individual's personality—the idea being that although sensory perception of colors is universal, an individual's preference for certain colors can reveal his or her inner psychology. In Dr. Lüscher's flash-card world, blue represents sensitivity and a "depth of feeling," as well as love, tranquility, and contentment; black is the color of hopelessness, of nothingness; while gray indicates concealment and a passive nature. In chromotherapy—color as a therapeutic tool, which has been used across cultures for centuries—blue is often used to help alleviate pain and is thought to lower pulse rates and body temperature. In the psychology of color blue again flaunts its mutable nature, representing both feelings of serenity and calm as well as feelings of sadness—sort of like the antidepressant ads that warn of depression as a side effect.

In early 2010 researchers writing in the journal *BMC Medical Research Methodology* described the creation of the Manchester Color Wheel, which they used to study the colors subjects preferred as it correlated to their state of mind. Healthy subjects who were in a good mood preferred a shade of yellow, while subjects in a depressed state routinely picked gray over blue. (It should be noted that most color/mood studies have been small in scale and spurious in methodology. As such there is no definitive study of color-mood associations.)

George Jones, the man with perhaps the longest legacy of melancholy in the history of recording, sums up the etymological entanglement of blue in his song "Color of the Blues" by singing with a circuitous logic à la Yogi Berra that "blue must be the color of the blues." The plainspoken simplicity of the statement seems to settle everything without saying much of anything at all. But it's certainly hard to argue with.

THE MISERABLE LIST: BLUE MUST BE THE COLOR OF THE BLUES

1. "I'm Lonely and Blue"—Jimmie Rodgers (1929)
2. "Blue Gardenia"—Dinah Washington (1955)
3. "Color of the Blues"—George Jones (1955)
4. "Mr. Blue"—The Fleetwoods (1959)
5. "Born to Be Blue"—Chet Baker (1965)
6. "Way to Blue"—Nick Drake (1969)
7. "Blue and Lonesome"—Little Walter (1970)
8. "Blue Valentine"—Tom Waits (1978)
9. "The Bluest Blues"—Alvin Lee (1994)
10. "Blue"—Cat Power (2008)

MARK EITZEL

He's been called America's Greatest Living Lyricist and the American Morrissey (though he's referred to himself as "America's favorite cripple" and has plotted his musical bearing as "a cross between Phil Collins and William Shatner," among other self-inflicted digs). But while these appellations could be debated, that Mark Eitzel is one of modern rock's most enduring and literate songwriters— uniquely wounded and distinctly American, with a keen eye for life's littlest chiaroscuro moments—isn't really up for discussion. Mark

Eitzel was born in 1959 in California, but his father was a civilian working with the US Army, which led to the family drifting between countries, including Japan and England, before eventually returning to the United States. Early in his career, as a member of the post-punk group Naked Skinnies, Eitzel's erratic, alcohol-fueled stage etiquette became the stuff of legend. One such incident—in which the singer attacked a member of the audience—was the last straw for the other members of the band. Soon after, the singer recorded the seven-song cassette *Mean Mark Eitzel Gets Fat*, which featured the seeds of what would become American Music Club's first album, *The Restless Stranger*. AMC would release a string of critically lauded, commercially overlooked albums before a mixed-bag last hurrah in 1994 (*San Francisco*). Eitzel, always the bruised heart of AMC, had already recorded his first solo album in 1991 (*Songs of Love Live*), and set to work on what would become his second solo release, 1996's jazz-inflected *60 Watt Silver Lining*. In 1997 the singer entered the studio with R.E.M. guitarist Peter Buck to write and record *West*, the purposefully rushed recording process and the marriage of Eitzel's dusty baritone to Buck's chiming guitars resulting in an album of cloud-covered, sky-hiding beauty. Eitzel's best top-to-bottom solo album came with 1998's *Caught in a Trap and I Can't Back Out 'Cause I Love You Too Much, Baby*, and from the brief acoustic opener "Are You the Trash" through the otherworldly "Go Away," where guitars fall like sheets of rain, and the jewel-box closer "Sun Smog Seahorse," it's also his darkest release. After the obligatory flirtation with electronic music (2001's *The Invisible Man*) and the obligatory covers album (2002's *Music for Courage and Confidence*), Eitzel released the revelatory *The Ugly American* in 2003, which featured songs from his own back catalog reinterpreted with traditional Greek instruments. AMC staged a comeback of sorts with the 2004 release of *Love Songs for Patriots*, but the reformation didn't stop Eitzel from recording and releasing new material under his own name, as the lackluster *Candy Ass* appeared in 2005, followed by AMC's *The Golden Age* in 2008 and the brilliant but obscure *Klamath* (available for purchase only through Eitzel's website) in 2009.

In a 1989 interview with *Melody Maker*, Mark Eitzel confided his love of sad music: "I've just always liked sad songs," said the singer. "Nick Drake, Joy Division, country music . . . You could play 'Stand by Your Man' next to 'Love Will Tear Us Apart,' they're speaking the same language and they're speaking to me."

See also: American Music Club

THE MISERABLE LIST: MARK EITZEL

1. "Blue and Grey Shirt"—*Songs of Love Live* (1991)
2. "Saved"—*60 Watt Silver Lining* (1996)
3. "Stunned and Frozen"—*West* (1997)
4. "Nice Nice Nice"—*Lover's Leap USA* (1997)
5. "Go Away"—*Caught in a Trap . . .* (1998)
6. "Christian Science Reading Room"—*The Invisible Man* (2001)
7. "Here They Roll Down"—*The Ugly American* (2003)
8. "Sleeping Beauty"—*Candy Ass* (2005)
9. "I've Been a Mess"—*Ten Years of Tears* (2006)
10. "Why I'm Bullshit"—*Klamath* (2009)

MARIANNE FAITHFULL

Marian Evelyn Faithfull, Baroness Sacher-Masoch, was born on December 29, 1946, in Hampstead, London, to a British military officer/professor of psychology and a ballerina with aristocratic ties to Austria's Hapsburg Dynasty—her great-great-uncle Leopold von Sacher-Masoch was the author of the nineteenth-century erotic novel *Venus in Furs*, from whence we get the word *masochism*. After a rough childhood marked by her parents' divorce, as well as bouts of tuberculosis, Faithfull began singing at coffeehouses in the early sixties and, at a party for the Rolling Stones in early 1964, met the group's legendary manager Andrew Loog Oldham, who instantly set

to work fashioning a career for the teenage nymph. Mick Jagger and Keith Richards (with prodding from Oldham) penned her first single, the gentle, insouciant hit "As Tears Go By," which the Stones would record themselves a year later. By her third single, 1965's "This Little Bird," her vocals were markedly more confident and her trademark Weimar cabaret-style delivery was beginning to take root. The first act of her musical career saw her record a long string of gentle weepers that fall somewhere between Scott Walker's more syrupy sixties songs, the pastoral thrum of Brian Jones–era Stones, and Nico's early pre–Velvet Underground singles—which, coincidentally, were also created under the watchful eye of Oldham. A haunting church-choir take on the Beatles classic "Yesterday" was another hit in 1965, as was 1967's "Is This What I Get for Loving You." She married in 1965 and gave birth to a son the same year, but was soon divorced and ensconced in a very public relationship with Jagger—a four-year dalliance aligning with the Stones' late-sixties prime, during which she served as muse for classics like "Wild Horses" and "You Can't Always Get What You Want." Faithfull also worked as an actress during the late sixties, notably appearing as herself in Jean-Luc Godard's 1966 film *Made in U.S.A.*, opposite Alain Delon in director Jack Cardiff's campy *Girl on a Motorcycle*, and infamously becoming the first person to say "fuck" in a mainstream studio film during 1967's *I'll Never Forget What's 'Isname*. As the sixties came to a close, Faithfull was wracked by addiction to hard drugs, a struggle she captured in the lyrics to "Sister Morphine," which she cowrote with Jagger. By the end of 1970, however, her relationship with the Stones' singer had played itself out, she had lost custody of her son, and her career had all but vanished. She soon found herself homeless in London, jumping from cocaine to heroin, and suffering from anorexia nervosa. Friends and strangers helped as they could, including producer Mike Leander, who recorded a series of songs with Faithfull in an attempt to jumpstart her career (the recordings would be universally passed over, and they did not receive a proper release until 2005 as the album *Rich Kid Blues*). A bout of severe laryngitis following years of drug abuse permanently scarred her singing voice,

leaving it, as she has described it, "loaded with time" and "mature like brie cheese." She grabbed hold of the slightest threads of her career when she released the country-and-folk-influenced album *Dreamin' My Dreams* in 1977, but its straightforward selection of songs and execution contained no evidence of the explosive reinvention waiting in the wings. Released in early 1979, Faithfull's harrowing post-punk, new-wave album *Broken English* is her undoubted masterpiece. "This is the first time anything's been asked of me in the music world," Faithfull said upon the album's release, and she delivered. The title song opens the album with a Berlin-era Bowie-meets-Human-League bleak disco beat and nervous synthesizers. It's a fantastic moment that reframed Faithfull as a survivor who still had a few tricks up her sleeve. The album also includes a stark reading of John Lennon's "Working Class Hero" and the bitter and unforgiving "Why d'Ya Do It?," a tour de force of sexual jealousy. The heart of the album, though, is Shel Silverstein's (yes, *that* Shel Silverstein) "The Ballad of Lucy Jordan"—a synth-heavy downer about the dreams we leave behind that features a suicide attempt and ends with a veiled drive to a mental hospital. Despite the dramatic career resuscitation, Faithfull was still struggling to manage her addictions—she fell down a flight of stairs and broke her jaw while inebriated, and at one point her heart actually stopped—but by the middle of the decade she was seeking help. It was while at a treatment facility that she fell in love with Howard Tose, a mentally ill man seeking help for his own addictions. The affair would lead to another divorce for Faithfull (this time from Ben Brierly of the punk group the Vibrators, whom she had married in 1979) and would end in tragedy when Faithfull suggested a temporary separation and Tose committed suicide by jumping from the window of their apartment. Her next reinvention came as a modern Billie Holiday—the addictions that both women suffered through led to their delicate voices breaking apart far too early—with 1987's smoldering *Strange Weather*, an album filled with moody renditions of jazz classics, including a smoky reimagining of her first hit, "As Tears Go By." She was remarkably solid throughout the 1990s, teaming up with David Lynch collaborator

Angelo Badalamenti for 1995's *A Secret Life*, as well as returning to acting. A recording of songs from her Kurt Weill–themed stage show, *An Evening in the Weimar Republic*, was released as *20th Century Blues* in 1997, and her infatuation with Weill's work continued as she mounted a large orchestral tour that culminated in the 1998 release *Weill: The Seven Deadly Sins and Other Songs*. The following year she returned to her rock roots and released *Vagabond Ways*— another stark album that highlighted her own compositions as well as those by Leonard Cohen and Pink Floyd's Roger Waters. Faithfull recorded a series of shadowy duets with contemporary rock's most interesting personalities, beginning with 2002's *Kissin' Time* (which featured Beck, Blur, Billy Corgan, Jarvis Cocker, and Dave Stewart) and running through 2008's *Easy Come Easy Go* (which featured duets with Chan Marshall [Cat Power], Nick Cave, and Antony Hegarty). Few have gone from glamour to gutter and back again as Faithfull has, and although the single word most used to describe her story is *tragic*, without those twists of fate, how would everything she touches smolder with such experience?

THE MISERABLE LIST: MARIANNE FAITHFULL

1. "As Tears Go By"—Single (1964)
2. "Sister Morphine"—Single (1969)
3. "Broken English"—*Broken English* (1979)
4. "The Ballad of Lucy Jordan"—*Broken English* (1979)
5. "Strange Weather"—*Strange Weather* (1987)
6. "Times Square"—*Blazing Away* (1990)
7. "She"—*A Secret Life* (1995)
8. "Alabama Song"—*Weill: The Seven Deadly Sins and Other Songs* (1998)
9. "Incarceration of a Flower Child"—*Vagabond Ways* (1999)
10. "Song for Nico"—*Kissin' Time* (2002)

FELT

Not to be confused with the hip-hop based group of the new millennium, or the short-lived blues-based pop group from the early seventies, Felt was the nom de rock of Lawrence Hayward (a.k.a. Lawrence, who dropped his surname after finding he shared it with a member of the Moody Blues). His fascination with Television's two late-seventies albums (*Marquee Moon* and *Adventure*) and all that informed them infused a string of fantastically maudlin pop records touched by shimmering guitars and Hayward's deadpan Lou Reed–lite delivery. A bit of an odd bird, Hayward subscribed to a "new Puritanism"—something of a fey straightedge lifestyle that shunned sex, drugs, and alcohol—and declared early on that Felt would only exist for ten albums—a contract he kept. Felt began as a bedroom pop experiment with a rollicking, fuzzy, tangle of a debut single, "Index" in 1979, that worked in stark contrast to the synth-heavy new wave that was the reigning flavor at the time, and resulted in a contract with Cherry Red Records. Although only six tracks long, 1982's *Crumbling the Antiseptic Beauty* was a huge sonic step forward, as the guitars rang clear—largely thanks to the arrival of classically trained guitarist Maurice Deebank—drums thudded with precision, and Lawrence's breathy Reed impression locked in. Another mini-album, *The Splendour of Fear*, appeared in 1984, just months before their first classic release, *The Strange Idols Pattern and Other Short Stories* (also '84). Robin Guthrie, of Cocteau Twins, stepped in to produce 1985's *Ignite the Seven Cannons,* which marked both the first appearance of keyboardist Martin Duffy and the group's biggest single, the atypically dreamy "Primitive Painters," which also featured Guthrie's partner in crime Elizabeth Fraser on backing vocals. Deebank left the group before recording commenced on 1986's instrumental *Let the Snakes Crinkle Their Heads to Death*; at ten tracks and a running time that fails to break the twenty-minute mark, it sounds as if someone accidentally erased the vocals. Felt 2.0 truly kicked off with *Forever Breathes the Lonely Word*, also released in 1986. Its cover photo of

Duffy was reflective of the keyboardist's import to the group's new sound, his wheezing organs bringing a new urgency to Lawrence's songs both here and on the mini-album masterpiece that followed, 1987's *Poem of the River*. The following year, the enigmatic *Pictorial Jackson Review* was released—with its top-heavy string of brilliant and blistering organ-dappled pop up front, and fifteen-plus minutes' worth of drifting instrumentals at its close. The group's penultimate album, 1988's *Train Above the City*, is its most perplexing, another rather forgettable instrumentals collection split between upbeat lounge jazz and downbeat, vibe-heavy pop, none of which feature Lawrence's involvement beyond providing titles. But Lawrence came back swinging with the group's tenth and final album, 1992's confessional *Me and a Monkey on the Moon*, easily among their best work. Produced by the Sound's Adrian Borland, the album expanded their sonic palette, while Lawrence's newfound autobiographical approach infused the songs with a warmth missing from much of their earlier work.

THE MISERABLE LIST: FELT

1. "Index"—Single (1979)
2. "Fortune"—*Crumbling the Antiseptic Beauty* (1981)
3. "The Stagnant Pool"—*The Splendour of Fear* (1984)
4. "Crystal Ball"—*The Strange Idols Pattern and Other Short Stories* (1984)
5. "Primitive Painters"—*Ignite the Seven Cannons* (1985)
6. "Rain of Crystal Spires"—*Forever Breathes the Lonely Word* (1986)
7. "Declaration"—*Poem of the River* (1987)
8. "Apple Boutique"—*The Pictorial Jackson Review* (1989)
9. "Don't Die on My Doorstep"—*The Pictorial Jackson Review* (1989)
10. "I Can't Make Love to You Anymore"—*Me and a Monkey on the Moon* (1992)

THE FIELD MICE

ormed in South London by singer/guitarist Robert Wratten and bassist Michael Hiscock in 1988, the duo released their debut as the Field Mice later that year with the *Emma's House* EP on cult smash label Sarah Records, a twee bastille during the late eighties and early nineties that became inextricably linked to the band. The single featured four songs and was bookended by the "sheet of gray clouds" that hang over "Emma's House" and the bouncy gloom of suicide-note fantasy "The Last Letter." When French music monthly *Les Inrockuptibles* named the group's second single, 1989's "Sensitive," Single of the Month, the magazine's adoration went so far that its entire editorial staff signed the review. Single of the Week nods also came from *Melody Maker* and *NME,* and St. Etienne scored an indie hit with a dance-floor rendition of the Field Mice song "Kiss and Make Up" as the band became Sarah's (somewhat reluctant) ambassadors of bed-sit pop. Guitarist and keyboardist Harvey Williams (of fellow Sarah act Another Sunny Day) signed on before the recording of the two-part *Autumn Store* singles, which featured the arcadian grief of "Anyone Else Isn't You," a song introduced with the Dr.-Seuss-on-downers opening, "Sad am I / I'm sadder than sad" and includes the gently laconic refrain "I cannot picture myself ever, ever being happy again." Keyboardist and vocalist Annemari Davies and drummer Mark Dobson joined for 1991's *Missing the Moon* single, which featured the mournful "A Wrong Turn and Raindrops" in which Wratten grimly recalls perfect moments with a perfect girl while "killing time on London Bridge," before the chorus brings us up to speed on the relationship: "I've never been more lonesome / Life's never been less fun / She's no longer here / She is gone." The group released their final long-player, 1991's *For Keeps*, and continued to explore their ambient, dream-pop, and dance leanings. By the end of the year, though, the band had started to come apart at the seams, thanks to the diverging interests of Sarah Records and the group, Davies's unpredictable behavior due to increasing bouts of stage fright,

and a burgeoning relationship between her and Wratten. The Field Mice self-destructed at a November 1991 gig in Glasgow that began with Wratten quitting the group and ended with onstage fisticuffs. The final punctuation in the Field Mice story came a few weeks later, when the band played a farewell gig in London, encoring with "End of the Affair," a dispirited ballad peppered with apropos lines like "I can't stand being in the same room as you" and the constantly repeated refrain "This is it, isn't it?" Wratten, Davies, and Dobson went on to form Northern Picture Library, releasing 1993's *Alaska*, but when Wratten and Davies split, the group came to a screeching halt. Heartsick, Wratten soon poured himself into the songs that would become 1996's Trembling Blue Stars debut, *Her Handwriting*. The Field Mice may carry more cultural currency, but Wratten has released far more material under the Trembling Blue Stars banner, most of it brimming with the same fragile melancholy found in the best Mice masterpieces, particularly "ABBA on the Jukebox" (*Her Handwriting*), "Never Loved You More" (from 1998's *Lips That Taste of Tears*), "Sometimes I Still Feel the Bruise" (from 2000's *Broken by Whispers*), "A Statue to Wilde" (from 2007's *The Last Holy Writer*), and "The Lowest Arc" (from 2010's *Cicely Tonight, Vol. I* EP). Wratten's final set of songs as Trembling Blue Stars, *Fast Trains and Telegraph Wires*, was released in 2010.

GALAXIE 500

A 1972 ad for the Ford Galaxie 500 features the big shiny wheels flying up a curvy mountain road with the words "Ford Galaxie 500—Quiet Plus" set respectfully beneath. Seventeen years later, "Quiet Plus" could've been an ad introducing the world to the lo-fi bedroom fundamentalists who took their name from the car. The Galaxie 500 trio of Dean Wareham, Damon Krukowski, and Naomi Yang fashioned a hypnotic nest of third-generation Velvet Underground drone-pop, infused it with lo-fi melancholy, slathered it with

reverb, and propelled both the slowcore and shoegaze movements in the process. Slight New Zealand transplant Wareham met Krukowski and his girlfriend, Yang, in 1981, when all three attended the Dalton School in New York City. The three eventually landed at Harvard, where Wareham and Krukowski played together in Speedy and the Castanets and the short-lived Johnny Guitar. After graduating, Wareham returned to New York, and when Krukowski and Yang—both then in Harvard grad programs—returned for a summer break, Galaxie 500 was born. Taking their name from a friend's Ford, the trio played a handful of shows before recording a three-song demo that caught the attention of Shimmy Disc founder Kramer, who signed up to produce and release their first full-length, 1988's *Today*, and doused the group's minimalist purr with springy reverb, adding a druggy fog to their moody detachment. *Today* featured the two diamonds from their debut single—the antisocial "Tugboat" ("I don't wanna stay at your party / I don't wanna talk to your friends") and "Oblivious"—as well as a buzzing cover of Jonathan Richman's "Don't Let Our Youth Go to Waste." The trio signed to Rough Trade for their defining statement, 1989's *On Fire*, an album of dimly lit dirges bookended by circular dream-pop opener "Blue Thunder" and a naive yet touching take on George Harrison's "Isn't It a Pity." By the time Galaxie 500 headed into the studio to record 1990's *This Is Our Music* the group was at the peak of its powers and simultaneously beginning to fray. Shrugging off some of the twee sentiment of earlier releases, *This Is Our Music* features their most assured performances and a glowing set of songs that includes the bohemian drone of "Hearing Voices" and Naomi's delicate vocal turn on Yoko Ono's blissful "Listen, the Snow Is Falling." The contentious end came with a phone call from Wareham, who later wrote in his 2008 autobiography, *Black Postcards*, "I quit because I couldn't stop thinking about quitting." Wareham wasted little time forming Luna, while Krukowski and Yang continued to work together, first as Pierre Etoile, releasing the three-song *In the Sun* single on Rough Trade shortly before the label went bankrupt. Krukowski wisely bought up the Galaxie 500 master tapes at auction in the late nineties and Rykodisc eventually rereleased the group's entire catalog, along with

a greatest-hits compilation and the previously unreleased live recording *Copenhagen*. Krukowski and Yang changed their name to the fittingly simplistic Damon & Naomi and released *More Sad Hits* via Sub Pop in 1992. While Wareham's Luna explored shimmering guitar pop flecked with only sporadic reminders of his Galaxie 500 days—though he could never escape that voice—Damon & Naomi ran with Galaxie's cloudy currents, expanding on its bleary-eyed slowcore and dream-state psychedelia with remarkable consistency across a handful of albums, chief among them the 2000 collaboration with Japanese experimentalists Ghost, aptly titled *Damon & Naomi with Ghost,* and the first release on their own 20/20/20 label, 2005's *The Earth Is Blue*.

HENRYK MIKOLAJ GÓRECKI

Born on December 6, 1933, in Czernica, Silesia, in southern Poland—a town about thirty miles outside of Auschwitz—Henryk Mikolaj Górecki (pronounced Go-ret-ski) was one of the world's most widely known modern classical composers thanks to a 1992 recording of his Symphony No. 3, Op. 36 (*Symphony of Sorrowful Songs*), which found its way to the top of the charts on both sides of the Atlantic. Górecki's mother died on his second birthday, darkening the young boy's countenance considerably, and though both his father and his mother were musically inclined, as the would-be composer grew, his father and stepmother proved less than supportive of his musical curiosity. (They even forbid him to play on his mother's upright piano, though they eventually conceded to violin lessons when he was ten.) In 1945 Górecki dislocated his hip while playing with a neighbor and a subsequent misdiagnosis and significant delay in treatment led to permanent damage—this was just the beginning of numerous health problems that plagued the composer during his lifetime, many of which arose from the polluted industrial city in which he made his home. His thirst for music proved insatiable—he once swapped a table-tennis racket for the score of Beethoven's Ninth

Symphony—and he began writing piano miniatures and songs, his desire to compose and his melancholic streak (particularly in early pieces such as the Four Preludes) evident from the beginning. He studied music at the State Higher School of Music (now the Academy of Music), in Katowice, and gave his first all-Górecki concert as a student in 1958. Graduating with distinction in 1960, he soon gained his first international success, his Symphony No. 1 winning the top prizes from the Polish Composers' Union in 1960 and the 1961 Biennial Festival of Youth in Paris. Along with fellow composers Krzysztof Penderecki and Kazimierz Serocki, Górecki was recognized as a leader of the new Polish renaissance that rose from the cultural mordancy of Stalinism that gripped the country following WWII. He quickly became a temperamental force in the ordinarily calm waters of the classical world, composing his earliest works—Symphony No. 1 and *Scontri* (Collisions)—in a confrontational form of serialism that established him as a cultural force while simultaneously putting him at odds with communist party officials. After the Stalinist thaw that followed the Russian dictator's death, in March 1953, Górecki veered in a more overtly romantic direction that drew on his country's traditional folk music, sacred texts, and minimalism. Overarching themes were an important starting point to Górecki's process, and the Symphony No. 3 (completed in 1976), his most popular and enduring work, epitomizes the practice. Composed of three independent laments—a nineteenth-century Silesian folk song of a mother grieving for her son at war; a prayer carved into the wall of a former Gestapo prison by an eighteen-year-old girl ("Oh, Mamma, do not cry—Immaculate Queen of Heaven supports me always"); and a fifteenth-century Polish folk song that contains a passage of the Virgin Mary speaking to Jesus as he is dying on the cross—Górecki slowly built a work exploring the idea of motherhood during wartime. In 1981 he wrote the chorale piece *Miserere* to protest police violence against solidarity, and, as the communist police state began to fall away during the late eighties, his music began to reach ever-wider audiences. Although the Symphony No. 3 had been recorded previously, it wasn't until 1992's Elektra/Nonesuch release featuring

the London Sinfonietta and popular soprano Dawn Upshaw that it clicked with a larger audience—once embraced it was nearly unstoppable. A calm respite of holy minimalism (see: Tavener, Pärt, Kancheli, et al.) written by one of the most tempestuous individuals in the contemporary classical world, it climbed to the top of the classical charts in both the US and UK, where it remained for months, and eventually invaded the British pop charts, peaking at number six. (Bristol trip-hop duo Lamb even spun it into a six-and-a-half-minute drum-and-bass exploration, titled appropriately "Górecki.") It has since gone on to sell more than a million copies, but, much like Samuel Barber's "Adagio for Strings"—with which it shares a sweeping, melancholic romanticism—it has not generated popular interest in Górecki's other works. When asked in 1993 how he was dealing with the shock of his hard-won "overnight" success, he snapped (via translator), "Everybody asks that. Perhaps it sounds a bit rude," he said, "but I try not to know the true Górecki at all." Following his sliver of pop success, he completed works intermittently, including 1995's string quartet *Songs Are Sung*, which was written for Kronos Quartet and took thirteen years to finish. His Symphony No. 4 was set to premiere in London in April 2010, but was canceled due to the composer's continued health problems. Górecki died of a lung infection on November 12, 2010.

RICHARD HAWLEY

The Sinatra of Sheffield" didn't hit upon his own voice until he was in his mid-thirties, after serving time as guitarist in B-level Brit-pop group Longpigs, becoming an honorary member of Pulp, and working as a guitar for hire. When he did, though, he spun his longtime love for crooners like Jim Reeves, Sun Records–style rock 'n' roll, and the brooding majesty of Scott Walker's 1960s recordings into a successful career. Born Richard Willis Hawley, on January 17, 1967, in Sheffield, South Yorkshire, he learned to play guitar from

his father and his uncle—both steelworkers by day and members of the local Esquire Club house band after hours—and by fourteen he was on the road, touring England with Chuck Power and His Rock 'N' Roll Band. He briefly joined the John Peel–approved Tree-bound Story before signing on with indie darlings Longpigs, who would break the top-twenty singles chart in the UK with the skuzzy single "She Said" before dropping out of sight as their label (U2's short-lived Mother Records) shut down the day after their second album was released. As Hawley says, "Everything we did went pear-shaped!" Hawley turned into a sought-after session guitarist, working with Robbie Williams, Beth Orton, and Gwen Stefani, and becoming an honorary member of Pulp after joining the group for the lengthy tour promoting their 1999 release *This Is Hardcore*. A mature artist by the time he released his self-titled debut mini-album in 2001, Hawley's sound was clearly established at the outset, and though his confidence and his skills have sharpened, the sound has rarely wavered from the tremolo-soaked love letter to early rock evidenced here. (When cornered about the sincerity with which his music reflects that of his idols his response is often a lighthearted comment à la "I'm just a cheesy fucker.") Lush arrangements were added to his crooning ballads for 2002's *Late Night Final*, and his sound truly solidified on 2003's *Lowedges*. He collaborated with A Girl Called Eddy for her gorgeous 2004 self-titled debut album and in 2005 he released his fourth solo album, *Coles Corner*, finding himself with another flood of critical accolades and a Mercury Prize nomination to boot. More people than ever were discovering his music, and his 2007 album *Lady's Bridge* (a difficult album for Hawley in that his father died midway through the recording process), became his biggest hit, helped along by the celebratory single "Tonight the Streets Are Ours." He followed up *Lady's Bridge* with his most personal statement yet, *Truelove's Gutter*, a labor of love he embarked upon with the directive from Mute boss Daniel Miller to make the album he'd always wanted to make. The resultant work—named after a place in his native Sheffield, as was *Coles Corner* and *Lady's Bridge*—was a daydream of ruminative ballads,

the highlight being the nearly ten-minute "Remorse Code." In 2010 Hawley released the *False Lights from the Land* EP and the four-part radio documentary *The Ocean*—his obsession with the ocean has even led him to claim that he would like to be resurrected as a seahorse.

Oh, the Humanity!
Disasters and Depressions

"If it bleeds it leads" was not expressly an invention of the twentieth-century news world. Once legitimate sources of news, sold by musicians following their performances and by barkers who acted as a cross between busker and town crier, the broadside ballads, popular from the sixteenth through the nineteenth centuries, were rife with tragic tales of steam engine derailings and mine collapses. As handwritten newsletters begat newspapers, cable TV, and Twitter, the need to memorialize disasters in song has largely dissipated. Turning the clock back, we see a different world, where Charley Patton's howled reportage on the flooding of the 1927 Mississippi River in 1929's "High Water Everywhere" allowed those who didn't experience the disaster an eye into the world of those who did. Fires, blizzards, cyclones, and earthquakes (the Library of Congress holds more than a dozen songs about the 1911 San Francisco earthquake) were all memorialized in song, but there is a relative absence of contemporary disaster songs due to the ubiquity of twenty-four-hour news and real-time acts of journalism and civilian journalism.

As the world industrialized in the eighteenth century, the shift from agricultural harvests to the reaping of "dusty diamonds" during the coal boom of the late nineteenth and early twentieth centuries made coal mining even more hazardous than it already was. The

dangers of a mine shaft collapsing or flooding, a mishap with explosives and afterdamp (a toxic mixture of fumes that remains following a flammable-gas explosion) violent labor disputes, and the long-term effects of diseases like black lung are all risks associated with the job. And they've all been the seedbed for song. While most miners who have lost their lives on the job have died from isolated incidents—as the traditional song "Only a Miner," first recorded in 1927, affirms ("He's only a miner been killed in the ground / Only a miner and one more is found / Killed by an accident no one can tell / His mining's all over, poor miner, farewell")—mining disasters that kill and injure dozens make up a larger portion of the bituminous tradition. As folklorist and labor activist Archie Green noted in his book *Only a Miner*, the mining industry "produced more disaster songs" than any other.

On September 6, 1869, more than a hundred men and boys suffocated while trapped inside the Avondale mine, after a wooden flue partition caught fire. The "Avondale Mine Disaster" broadside appeared within weeks of the tragedy and, with the advent of recording technology paralleling the coal boom of the early twentieth century, songs about the hazards of colliery life would become even more popular. On December 6, 1907—during the most treacherous year in the history of US coal, according to the Mine Safety and Health Administration (MSHA)—a series of explosions tore through the Fairmount mines in Monongah, West Virginia, killing 362 men and boys. It remains the worst mining disaster in the history of the United States, memorialized by Blind Alfred Reed, who recorded "Explosion in the Fairmount Mine" in 1927.

According to the MSHA, more than fifteen hundred deaths related to coal mining in the United States occurred per year between 1936 and 1945, the years immediately following the boom, and dozens of mine songs were recorded during the period, including the Carter Family's 1938 recording of "Coal Miner's Blues"; "McBeth Mine Explosion" by Cap, Andy, and Flip from the same year; and Charlie Maggard's "Explosion at Derby Mine" from 1940. Partially based on newspaper accounts, Woody Guthrie wrote three songs in tribute to the miners killed in the Centralia disaster of 1947: "The

Dying Miner," "Talking Miner," and "Miners' Kids and Wives." "The Dying Miner" is of particular note as it is told from the point of view of a trapped miner writing a final note to his family while slowly perishing from exposure to afterdamp. (Guthrie also wrote "Ludlow Massacre" about the 1914 attack by the Colorado National Guard on a tent colony of more than a thousand striking miners and their families that occurred in Ludlow, Colorado, on April 20, 1914, and resulted in the death of nineteen individuals.) "The Ballad of Springhill" was written by Peggy Seeger in 1958 to commemorate the Springhill mining disaster earlier that year. Spurred by the most devastating underground earthquake (also referred to as a "bump") in mining history, Seeger's song has since been recorded by Peter, Paul, and Mary, and was performed regularly by U2 during the *Joshua Tree* tour. "West Virginia Mine Disaster," an a cappella heartbreaker written and recorded by folk artist Jean Ritchie for her 1971 album *Clear Waters Remembered*, is unique in that the song's narrator is a miner's wife who is hearing the news of a flood and wondering whether her husband is still alive.

In 1967 the Bee Gees scored with "New York Mining Disaster 1941," a song inspired by the 1966 Aberfan mining catastrophe in Wales—the collapse of a mountain of slag and debris took the lives of nearly 150 people, many of whom were children just beginning their school day. (The tragedy also inspired David Ackles's "Aberfan," from his 1973 album *Five & Dime*, and Thom Parrott's "The Aberfan Coal Tip Tragedy.") Just a few years later the Buoys—who, incidentally, were from the same area of Pennsylvania where the Avondale mining disaster occurred—were responsible for what must be the strangest mining-disaster song on record. Written by Rupert Holmes—who is better known for "Escape (The Piña Colada Song)"—"Timothy" clawed its way into the top twenty in 1971—quite an accomplishment for a song about trapped miners who cannibalize the song's namesake ("My stomach was full as it could be").

Songs that magnify the specific hardships of a bituminous-tinged life have also found plenty of success. "Sixteen Tons" was a gigantic crossover number one for Tennessee Ernie Ford in 1955; Lee Dorsey

had a hit with "Working in a Coal Mine" in 1966; Jim Ford's over-looked blue-eyed Southern-funk classic "Harlan County" was the title track for his 1969 album; and Darrell Scott's "You'll Never Leave Harlan Alive," from his 1997 album *Aloha from Nashville,* has since recorded by Patty Loveless, Brad Paisley, and Kathy Mattea, who included it on her 2008 concept album, *Coal.*

And, of course, Loretta Lynn's autobiographical "Coal Miner's Daughter" became a country number one in 1970 and provided the inspiration for the 1980 film of the same name.

During the earliest days of the Industrial Revolution much of the coal that so many miners risked their lives to dig from the earth went to power the roaring steam engines of trains and ships, both of which would produce rich veins of disaster songs: the former from multiple catastrophes, the other highly concentrated on one major tragedy that still fascinates the world.

As with their mining brethren, train-disaster songs have their roots in broadsides like "Verses on the death of Miss Annie Lily, one of the victims of the accident on the North Pennsylvania Railroad" and "The Killed by the Accident on the North Pennsylvania Rail-road, July 17th 1856," both of which reference the same disaster: a collision of two trains at Camphill Station near Philadelphia that killed sixty-six and injured more than a hundred others. By 1889 the death toll resulting from US rail accidents topped well over 6,000, while Germany's rail fatalities barely numbered 600—even given the geographical size difference, the discrepancy is staggering.

Perhaps the most popular rail-tragedy ballad, "Wreck of the Old 97" comes from the earliest days of the recording industry. It was first recorded in 1923 by G. B. Grayson and Henry Whitter. But it was made popular by Vernon Dalhart's 1924 recording, largely due to its inclusion on the same 78 as the wildly popular B-side, "The Prisoner's Song." "Wreck of the Old 97" details the tragedy of the Fast Mail train of the Southern Railway on its fateful run between Monroe, Virginia, and Spencer, North Carolina, on September 27, 1903, which claimed the lives of nineteen, including engineer Joseph A. Broady, when it derailed at Stillhouse Trestle near Danville, Vir-ginia. Just as blame for the crash was never fully ascertained, neither

do we know who rightly authored the song that bears tribute to the tragedy. (Another popular Dalhart train-disaster ballad was "The Wreck of the 1256," which sold well into the six figures upon its recording in 1926.)

Other steam-engine catastrophes that were immortalized in song include "The Wreck of the Virginian," by Blind Alfred Reed (who also recorded the "Fate of Chris Lively and Wife," wherein it is learned that a wagon is no match for a speeding train); "Wreck of Number 52," by Cliff Carlisle; "The Unfortunate Brakeman," by the Kentucky Ramblers; "The Wreck of the Edmund Fitzgerald," by Gordon Lightfoot; and the purely fictional "The Wreck of the Number Nine," a sad country strummer that was written by Carson Robison—a largely forgotten country music singer/songwriter who also wrote the topical hit "The John T. Scopes Trial"—and recorded by Marty Robbins, Hank Snow, Jim Reeves, and Doc Watson.

As ubiquitous as train-disaster songs were, rail tragedies couldn't hold a candle to the nearly impossible story of the sinking of the great unsinkable ship *Titanic*—a real-life tragic myth of unprecedented proportions ripe for metaphorical exploitation.

The great ship departed on her maiden voyage from Southampton, England, to New York City on April 10, 1912. Four days later, it struck an iceberg in the freezing waters of the North Atlantic that left a nearly 300-foot gash in the starboard hull, allowing water to fill six of the sixteen watertight compartments. (It was designed to absorb the flooding of two—which was the ship's primary safety innovation.) The *Titanic* sank the next day, resulting in the deaths of 1,517 people. It was one of the deadliest peacetime maritime disasters in history. Steven Biel, author of *Down with the Old Canoe: A Cultural History of the Titanic*, wrote that "the disaster produced a contest over meaning that connected the sinking of an ocean liner in a remote part of the North Atlantic with some of the important and troubling problems, tensions, and conflicts of the time." The distant waters of the Atlantic had swallowed modernity's Tower of Babel, and artists seized the opportunity to address grief, class divides, racism, and the vanity of humankind.

James Cameron's 1997 cinematic megahit *Titanic* helped to

cement the myth in the new millennium—musically seared into the popular consciousness with the ubiquitous Celine Dion hit "My Heart Will Go On," itself a disaster song of sorts in some circles. But in 1912, recording technology wasn't yet ripe enough to capture the zeitgeist, but before the year was out, plenty of composers published sheet music for ballads including "Just as the Ship Went Down," "In Memory of the *Titanic* Catastrophe," "The Sinking *Titanic*," "My Sweetheart Went Down with the Ship," and "The Wreck of the *Titanic*: A Descriptive Piano Composition for Piano Solo." These genteel compositions were miles from the somewhat celebratory tack taken in *Titanic*-themed songs that bubbled up in the African-American community. As Biel puts it: "Boasting about being nowhere near the scene of a disaster was a tradition of sorts in black folk songs." The most popular black ballad of the disaster came from Huddie Ledbetter (better known as Leadbelly) who recorded "The *Titanic*" in 1948 (he reportedly wrote it in 1912). In the song, Leadbelly addresses the racism that pervaded life, including the *Titanic* manifest, when he sang, "Jack Johnson want to get on board / Captain said, 'I ain't haulin' no coal.' " (Johnson—the controversial heavyweight boxing champ at the time—never actually attempted to sail on the *Titanic*.) Another story that circulated, that the only black member of the crew to perish was trapped in the boiler room, was also false—the ship held no blacks as either passengers or crew. (New England folk singer Jaime Brockett achieved a modicum of success in the late sixties/early seventies with a thirteen-minute-plus nervy drug-culture update of Leadbelly's "The *Titanic*" rechristened "The Legend of the U.S.S. *Titanic*." In it, Brockett expands on the apocryphal notion that Johnson was denied entry to the ship—though, to be fair, Brockett's version makes the *Titanic* a US vessel (it was a British ship), has the ship launching from New York in 1913, and suggests Captain Smith was high when the ship hit the iceberg, among other oddities.) One of the most popular versions of the African-American "toast" tradition—an improvised narrative that bridges the blues and rap—is "Shine and the *Titanic*," a version of which appears in the 1975 blaxploitation film *Dolemite*, and tells

the tale of a black coal stoker who warns of the ship's impending danger to no avail, and who ultimately saves himself.

The Jewish community in America was particularly hard-struck by the *Titanic* disaster, as it occurred during the nadir of Jewish emigration to the United States. A number of songs in Yiddish were penned about the tragedy, including "Der Naser Keiver" ("The *Titanic*'s Disaster") and "Lid Fun *Titanic*" ("Song of the *Titanic*").

One of the earliest recorded songs about the sinking was Ernest Stoneman's 1924 recording of "The *Titanic*." The song placed the hubris of man in the shadow of God's will (a consistent theme during the industrial revolution), with Stoneman introducing the ship that "the water could not go through" before the Almighty appears to show that this hubris "the world it could not stand." The same theme was explored in 1938's "Down with the Old Canoe," which was written and recorded by the Dixon Brothers more than a quarter century after the tragedy: "When you think that you are wise / then you need not be surprised / that the hand of God should stop you on life's sea."

The year 1927 saw an explosion of *Titanic* songs. William and Versey Smith tweaked "The *Titanic*" to highlight a perceived class struggle, as the rich declare "they would not ride with the poor," who, of course, would then become "the first who had to go." Richard "Rabbit" Brown's "The Sinking of the *Titanic*" recalled "the music played as they went down / On that dark blue sea / And you could hear the sound of that familiar hymn singin' / 'Nearer Oh My God to Thee.'" In the 1930s, during the height of the Great Depression, singers were still painting the epic scene of the ship's last stand with songs like Hi Henry Brown and Charlie Jordan's "*Titanic* Blues," but the greatest ballad to rise from the sinking is likely "The Great Ship Went Down," recorded by the Cofer Brothers in 1929. (Among the popular, classical, and sacred music included in the *White Star Line Music Repertoire* on the ship was a song composed "for baritone or bass voice" by A. J. Lamb and H. W. Petrie in 1897 and seemed a curious addition to a seagoing musical library: "Asleep In the Deep.")

That great ship going down seemed to represent the moment of

the industrialized world's loss of innocence and its distant occurrence in the middle of the frigid Atlantic made it all the more haunting. There is no similar mystery with our short-lived fascination with the zeppelin, and there is perhaps no more dramatic tragedy of World's Fair–era technological optimism than the May 6, 1937, *Hindenburg* disaster. The zeppelin engulfed in flames in mere moments, its skin disappearing in the blink of an eye, leaving only the steel window-box frame to collapse in on itself as it crashed into the earth. Radio reporter Herbert Morrison, the only reporter on the scene that day, choked on his words and gave us the emotional line, "Oh, the humanity!" as workers ran from the conflagration. The accident became front-page news around the world, also giving us the "*Hindenburg* Syndrome" (shorthand for a general reluctance to explore hydrogen as fuel) and the "*Hindenburg* Omen" (a complex pattern of indicators that forecast a stock market crash). It also gave us Leadbelly's two-part blues "The *Hindenburg* Disaster"; "Balloon Burning," by the Pretty Things; Captain Beefheart's "The Blimp (mousetrap-replica)"; and the cover of the first Led Zeppelin album (reimagined through a Radiograph pen). (Footage no less horrific for its grainy, blurred images exists of other Zeppelin disasters such as the destruction of the USS *Akron*, which crashed into the Atlantic off the coast of New Jersey on April 4, 1933, killing all but three crewmembers, and inspiring folk singer Bob Miller to write and record "The Crash of the *Akron*" within twenty-four hours of the accident.)

Although the sinking of the *Titanic* and the spectacular conflagration of the *Hindenberg* left a round of songs to mark the tragedies, they were disasters not nearly as culturally influential as either the flooding of the Mississippi River that occurred at the start of 1937 (more than 1,100 people lost their lives) or the Great Mississippi Flood that occurred a decade previous. Happening as it did during the golden age of the Delta Blues, the Great Mississippi Flood inspired dozens of songs, some of whom actually witnessed the devastation and many of whom did not.

Recorded in February 1927 by Bessie Smith—before the flood struck—"Muddy Water (A Mississippi Moan)" had been captured

on record the previous year by Ben Bernie and His Hotel Roosevelt Orchestra. Smith's version nonetheless became the standard blues anthem about the flood, amid Charley Patton's "High Water Everywhere" and Kansas Joe McCoy and Memphis Minnie's "When the Levee Breaks" (made popular by Led Zeppelin in 1971, just three years before Randy Newman released the powerful flood ballad "Louisiana 1927" as part of his Southern song cycle, *Good Old Boys*). Barbecue Bob's "Mississippi Heavy Water Blues" is a sullen song about a man who watched his "gal [get] washed away." The recording from June 1927 opens with a blast of static that sounds eerily like a wall of rain before a lurching series of chords (like boots stuck in mud) kicks off the song. Bob bemoans his house that is now gone, the endless mud, and his loneliness, and as if he desired to underscore the sincerity of his pain he ends the song by doing away with his nom de blues for the final line, "Robert Hicks is singin' / That's why I'm crying Mississippi heavy water blues."

The flip side to the clinging mud and rushing waters of the flood ballad can be found in the crop and bank failures of the 1930s Dust Bowl, most specifically, Woody Guthrie's landmark 1940 album *Dust Bowl Ballads,* which was the singer/songwriter's first recording, often referred to as the first concept album. Born in Oklahoma, the Dust Bowl bard knew the "Okie" spirit well, mining his experience for songs like "The Great Dust Storm (Dust Storm Disaster)," "Dust Pneumonia Blues," "Dust Can't Kill Me," and, perhaps suggesting that he'd just about exhausted the theme, "Dusty Old Dust." Guthrie's spirit and the husk of hurt from the Dust Bowl lives on through Dylan, Wilco and Billy Bragg's reworkings of Guthrie's songs on the *Mermaid Avenue* albums, Bruce Springsteen's *The Ghost of Tom Joad*, and more contemporary Dust Bowl ballads such as Alison Krauss and Union Station's "Dust Bowl Children" and Mumford and Sons' "Dust Bowl Dance."

No contemporary natural disaster has reverberated with as great a musical coda as 2005's Hurricane Katrina. As the storm grew in ferocity and the levees gave way—an act that some would say rightfully classifies Katrina a manmade disaster—large swaths of New Orleans,

a city more than fifty percent below sea level, were drowned. As devastating as the storm and the flooding were, it was the aftermath that haunted the nation and the world—the confused frustration punctuated by Kanye West's impromptu commentary during a nationally televised fund-raising special ("George Bush doesn't care about black people"). Katrina led some to question whether the day the storm hit was the day the music died, as it scattered a tightly knit group of musicians across the country and stunned those that remained in the devastated city. It also serves as an example of the relative health of the disaster song.

In the weeks following the touchdown of Katrina, Mos Def released "Dollar Day (Katrina Klap)" (performed over New Orleans hip-hop artist Juvenile's instrumental track "Nolia Clap"), TV on the Radio released the song "Dry Drunk Emperor," partly inspired by the aftermath of the storm, and Texas hip-hop group K-Otix released "George Bush Doesn't Care About Black People." These are songs of anger and frustration, while most of the other songs about Katrina flow in a more comfortable manner, such as the Dixie Chicks' "I Hope," Steve Forbert's "Song for Katrina," and Prince's gospel-tinged "S.S.T." But very few pop songs expressed the grief and loss of the tragedy in the way the brass bands did, reclaiming their history to breathe new life into funeral dirges such as "Garland of Roses," which had not seen so much attention since the 1950s. Those that did dig a bit deeper include the shrouded groove of Elvis Costello's "River in Reverse" and Susan Cowsill's touching "Crescent City Sneaux." Cowsill lost her home and possessions to the storm, and her brother, Barry Cowsill—both from the 1960s sunshine-pop group the Cowsills—died in the aftermath. "Crescent City Sneaux" provides a moment of turning the clock back, imagining, if only briefly, that "the wind and the panic and the rain" turned into "a soft and quiet snow." Another notable song to come from the destruction of Katrina is Steve Earle's "This City." A muted and grieving, if hopeful, song, it suggests that the vibrancy of New Orleans's community and culture is a true collaborative memory that "won't wash away" and "won't ever drown."

The cultural DNA of New Orleans may have resulted in more songs about the devastation that followed in the wake of Katrina, just as it galvanized local traditions like jazz funerals. But tragedies

of another sort are no longer as richly eulogized, evidenced by the dearth of material concerning the 2008 global financial crises. In contrast, the Great Depression spawned undeniable classics like Bing Crosby's wounded croon on "Brother, Can You Spare a Dime?," Blind Alfred Reed's "How Can a Poor Man Stand Such Times and Live?" (1929), Skip James's "Hard Time Killing Floor Blues" (1931), and "No Depression in Heaven," by the Carter Family (1936). One could argue that in the years following the economic collapse of 2008 nothing truly enduring has been recorded about the economic crisis, perhaps indicative of the intricacies and scope of the collapse. It's also likely to be the result of an atomized audience that allows listeners to find the music they want without having to hear anything they don't, as opposed to an earlier time when the ubiquity of pop radio playlists ensured everyone heard the same songs and MTV spent time making and breaking musicians rather than reality TV stars. Perhaps we're just too near the crisis to observe the songs spun from its damaging effects, and the coming years will allow us to see that protest singers haven't gone anywhere, their songs are just silenced beneath the noise rather than washed away.

THE MISERABLE LIST: DISASTER STRIKES!

1. "He's Only a Miner Killed in the Ground"—Ted Chestnut (1928)
2. "The Wreck of the Number Nine"—Marty Robbins (Recording date unknown; released 1983)
3. "The Great Ship Went Down"—Cofer Brothers (1929)
4. "How Can a Poor Man Stand Such Times and Live?"—Blind Alfred Reed (1929)
5. "Ohio Prison Fire"—Charlotte and Bob Miller (1930)
6. "West Virginia Mine Disaster"—Jean Ritchie (1971)
7. "Louisiana 1927"—Randy Newman (1974)
8. "Radioactivity"—Kraftwerk (1975)
9. "We Almost Lost Detroit"—Gil Scott-Heron and Brian Jackson (1977)
10. "This City"—Steve Earle (2011)

SONG ESSAY: "BROTHER, CAN YOU SPARE A DIME?"

Brother, Can You Spare a Dime?" emerged from the pop epicenter of American music in the 1920s, Tin Pan Alley—a hotspot for quick, jovial songs that tended to look for the silver lining rather than gloom about the rain—but it spoke with a pathos more commonly found in the blues and folk music of the Appalachians and the rural South, both in its key and its lyrics. Written by lyricist E. Y. Harburg (*The Wizard of Oz*, "April in Paris," "It's Only a Paper Moon," and "Lydia, the Tattooed Lady") and composer Jay Gorney for the Broadway musical revue *Americana*, the song surprisingly opens in a minor key. A producer for the show wanted to put the song in the hands of a classically trained singer, but after an audition in which an opera singer took the stage in full costume, Gorney said to the producer, "I want a mug. A guy, a fellow who's been through this depression, not a well-fed person," and he nominated vaudeville ventriloquist Rex Weber, who was well-known at the time for his comic numbers. Weber made the song a hit, and it was such a showstopper that it was quickly moved from the first act to the second act finale.

The song is neither jazz nor folk nor pop; it protests in the most unassuming way, by simply asking, "How could this have happened?" Its Broadway premiere occurred at the nadir of the Depression, on October 5, 1932, and shocked audiences with its realism. Gorney recalled that it was the first popular song "to treat the wreckage of the Depression seriously." Just twenty days after the song debuted, crooner Bing Crosby, whose deep, mellow voice had already steered melancholy hits such as "Just One More Chance" and "Dancing in the Dark," headed into the studio to tackle Broadway's latest sensation.

When Crosby recorded the song, Brunswick, realizing they had bottled lightning, rushed the record into stores. Within two weeks it was the number one song in the country and well on its way to defining the era. Crosby, notes biographer Gary Giddins, had been reshaped only recently by the Paramount Pictures publicity department, from a good-time drunk into "the aristocrat of the people: a North Star of stability, decency, and optimism." He was the perfect

choice to tackle the song that Gorney's daughter, in her biography of her father, *Brother, Can You Spare a Dime?*, referred to as "an unusual torch song: a man crying for a job, a chance to make a living."

The melody is based on a Russian-Jewish lullaby that Gorney's mother had sung to him when he was a child. Odd for such a big hit, it has both a minor verse and a minor chorus, though it does leap into the major during a reminiscence about building a railroad that "raced against time," before plummeting back into the minor reality of the day. The music is much like the slow, steady march of burlap-covered feet in the endless breadlines that lyricist Harburg—and every New Yorker—witnessed in Columbus Circle and Central Park.

Rudy Vallee recorded the song on Crosby's heels (a slightly more upbeat take) and also scored a number one before the year was out. Vallee's spoken-word preface sheds light on the song's anomalous place on 1932's pop landscape, as he refers to it as "both poignant and different."

Harburg and Gorney were both socialists whose political fires had been stoked by Black Friday and the ripple that rang out from the dissolution of so much Wall Street wealth. The workingman was being squeezed by the rich on the East Coast and decimated by Mother Nature and the Dust Bowl on the West. In his book *Hard Times: An Oral Biography of the Great Depression*, venerated radioman and author Studs Terkel interviewed Harburg, not only about "Brother, Can You Spare a Dime?" but also about being co-owner of the Consolidated Electrical Appliance Company. "Bango! . . . 1929," Harburg said. "All I had left was a pencil." The Depression proved an unexpecting boon for the future songwriter, who had "detested" life as a businessman, saying, "When I lost my possessions, I found my creativity. I felt like I was being born for the first time. So for me the world became beautiful." He talks to Terkel about the collapse of American business ("the Rock of Gibraltar") and the breadlines he would see while walking the New York streets, the largest of which was run by media tycoon William Randolph Hearst. "Brother, Can You Spare a Dime?" grew from the enormity of Hearst's breadline operation, which saw hungry, broken men queued up for blocks around Columbus Circle. (*Americana*, the musical from which "Brother . . ."

blossomed, featured a skit in which Mrs. Ogden Reilly, owner of the *Herald Tribune*, became jealous of the size of Hearst's breadline operation.)

Harburg took the colloquial greeting he'd heard often during those days and used it for the title, while the bruised heart at the center of the song is the question he often pondered: "I built the railroads. I built that tower. I fought your wars. I was the kid with the drum. Why the hell should I be standing in line now? What happened to all this wealth I created?" In Harburg's view it was never about simple begging: "It's more than just a bit of pathos. It doesn't reduce him to a beggar. It makes him a dignified human, asking questions—and a bit outraged, too, as he should be."

"Brother, Can You Spare a Dime?" is similar to "Remember My Forgotten Man," from the film musical *Gold Diggers of 1933*; both songs explore the broken bargain that hit working-class men who once "worked behind a plow" and "built a railroad," before they became penniless, objects of sympathy. But where "Remember My Forgotten Man" gives no voice to the abject, "Brother, Can You Spare a Dime?" rings through in first person, perhaps its most touching plea coming directly as a result: "Don't you remember? They called me 'Al' / It was Al all the time." In their patriotism, though maybe naive ("Once in khaki suits / Ah, gee, we looked swell"), the reality of the Second World War quickly washed over them as "half a million boots went slogging through hell."

"Brother, Can You Spare a Dime?" gained momentum throughout 1932. With Herbert Hoover winning the G.O.P. renomination—in large part because no other suitable candidates wanted it—and energetic Democrat Franklin Delano Roosevelt in the running, skittish conservatives pressured radio stations to ban the song on the grounds that it was anticapitalist propaganda. But as Harburg points out, it was too late, "the song had already done its damage." Interestingly, the shoe was on the other foot after Roosevelt's election and the president asked for the song to be removed from radio playlists to help the country move past the Depression. Gorney's daughter recalled that her father and Harburg thought "they were the only songwriters who voluntarily kept one of their hit songs off the air to help the country."

There's a nice trick in the middle of the song, as it jumps an octave as Crosby reminisces on the days of building the railroad—the good years when everyone had work—but it folds in on itself as soon as it appears, buckling back into a distressing minor as the daydream dissolves and he's brought back to reality ("Once I built a railroad and now it's done") and his ubiquitous greeting, "Brother, can you spare a dime?"Ⓙ

HAYDEN

Born Paul Hayden Desser, on February 12, 1971, in Toronto, Canada, Hayden came from the Great White North riding the tail end of the lo-fi movement, crafting emotionally taut songs that fall somewhere between Beck's mumbled, lo-fi confessionals and scruffy grunge acts like Tar and Screaming Trees. His first self-released cassette, *In September*, appeared in 1994 and featured his lowly tuned guitar to better accommodate his muddy baritone, most of which would be cleaned up and rerecorded for his debut full-length, 1995's *Everything I Long For*, which the singer released on his own Hardwood Records label. The odd and personal album showcased the talented songwriter as a morose hyper-local journalist, tracking the mundane details (laundry baskets and a pair of ice skates) of suburban sadness. (In classic Dylan style, Hayden is reluctant to share insights about his songs, preferring to let listeners piece together their own narratives.) The shy songwriter soon found himself at the center of a major-label bidding war, settling on Outpost Records, a tributary of powerhouse Geffen, which won the rights to rerelease *Everything I Long For*, a slacker-generation snapshot that collects the miseries and injustices of low-wage jobs and the fear of growing old. He released a number of independently released seven-inch singles and EPs that quickly went out of print, and was pegged to write the title song for actor Steve Buscemi's directiorial debut, *Trees Lounge*. The eight-song *Moving Careful* EP was released in 1997, and *The Closer I Get*, a true follow-up to *Everything I Long For*, finally materialized in 2008. The album took a less ramshackle, more pop direction as the singer recorded with a full band

on many of the songs, including first single, "The Hazards of Sitting Beneath Palm Trees." *The Closer I Get* found modest success, but after touring and racking up a number of critical adulations, Outpost was dissolved and Hayden found himself without a label. The singer all but disappeared, leaving many to wonder whether he would ever surface again, but in 2001 it was announced that he was back in the studio, recording what would become *Skyscraper National Park*, which he chose to release in handmade packages and limited to one hundred copies. The album didn't veer from what he had done previously, but it did include both some of his most easily digestible tracks ("Dynamite Walls") as well as his most disturbing, notably "Bass Song," in which the singer imagines his own murder in his home studio during a snowstorm. Reaction to the disc was positive, leading Universal to sign the still operational Hardwood to a distribution deal and give the album a wide release. In 2002 he released the double-disc live album, *Live From Convocation Hall*, and two years later his next studio release, *Elk-Lake Serenade*, appeared to critical acclaim. In 2008 Hayden released the deceptively expansive set *In Field & Town* and followed up quickly with 2009's *The Place Where We Lived*. "Generally there's too much happiness in the world," he deadpanned in a 2008 interview, "so it's my job to bring it down a notch."

BILLIE HOLIDAY

Few performers are as inseparable from the fog of melancholy as Lady Day, Billie Holiday. Her ability to channel the often bleak realities of her life—rape, prostitution, alcohol and heroin addiction, abusive lovers—through her bittersweet voice made her one of the most beloved singers the world has ever known. She was born Eleanora Fagan on April 7, 1915, in Philadelphia, where her mother, Sadie Fagan, then nineteen, had taken a live-in domestic position on the assurance that her baby would be born in a hospital. Soon after, the young mother brought her baby home to her native Baltimore. Billie's father, Clarence Holiday, was a teenaged musician who became

one of the premier jazz guitarists in the country during the 1920s; he never married Sadie, and was a sporadic presence in his daughter's life, but did provide the young Holiday entrée to the Baltimore jazz world. At nine, Holiday was placed in school at the House of the Good Shepherd for Colored Girls—her autobiography claims her juvenile incarceration was unjust punishment that followed her rape by a neighbor. Court records, however, show that a probation officer had caught up with her regarding the fourth grader's extensive record of playing hooky, though she may have been released and subsequently returned to the school following a rape in 1926. When she was finally released from the school, in 1927, she moved with her mother to New Jersey, and then to Brooklyn, New York. Holiday began spending her evenings as a young prostitute, and though most historians believe she was likely singing in New York City clubs as early as 1930, her own notoriously apocryphal autobiography states that she was discovered during a dancing audition at a speakeasy in 1933. In any event, 1933 did prove to be the year of her big break, when legendary producer John Hammond—then just a few years older than the teenaged Holiday—wrote about the singer ("a real find") in *Melody Maker* and brought bandleader Benny Goodman to watch her perform. She soon cut a demo at Columbia Records and joined Goodman for her commercial debut that November with "Your Mother's Son-in-Law." Her career continued to gain steam as she performed at the Apollo Theater, appeared in a one-reel film with Duke Ellington, and found her way back to the studio. She toured and continued to record throughout the remainder of the 1930s, doing some of her best work with trumpeter Buck Clayton and tenor saxophonist · Lester Young—whom she nicknamed Pres and who would return the favor by crowning Holiday Lady Day. After being mysteriously fired from Count Basie's touring orchestra in 1938 she was quickly snapped up by Artie Shaw, making Holiday one of the first instances of a female black singer fronting an all-white band. She quit the Shaw band, however, after a short time. Holiday's material while performing with the big bands was reasonably bright, but after she began singing regularly at New York's famous Café Society—the first popular interracial nightclub in the city—her repertoire darkened. Her

phrasing and timing were impeccable, and she seemed to have found a truth in the sadness of her songs during this time; her sessions began to focus on somber material such as "I'm in a Low Down Groove," "Am I Blue?," "Jim," "I Cover the Waterfront," along with the best of her own excursions into songwriting, "God Bless the Child," and a haunting song about the terrors of lynching, "Strange Fruit." The latter song—written by Jewish school teacher Abel Meeropole (also known as Lewis Allan) as an acrid reprisal against the violent racism still extant in the South—would become the highlight of her act, and though Hammond and Columbia refused to release "Strange Fruit," Holiday soon found a home for it on the Commodore label. Upon its release, in 1939, it was promptly banned by a majority of radio outlets, but the then burgeoning jukebox market made it a controversial hit. She signed to Decca in 1944 and recorded classics like "Lover Man," "Don't Explain," and "Good Morning Heartache." Though at her artistic peak, this period of her life also proved to be the beginning of the singer's tragic end. In 1941 she had married her first husband, Jimmy Monroe, and whether or not he was the cause of Holiday's escalating drug use during this time is hard to know. The marriage dissolved, and by 1945 Holiday had announced that she had received a Mexican divorce—which seems not to have been the case—and she was soon married to trumpeter Joe Guy. She lost a great deal of money attempting to fund her own orchestra and then experienced the shock of her mother's death in 1947. Soon after, she may have attempted suicide and was arrested for heroin possession. Back in 1940 the city of New York had initiated a program that required artists to carry a "cabaret card" in order to perform in nightclubs that sold liquor, a proviso made impossible for Holiday following her conviction. She returned to recording for Decca until 1950, and in 1952 she began recording for jazz-label-owner Norman Granz's Clef Records (his launch of the legendary Verve label was still a few years away). Under the direction of Granz she returned to the more intimate combo work that she had done at the beginning of her career, yet at this point her instrument reverberated with a cracked and weathered patina. If ever a vocalist lived at the precise center between the sacred and profane it was Holiday during the 1950s, her voice now worn but still containing the

hypnotic power of a fire's last glowing embers. She toured Europe in 1954, and in 1956 her autobiography was released. Two years later her final album, the controversial *Lady in Satin*, appeared and almost immediately split fans into two camps—those who derided the syrupy string arrangements of Ray Ellis, and those who prize it for its historical import and Holiday's brave performance. Hearing her speak in outtakes from the sessions makes one wonder how she managed to keep singing at all. She traveled to Europe to perform, but in May 1958 she collapsed, heart and liver disease taking their toll, and returned to New York. Still an addict, Holiday devised a way to procure heroin even from her deathbed and was arrested in her room during the afternoon of July 17. She died later that day as her body gave in to the combined stresses of withdrawal and heart disease. She was only forty-four years old when she died, though her voice was so broken by addiction and stress that she sounded like she could have easily been twice her age. In death, Holiday's fame continued to spread, the mythology that surrounded her taking on a life of its own. In 1972 Diana Ross starred as the ill-fated singer in the biopic *Lady Sings the Blues*, and biographies seem to be continuously published in an attempt to separate the elusive truths from the numberless fictions that compose the life and art of Lady Day.

THE MISERABLE LIST: BILLIE HOLIDAY

1. "Mean to Me"—B-side, *I'll Get By* (1937)
2. "Long Gone Blues"—Single (1939)
3. "Strange Fruit"—Single (1939)
4. "God Bless the Child"—Single (1941)
5. "Gloomy Sunday"—Single (1941)
6. "My Man"—B-side, *I Loves You Porgy* (1949)
7. "I Can't Face the Music"—B-side, *Remember* (1954)
8. "Good Morning Heartache"—*Lady Sings the Blues* (1956)
9. "Some Other Spring"—*Lady Sings the Blues* (1956)
10. "I'm a Fool to Want You"—*Lady in Satin* (1959)

SONG ESSAY: "STRANGE FRUIT"

Before Billie Holiday would perform "Strange Fruit" at New York's integrated Café Society, all the cluttering buzz of the nightclub would come to a complete halt, the waiters asking for silence before a lone, smoke-caressed spotlight would illuminate the face of the jazz ingénue then known largely for hits like "What a Little Moonlight Can Do" with Teddy Wilson and His Orchestra, from 1935. But now the audience was about to hear something dramatically different, a grisly, heartbreakingly poetic, unsentimental indictment of lynching in the South.

"Strange Fruit" is a curio in many ways. With its drifting flecks of melancholy jazz and campfire folk, its abrupt ending and dramatic hint of Broadway, it sounds like little else. The song's lumbering swing rhythm echoes a slow, comfortable Southern evening, and the lyrics are specifically brutal in their use of the beauty of the South—its breezes, scents, and rich sense of gallantry against itself to denounce the terrors of lynching. The breezes only nudge the hanging bodies, and the "scent of magnolia" is sweet only until it is harshly replaced by the "smell of burning flesh." Nature is also co-opted, as the wind, sun, rain, and trees turn evil as a metaphor for the unnatural nature of racism. It ends abruptly on a thudding chord and Holiday's rising and falling extension on the last word of the final phrase: "Here is a strange and bitter crop."

The audience sat rapt while the brutal song enveloped it in a collective fog of grief, and as that abrupt ultimate chord hung in the air the spotlight vanished, leaving the house in darkness for a brief moment before the lights went up to reveal that Holiday, too, had vanished. "It was a beautifully rendered thing, like a great, dramatic moment in the theater," cartoonist Al Hirschfeld, present at one of Holiday's performance, recalled.

Drummer Max Roach called Holiday's recording of "Strange Fruit" "more than revolutionary," legendary producer Ahmet Ertegun called it "a declaration of war" and "the beginning of the civil rights movement," and *Time* magazine named it the song of the century in December 1999, saying, "In this sad, shadowy song about

lynching in the South, history's greatest jazz singer comes to terms with history itself."

For all that, "Strange Fruit" had inconspicuous beginnings. Born as a poem written by New York City Jewish-American high school teacher Abel Meeropol (under the pen name Lewis Allan) and first published as "Bitter Fruit" in the January 1937 edition of teacher's union magazine *The New York Teacher*. Meeropol—well known in intellectual circles for his agitprop songs—then set his poem to music and began performing it around New York City. Others picked up on its undeniable power and began performing it as well, including black vocalist Laura Duncan, who eventually presented it at Madison Square Garden. Whether Café Society founder Barney Josephson initially brought Meeropol and his song to Holiday (who was then only twenty-three years old), or whether Meeropol just showed up with a desire for Holiday to perform "Strange Fruit" is a matter of some debate, but Meeropol eventually appeared at the nightclub and ran through his new song for Holiday. Josephson and producer Bob Gordon were bowled over by the power of the lyrics, but Meeropol recalled an incommunicative Holiday, who asked only the meaning of the word *pastoral* during their meeting. (Holiday, who had a notorious flair for the apocryphal, would later claim that the song was written specifically for her or that she was responsible for coauthoring it. She also recalled a long silence following her first public performance of the song, whereas Meeropol remembered a more immediate "thunderous applause.") Josephson gave the song to arranger Danny Mendelsohn, who shaped Meeropol's original music to an unknown degree, though some—including regular Holiday songwriter Arthur Herzog—maintain his influence was as important to the song as that of Meeropol and Holiday.

Not long after her first performance of the song at Café Society, *New York Post* writer Samuel Grafton wrote excitedly that it was "a fantastically perfect work of art" and that "if the anger of the exploited ever mounts high enough in the South, it now has its Marseillaise." Black sentiment regarding the song, however, was split from the beginning, with college students and older progressive African-Americans such as Paul Robeson believing that it portrayed blacks

as victims, while many black intellectuals regarded it as sacred, "like sitting in church," said *Pittsburgh Courier* journalist Frank Bolden, "it was like a hymn to us."

Regardless of how listeners interpreted the song, when Holiday performed it the world stopped spinning, necessitating its placement at the end of every performance—when Holiday called for it the night was over. She practiced the song at small private parties and get-togethers before debuting it at Café Society, and Meeropol recalled that when she finally did officially perform the song, it "was incomparable and fulfilled the bitterness and shocking quality I had hoped the song would have."

Columbia Records refused to record the song, a decision that surprised and deeply upset Holiday, but she moved forward to record it for Commodore Records instead. "Strange Fruit" debuted on the *Billboard* charts at number sixteen on July 22, 1939. Its B-side, "Fine and Mellow," was a blues number about domestic violence that, despite Holiday's belief that the A-side was the sales winner, turned out to be the larger hit for Commodore. At a time when singers would often sing and record material that others had made famous, "Strange Fruit" was one of the first popular songs to be associated with one specific artist and one specific recording. Though some artists, particularly singer Josh White, performed the song, most renditions of it didn't appear until after the civil rights movement wound down in the 1970s.

The original Commodore single is the definitive take, with its lonely trumpet solo and sympathetic piano runs, but it moves more quickly than subsequent recordings and live renditions would capture. The studio recording from June 7, 1956, is worth noting, as it features a blaring trumpet solo from Charlie Shavers, a visceral punch in the gut that opens the song and counters Holiday's more restrained performance and the song's dark poetry. Yet this version also contains too many clever elements that distract from the simple power of the song, including an all-too-playful piano accompaniment by Wynton Kelly and a dramatic single percussive exclamation point. A handful of live recordings, of varying degrees of quality, are in existence as well. In some, Holiday does little more than mumble her

way through the song, while others are fantastic, such as the *Jazz at the Philharmonic* recording captured at the Embassy Theatre in Los Angeles on April 22, 1946 (which is often included on Verve collections of her work).

David Margolick, in his book-length study of the song, *Strange Fruit: The Biography of a Song*, says that it "marked a watershed, praised by some, lamented by others, in Holiday's evolution from exuberant jazz singer to chanteuse of lovelorn pain and loneliness." Margolick also astutely notes that once Holiday added it as a regular piece of her set, "some of its sadness seemed to cling to her," precisely why legendary critic and producer John Hammond (the man credited with "discovering" Holiday when she was just seventeen years old) believed that the song was "artistically . . . the worst thing that happened to her," as after its success she turned more and more to the dirgelike ballads that defined her final years.

In the 1960s "Strange Fruit" fell out of favor as the idealism that buoyed the civil rights era clashed with a song Margolick said was "too depressing or too bitter or too redolent of black victimhood." The unique quality of the song, however, returned it to prominence shortly thereafter and it's since been recorded by a wide range of artists, including Cocteau Twins, Robert Wyatt, Tori Amos, Sting, Dee Dee Bridgewater, Cassandra Wilson, John Martyn, Jimmy Scott, Abbey Lincoln, Lou Rawls, Jeff Buckley, Siouxsie and the Banshees, The Gun Club, UB40, and the Twilight Singers—101 Strings even cut an instrumental version. Nina Simone is the only artist of note who, for a short time, made the song a part of her regular repertoire before dropping it, saying it was "too hard to do."

Diana Ross cut an unconvincing version of the song for her role as Holiday in the 1972 film *Lady Sings the Blues*, and Eartha Kitt, while portraying Holiday in a one-woman show during the 1980s, hesitantly sang it, saying later, "I could hardly get through it." It uncomfortably exists as a small handful of down-tempo and dance remixes, and it incomprehensibly gets a spin on the turntable as a weapon of seduction in the 1986 hit *9½ Weeks*—dispensing with jazz and blues critic Albert Murray's suggestion that "you don't get next to someone playing 'Strange Fruit.'"

In 1994 Judge Stephen Reinhardt used the song as part of an argument to the United States Ninth Circuit Court of Appeals that death by hanging—which is still legal in New Hampshire (at the behest of corrections officials) and in Washington (where a defendant sentenced to a death penalty may still choose hanging)—should be considered cruel and unusual punishment: "To many Americans, judicial hangings call forth the brutal images of Southern justice immortalized in a song hauntingly sung by Billie Holiday." The full text of the song appeared in his footnotes. The court, in a six-to-five decision, disagreed with his opinion.🖤

SKIP JAMES

A deeply original American voice, Skip James was a talented guitarist (specializing in droning bass notes and minor tunings), pianist, and vocalist who sang in a haunting falsetto, and was not only one of the most adept composers of the original Delta bluesmen (epitomizing the "Bentonia School" of country blues) but also perhaps the most astute observer of life's dark nature. Born on June 21, 1902, in Yazoo City, Mississippi, Nehemiah Curtis "Skip" James was raised on the Woodbine Plantation outside the city. His father, a bootlegger, left his wife and son in 1907. In 1912 his mother bought James his first guitar for $2.50 and he soon learned his first song, "Drunken Spree," from guitarist Henry Stuckey. James dropped out of high school in 1919 and worked in various road, levee, and lumber camps and wrote his first song, "Illinois Blues," during this time. He moved to Weona, Arkansas, to become a lumber grader in 1921 and met pianist Will Crabtree, who would become a significant influence in terms of both his piano style and his lifestyle. He stayed in Weona until 1923, working as both pianist and pimp, until a dispute with one of his women drove him out of town. He soon surfaced in Memphis, where he found employment as a piano player at a brothel. Prohibition was the likely impetus for his move back to the Bentonia area, where he became a sharecropper and began supplementing

his income by bootlegging "white lightning." He continued to play, and developed a three-finger playing style (also practiced by Charley Patton, Mississippi John Hurt, and others), but his distinctive sound was based on his E-minor tuning, which he referred to as "cross-note tuning." In February 1931, after having been spotted by a Paramount Records talent scout, he traveled to Grafton, Wisconsin, to cut eighteen tracks in a historic session that captured some of the most devastating blues ever carved in wax, including "Hard Time Killing Floor Blues," "22–20 Blues," and "Devil Got My Woman" (which was the primary inspiration for Robert Johnson's "Hellhound on My Trail"). The tracks quickly established James as a major talent, but when Paramount attempted to get him to record again in late 1931 or early 1932 he refused the offer, saying he had "gotten religion" following an emotional meeting with his estranged father, who had become a Baptist minister. James followed his father to Plano, Texas, and attended, but did not graduate from, seminary school. Following his mother's death in the early 1950s, James returned to Bentonia and by the early sixties he was rediscovered living in a hospital in Tunica, Mississippi. His rediscovery, and the nearly simultaneous rediscovery of Son House, in Rochester, New York, sparked the great blues revival of the mid-sixties. James was deeply cautious of the revival, though he did appear at the Newport Folk Festival in July 1964 (his first performance in more than thirty years) and recorded for a number of labels until he died in Philadelphia on October 3, 1969, from cancer. James is buried, with his wife, in Bala Cynwyd, Pennsylvania, just outside of Philadelphia.

JANDEK

An astonishingly reclusive singer and guitarist, Jandek creates free-associative, DIY outsider folk that would seem little more than the barely musical derangements of an obsessive-compulsive if not for the fact that each step along his tricky path features an inspiring amount of dedication spiked with moments of revealing

perception and brilliant (if jagged) humor. Jandek isn't really a group or a person, but a concept, with the man who has come to represent Jandek acting variously as performer, as the record label Corwood Industries, and as "a representative of Corwood Industries," in what amounts to a decades-long piece of performance art. (The mysterious Corwood Industries has been represented in the same intriguing manner since its inception, and although it now has a website, at corwoodindustries.com, it still relies solely on the same post-office box it did in 1978: Corwood Industries, Box 15375, Houston, TX 77220.) What has been reported about the man behind the myth includes that he studied philosophy in college, lives in an affluent suburb of Houston, works (or did work) a white-collar job of some stripe, and, in what is widely believed to be the only interview with him to have been caught on tape, he has described the origin of his name, saying, "It was January and I was speaking with somebody on the phone named Decker, so I just combined the two." For three decades he has appeared on the covers of Jandek albums in blurry and sun-spotted snapshots as a child, a teenager, and an adult—the overall effect is eerie in its persistence. And listening to Jandek is just as unsettling an experience: a de-tuned guitar (though he has suggested he does tune it) is picked and pawed at in random patterns, laying a disjointed bed for stream-of-conscious lyrics delivered in a reedy, screen-door-creak of a whisper. In the 2003 documentary *Jandek on Corwood*, which struggled to define the performer and his place in the cultural landscape, writer Douglas Wolk says, "I sometimes think of Jandek's songs as being a thirty-three volume suicide note. He always sounds like he's about to sign off." He has released dozens of albums, beginning with 1978's *Ready for the House*, which was originally credited to the Units but has since been labeled a Jandek recording. His catalog is often divided into different periods, one beginning with 1982's *Chair Beside a Window*, which features a female vocal (from a woman named "Nancy") and can nearly be considered a "Jandek goes electric" phase as the music gets more energetic and collaborators are brought in. Another phase begins with 1987's *Blue Corpse*—an album many Jandek fans suggest as a starting point for

new listeners, along with 1989's *The Living End*—Jandek melds his previous work into something more, ahem, accessible. Much of the energized collaboration has disappeared, though there is still a sense that others are involved from time to time. There are scattered a cappella releases, which sound like the haunting of a prairie mansion, and then there are releases like 1997's *I Woke Up*, which seems to feature a different male vocalist (someone possibly named "Mike") and is bathed in guitar effects and harmonica. Surprisingly, in 2004 Jandek agreed to perform his first live concert in Glasgow, and has since played a number of live dates around the world, releasing recordings of many of them. When *Texas Monthly* contributor Katy Vine tracked down Jandek in Houston during the late 1990s, he invited her to have a beer at an upscale bar. She asked him at one point if he wants people to "get" what he's doing. His deadpan reply? "There's nothing to get."

GEORGE JONES

The man Gram Parsons once called the King of Broken Hearts, George Glenn Jones, was born on September 12, 1931, in Beaumont, Texas, and racked up more top-ten country hits in his long career than anyone besides Eddy Arnold. At nine, Jones was learning how to play the guitar, and by sixteen he was singing on local radio. His first marriage (and his first divorce) and a stint in the army didn't keep him from the microphone, and even though his first singles for Starday Records were roundly ignored—including two rockabilly sides he recorded as Thumper Jones—by his fifth attempt, 1955's "Why, Baby, Why," he had a hit. By the end of 1956 he had become a regular fixture on the country charts, shared the stage with Elvis Presley on the *Louisiana Hayride* radio program, joined the Grand Ole Opry, and released his first album, *Grand Ole Opry's New Star*. He rounded out the 1950s with two monster smashes, 1958's "White Lightning" and 1959's "Tender Years." After a label switch he hit number one with the coy ballad "She Thinks I Still Care," and began recording

duets with singer Melba Montgomery, including their first and biggest single, "We Must Have Been Out of Our Minds." Another label jump in 1965 accompanied a frenzied period of activity, with the Possum—a nickname given to Jones by disc jockeys who thought he looked like a possum on one of his album covers—recording nearly three hundred songs between 1965 and 1970 and producing seventeen top-ten hits during that time. Nashville's assembly-line process meant that his best albums—like 1963's *Blue and Lonesome* or 1965's *Trouble in Mind*—were little more than serendipity, but his talent and the sheer volume he laid to tape ensured there would be plenty of diamonds amid the lesser efforts. Following his second divorce—his heavy drinking a contributing factor—he set up shop in Nashville, where he soon met C&W's hottest up-and-coming female artist, Tammy Wynette. The two fell in love, married in early 1969, and began to navigate the complex contractual obligations that kept them from recording together. By the fall of 1971 Jones had a new home at Epic Records, and he ensconced himself in the studio with legendary Nashville producer Billy Sherrill, the architect of the lush string-wrapped countrypolitan sound. Sherrill's production and Jones's honky-tonk heartbreak were perfect complements and their first album, 1972's classic weeper *A Picture of Me (Without You)*, began a fruitful working relationship that would last into the 1990s. Meanwhile, the material found on the first Wynette/Jones duet album—1971's *We Go Together*—emblematized the couple's happiness ("Something to Brag About," "Lifetime Left Together"), but by the time they recorded the follow-up—1972's *Me and the First Lady*—cracks were beginning to show ("Great Divide," "We're Gonna Try to Get Along"). The relationship was becoming the stuff of tabloid legend, Jones slipping deeper into alcohol and drug abuse, and the two frequently fighting, often in public, which eventually led Wynette to file for divorce in August 1973. She withdrew the petition and the duo deftly turned out the number one hit "We're Gonna Hold On," but Jones's next single, a disturbingly powerful portrait of a broken marriage, titled "The Grand Tour," told a different story, as did the follow-up singles "The Door" and "These Days (I Hardly Get By)." Wynette and Jones

finally divorced in 1975, though they would continue to record and tour together. Following the split, Jones's personal life careened out of control as he drank heavily, became addicted to cocaine, went on violent intoxicated rampages, and often disappeared for days, missing an unbelievable fifty-four shows in 1979, a string that earned him the nickname "No-Show Jones." Though he had skirted rehab and had shed a third of his body weight due to his cocaine addiction, he still managed to mount an impressive comeback in 1980, charting with the Wynette duet "Two Story House" and then hitting number one with his biggest hit ever, the plot-twist tearjerker "He Stopped Loving Her Today." In between spinning out top-ten country hits he was involved in televised police chases, eventually cleaning up his act with the support of his fourth wife, Nancy Sepulvado. He continued to record, but the hits didn't come like they used to. He released his autobiography, *I Lived to Tell It All*, in 1996, and in 1999 was severely injured in a drunk-driving accident. He was charged with DWI and entered rehab, but still found time to release *Cold Hard Truth* later that same year.

THE MISERABLE LIST: GEORGE JONES

1. "Cup of Loneliness"—*Blue and Lonesome* (1963)
2. "Book of Memories"—*I Get Lonely in a Hurry* (1965)
3. "Things Have Gone to Pieces"—*New Country Hits* (1965)
4. "A Good Year for the Roses"—*George Jones with Love* (1971)
5. "A Picture of Me (Without You)"—*A Picture of Me (Without You)* (1972)
6. "The Grand Tour"—*The Grand Tour* (1974)
7. "Memories of Us"—*Memories of Us* (1975)
8. "Cryin' Time"—*Golden Ring* (with Tammy Wynette) (1976)
9. "The Battle"—*The Battle* (1976)
10. "He Stopped Loving Her Today"—*I Am What I Am* (1980)

JOY DIVISION

Joy Division released relatively little material during the band's lifetime, but birthed a tremendous mythology that primarily flutters around lead singer Ian Curtis, whose dark lyrics, voltaic performances, and suicide cut the blueprint for rock-and-roll tragedy. One of the first true post-punk bands—along with acts like Gang of Four and the Fall—the beginnings of what would become Joy Division came together in early 1977, soon after the Sex Pistols' first Manchester show, where guitarist Bernard Albrecht (later Bernard Sumner) and bassist Peter Hook met and laid the groundwork for the Stiff Kittens. An ad in a local record store brought vocalist Ian Curtis and drummer Steve Brotherdale into the fold. Renaming the group Warsaw—after David Bowie's drifting "Warszawa," from his 1977 Berlin-era album *Low*—the band set to work on writing material, debuting live just weeks later in support of the Buzzcocks. Brotherdale quit after recording a handful of demos and was quickly replaced by Stephen Morris. Another punk group, Warsaw Pakt, necessitated a final name change at the end of 1977 to the notorious Joy Division; the name was lifted from concentration-camp survivor Yehiel De-Nur's World War II novel *The House of Dolls*, in which it was used as slang for a group of female camp inmates forced to prostitute themselves to Nazi soldiers. (An early interview with *Sounds* magazine is almost dominated by the Nazi connection to their name.) They recorded their first official material in May 1978, but after an enterprising studio engineer added synthesizers to many of the songs at the last moment, under a personal belief that punk's day had ended and nothing was less punk than synthesizers, the band scrapped the album (it has since been officially released). Their first official release therefore became a collection of their 1977 demos released as an EP, *An Ideal for Living*, via the band's own Enigma label. These earliest recordings were a mixture of metal sludge and punk ferocity, holding only a faint hint of what the band would quickly become. Certain elements, however, particularly Curtis's detached baritone, stood firm from the first. The group recorded for John Peel and began working with producer Martin

Hannett in early 1979. A difficult producer and poor communicator, Hannett's methods, though odd, were responsible for crafting Joy Division's groundbreaking detached, dub-influenced sound. The results of the first sessions with Hannett would be two tracks ("Digital" and "Glass") for *A Factory Sample,* the first release by Tony Wilson's infamous Manchester-based Factory label, and would lead directly to 1979's cold-marble post-punk classic *Unknown Pleasures.* Sumner's brittle, metallic guitar and Hook's melodic bass runs dance gravely over the stark slapping of Morris's drums, while Curtis's bruising baritone awes and disappears—it was, and remains, insistent, mysterious, and revelatory. Another Peel Session followed in November, as the group's popularity continued to rise, based partially on rumors of Curtis's ill health, sparked by the manic, frightening stage persona he cultivated, which echoed the epileptic seizures that would at times overwhelm him. The group also possessed a monolithic ferocity during their live shows that was trapped in glass, cooled and evaporated on record. The band's schedule began to take its toll on Curtis, who was suffering more frequent onstage breakdowns, ultimately leading to the group canceling a number of shows on their planned European tour. Joy Division started working on a second album, again with Hannett, and released the single that would go on to define the group, "Love Will Tear Us Apart." The single became an instant sensation in the independent press and the band was soon prepping for its first US tour. Two days before their scheduled flight, though, Curtis was found dead by his wife, Deborah; he was hanging in their kitchen, Iggy Pop's *The Idiot* spinning silently on the turntable. Following his death the group's commercial successes came in waves as a rerelease of "Love Will Tear Us Apart" shot to number thirteen on the British singles charts and their second album, *Closer,* reached number six on the albums chart. The group, however, had a pact that Joy Division would dissolve if any member were to leave, prompting Hook, Morris, and Sumners to form New Order. The 1981 release of the odds-and-ends collection *Still* showed that the group's popularity had not waned as it peaked at number five on the British albums chart. In the years since, the dark mythology surrounding Curtis has continued to swell: his biography, *Touching from a Distance,* written by his wife, Deborah Curtis,

became required reading for alienated teenagers everywhere, and a film about the band, *Control*, directed by Anton Corbijn and based on Deborah Curtis's book, was released in 2007 to critical acclaim. The new millennium also saw a slew of Curtis-styled anchor-deep crooners, including Interpol's Paul Banks and Editors' Tom Smith, crowned rock's newest saviors, and in 2010 a ten-piece seven-inch box set appeared, featuring previously unreleased material—its title, +/-.

THE MISERABLE LIST: JOY DIVISION

1. "Digital"—Single (1979); *Substance* (1988)
2. "Day of the Lords"—*Unknown Pleasures* (1979)
3. "She's Lost Control"—*Unknown Pleasures* (1979)
4. "Isolation"—*Closer* (1980)
5. "Twenty-Four Hours"—*Closer* (1980)
6. "Love Will Tear Us Apart"—Single (1980); *Substance* (1988)
7. "Atmosphere"—Single (1980); *Substance* (1988)
8. "Dead Souls"—*Still* (1981)
9. "Exercise One"—*Still* (1981)
10. "Transmission (Live)"—*Les Bains Douches 18 December 1979* (2001)

SONG ESSAY: "LOVE WILL TEAR US APART"

Written between August and September of 1979 and debuted during their fall tour opening for the Buzzcocks, "Love Will Tear Us Apart" existed only briefly before it became christened as Ian Curtis's last will and testament. It has since become one of the most recognizable independent songs ever, has been covered by dozens of artists (including U2, Arcade Fire, Thom Yorke, Broken Social Scene, Bloc Party, and the Cure), named the Best Single of All Time by *NME* in 2002, and rightfully shows up on just about every list of the greatest songs ever recorded. Though some bristle at the idea of tying the song's fragile lyrics to Curtis's short and troubled life, there's ample evidence he was searching to excise some demons in the

song, saying in a rare audio interview that his approach to writing stressed "personal relations."

By 1980, just three years after forming, Joy Division was one of the most vital rock groups in the world. Their first album, *Unknown Pleasures*, was released in late 1979 and was hailed as an instant classic, while their live shows, on the strength of Curtis's intense performances, were drawing ever-larger crowds. Yet even as the group was gaining momentum, Curtis was suffering from an overwhelming onslaught of personal traumas. His epilepsy was exacerbated by his lifestyle, his doctors' having told him to avoid drinking, drugs, and too much excitement, and to make things worse, he was prescribed a series of barbiturates (such as phenobarbital and carbamazepine) to help control his epilepsy that further clouded his senses and may have amplified his depression and sense of isolation. But it was the failure of his marriage to Deborah Curtis, whom he had fallen in love with at the age of sixteen and who was also the mother of his daughter, Natalie, that stalked the corners of his mind. He oscillated wildly between obvious affection for his family and the rush of intense feelings he was experiencing for Belgian journalist Annik Honoré, whom he had met in October 1979. To compound his health and relationship troubles, he was also feeling at odds with his part in Joy Division. According to Deborah Curtis, in *Touching from a Distance*, the singer had no interest in recording anything beyond the "Transmission" single and *Unknown Pleasures*. She writes that Ian's "aspirations had never extended to recording 'Love Will Tear Us Apart' or *Closer*." The group's initial salvos had fulfilled his desires and his interest in the group was waning even as he felt a sense of dependence from the other members of the group, as well as Tony Wilson and the people at Factory. Deborah Curtis, though, insists he was little more than "a music-industry puppet" at this point. Commenting on the song's appearance during a February 8, 1980, University of London show, *NME* called it "a staggeringly melodic and momentous piece," while *Melody Maker* curiously asked, "Optimism on the way?" Little did anyone know that the troubled singer had little more than three months left to live.

"Love Will Tear Us Apart" was first caught on tape during the

group's November 1979 appearance on John Peel's Radio 1 show and subsequently recorded twice in-studio: First in January 1980 and again in March. The two studio sessions resulted primarily from Curtis's vocal; Tony Wilson had requested that the singer envelop himself in the best of Frank Sinatra and give his second attempt more of a hopeless croon—and it's the second, noticeably slower take that became the more popular version of the song. "Love Will Tear Us Apart" was first released as a single in April 1980 with "These Days" as well as the initial, faster version of the song on the flipside. The cover art, which featured nothing more than the title of the song and the Factory Records catalog number (twenty-three), was created using acid-etched metal and had the appearance of a weathered gravestone. In retrospect, it gave Deborah Curtis pause, feeling her husband "was already well ahead with his plans for his demise." *Melody Maker* praised it immediately as "a powerfully original piece of music."

The song is unabashed pop for a group as resolutely downtrodden and confrontational as Joy Division. It opens with an iconic thrum of guitar (the post-punk version of the instantly recognizable chord that introduces "A Hard Day's Night"), which quickly gives way to a simple synthesizer lead, Peter Hook's melodic bass, and Stephen Morris's mechanical beat, creating a lively, if sterile, mid-tempo bed for Curtis's languid vocal. The lyrics spell out the heartbreakingly simple ways in which relationships fade, marking love's demise through routine and daily failure. He asks, "Why is the bedroom so cold?" recognizing that something has disappeared even as "there's still this appeal we've kept through our lives." But it's in the final verse that his confusion closes in with all his "failings exposed," his "desperation takes hold" capped with the quixotic truth "that something so good just can't function no more." The dichotomy between the severe truths Curtis dredges up and his monotonous, robotic delivery is at the heart of the song's appeal. The faster studio recording, as well as the quickstep live performances in existence, aren't imbued with the same icy detachment and frigid confusion. They barrel on, while the March 1980 studio take creeps hesitatingly forward; it knows how everything ends and it's not rushing to get there.

Curtis had already attempted suicide at least one other time, going

so far as to write a note and ingesting a large number of phenobarbital, before confessing to his wife and being rushed to the hospital to have his stomach pumped. But on May 18, 1980, he finally succeeded in ending his life, hanging himself in the kitchen of his Manchester home. Deborah Curtis chose the song title for the words inscribed on her husband's memorial stone in the crematorium where his ashes rest. Following Curtis's suicide the single was rereleased—Tony Wilson almost collaborating with the singer from the grave on an unspoken plan to build his melancholy legend—and it climbed to number thirteen on the UK singles chart. It was rereleased in 1983 and charted again, peaking at number nineteen. The song was released three more times: in 1995, to mark both the release of the "best-of" album, *Permanent*, and to commemorate the fifteenth anniversary of Curtis's death; in 2007, to celebrate expanded, remastered editions of the band's three albums; and in 2009, in alternate versions culled from Martin Hannett's master tapes. The song's enduring appeal will no doubt lead to more cover versions and even more reissues of this post-punk cornerstone, but it's hard to imagine that any will come close to the heartbreaking appeal of the original. Ⓗ

LAMBCHOP

One of the most uniquely American acts to proudly come out of Music City, USA, countrypolitan chamber group Lambchop—which counted as many as fifteen members at one point—crafts a gothic take on Americana that rests largely on singer/songwriter Kurt Wagner's abstract front-porch poetry and cragged vocals. Formed gradually over the course of the mid- to late eighties, Lambchop (originally called Posterchild) began their recording career with 1993's "Nine"/"Moody Fucker" single. Their 1994 debut, *I Hope You're Sitting Down* (*Jack's Tulips*)—which featured an infamous bathroom-suicide narrative in "Soaky in the Pooper"—proved to be rough sketches of the full, clear sound they would unveil on their Billy Sherrill–styled masterpiece, 1996's *How I Quit Smoking*. The *Hank*

EP appeared shortly thereafter, and in the following year they tested their precociousness by titling their third album *Thriller*. A mixed bag and an obvious transitional statement, the album featured no less than three East River Pipe covers and a handful of originals, including opener "My Face Your Ass," in which Wagner delivers the declaration "I'll show your punk rock ass," in a bruised whisper. They pawed at old-school Southern soul on 1998's *What Another Man Spills*, covering "Give Me Your Love (Love Song)" and "I've Been Lonely So Long," as well as two more East River Pipe numbers, with Wagner exhibiting a new and surprising dry falsetto. All the sounds they had previously explored came together on 2000's *Nixon,* a gorgeous and unique patchwork statement that calls upon country, folk, rock, gospel, and soul, that can be rightfully be shelved alongside other vivid musical portraits of America, such as Charles Ives's *Central Park in the Dark*, Brian Wilson's *Smile,* David Ackles's *American Gothic*, and Bruce Springsteen's *Nebraska*. After the choirs and brass of *Nixon* faded, and Wagner had finally quit his job laying floors, Lambchop's notoriously big sound was dramatically whittled down to focus on his choking vocals and Tony Crow's piano for 2002's *Is a Woman*. They were greeted as idiosyncratic indie-rock royalty with the simultaneous 2004 releases of *Aw Cmon* and *No You Cmon*. Among the sprawling set of twenty-four songs were the foggy "Nothing But a Blur from a Bullet Train" and the introspective "Action Figure," about which, Wagner explained with typical humility, "You can tell when you hear these things that there's something pretty hard going on there, and I'll sort of leave it at that." Wagner faced down a cancer scare that fueled 2006's *Damaged*. Over the years, Wagner's songwriting slowly turned from frayed, string-laden country to the overcast pastoral pop that rules 2008's *OH (Ohio)* and songs like "Slipped, Dissolved and Loosed," "I'm Thinking of a Number (Between 1 and 2)," and "Sharing a Gibson with Martin Luther King, Jr." In 2009 the band released *Live at XX Merge,* which, together with two odds 'n' sods collections—2001's *Tools in the Dryer,* 2006's *The Decline of Country and Western Civilization, Part II: The Woodwind Years,* and a rare 2010 vinyl-only release via the Grapefruit

Record Club—form a complete picture of Lambchop's forgotten, live, and extracurricular activities since their inception. Dedicated to Vic Chesnutt, 2012's *Mr. M*, the group's eleventh album, placed Wagner's now relaxed growl in a lush, studio-molded sound self-described as a "psycho Sinatra."

THE MISERABLE LIST: LAMBCHOP

1. "Soaky in the Pooper"—*I Hope You're Sitting Down (Jack's Tulips)* (1994)
2. "I'm a Stranger Here"—*Hank* (1996)
3. "Theöne"—*How I Quit Smoking* (1996)
4. "I've Been Lonely for So Long"—*What Another Man Spills* (1998)
5. "Grumpus"—*Nixon* (2000)
6. "I Can Hardly Spell My Name"—*Is a Woman* (2002)
7. "Action Figure"—*Aw Cmon* (2004)
8. "Paperback Bible"—*Damaged* (2006)
9. "Slipped Dissolved and Loosed"—*OH (Ohio)* (2008)
10. "2B2"—*Mr.M* (2012)

Seasonally Affected
Falling Leaves, Falling Snow, Falling Tears

Melancholy were the sounds on a winter's night.

<p align="right">—VIRGINIA WOOLF</p>

Nature has always been the greatest source of metaphor for poets, writers, and musicians. The echoes of a tear found in a falling raindrop, the encroaching darkness of gathering storm clouds, and the crescent of life's stages spun from the clockwork of the seasons—the joys of germinating spring and blossoming summer, and the sorrows of the releasing fall and silences of winter. Ambient isolationist Thomas Köner says, "It's a kind of design question, this temperature thing. In a cold environment, everything slows down, and everything is going toward a stop event." And there is no "stop event" that looms larger than death.

The sorrows of the fading Celsius and first recognition of life's brevity and inevitable wane comes with the changing of the leaves in the fall. Compare Billie Holiday's sad celebration of "Autumn in New York"—the city's magic a thrilling melancholy that "can bring you up when you're let down," but is "often mingled with pain"—to the flowering fantasy of "April in Paris." If it's touched with melancholy it's likely the French have something to say about it, and with "Les Feuilles Mortes" ("The Dead Leaves"), known as "Autumn

Leaves" in the English translation by Johnny Mercer, they wonderfully capture the golden woe of autumn. The tune is sprinkled with the knowledge that "soon I'll hear old winter's song," yet the seasonally specific moment when the leaves start to fall is the cue for heartbreak. The song has become a standard for both vocal artists and instrumentalists—so popular that Serge Gainsbourg even paid homage to the song with his own "La Chanson de Prévert," which transfers the doleful power of the leaves in the original to the song itself. Its best renditions come from Cannonball Adderley with Miles Davis, who wrap the song's well-known melody in a dusky march; Edith Piaf, who recorded the song in both English and French; and Eva Cassidy, whose downtrodden folk reading brings the aching heart of the song front and center. Because of his droopy push-broom mustache, hangdog baritone, and the popularity of his late-sixties recordings with Nancy Sinatra—he wrote and originally recorded "These Boots Are Made for Walking"—most know Lee Hazlewood as a rumpled country-pop caricature, but when he laid himself low, as he does on "My Autumn's Done Come," a woozy meditation on aging, from his 1966 album, *The Very Special World of Lee Hazlewood*, he pulls no punches. He slurs "Throw all my tranquil pills away / Let my blood pressure go on its way," as he orders his "water short and his scotch tall" and comes to terms with reaching life's final chapters.

As leaves abandon trees, the days grow short, and the temperature dips, the number of blue songs about the gray weather begins to multiply. We now have a fairly sophisticated handle on why that is, but the explanations still have a small connection to the melancholy aspect of age-old humoral theory. Basically, each of the four humors—black bile, yellow bile, phlegm, and blood—loosely corresponds to one of the four elements, one of the four seasons, an internal organ, and specific qualities and characteristics: yellow bile equals fire, summer, the gall bladder, and anger, while black bile represents earth, autumn, the spleen, and despondency. If all four of the humors are in balance, then you should be a healthy, happy individual. The flip side is that every disease and disability can be traced to an imbalance in the four

humors. Too much blood and you're sanguine, more yellow bile than you need and you're choleric, and if you have a reserve of black bile you're melancholic, simple as that. Humoral thought dominated Western medicine for far longer than we may wish to be reminded of, beginning with Hippocrates and ending only in the nineteenth century, with the advent of modern medicine—more specifically, following Rudolf Virchow's 1858 theories of cellular pathology. A small strand of the concept survives today in the more refined form of what modern psychology refers to as seasonal affective disorder, or SAD (not to be confused with social anxiety disorder), a diagnosis first proposed by Norman E. Rosenthal in 1984, which states that seasonal change, particularly in fall and winter, can lead to an increase in depressive episodes. Though it's the darkness that seems to most affect people, it's little surprise that cold, ice, snow, and all things wintry have become synonymous with sadness: From Hank Williams's "Cold, Cold Heart" to the Chi-Lites' "Coldest Days of My Life" to Smog's "Cold Blooded Old Times," if it chills the bones it must also chill the heart.

There are few lines in the Monsters of Rock songbook as well-known as Foreigner's "You're as cold as ice / You're willing to sacrifice our love," a metaphor that repeats itself throughout culture, used more recently on Gwen Stefani's 2007 single "Early Winter," while Prince's "Sometimes It Snows in April" from his 1986 album *Parade* demonstrates how the sadness of the winter months can hang around a little longer than expected.

Written by Harlan Howard—one of the most important country songwriters in history, with thousands of compositions to his credit, including classics "I Fall to Pieces" and "Heartaches by the Number"—"The Blizzard" (1963), performed by Jim Reeves is the bitter tale of a man and his lame pony, Dan, struggling through a snowstorm with winds howling at the pair "like a woman's screams." Dan grows weaker as the two inch closer to the warmth of a barn, precipitating the fateful decision to stop amid the storm and rest. Their frozen bodies are recovered the following morning. Connie Smith's "The Deepening Snow," from her 1968 album *Sunshine and Rain*, is also chillingly grim; as she watches a fresh blanket of white

powder fall she imagines her recently deceased husband buried beneath it: "I can't stand the thought of my darling lying there in the deepening snow."

Roy Orbison's "Indian Wedding" features a young couple (Yellow Hand and White Sands) who wander into the hills to consummate their marriage only to be killed in a sudden snowstorm; "Snowflakes and Teardrops," by the Angels, is a sugary-sweet pizzicato tearjerker ("Because he went away / My winter's here to stay"); and the mournful swagger (if there is such a thing) of Bettye Swann's "(My Heart Is) Closed for the Season" (flashes of *The Shining*'s Overlook Hotel) is simply priceless.

More recently Dar Williams related the sorrows of a major depressive episode and suicide attempt in the graceful "After All," comparing her lowest moments to being trapped inside a "winter machine" while "everyone else is spring bound," and Bon Iver's instant-miserabilist-classic debut featured a number of songs chilled by the touch of wintry weather, including "Blindsided," "Blood Bank," and hidden track "Wisconsin." None of these, however, comes close to the epic sorrows of Franz Schubert's celebrated song cycle, *Winterreise*.

Based on the poem "Die Winterreise (The Winter Journey)," by Wilhelm Müller—celebrated in the nineteenth century, all but neglected now—and written during the winter of his own life, *Winterreise* is arguably the greatest song cycle ever written. The series of twenty-four songs for voice and piano concerns itself with a nameless heartbroken soul who takes to wandering the chilled wilderness in search of solace.

Schubert's compositions put the singer and the pianist on equal ground, the musical accompaniment eddying to capture and reflect not only the emotion of the text but also to reflect the world surrounding the wanderer—the birds, the frozen wind, rivulets of chilled water, and the sad drone of a hurdy-gurdy—all adding deeper layers of emotional truth to the whole. Müller, who was Schubert's friend, recalled the composer's melancholic state of mind during the writing of *Winterreise,* saying, "Winter was upon him." It is also often noted of Schubert's two song cycles based on Müller's poems, that the earlier *Die schöne Müllerin* (1823) was reflective of the late

spring during which Schubert began composing (he finished in September), while *Winterreise* was emotionally reflective of the darker winter months.

In the work, of which singer Elena Gerhardt famously said, "You have to be haunted by this cycle to be able to sing it," a brokenhearted man leaves the house of his beloved. Though the young woman's mother is keen on the couple's betrothal, the young woman's romantic interests lie elsewhere. So the man leaves in the middle of the night as he came, a stranger. He travels through the wilderness and eventually finds himself in a small village with an old hurdy-gurdy man, where he attempts to reconcile his loneliness.

Sometimes it's a deeper isolation and not just the change of seasons that can lead to a chilled inspiration. Contemporary classical composer John Luther Adams lives above the fifty-fourth parallel in Alaska's northern interior. Justin Vernon (Bon Iver) realized the emotional isolationism of Appalachia during winter on his debut album, *For Emma, Forever Ago,* after moving into his father's hunting cabin during the winter of 2006–2007; "I don't recall a lot of very concrete memories of it, because I think I was a little bit out of my head," he recalled.

When Robert Falcon Scott first lit upon the notion to enter the race to become the first man to reach the South Pole, he likely did not conceive of the numerous musical tributes that would eulogize his adventure in the years following his death during the tragic 1910 Terra Nova Expedition.

Much like other turn-of-the-century explorations, the race to the South Pole inspired a flurry of cultural artifacts, though, as other explorers began to return from distant lands, the widely held belief that the poles hid undiscovered civilizations and monsters lurking in snowdrifts was tempered. Scott's ill-fated journey, however, has proven a bleak muse for works such as Ralph Vaughan Williams's *Sinfonia Antarctica* (Symphony No. 7) and Thomas Köner's 1991 release *Nunatak Gongamur.*

Samuel Taylor Coleridge wrote about the haunting sound of ice in *Rime of the Ancient Mariner*: "The ice was here, the ice was there / The ice was all around / It cracked and growled, and roared and

howled / Like noises in a swound!" These otherworldly sounds are stretched into sheets of noise in the barbiturate crawl of Köner's work, reflective of the vast, lonely landscape of the frozen north. They're made microscopic in "brash ice" by composer Cheryl Leonard, who traveled to Antarctica to collect the sounds of a frozen world slowly thawing—aspects of her work sound like a gold-standard noise machine, while others, like a layered bed of gently cracking ice, recall IDM and glitch. She also fashioned instruments from objects such as shells, rocks, and penguin bones, meant to accompany her live performances.

The hardship of winter is contrasted with a hope for the brighter future found in warmer climates in Merle Haggard's stagflation ballad "If We Make It Through December," which serves double duty as one of the saddest holiday songs ever written.

Almost as soon as there were Christmas songs there were sad Christmas songs. Dozens of holiday-themed blues were recorded during the 1920s and 1930s. Blind Lemon Jefferson recorded his "Christmas Eve Blues," Blind Blake laid down "Lonesome Christmas Blues," and Mary Harris (a.k.a. Verdi Lee) cut no less than five holiday-themed blues songs with guitarist Charley Jordan at an October 31, 1935, recording date, including "Christmas Tree Blues," "No Christmas Blues," and "Happy New Year Blues," which finds the singer exhorting Jordan to "play it for me 'til I get young again."

The Queen of Country Music, Kitty Wells, included the amazingly miserable "Christmas Ain't Like Christmas Anymore" on her 1962 album *Christmas Day with Kitty Wells*, and Buck Owens searched for "Blue Christmas lights / Just as blue as me" on his 1965 album *Christmas with Buck Owens and His Buckaroos*.

There's a long tradition of writing songs about spending the holidays in the clink, including Leroy Carr's "Christmas in Jail (Ain't That a Pain)"—"It's mighty dark and blue behind those bars"— Victoria Spivey's "Christmas Morning Blues" (which features Lonnie Johnson on guitar and is not only a miserable holiday song but also a murder ballad), the Youngsters' "Christmas in Jail," and John Prine's "Christmas in Prison."

Bing Crosby's classic take on the Irving Berlin wartime smash "White Christmas" became a hit with homesick GIs during World War II and remains both the only single to top the charts on three separate releases and the greatest-selling single record of all time—Der Bingle moving more than 50 million units worldwide, according to the *Guinness Book of World Records*. (Crosby famously recorded the original in just eighteen minutes in May 1942, later saying that "a jackdaw with a cleft palate could have sung it successfully." The ubiquitous version most encounter now was recorded later in 1947, the original master having been damaged by overuse.) Jumping ahead to the turbulent 1960s we find the fantastic and rare 1967 track "Christmas in Vietnam" (not to be confused with Johnny & Jon's "Christmas in Viet Nam" or the Soul Searchers' "Christmas in Viet Nam"), by Private Charles Bowens, which opens with the sad strains of "Taps" before unfolding into a surprisingly tight soul dirge direct from the foxholes, Bowens digging deep to let everyone back home know "it's gonna be a dark, dark Christmas for me."

Cutting Christmas songs continues to be a respected pastime for musicians. A slew of indie-rock-themed collections were made available in the late 1990s and early 2000s, including fantastically glum tracks like Death Cab for Cutie's "Christmas (Baby Please Come Home)" and Coldplay's take on "Have Yourself a Merry Little Christmas." Low recorded a holiday seven-inch in 1997 ("If You Were Born Today [Song for Little Baby Jesus]"/"Blue Christmas") and followed it with a 1999 holiday EP that included both of those tracks and added an additional six, including a droning "Little Drummer Boy" that puts Bing and Bowie to shame. The prolific Sufjan Stevens released a Christmas boxed set composed of material he had been stockpiling over time. Besides covering classics, Stevens also added great new additions to the seasonal songbook like "That Was the Worst Christmas Ever!" and "Did I Make You Cry on Christmas Day? (Well, You Deserved It!)."

Thankfully, though, we survive the cycle of the seasons. Clouds dissipate, ice thaws, and snow melts. Playlists inevitably warm with the weather, and as the flowers bloom the hunt for the latest summer jam begins anew.

THE MISERABLE LIST: S.A.D.

1. "Der Leiermann" (*Winterreise*) — Franz Schubert (1827)
2. "At the First Fall of Snow" — Hank Williams (1955)
3. "The Blizzard" — Jim Reeves (1961)
4. "My Autumn's Done Come" — Lee Hazlewood (1966)
5. "The Coldest Days of My Life" — The Chi-Lites (1972)
6. "Winter" — The Rolling Stones (1973)
7. "Winter Time" — Steve Miller Band (1977)
8. "Sometimes It Snows in April" — Prince (1986)
9. "Winter" — Tori Amos (1992)
10. "Wisconsin" — Bon Iver (2010)

THE MISERABLE LIST: BLUE CHRISTMAS

1. "No Christmas Blues" — Mary Harris and Charley Jordan (1935)
2. "Have Yourself a Merry Little Christmas" — Judy Garland (1944)
3. "Blue Christmas" — Elvis Presley (1957)
4. "Christmas Ain't Like Christmas Anymore" — Kitty Wells (1962)
5. "Christmas Time Is Here" — Vince Guaraldi (1965)
6. "Christmas in Vietnam" — Private Charles Bowens and the Gentlemen from Tigerland (1967)
7. "River" — Joni Mitchell (1971)
8. "If We Make It Through December" — Merle Haggard (1973)
9. "2000 Miles" — The Pretenders (1983)
10. "Little Drummer Boy" — Low (1999)

MARK LANEGAN

Born November 25, 1964, Mark Lanegan came from a deeply dysfunctional home and turned to heavy drug use as a form of escapism during his teenage years. At eighteen he was arrested and sentenced

to a one-year prison term for drug-related crimes, narrowly avoiding the sentence by entering a yearlong rehabilitation program. Afterward, Lanegan befriended brothers Vann and Gary Lee Conner and began working in the Conner family store, repossessing rented appliances. Within a few years the brothers and Lanegan had formed the Screaming Trees—Lanegan started on drums, but was apparently so bad they made him the singer instead—and began performing in area clubs. Sub Pop picked up the group to release their first work, 1985's *Other Worlds* EP, the group releasing subsequent work via the Velvetone and SST labels before settling at Epic Records for 1991's *Uncle Anesthesia*. During their time at SST, Lanegan released his first solo album, 1990's barstool fairy tale *The Winding Sheet,* which featured a set of bleary dirges cowritten by Lanegan and producer Mike Johnson. *The Winding Sheet* is likely the darkest release to come from the foggy woods of the Pacific Northwest during the grunge era. Lanegan's vocal—a husky, weatherbeaten growl, part Leonard Cohen despair, part Jim Morrison swagger—is at ease throughout the album, which would set the tone for his future solo releases and featured friend and future rock savior Kurt Cobain on the songs "Down in the Dark" and a rendition of Leadbelly's "Where Did You Sleep Last Night?" The Screaming Trees reconvened for 1992's *Sweet Oblivion,* which included the alternative hit "Nearly Lost You," its success driven in part by its inclusion on the soundtrack to Cameron Crowe's grunge comedy *Singles.* After touring in support of the album, Lanegan went back into the studio to record his second solo release, 1996's *Whiskey for the Holy Ghost.* The Screaming Trees finally got their act together for 1996's *Dust,* but the flannel-buffed luster of grunge had faded and the group slowly fell apart (though they wouldn't officially announce their breakup until 2000). Lanegan stuck close to his template of constantly wrestling old habits and demons on 1998's *Scraps at Midnight,* 1999's *I'll Take Care of You,* and 2001's *Field Songs.* He became a member of Josh Homme's stoner-rock revivalism group Queens of the Stone Age following his work on their 2000 album *Rated R.* In 2003 he provided vocals on the Twilight Singers' album *Blackberry Belle,* with Greg Dulli returning the favor for a turn on Lanegan's 2004 release, *Bubblegum.* The quid pro quo resulted in

the two forming the Gutter Twins, though they wouldn't perform as such until September 2005 and wouldn't release their first album until 2008's *Saturnalia*—Lanegan's whiskey-aged growl giving deperate heft to Dulli's slick melodrama. In 2006 Lanegan appeared as the rough-edged foil to former Belle and Sebastian singer Isobel Campbell (a decidedly darker Lee Hazlewood to Campbell's Nancy Sinatra) on her third solo album, *Ballad of the Broken Seas*. The collaboration proved fruitful, and the two would work together again on 2008's *Sunday at Devil Dirt* and 2010's *Hawk*, which featured Lanegan tapping into the songbook of kindred spirit Townes Van Zandt.

LOW

Formed in Duluth, Minnesota, in 1993 by guitarist/vocalist Alan Sparhawk; his wife, drummer/vocalist Mimi Parker; and the first in a revolving cast of bass players, John Nichols—Low remains the most aristically and commercially successful of the handful of sleepy, snowdrift bands that used traditional rock instruments to make narcoleptic slowcore pop. Their first release arrived the following year, with *I Could Live in Hope*, which they followed with 1995's *Long Division*. Also in 1995, the group contributed their version of Joy Division's "Transmission" to the tribute album *A Means to an End: The Music of Joy Division*, turning Curtis and Co.'s jittery masterstroke into a slow-burn, near-pastoral memory of the original. It turned out so well that Low released the *Transmission* EP the following year. In 1996 the group also released *The Curtain Hits the Cast*, containing the gorgeous dirge "Over the Ocean" that would become a college-chart success. Producer Steve Albini, who had worked with the group on the *Transmission* EP, returned for their breakout album, 1999's *Secret Name*, which featured Parker's ethereal "Weight of Water" and the haunting duet "Missouri," in which husband and wife slowly twist the pronunciation of the Show-Me State from "Missouri" to "misery." In

2000 the band released the *Christmas* EP, reaching their biggest audience yet, thanks to their radio-static cover of "Little Drummer Boy." As genuinely fuzzy as it is, it made its way into a Gap holiday commercial. Albini was back for 2001's *Things We Lost in the Fire*, which featured pulsating murder ballad "Sunflower" and the sludge-heavy "Dinosaur Act." Also in 2001 Sparhawk and Low bassist Zak Sally released the synth-pop "Crash/We'll Be Philosophers" single as the Hospital People. Sparhawk's other projects have included the sloppy blues-punk of Black-Eyed Snakes and, more recently, the melodic stoner-rock trio Retribution Gospel Choir. Low, meanwhile, has only become more lachrymose with age—with 2002's *Trust*, 2005's *The Great Destroyer*, and 2007's album of slow-motion murder ballads, *Drums and Guns*, each proving to be made of darker stuff than the last.

THE MISERABLE LIST: LOW

1. "Words"—*I Could Live in Hope* (1994)
2. "Transmission"—*Transmission* EP (1995)
3. "Over the Ocean"—*The Curtain Hits the Cast* (1996)
4. "Weight of Water"—*Secret Name* (1999)
5. "Missouri"—*Secret Name* (1999)
6. "Dinosaur Act"—*Things We Lost in the Fire* (2000)
7. "(That's How You Sing) Amazing Grace"—*Trust* (2002)
8. "Last Snowstorm of the Year"—*Trust* (2002)
9. "Monkey"—*The Great Destroyer* (2005)
10. "Murderer"—*Drums and Guns* (2007)

THE MAGNETIC FIELDS

Named after the André Breton and Philippe Soupault surrealist novel *Les Champs Magnétiques*, the Magnetic Fields flickered to life when songwriter and ABBA fan Stephin Merritt met drummer/

indie-rock scenester Claudia Gonson at Harvard, and the two began shaping Merritt's bedroom symphonies for a live band. Now feted as "the Cole Porter of his generation" and sketched as something of a lovable curmudgeon (he's been called "the most miserable man in rock" more than once), the prolific Stephin Merritt is at the heart of the Magnetic Fields' blend of sixties Brill Building pop (Bacharach and David, Goffin and King), indie twee (Field Mice, Belle and Sebastian), eighties synth-pop (OMD, Pet Shop Boys), and the span of the Great American Songbook (Arlen to Youmans). Merritt shaped clever pop that the group recorded on cheap keyboards with clunky electro beats, resulting in an alluring confluence of naive ambition and economic reality. In 1988 a Capitol Records A&R rep offered the group $2,000 to record a demo with an option to sign if she liked what she heard. Merritt used the funds to record *The Charm of the Highway Strip*, an album informed by trains, planes, and automobiles and infused with a vague C&W influence. Merritt reluctantly sang with the hopes that singer Susan Anway could record over his downer baritone, which often sounds three winks from an afternoon nap. The A&R rep didn't like what she heard, simply saying, "I hate Johnny Cash." The Fields' next effort was their official first long player, 1989's *Distant Plastic Trees*, and though it was self-released in the US it found a home with RCA Victor in Japan and the Red Flame label in the UK. It contained the majestically dour "100,000 Fireflies," which featured the sweet, reserved vocals of Anway hovering over a forlorn toy-piano melody, as well as one of Merritt's greatest opening lines: "I have a mandolin / I play it all night long / It makes me want to kill myself." The group continued to record, releasing two singles via Harriet Records, self-releasing their second album, 1992's *The Wayward Bus* (which they doubled up with *Distant Plastic Trees*), and the "five loop songs" of *The House of Tomorrow* EP, which appeared the same year on Chicago's Feel Good All Over label. In early 1994 Merge Records released a tinkered version of *Charm of the Highway Strip*, which showed up just months before Feel Good All Over released *Holiday*. The following year Merge released *Get Lost* and rereleased *The Wayward Bus/Distant Plastic*

Trees, while Merritt got carried off by the first of many side projects when he turned around the 6ths' first album, 1995's lisp-taunting *Wasps' Nests* (*Hyacinths and Thistles* followed in 2000). Considered by many to be a weak link in the Magnetic Fields' early run, 1995's *Get Lost* is nonetheless stacked with jewel-box miserabilism, including, but not limited to, "The Desperate Things You Made Me Do," "Don't Look Away," "When You're Old and Lonely," and "All the Umbrellas in London." In 1997 Merritt delved into two new projects that would sporadically release new works: the Gothic Archies (eighties goth darkens the doorstep of sixties bubblegum) and Future Bible Heroes (Merritt and Gonson go clubbing with DJ Christopher Ewen). Then, while listening to Stephen Sondheim and writing lyrics in a Lower East Side bar, Merritt's thoughts drifted to American composer Charles Ives and his *114 Songs* collection. Merritt lit upon the idea to record a revue titled "100 Love Songs" that would explore *l'amour* in a series written without regard to genre boundaries and be performed by a series of guest vocalists. The realities of creating 100 Love Songs soon became clear, and it was whittled to the suggestive and more manageable *69 Love Songs*, a 1999 triple album that the aloof Merritt later described as "a denial of inspiration and confession and autobiography and sincerity." The collection ended up on critics' year-end lists on both sides of the Atlantic and thrust the Magnetic Fields into the spotlight. Beginning with the moody soundtrack to 2002's *Eban and Charley*, Merritt began regularly composing for film and stage, including the 2003 film *Pieces of April* and the 2009 Off-Broadway adaptation of Neil Gaiman's *Coraline*. The group jumped from Merge to Nonesuch for the follow-up to *69 Love Songs*, the conceptual *i* from 2004 (every song started with the letter "I"). *Distortion* (2008) looked to noise-pop acts like Jesus and Mary Chain to provide the sonic template, while in 2010 Merritt flipped the coin to craft what amounts to the Magnetic Fields' "unplugged" (Merritt prefers "orchestral folk") album *Realism*, which was inspired by Merritt's love of the Judy Collins albums *In My Life* (1966) and *Wildflowers* (1967). Also in 2010 Merritt's "Book of Love" (from *69 Love Songs*) became a standout track on Peter Gabriel's covers album, *Scratch My Back*.

THE MISERABLE LIST: THE MAGNETIC FIELDS

1. "100,000 Fireflies"—*Distant Plastic Trees* (1991)
2. "Lonely Highway"—*The Charm of the Highway Strip* (1994)
3. "Torn Green Velvet Eyes"—*Holiday* (1994)
4. "Don't Look Away"—*Get Lost* (1995)
5. "Either You Don't Love Me or I Don't Love You"—*The House of Tomorrow* EP (1996)
6. "I Don't Believe in the Sun"—*69 Love Songs* (1999)
7. "No One Will Ever Love You"—*69 Love Songs* (1999)
8. "Asleep and Dreaming"—*69 Love Songs* (1999)
9. "I Looked All Over Town"—*i* (2004)
10. "I'll Dream Alone"—*Distortion* (2008)

MORRISSEY

Virginia Woolf once wrote, "The beauty of the world which is so soon to perish, has two edges, one of laughter, one of anguish, cutting the heart asunder." She could have been describing the career of the "Pope of Mope," Steven Patrick Morrissey, whose renown as a gloomy crooner is underpinned by a cutting sense of humor. Born on May 25, 1959, in Manchester, England, Morrissey has talked openly about his preteen sense of isolation and of his teenage years as a bed-sit misfit in his hometown. "I was always one of those very old children," he told an interviewer in 1984. Enthralled by the underbelly of popular culture, Morrissey absorbed obscure cinema and the poetry of Oscar Wilde and New York rebel Patti Smith alongside the melodramatic girl-group sounds of the 1960s and the theatricality of glam's first wave during the 1970s. He was a regular feature on the letters pages of British weeklies *NME* and *Melody Maker* and was the president of the UK chapter of the New York Dolls fan club—his first success coming as a writer of short biographies of the Dolls and James Dean. He briefly joined guitarist Billy Duffy (later of the Cult)

in groups the Nosebleeds and Slaughter and the Dogs, where the two wrote a string of songs together. Then, on the suggestion of Duffy and others, the young John Maher (soon Johnny Marr) showed up at Morrissey's doorstep suggesting they, too, work out some songs. While Marr explored his interest in jangly, British Invasion pop, Morrissey turned the smokestack despair of their Mancunian brethren Joy Division on its ear, crafting kitchen-sink realism filled with wildly romantic gestures and untraditional pop fodder such as homosexuality and child abuse. The Smiths' miserabilism was Morrissey's creation. By the time the Smiths broke up, in 1987, shortly after Marr's decision to exit the group, they had reestablished the guitar's pop primacy, given strength to the notion of independently produced records, and created one of the most important catalogs in the history of rock. Morrissey, for his part, walked away with an open-ended question: Could the eccentric singer carry on without his musical abettor, Johnny Marr? In stepped Stephen Street, who had produced the Smiths' final album, *Strangeways, Here We Come*. Street sent Morrissey some song demos and the singer jumped at the chance to move things forward. Vini Reilly, from Duritti Column, signed on as guitarist, and with the early 1988 release of Morrissey's first solo single, "Suedehead," and album, *Viva Hate* (so named, he said, because "hate makes the world go round"), the Mozfather confirmed that his talents didn't vanish when Marr packed up his Rickenbacker. After a falling-out with Street over royalties, Morrissey moved on to work with Clive Langer ("November Spawned a Monster") and Fairground Attraction guitarist Mark Nevin ("[I'm] The End of the Family Line"), the resulting tracks forming most of what would become the 1990 compilation album *Bona Drag* and 1991's *Kill Uncle*—the former as universally praised as the latter is regularly gibed as aimless and haphazard. Unable to tour owing to other commitments, Nevin was struck in favor of two new-wave rockabilly guitarists—the Memphis Sinners' Alain Whyte and Martin "Boz" Boorer of the Polecats, who had also previously worked with Sinéad O'Connor. They would prove to be Morrissey's most long-lasting partnerships. Save two holdovers from his work with Nevin, Morrissey wrote most of 1992's *Your Arsenal* with Whyte. The album,

which was produced by former David Bowie guitarist Mick Ronson, brought Mozzer's love of rockabilly and glam to the fore, resulting in the singer's heaviest and most enduring albums. His first collaborations with Boorer, for 1994's *Vauxhall and I*, proved incredibly fruitful, the two banging out the magnificent "Now My Heart Is Full" and "The More You Ignore Me, the Closer I Get," and brought about Morrissey's return to the UK top ten. They proved to be Morrissey's break in the States as well, inching into the top fifty. *Vauxhall and I* would in some ways also prove to be the last big hurrah for the singer. He was sidelined during the remainder of the nineties by the frothy Brit-pop revival (Suede, Blur, Oasis, Pulp), and by a midlife crisis that included losing a public court battle against Mike Joyce over the Smiths' performance royalties. The judge verbally slapped the peculiar singer, calling him "devious, truculent, and unreliable." It didn't help that 1995's *Southpaw Grammar* was a difficult and severe album that referenced outsized seventies prog and opened with the eleven-minute dirge "The Teachers Are Afraid of the Pupils." (The song lifted its theme from Shostakovich's Fifth Symphony and also happened to be the best song on the album.) Although 1997's *Maladjusted* featured perfect pop like "Alma Matters" and lofty tracks like "Ambitious Outsiders," it failed to find much of an audience, and Morrissey remained in the shadows. Taking the hint, he largely dropped out—minus a couple of tours—relocating to Los Angeles. When the singer finally did make his grand return with 2004's *You Are the Quarry*, he was welcomed back with open arms. The album's best tracks ("Irish Blood, English Heart," "First of the Gang to Die") blinded with a glaring pop shine via producer Jerry Finn, who had made his name producing acts like Green Day, Blink-182, and Sum 41. The headline for 2006's *Ringleader of the Tormentors* was that Morrissey, always cagey about his personal life and, in particular, aspects of his sexuality—he has publicly existed on a sexual continuum somewhere between asexual and bisexual—had found love, singing about it in as frank a manner as ever on "Dear God, Please Help Me." In 2007 he had a public scuffle with *NME* after a writer for the music weekly accused the singer of racism following

his comments on immigration and the disappearing British identity. Racism is a thorny issue that has dogged the singer throughout his career, from his music ("Bengali in Platforms," "National Front Disco") to comments like his rebuke of the Chinese as a "subspecies" in a 2010 *Guardian* interview. (For his part, Morrissey denies all such accusations, chalking every instance up to misunderstanding or out-of-context conclusions, and has performed at benefit concerts such as Artists Against Apartheid.) The singer continued his third-act revival with 2009's *Years of Refusal*, which was again produced by Finn—who tragically died of a brain hemorrhage in 2008 before the album's release. A few years previous to the breakup of the Smiths, an interviewer asked Morrissey what he thought would become of him should the band ever split. The singer replied, "Misery, despair. I'll probably end up in a room somewhere, bearded and with a beer belly, surrounded by books and a cat." His reputation would have been secured had he never sung a note following the dissolution of the Smiths, and while his solo career has never hit the bewildering and brilliant heights of his collaborations with Marr, he has continuously and faithfully added bleak chapters to an already transcendent songbook.

THE MISERABLE LIST: MORRISSEY

1. "Everyday Is Like Sunday"—*Viva Hate* (1988)
2. "Will Never Marry"—B-side, *Everyday Is Like Sunday* (1988)
3. "Late Night, Maudlin Street"—*Viva Hate* (1988)
4. "Yes, I Am Blind"—B-side, *Ouija Board, Ouija Board* (1989)
5. "November Spawned a Monster"—Single (1990)
6. "(I'm) The End of the Family Line"—*Kill Uncle* (1991)
7. "I Am Hated for Loving"—*Vauxhall and I* (1994)
8. "Trouble Loves Me"—*Maladjusted* (1997)
9. "Come Back to Camden"—*You Are the Quarry* (2003)
10. "You Were Good in Your Time"—*Years of Refusal* (2009)

THE NATIONAL

Fusing the dark dramatics of England's gloom-rock royalty (Joy Division, Echo and the Bunnymen, et al.), the blue-collar roots rock of Bruce Springsteen and Wilco, and the measured miserabilism of slowcore acts like Red House Painters, the National became one of the most popular rock acts of the new millennium. Though all the members of the group have roots in Cincinnati, Ohio (performing in local groups Nancy and Project Nim), they didn't come together as the National until 1999, after they had all relocated to Brooklyn, New York. Composed of two sets of brothers—Aaron and Bryce Dessner on bass and guitar (respectively) and Scott and Bryan Devendorf on guitar and drums (respectively)—the final piece of the puzzle came in the form of tall, lanky, and literate mope Matt Berninger, with his dense, slurring baritone and bruised New York stories of drinking, fucking, and wallowing (sometimes all three at once). The group's 2001 self-titled debut was released on the Dessners' own Brassland label and was welcomed with the kind of acclaim that would regularly wash over the group with subsequent releases. *Sad Songs for Dirty Lovers* was released in 2003 (also on Brassland) and named album of the year by *Uncut* and the *Chicago Tribune*, while 2004's *Cherry Tree* EP marked their Brassland finale, the band afterward jumping to Beggars Banquet for the release of their breakout record that ruled year-end lists on both sides of the Atlantic. *Alligator* (2005) represented a maturation of both their restrained garage sound and Berninger's downer aesthetic, with songs like "Karen" ("I've lost direction and I'm past my peak"), "Baby, We'll Be Fine" ("I'm so sorry for everything"), and "All the Wine" dominating. Awash in political discontent for the Bush era, as well as the minutiae of social intercourse, 2008's *Boxer* again met with zealous praise; its centerpiece, "Fake Empire," becoming an indie anthem for the Obama 2008 candidacy. Also that year the group also released both the documentary *A Skin, A Night*, which followed the band through the making of *Boxer*, and *The Virginia* EP, a brief rarities collection. The woozy *High Violet* debuted at number three in its first week, which also happened to be the weakest seven-day

period for album sales since 1991. An atmospheric album wet with misery, *High Violet* opens with a procession of downcast, smouldering songs ("Terrible Love," "Sorrow," "Anyone's Ghost," and "Little Faith") before sparking to life with "Afraid of Everyone" and the album's slumped backbone, "Bloodbuzz, Ohio," which featured the "it" chorus for the economic collapse: "I still owe money to the money to the money I owe."

THE MISERABLE LIST: THE NATIONAL

1. "Theory of the Crows"—*The National* (2001)
2. "Cardinal Song"—*Sad Songs for Dirty Lovers* (2003)
3. "Wasp Nest"—*Cherry Tree* EP (2004)
4. "Karen"—*Alligator* (2005)
5. "Baby, We'll Be Fine"—*Alligator* (2005)
6. "Mistaken for Strangers"—*Boxer* (2007)
7. "Racing Like a Pro"—*Boxer* (2007)
8. "Anyone's Ghost"—*High Violet* (2010)
9. "Bloodbuzz, Ohio"—*High Violet* (2010)

MICKEY NEWBURY

Better known as a songwriter than a performer—John Prine said he was "probably the best songwriter ever"—Mickey Newbury's work was draped in the same darkness as that of his friend and contemporary Townes Van Zandt. Best known for having penned the psychedelic fuzz-country hit "Just Dropped In (To See What Condition My Condition Was In)," Newbury helped to revolutionize country music in the sixties and seventies with his emotionally taut confessional songs, even as success as a performer eluded him. Mickey Newbury was born Milton J. Newbury on May 19, 1940, in Houston, Texas. Like Leonard Cohen, Newbury was initially drawn to poetry before he began marrying his words to music and

performing on the coffeehouse folk circuit. He sang briefly for the Embers, and hung out in Houston's black blues clubs, where Clarence "Gatemouth" Brown dubbed him the Little White Wolf. After a stint in the Air Force he returned to music, and by 1963 he landed a job penning tunes for Acuff-Rose. His new gig required a move from Houston to Nashville—a cultural hotbed during the early sixties—where the young singer/songwriter found himself befriending brothers in arms Kris Kristofferson and Townes Van Zandt, among others. In an empirical nod to Newbury's unconventional mix of styles, the singer soon had four songs in four different charts at once: Andy Williams's take on "Sweet Memories" sat atop the Easy Listening chart; "Time Is a Thief," by Solomon Burke, was an R&B number one; "Here Comes the Rain, Baby," by Eddy Arnold, ruled the country chart; and "Just Dropped In (To See What Condition My Condition Was In)," by Kenny Rogers and the First Edition, was a pop hit. Signing to RCA, Newbury made his first recording under his own name, 1968's *Harlequin Melodies,* which was given the full Nashville treatment—his songs dressed with everything *and* the kitchen sink. The singer/songwriter later dismissed it, even though it holds up well and contains a rare Townes Van Zandt cowriting credit on the mournful "Mister Can't You See." Newbury immediately fought to be released from his RCA contract and began working outside the Nashville studio system, recording with engineer Wayne Moss in a shoebox-sized four-track studio housed in a converted garage. The first record to spring from this minimalist arrangement was 1969's masterful *Looks Like Rain,* which features the spectacularly melancholic "She Even Woke Me Up to Say Goodbye" and the epic folk dirge "San Francisco Mabel Joy." The album didn't get the promotion Newbury had hoped for and, feeling underappreciated, he soon jumped ship again for Elektra, a songwriters' haven during the sixties and seventies and home to artists such as David Ackles, David Blue, and Joni Mitchell. His first Elektra album, 1971's *'Frisco Mabel Joy,* debuted his only hit (it peaked at twenty-seven), "An American Trilogy," a Coplandesque suite that merged "Dixie," "Battle Hymn of the Republic," and the lullaby/spiritual "All My Trials." Elvis Presley would go on to make the song a staple of his Vegas concerts,

although its celebration of the Jim Crow–era "Dixie" made it a constant target by those who believed the song held racist sentiments, a falsehood that continually troubled Newbury. Most of his 1970s output, beginning with 'Frisco Mabel Joy and ending with 1979's *The Sailor*, was remarkably consistent in both quality and its ineffable shadow of sadness. Newbury continued to record during the 1980s, but slowly became more and more reclusive, giving up touring, with the exception of intermittent "house" concerts. He started the decade with an induction into the Nashville Songwriters Hall of Fame, and would release two less than stellar albums in the ensuing ten years. Yet, beginning with 1994's *Nights When I Am Sane*, a live acoustic album, he gathered himself for a late-career blossoming that included 2000's *Lulled by the Moonlight* and *Stories from the Silver Moon Cafe*. The final studio recording released during his lifetime—and among the best of the bunch—is 2002's conceptual *A Long Road Home*, which captures an artist struggling in a different sense. Newbury was receiving full-time oxygen treatments for his emphysema during the recording, leaving his vocal cracked and winded, infusing the songs with a weathered grace. In a 2000 online interview Newbury, plainspoken as ever, said, "I will continue to write songs, I suppose, until my last breath." And that's exactly what he did. Mickey Newbury died on September 29, 2002, at the age of sixty-two after a prolonged battle with pulmonary fibrosis. In an interview shortly before his death he wondered aloud, "How many people have listened to my songs and thought, 'He must have a bottle of whiskey in one hand and a pistol in the other'? Well, I don't. I write my sadness."

THE MISERABLE LIST: MICKEY NEWBURY

1. "Here Comes the Rain, Baby"—*Harlequin Memories* (1968)
2. "She Even Woke Me Up to Say Goodbye"—*Looks Like Rain* (1970)
3. "San Francisco Mabel Joy"—*Looks Like Rain* (1970)
4. "'Frisco Depot"—'*Frisco Mabel Joy* (1971)

5. "When Do We Stop Starting Over"—*Lovers* (1975)

6. "Makes Me Wonder If I Ever Said Goodbye"—*Rusty Tracks* (1977)

7. "Just Dropped In (To See What Condition My Condition Is In)/Wish I Was a Willow Tree (Medley)"—*Triad Studio Sessions* (1991/ Unreleased)

8. "Four Ladies"—*Nights When I Am Sane* (1994)

9. "What Will I Do"—*Nights When I Am Sane* (1994)

10. "So Sad"—*A Long Road Home* (2002)

NICO

Born Christa Päffgen, on October 16, 1938, in Cologne, Germany, Nico (a nickname given to her by photographer Herbert Tobias) left school at thirteen to pursue modeling, quickly jumping from print to television to film, landing a bit part in Federico Fellini's 1960 classic *La Dolce Vita*. She moved to New York to work with renowned acting coach Lee Strasberg, and in 1962 gave birth to a son, Christian Aaron "Ari" Päffgen. (Though famous French heartthrob Alain Delon was always believed to be the father—Delon's mother and her husband adopted the child—Delon always denied paternity.) Nico starred in the 1963 film *Strip-Tease*, recording its title song (written by French gadabout Serge Gainsbourg), and in 1965 she was spotted by Rolling Stones manager Andrew Loog Oldham, who took her into the studio to record her debut single, a cover of Gordon Lightfoot's "I'm Not Sayin'." The single, including a song cowritten by Jimmy Page ("The Last Mile") on the B-side and featuring both Page and mythic Stone Brian Jones on guitar, flopped (although in 2009, Morrissey identified the recording as one of his "desert island" discs). Enter Andy Warhol, who placed the model/singer with a seedy group of musicians calling themselves the Velvet Underground and produced their monumental debut, 1967's *The Velvet Underground and Nico*. Her deadened, cold-comfort enunciations blanket the Velvet's hypnotic drone in "Femme Fatale," "I'll Be Your Mirror," and

"All Tomorrow's Parties," one of the most mysteriously bewitching moments in the history of rock. She quickly set to work pursuing her own career, releasing *Chelsea Girl* later that same year. Though it featured a strong set of songs contributed by John Cale, Lou Reed, Sterling Morrison, and Jackson Browne, the album was dismissed by Nico due to the arrangements added by producer Tom Wilson; she boiled down blame for lackluster performance to one thing: "the flute." Drawing on European folk traditions, Gregorian chant, and the drone experiments of La Monte Young and the Dream Syndicate (which included Nico's lover, confidant, and producer, John Cale), with lyrics written under the sway of the Doors' Jim Morrison, 1969's *The Marble Index* is a minimal and oppressively grim statement that has since become a major goth touchstone. Reflecting on its haunting countenance nearly a decade after its release, Lester Bangs wrote, "*The Marble Index* scares the shit out of me." As if Nico's emotionally cool vocal wasn't distancing enough, she had taken to playing the harmonium, and every track was drenched with the instrument's droning, wheezing tones. By 1970's *Desertshore* she had become a more adept composer and a more agile harmonium player—Cale's production and arrangements didn't hurt, either—and tracks like "The Falconer" and "My Only Child" glisten with a forbidding beauty. Her output darkened for 1974's *The End*, an album informed by her relationship with Morrison, who died mysteriously on July 3, 1971. There are two standout cuts on the album: Nico's own version of the Doors' classic "The End," which she infuses with a blackness that flows into the ears like a slow-motion poison, and "You Forgot to Answer," which relates Nico's last memories of seeing Morrison alive—in a cab, the morning that he died—and the intense misery she felt when she realized that he didn't answer her phone call later that day because he had died in his hotel bathtub ("The high tide is taking everything / And you forgot to answer"). Again produced by Cale, the album also featured Brian Eno on synthesizers, and is the last complete listening experience required of Nico's work, as she had already begun the downward spiral into a world of addiction and paranoia, spending much of the late 1970s in hiding, convinced that the Black Panthers had a contract out on her life. She wouldn't

206 :(THIS WILL END IN TEARS

record again until 1981's *Drama in Exile*, which featured a mixture of rock and Middle Eastern influences. Cale produced her final studio album, 1985's *Camera Obscura*, her voice noticeably deeper and obviously abused. Throughout the eighties a handful of her concerts were recorded, including her final concert from June 6, 1988, released as *Fata Morgana*. The best of these live releases is *Heroine*, which was recorded on an unidentified date with an unknown backing band, but features the sort of stark, minimalist setting that allows her weathered voice to shine. On July 18, 1988, while vacationing in Ibiza, Spain, with her son, Nico suffered a minor heart attack while riding a bicycle, striking her head as she fell. She was wrongly diagnosed as suffering from heat exposure and died that same evening; postmortem X-rays revealing that the trauma to her head had caused a severe cerebral hemorrhage. She was buried in Grunewald Forest Cemetery, in Berlin, and a handful of friends played a recording of "Mütterlein," from *Desertshore*, at her funeral.

THE MISERABLE LIST: NICO

1. "I'm Not Sayin'"—Single (1965)
2. "All Tomorrow's Parties"—*The Velvet Underground and Nico* (1967)
3. "Chelsea Girls"—*Chelsea Girl* (1967)
4. "Frozen Warnings"—*The Marble Index* (1969)
5. "My Only Child"—*Desertshore* (1970)
6. "All That Is My Own"—*Desertshore* (1970)
7. "You Forgot to Answer"—*The End* (1974)
8. "The End"—*The End* (1974)
9. "My Funny Valentine"—*Camera Obscura* (1985)
10. "My Heart Is Empty"—*Nico in Tokyo* (1986)

Decay, Disintergration, Disease

The common usage of *decay*—to define the slow disintegration of just about anything material or corporeal—has a slippery connection to the history of music.

You can hear it in the dusty, weathered voices on late recordings by Johnny Cash or Bettye LaVette or the prematurely battered vocals of Billie Holiday or Marianne Faithfull; its presence is overwhelming in the work of some of the twenty-first century's most important sound artists like William Basinski, the Caretaker, and Yasunao Tone. The strings, amplifiers, wax cylinders, magnetic tape, disc players, and iPods that inevitably wear down or break, and the body's own susceptibility to disease and gradual degradation, often provide the spark of innovation along the way: Creative evolution springs from obsolescence and soft destruction. Author Henry Miller once explained, "I have always looked upon decay as being just as wonderful and rich an expression of life as growth," a sentiment at the worn heart of two important innovations in twentieth-century music: fuzz guitar and vinyl scratching.

Willie Kizart, the guitarist for Ike Turner's Kings of Rhythm, may not be a household name to most music lovers, but the guitarist's performance on 1951's "Rocket 88"—a song Sam Phillips, among

others, have called the very first rock recording—is a critical moment in modern music history. En route to a recording session at Phillips's Sun Studios, Kizart's amplifier was serendipitously hobbled by a burst speaker cone when it fell from the roof of the group's van onto Highway 61. In an attempt to repair the cone, Phillips stuffed the amp with newspaper and, after experimenting with the amp's deeper, fuzzlike tone, decided to run with it, arguably giving birth to both rock 'n' roll and guitar distortion at the same moment.

In the 1950s poets Ian Sommerville and William S. Burroughs experimented with what they referred to as "inching" tape, which Burroughs described in his own grammatically inventive manner as a sound "produced by taking a recorded text for best results a text spoken in a loud clear voice and rubbing the tape back and forth across the head." More than two decades later Grand Wizard Theodore began experimenting with the same disruptive sounds, using records rather than tape, integrating the sharp bursts of noise into rhythms, and turning the "inching" of tape into "scratching," which would soon after become the distressed technology critical to the evolution of hip-hop. Even though in recent years scratching has taken a backseat to the digital wizardry of complex beat production, its import to the form is undeniable.

In music theory "decay" is a relatively simple idea indicating the slope between the highest point of a note or tone's initial "attack" and the moment it hits a level of "sustain." Yet decay, by definition, also stands for decomposition, ruination, and declining strength, size, quality, or condition. As an implement in a composer's toolbox, decay in this strict sense is rarely referenced, even as technology makes its use now nearly unavoidable.

In William Styron's letter from the depths of depression, *Darkness Visible*, he recalls hearing the voice of a friend who had fallen into a long period of despair:

> I remembered that his hands trembled and, though he could hardly be called superannuated—he was in his mid-sixties—his voice had the wheezy sound of very old age that I now realized was, or could be, the voice of depression; in the vortex of my severest pain I had begun to develop that ancient voice myself.

This "ancient voice" that Styron succumbs to, that seems to radiate depression (or at least underline the condition in wavy black ink), found its way into popular music early on, and singers such as Leonard Cohen, Kris Kristofferson, Tindersticks' Stuart Staples, and the National's Matt Berninger have built careers in part on this low, mumbling, weary voicing.

The human singing voice is created by a complex group of systems, and aging affects nearly every aspect of this chain. The lungs, which push the air needed to vibrate the vocal folds (a.k.a. the vocal cords), lose their elasticity and precise control over their intake, meaning output is compromised. The vocal folds dry out, atrophy, and lose bulk, as other muscles do; the flexible tissues that are responsible for vibrato during voicing become thinner and stiffen; and the cartilage frame of the larynx gradually ossifies (turns to bone), all of which can result in reduced range, a "wide" vibrato, a dry or gruff sound, and a loss of projection. It remains a medical mystery why some people retain a youthful and resonant speaking voice well into their eighties while others begin to sound old as early as their fifties, though genetics seems to play a key role.

Billie Holiday was perhaps the first truly popular recording artist to take full advantage of a deeply distressed tone in her voice. Her final release, 1958's *Lady in Satin*, is a contentious recording among her fans, partly due to the cloying string arrangements that blanket the album, and partly because Holiday's voice is anemic, hollow, a slight illusion of what it once was. Hearing her sing on these final recordings, it's hard to believe she was only forty-four years old when she died. Since that time, a voice chiseled into such compromises has become something certain singers desire. The earliest records of Tom Waits's career—1973's *Closing Time* and 1974's *The Heart of Saturday Night*—showcase a bluesy singer/songwriter with a boozy, adenoidal, but easygoing voice. It wasn't until 1975's *Nighthawks at the Diner* that he began dramatically pushing his vocal cords to their breaking point—it's rumored that he used to scream into a pillow until his voice gave out—to achieve the smoke-damaged growl that has personified the iconoclastic singer ever since (and added a wounded gravitas to his numerous ballads). In fact, his rusted-through croon

so exemplifies him that he has had to sue on multiple occasions to stop advertisers from using Waits soundalikes (a notion that should bring to mind Harley-Davidson's attempt to trademark the growling exhaust sound of its crankpin V-Twin engine). But where Waits mapped out his own disintegration, Marianne Faithfull came upon it accidentally. Faithfull became a star during the mid-sixties as a wide-eyed waif with a clear, seductive voice, but before the singer reached her thirties she had deeply damaged her instrument through extreme drug use, alcohol, cigarettes, and stress. Like the Velveteen Rabbit, who learned that "by the time you are Real, most of your hair has been loved off, and your eyes drop out and you get loose in the joints and very shabby," Faithfull says she considered her new voice a relief, claiming that her pure, youthful, classically trained voice simply "didn't say anything."

The final act in Johnny Cash's long career pivoted on his deep, weathered voice. For the first *American Recordings* sessions, producer/guru Rick Rubin and Cash chose troubled material including Danzig's "Thirteen," Leonard Cohen's "Bird on a Wire," Tom Waits's "Down There by the Train," and Nick Lowe's "The Beast in Me" and recorded them with the same stark simplicity that Bruce Springsteen used to record his bleak American masterpiece, *Nebraska*. Rubin filled the singer's Tennessee cabin with recording equipment and captured Cash in his element: just the man, his gravelly voice, and his plaintive guitar. The restrained recordings give room to the earthiness of his degraded, weakened vocals.

But many composers and musicians have overcome far greater disabilities. Even a short list contains a staggering amount of musical genius: Beethoven began going deaf in his mid-twenties; Blind Lemon Jefferson, Blind Willie McTell, Ray Charles, and Stevie Wonder were all either born blind or lost their sight early in life; and contemporary drummer Evelyn Glennie—who has been profoundly deaf since the age of twelve—performs barefoot to better feel the vibrations from her drums. (Glennie wrote a brief essay to describe her condition and its effect on her music in which she states, "My hearing is something that bothers other people far more than it bothers me.")

Czech composer Bedřich Smetana completed his autobiographical

String Quartet No. 1 (titled "From My Life") in 1876, after he had suddenly gone deaf, a transformation dramatically caught in his musical reminiscence. After recalling his youth and love for his wife and the arts, the fourth movement begins as a representation of the professional recognition the composer attained for his nationalistic music and the joy that welled up within him following his success. But as the music pulses forward, vivace (lively), the unsuspecting listener is caught off guard by a swift gathering of black clouds through which pierces one lone and extended high E—representing the fateful ringing in the ears that preceded the composer's shocking hearing loss—his joy, he said, "checked by the catastrophe of the onset of . . . deafness, the outlook into the sad future . . ."

And with the knowledge that our health can be stolen at any moment, it's little surprise that disease has become a thematic element in the history of song.

Tuberculosis inspired songs such as "TB Blues" and "Whippin' That Old TB" (both recorded by Jimmie Rodgers), and Van Morrison's "T.B. Sheets" (also recorded wonderfully by John Lee Hooker with Morrison's aid), and it served as the cause of death for both Mimì in Puccini's *La Bohème* and Violetta in Verdi's *La Traviata*. The influenza pandemic of 1918–1919, which killed more people than World War I (estimates range from 30 to 50 million people died worldwide), interestingly resulted in very few songs beyond a half-baked children's rhyme ("I had a little bird and its name was Enza / I opened the window and in-flew-Enza"), the "The Influenza Blues" and "The I-N-F-L-U-E-N-Z-A Blues," alongside forgotten music-hall songs—one of which contained sneezes in the score.

Perhaps the most widely known song believed to be based on disease has nothing to do with disease at all. "Ring Around the Rosie" is often thought to have been written during one of the two major European outbreaks of the Black Plague (1347 or 1665), yet evidence suggests it was written much later and has nothing to do with any disease, let alone the plague. For a truly great Black Plague listening experience, dig up Eric Burdon and the Animals' protogoth "The Black Plague," a spoken-word concoction that creeps along to the tolling of bells and grim chant, and features lines like "The

bodies of unfortunates bloat in the hot sun outside the castle walls."

Music's enduring connection to sex resulted in a greater number of venereal-disease tunes, many of which sprang up in the 1920s and 1930s as reworkings of the influential ballad "The Unfortunate Rake," including "Bad Girl's Lament," "Pills of White Mercury," and the British barracks favorite "Young Trooper Cut Down in His Prime." (A young Bowie could have written the line "Flash-girls of the city have quite ruined me.") Evidence also links "The Unfortunate Rake" to "St. James Infirmary" and "The Cowboy's Lament." Bob Dylan even recorded a handful of VD songs that originated in the Woody Guthrie songbook, including "VD Blues," "VD Gunner's Blues," "VD City," and "VD Waltz."

When AIDS began to spread during the early to mid-1980s, taking the spotlight with the deaths of actor Rock Hudson, British politician (and son of the former prime minister) Nicholas Eden, and Queen singer Freddie Mercury, the music world took note and organized awareness and fund-raising events, such as the Freddie Mercury Tribute Concert in 1992. In the years that followed, many artists penned heartfelt material about the toll of the disease, including Elton John ("The Last Song"), Sarah McLachlan ("Hold On"), Mark Eitzel ("Blue and Grey Shirt"), Lou Reed ("Halloween Parade"), and Bruce Springsteen ("Streets of Philadelphia").

Though heart disease remains the biggest killer in developed nations, cancer's unkind progress seems to have more fiercely gripped the imaginations of songwriters. Writing for *Slate* in May 2007, Ron Rosenbaum dubbed a number of country songs that appeared in the mid-2000s "cancer country" and asked if the genre's "relentless effort to make you weep at all costs" had finally gone too far, naming Tim McGraw's "Live Like You Were Dying" (2004), Rascal Flatts' "Skin (Sarabeth)" (2004), and Craig Morgan's "Tough" (2007), all of which were hits as evidence. But country wasn't the only genre to tackle the mystery and pain of cancer at that time, as evidenced by Sufjan Stevens's "Casimir Pulaski Day" (about a young woman dying of bone cancer, from 2005's *Illinois*), My Chemical Romance's "Cancer" (from their 2007 album *The Black Parade*), and a number of songs written by Mark Oliver Everett, of Eels, following the death

of his mother from lung cancer. Written and recorded as his body suc-cumbed to mesothelioma, it's impossible to listen to Warren Zevon's final, subtle heartbreaking message, "Keep Me in Your Heart," without being moved: "Sometimes when you're doing simple things around the house / Maybe you'll think of me and smile."

Mental health—beyond the looming specter of depression—has also played a part in music history via drug-damaged souls, such as Pink Floyd's Syd Barrett and the Beach Boys' Brian Wilson, and suf-ferers of schizophrenia and other mental ailments, such as pioneering producer Joe Meek (who eventually shot his landlady and himself), Moby Grape's Skip Spence, and Wesley Willis (who famously greeted his fans with a loving head butt).

It's long been recognized that Alzheimer's sufferers can often rec-ognize and sing songs long after they've lost touch with names and faces. More recent evidence suggests that music may even aid in the creation of new memories. Alzheimer's is just one of the diseases of memory at the conceptual center of much of James Leyland Kirby's dark ambient work. Recording both under his own name and as the Caretaker, Kirby has explored the phenomenon of recall on mul-tiple releases, particularly the 2008 album *Persistent Repetition of Phrases*, which features songs built on the themes of Alzheimer's, lacunar amnesia (when the memory erases a specific event), and past-life regression, among other vagaries of memory. The grief-shedding Chocolate Genius song "My Mom" tackles the disorienting decay of recall that Alzheimer's entails, and does so with a mixture of patient understanding and stoic heartache: "Five times exactly / No more or no less / She says, 'How you been eating boy?' / I say, 'Okay, I guess.'"

Whereas diseases such as Alzheimer's may be largely neglected in the history of music, it would be hard to limit yourself when calling out classic miserable material about drug and alcohol abuse. They don't say sex, drugs, and rock 'n' roll for nothing: Velvet Underground's "Heroin," John Prine's "Sam Stone," Pink Floyd's "Comfortably Numb," Neil Young's "Needle and the Damage Done," Townes Van Zandt's "Kathleen," the Replacements' "Here Comes a Regular," Nine Inch Nails' "Hurt," Elliott Smith's "King's Crossing," and on ad infinitum. One noticeable commonality in these songs is the close

personal connection to the material of the musicians who composed and performed them. After all, "write what you know" is the first advice writers receive, and none of these artists ever had cholera.

Any addiction—video games, shopping, smoking—can have deleterious effects on the abuser, but drugs and alcohol are particularly pernicious in both their chemical command over users and the way they speed the breakdown of the body and mind. As just one example, heroin has had a persistent grasp on the imagination of artists for decades, from Billie Holiday, Charlie Parker, and Miles Davis during the height of jazz in America to the "heroin chic"—wiry limbs, sharp bones, dark-rimmed eyes, and a distant, hollow gaze—that dominated fashion during the 1990s. Heroin colored the passings of Tim Buckley, Kurt Cobain, Janis Joplin, Frankie Lymon, Layne Staley (Alice in Chains), Sid Vicious, and Andrew Wood (Mother Love Bone), among many others. Alcohol, cocaine, codeine, morphine . . . they've all played their part in stealing away artists before their time.

Spiritualized's "Death Take Your Fiddle" is unique in that it both thematically addresses the tight grip of addiction and unfolds over the distressing sound of a methodically gasping respirator, suggesting a medical death as well as a spiritual one. Matmos's 2001 release, *A Chance to Cut Is a Chance to Cure,* was built using the sounds of surgeries and medical instruments, tweaking them into one of the most fascinating electronic releases of the decade. Though much of the surgery is more aesthetic in nature than disturbingly bleak or necessary ("California Rhinoplasty" is composed of sounds from a nose job, for example), the album still has its dark side in theory, if not in application: There's a hint of cruelty in using an audiologist's tests for deaf children to create a driving dance-floor thumper, and "Memento Mori" was built using the human skull as a percussive instrument.

Written in 1725 by Marin Marais, one of the earliest composers of program music (music conceived to convey a narrative), "Tableau de l'Opération de la Taille" (also known as "Tableau of a Lithotomy" or "The Gallbladder Operation") is a little-known piece for viola da gamba, harpsichord, and voice. This curious piece of music can be found in a handful of places, but the most curious is likely an old

gatefold single from the 1960s created by the pharmaceutical company Norgine. Side one is a sleepy sales representative's pitch to doctors about Norgine's laxative products ("Can we begin by talking about constipation?"), while side two features Marais's composition with the original French text translated into English:

> Aspect of the surgical apparatus
> The patient quails as he beholds it
> He mounts the operating scaffold
> Seized with panic he thinks of fleeing
> He reconsidereth
> He is bound with cords of silk
> The surgeon maketh his incision
> The forceps is introduced
> Hereupon the stone is brought forth
> Here, as it were, the voice faileth
> The blood, it floweth
> The surgeon unloosens the silken cords
> And now though art put to bed
> Relief and rejoicing

Another translation of "Here, as it were, the voice faileth" is "He screams," but it's not likely that the fine folks at Norgine wanted to share such a horrific surgical script with their doctor-consumers.

Thankfully the tools of the surgical arts have progressed since the days of Marais's musical journalism, something that can also be said for the tools of music production. Yet these tools aren't built to last, and their inevitable breakdown often proves not to be an ending but rather another kind of beginning.

In *Wire* magazine, Rob Young wrote that "the glitch is only conceivable in a world where music has become partly or wholly mechanized." In other words, the technological act of recording resulted in the kind of vulnerable objects necessary for "cracked" soundworks to spring into existence. Wax that melts, tape that decays, and discs that scratch are all critical pieces in the history of cracked media or "glitchworks." An early example would be Frippertronics, used in

numerous recordings by King Crimson guitarist Robert Fripp in the late 1960s. Frippertronics is the fanciful term for a tape-delay system created by stringing tape between two reel-to-reel machines. What is recorded on the first machine is played moments later through the second. This can also be treated as a degenerative delay if the initial signal is mixed into the inputs of the first machine, creating, over time, a decaying loop that slowly disintegrates into a haze of feedback. A more recent example of cracked media can be heard in Yasunao Tone's "de-controlling" of CD-player playback devices to create "skips" (random sound fragments)—an approach that modern error-correction technology has stilted. The best example is the work of William Basinski, particularly his mournful "Disintegration Loops" series, which is based on the decomposition of tape loops first made by the composer in the 1980s—as the decaying tapes flake away, a slowly evaporating new piece of music is captured in the destruction.

From Herodotus and Ponce de León to hair dye and facelifts, the dream of eternal youth clouds our minds while the inevitable decay of our corporeal selves remind us of the brevity of life. Just as our own parts slowly wear down, cones burst, and tape slowly disintegrates, musicians have adapted to these changes, folding the rough edges of experience and the facts of obsolescence into their art, often to cheerless effect.

THE MISERABLE LIST: DISINTEGRATION

1. String Quartet No. 1—Bedřich Smetana (1876)
2. *Quartet for the End of Time*—Olivier Messiaen (1941)
3. "The End of a Love Affair"—Billie Holiday (1958)
4. "Midnight in a Perfect World"—DJ Shadow (1996)
5. "Love Will Tear Us Apart"—Disc (1998)
6. "Lady in Red"—Chris De Burgh remix by V/Vm (2000)
7. "d|p 1.1"—William Basinski (2002)
8. "Hurt"—Johnny Cash (2002)
9. "Chimeras"—Tim Hecker (2006)
10. "Nadelwald"—Hauschka (2008)

THE MISERABLE LIST: DISEASE

1. "The Gallbladder Operation"—Marin Marais (1725)
2. "The Black Plague"—Eric Burdon and the Animals (1967)
3. "The Needle and the Damage Done"—Neil Young (1972)
4. "T.B. Sheets"—John Lee Hooker (1972)
5. "Streets of Philadelphia"—Bruce Springsteen (1993)
6. "My Mom"—Chocolate Genius (1998)
7. "Keep Me in Your Heart"—Warren Zevon (2003)
8. "Skin"—Rascal Flatts (2004)
9. "Casimir Pulaski Day"—Sufjan Stevens (2005)
10. "Lacunar Amnesia"—The Caretaker (2008)

SONG ESSAY: "D|P 1.1"

Beginning in 1978, the young composer William Basinski, inspired by the ambient works of Steve Reich and Brain Eno, began experimenting with reel-to-reel tape, and in 1982, he crafted a series of lean, elegiac, and pastoral loops, which were eventually boxed up and stored away for nearly twenty years.

In 2001 he sought to transfer the original recordings from the analog reel-to-reel tapes onto a digital hard disk. This is where it all falls apart, or comes together, or, more accurately, both. Basinski pulled a tape from his old collection of loops and began the process of transferring the tape to a new digital source as he wandered off to make some coffee. When he returned to the tape he noticed that the glue had lost its integrity and the iron oxide on the tape had turned brittle over time, sloughing from the plastic beneath, each new bare pinhole leaving a silence. The composer recalled the moment for the online magazine *FACT* in 2009, saying, "I was incredibly moved by the whole redemptive quality of what I'd just experienced." He composed a new French horn countermelody, and the disintegration loops were born.

"d|p 1.1" is a warm cycle of droning underwater brass and cheap, springy electronic thwacks. Over time, as the longer melodic passages

decompose, they become more percussive, like the distant cracking of cannon fire, while an unnoticed drone of electrical hum becomes more evident as it works its way toward a final silence. Though it is built on a brief loop of ponderous melancholy, the cycle of its destruction takes more than an hour. It is the sound of a mechanical heartbeat crawling to a stop, the breath slowly seeping from the speakers: "The music was dying," Basinski wrote. It is the sound of a machine giving into its own obsolescence, removing itself from the equation. Its long, echoing rhythms do have wide-ranging antecedents in the resonance of whale song, recordings made inside the wombs of pregnant women, drone and ambient works of the seventies and eighties, the cracked-media experiments of artists such as Alvin Lucier (specifically his 1969 experimental piece "I Am Sitting in a Room"), Robert Fripp's "Frippertronics," and Yasunao Tone's damaged-turntable-and-CD works.

Though not overtly Americana, the bucolic melancholy of the music could be the sound of distant rolling storm clouds on an arid Texas plain (Basinski was born and raised in Houston). But as the composer—who lived in Brooklyn, New York, just minutes from lower Manhattan when he created the *Disintegration Loops*—was basking in the ambient glow of his serendipitous achievement and continuing to transfer other eroding tapes in a similar fashion, two hijacked planes flew into the twin towers of the World Trade Center. From his roof, Basinski saw the towers fall, and the haunted longing of his new music meshed only too well with the shock and mourning that followed. Setting up a neighbor's video camera, he caught the mountain of black smoke billowing slowly into the sky from lower Manhattan. He paired the film with "dlp 1.1" and created a moving, solemn tribute, his elegy to the moment. He knew he had also created a major work, which *Pitchfork* writer Joe Tangari described as the sound of "the inevitable decay of all things, from memory to physical matter, made manifest in music," and, less convincingly, that the disappearing loops are "the kind of music that makes you believe there is a Heaven, and that this is what it must sound like." Basinski himself described the work by saying, "Tied up in these melodies

were my youth, my paradise lost, the American pastoral landscape, all dying gently, gracefully, beautifully."

In "d|p 1.1" there is a lengthy, constant extinction of the music as the tape sedately sloughs away for much of its running time, while at two key moments—at roughly forty minutes and again toward the very end of the piece—the minute abrasions give way to larger patches of erosion and the decomposition becomes more apparent, the sound crumbling quickly in these brief moments, almost representative of the felling of the twin towers.

The subsequent deterioration of these loops, when tied to the national crisis of identity and partisan divides that have followed the events of 9/11, backstitch the *Disintegration Loops* into the fabric of American arts: It is the undeniable sound of a nation's grieving and coming to terms with the sense that nothing would be the same again, that the order of the world had been compromised.

Joseph Fisher, writing in 2010 for PopMatters, called the *Disintegration Loops* "the most significant representation of the political and cultural tensions of post–9/11 America." Just as the rhythm and melody of Basinski's original loop is lost over its running time, so, too, did the events of 9/11 make many question the values of American foreign policy, our devout consumerism, our national identity, and the global impact of our lives; perhaps the United States was also lost. The moment marked the end of the twentieth century and no musical event marks the moment as well as the *Disintegration Loops*.

In describing magnetic tape for his book *Ambient Century*, Mark Prendergast called it "the single greatest invention of the twentieth century in electronic music," and while tape manipulation as an art form may have now taken a backseat to laptops and hard drives, Basinski's *Disintegration Loops* show that, even with its dying breath, magnetic tape pushes modern music forward.

Interestingly, as "d|p 1.1" fades into a thrum of ambient sound, it could also be seen as a grave marker for the end of analog—Napster's court-ordered shutdown amid a storm of controversy occurred just weeks before the attacks of September 11, and Apple introduced the

first iPod (October 23, 2001) just weeks afterward. In effect, the digital revolution cocooned the creation of the first *Disintegration Loops*. (The eventual release of the first *Disintegration Loops* material, in early 2003, also coincided with the opening of Apple's iTunes store in April of that year.)

The creation of *Disintegration Loops* was, like many creative breakthroughs, a matter of chance—Basinski didn't expect his neglected loops to fall apart, but when they did, they revealed new possibilities. Without the destruction of the older tape loops, the newer pieces are unimaginable, or, in the process of "saving" his music Basinski had to be willing to lose it. "Life and death were being recorded here as a whole: death as simply a part of life: a cosmic change, a transformation," wrote Basinski of his compositions, a belief that echoes central themes of reincarnation and rebirth in some religions. Within all of the endings that the *Disintegration Loops* contain and complement—Basinski's original loops, American optimism, the twentieth century, analog tape, the institutionalized recording industry—is hope.Ⓛ

STINA NORDENSTAM

The first thing listeners notice about the talented, semi-reclusive singer/songwriter Stina Nordenstam (born Kristina Marianne Nordenstam, on March 4, 1969, in Stockholm, Sweden) is her breathy, shy, teacup voice, which draws comparisons to artists such as Blossom Dearie, Lori Carson, Rickie Lee Jones, CocoRosie, and, more often than not, Björk. Nordenstam's debut, 1991's *Memories of a Color*, appeared when the singer was just twenty-two years old. A compelling mixture of cabaret jazz and soft, ambient pop, the album inspired interest at label 4AD, which attempted to sign Nordenstam. Though the deal fell through, the experience was not without a silver lining, as it introduced the singer to 4AD acts such as Red House Painters and This Mortal Coil, which would prove influential on her second album, 1994's *And She Closed Her Eyes*, a haunting record that also features her biggest hit, "Little Star," of

which the singer, reluctant to discuss any meaning held within her songs, has remarked, "It's about a suicide, I think." The song, which featured a video directed by Michel Gondry when it appeared as a single in 1994, was plucked for the soundtrack to Baz Luhrmann's 1996 film *William Shakespeare's Romeo + Juliet*. The mood grew increasingly dim for Nordenstam's 1996 release, *Dynamite*, as she applied industrial-informed beats and abrasive guitars to her otherwise delicate music-box material. She continued to follow the course set on *Dynamite* on her 1998 covers album, *People Are Strange*, which featured renditions of songs by Leonard Cohen ("I Came So Far for Beauty," "Bird on a Wire"), Rod Stewart ("Sailing" and "Reason to Believe"), Prince ("Purple Rain"), and, of course, the Doors. Still resolutely melancholic, yet with a newfound pop sensibility, 2001's *This Is Stina Nordenstam*, and 2004's *The World Is Saved*, seemed to be a summation of all that had come before, with wisps of jazz, folk, industrial, and ambient twining their way through her material. Nordenstam, who has rarely performed live since initially touring to support her debut, and who infrequently grants interviews, has yet to release a follow-up to *The World Is Saved*, though she has collaborated on recordings with other artists, including David Sylvian's Nine Horses project, Vangelis, Mew, Bill Laswell, and Yello.

THE MISERABLE LIST: STINA NORDENSTAM

1. "I'll Be Cryin' for You"—*Memories of a Color* (1991)
2. "Crime"—*And She Closed Her Eyes* (1994)
3. "Little Star"—*And She Closed Her Eyes* (1994)
4. "And She Closed Her Eyes"—*And She Closed Her Eyes* (1994)
5. "Mary Bell"—*Dynamite* (1996)
6. "I Could Still (Be an Actor)"—*The Photographer's Wife* EP (1996)
7. "I Came So Far for Beauty"—*People Are Strange* (1998)
8. "Everyone Else in the World"—*This Is Stina Nordenstam* (2002)
9. "Get On with Your Life"—*The World Is Saved* (2004)
10. "This Morning Belongs to the Night"—*The World Is Saved* (2004)

WILL OLDHAM/PALACE/ BONNIE "PRINCE" BILLY

orn on December 24, 1970, in Louisville, Kentucky, Will Oldham
achieved major artistic cred when, at seventeen, he starred along-
side Chris Cooper, David Strathairn, and James Earl Jones in the John
Sayles film *Matewan,* about the 1920 attempted unionization of coal
miners in a small West Virginia town. Oldham attempted a go at Hol-
lywood but rapidly became disillusioned and returned to Louisville,
where he would begin writing and recording songs that reflected both
his hometown's deeply independent subculture and his love of early
American artists. (He also shot the black-and-white photograph that
graces the cover of Slint's influential 1991 debut, *Spiderland.*) Taking
the name Palace Brothers—inspired by the "Palace Flophouse" in
John Steinbeck's short novel *Cannery Row,* as well as the brothers
Everly and Louvin—Oldham fashioned scruffy, lo-fi settings for his
strangulated vocals and cut-and-paste, back-porch poetry, and his
American-gothic miniatures eventually caught the attention of Chica-
go's Drag City label. He quickly began releasing singles, compiling his
best early work for 1993's *There Is No One What Will Take Care of
You.* A series of critically acclaimed singles, EPs, and albums, along
with quixotic name changes (Palace Music, Palace Songs, Palace) fol-
lowed, and with the claustrophobic austerity of *Arise Therefore* (and
a handful of singles) in 1996, Oldham retired the Palace placard. He
released 1997's *Joya* under his own name before rolling out a new
nom de plume, Bonnie "Prince" Billy, for 1999's *I See a Darkness*
(*Joya* has since been rechristened a Bonnie "Prince" Billy album).
Bleak even by Oldham's standards, *I See a Darkness* creaks along
with a shadowy dread on gorgeous cuts like "A Minor Place," "Death
to Everyone," and "I See a Darkness." Johnny Cash recorded a ver-
sion of the latter for his 2000 release, *American III,* introducing Old-
ham's material to a wider audience. Oldham traveled to Iceland to
record 2006's spare, unsettling *The Letting Go,* but by 2008's *Lie
Down in the Light,* he revealed a jaunty confidence, and on 2009's

Beware he was tossing off unsteady hoedowns like "Beware Your Only Friend," "You Don't Love Me," and "I Am Goodbye," each dressed with a lush, countrypolitan sound. The loose Laurel Canyon vibe that has rested within all his records came to the forefront for 2010's *The Wonder Show of the World*.

THE MISERABLE LIST: WILL OLDHAM

1. "Ohio River Boat Song"—Single (1993); *Lost Blues and Other Songs* (1997)
2. "Idle Hands Are the Devil's Playthings"—*There Is No One What Will Take Care of You* (1993)
3. "All Gone, All Gone"—*Hope* EP (1994)
4. "Gulf Shores"—B-side, *West Palm Beach* (1994)
5. "The Sun Highlights the Lack in Each"—*Arise Therefore* (1996)
6. "I See a Darkness"—*I See a Darkness* (1998)
7. "Wolf Among Wolves"—*Master and Everyone* (2003)
8. "Cursed Sleep"—*The Letting Go* (2006)
9. "You Can't Hurt Me Now"—*Beware* (2009)
10. "Troublesome Houses"—*The Wonder Show of the World* (2010)

ROY ORBISON

The only performer Elvis Presley dared not share a stage with, the Big O, Roy Orbison, sent shivers through millions of transistor radios during the early years of rock 'n' roll with an angelic voice that weaved operatic melodrama through heartbreaking hits such as "Only the Lonely" and "It's Over," making it okay for men to cry and wear their sunglasses at night. Born Roy Kelton Orbison on April 23, 1936, in Vernon, Texas, the singer recalled that it "all started with me walking down a dusty road with my father, and him asking me what I wanted for my birthday." He dreamed of a harmonica, but his father bought him a guitar instead. "I ain't had any formal training," he recalled. (He

came by his trademark sunglasses through chance, as well, after leaving his regular glasses on an airplane before touring with the Beatles in 1963; they were, in fact, prescription sunglasses, and Orbison dealt with multiple sight disorders throughout his life.) He wrote his first song, "A Vow of Love," in 1944 and became a regular on local radio the next year. In late 1946 the Orbison family moved to Wink, Texas, and in 1949, at the age of thirteen, he was fronting his first group, the Wink Westerners. The group toured locally, enjoying some small successes with regional radio and television programs, and made it to Dallas to record "Ooby Dooby" and "Hey, Miss Fannie." In 1955 Orbison enrolled at Odessa College and the group rechristened themselves the Teen Kings and scored a weekly TV show. Elvis Presley and Johnny Cash both appeared on the show to promote their local appearances, and when Orbison asked Cash for advice on getting a record released, the Man in Black replied with the phone number for Sun Records' guiding light, Sam Phillips. In an infamous, if brief, exchange, Phillips hung up on Orbison, saying, "Johnny Cash doesn't run my record company!" Soon after, the start-up Je-Wel label asked the Teen Kings to record for them. In the studio they cut a version of the Clovers' "Trying to Get to You" and took another stab at "Ooby Dooby." The recordings made their way to Phillips, who finally invited the group to Sun studios in Memphis. They set down "Go Go Go (Down the Line)" and rerecorded "Trying to Get to You" and "Ooby Dooby" (again) and, soon after, set off on a tour of southern drive-ins, performing on projection-house roofs between films. Sun's release of "Ooby Dooby" peaked at fifty-nine on the charts, but when subsequent singles failed to meet with success, the Teen Kings called it a day. Orbison stayed under the thumb of Phillips and Sun producer Jack Clement—who told Roy, "Don't ever be a ballad singer—you'll never make it"—until he and Phillips had a massive falling-out in 1958. Orbison decided to quit the business but wound up focusing more on the craft of songwriting and penned "Claudette" (named after his then wife), which wound up a hit for the Everly Brothers. He soon signed a publishing contract with Acuff-Rose, landing his compositions in the hands of Buddy Holly, Rick Nelson, and Jerry Lee Lewis. Orbison had a short, unsuccessful

stay with RCA and eventually signed with Monument Records in 1959. It was there that Orbison, his songwriting partner Joe Melson at his side, took the first steps toward realizing his sound with the song "Uptown," which built upon the fullness of the Nashville Sound employed by Chet Atkins and Patsy Cline's producer Owen Bradley, though Orbison and Melson brought in violins where fiddles traditionally would have been used. "Uptown" was modestly successful but was soon eclipsed by the song that crystallized Orbison's mature style and took him to the top of the charts. After unsuccessfully attempting to sell Elvis Presley and the Everly Brothers on the magic of "Only the Lonely," Orbison and Melson decided to record it themselves. Studio engineer Bill Porter placed the vocal mic extremely close to Orbison, which allowed for an incredible clarity to his soaring voice—he once owned up to possessing "a melancholy something"—over a bed of lush strings, and the combination took the song to number one in the UK and number two in the US. Over the next five years Orbison would deliver fifteen top-forty hits for Monument, including "Crying," "In Dreams," "It's Over," and "Oh, Pretty Woman," which famously hit number one in the US at the frothy peak of the British Invasion. Claudette's infidelities led to a divorce in 1964, but the couple remarried the following year, the same year Orbison left Monument for MGM, precipitating a steep decline in his fortunes, both personally and professionally. In June of the following year Claudette died when her motorcycle was struck by a semi-trailer (Roy was an avid motorcyclist and would continue riding, sometimes dangerously, for the rest of his life) and the 1968 film *The Fastest Guitar Alive*—Orbison's attempt to break onto the silver screen, as his friend Elvis Presley had done—was met with little enthusiasm. This failure seemed inconsequential, though, compared to the conflagration that engulfed his home later that same year, claiming the lives of two of his three sons. Incredibly, on the heels of such biting tragedy, he released the best of his mid-career records: *The Many Moods of Roy Orbsion* in 1969 and *The Big O* in 1970. Also in 1969 the then thirty-three-year-old Orbison married nineteen-year-old Barbara Jakobs, and the couple would go on to have two sons, remaining together until Orbison's death. The singer's

roller-coaster affair with providence declined again through the 1970s and '80s, until director David Lynch inserted the early-sixties hit "In Dreams" into his groundbreaking 1986 art-house film *Blue Velvet*, breathing a nitrous oxide–fueled hit of new life into the magic of the singer's operatic pop. Soon after, Roy joined George Harrison, Bob Dylan, Tom Petty, and Jeff Lynne in the supergroup to end all supergroups, the Traveling Wilburys. Orbison (billed as Lefty Wilbury) and Co. expectedly scored a hit with their first single, "Handle with Care," in 1988, but before the release of second single, "End of the Line," Orbison died of a heart attack (December 6, 1988). Within months his spectacular comeback album, *Mystery Girl*, would be released posthumously, and his majestic voice would be soaring at the top of the charts once again thanks to the album's opening track, "You Got It," and the Bono/Edge–penned, "She's a Mystery to Me." When prodded by *NME* in 1980 about the melancholic streak in his music, Orbison responded that he just wrote about longing and heartbreak and that he happened to know that a song near the top of the British charts at the time was "about living underground in a cave because of an atomic holocaust." That was the Jam's "Going Underground." "Now that's miserable," Orbison quipped. "That's really miserable!"

THE MISERABLE LIST: ROY ORBISON

1. "Only the Lonely"—*Sings Lonely and Blue* (1960)
2. "Running Scared"—*Crying* (1961)
3. "Crying"—*Crying* (1961)
4. "In Dreams"—*In Dreams* (1963)
5. "It's Over"—Single (1964)
6. "(I'd Be) A Legend in My Time"—*Roy Orbinson Sings Don Gibson* (1967)
7. "Truly, Truly, True"—*Roy Orbison's Many Moods* (1969)
8. "Southbound Jericho Parkway"—*Single* (1969)
9. "Not Alone Anymore"—*The Traveling Wilburys, Vol. 1* (1988)
10. "She's a Mystery to Me"—*Mystery Girl* (1989)

PEDRO THE LION/DAVID BAZAN

orn in January 1976, the son of a pastor, Washington State native David Bazan performed with fellow singer/songwriter Damien Jurado in the Guilty during the early 1990s, but by mid-decade Pedro the Lion had come together, taking their name from Bazan's unrealized children's book concept, and would shortly go on to make Bazan the first major Christian-indie-rock star to break through to mainstream success. Released by Tooth & Nail in 1997, the *Whole* EP, with its stripped gloom and soft laments, found the group lumped into the slowcore scene that also included Bedhead, Ida, and Low. *It's Hard to Find a Friend* was released in 1998 and showed a marked growth in Bazan's songwriting. It was followed shortly afterward with the loose concept EP *The Only Reason I Feel Secure*, originally titled *The Only Reason I Feel Secure Is That I Am Validated by My Peers*. The EP was compiled as a rumination on criticism. Bazan pared Pedro to a one-man operation for 2000's curious concept album, *Winners Never Quit*, about a politician and his unruly brother. Doomed relationships are often at the heart of his songs, and over the years he's discovered curious ticket stubs ("Bad Diary Days"), questioned why he always has to make the first move ("I Am Always the One Who Calls"), and discovered empty dresser drawers ("Criticism as Inspiration"). His third full-length release, 2002's *Control*, took it a step further, imaging the story of a father and husband who cheats on his wife and is eventually killed by her.

Opening track "Options" is heavy with despair as Bazan purrs the unhappy wife's refrain: "But for now / I need you." The album also finds Bazan (along with Casey Foubert on bass, percussion, and keyboards) making the biggest noise he'd made thus far on songs such as "Rapture" and "Penetration."

Bazan has identified *Winners Never Quit* and *Control* as being critical of his view of the church, and he told *Tiny Mix Tapes* in 2009 that shortly after that he simply "stopped believing in some

228 :(THIS WILL END IN TEARS

of the main tenets" of his faith. The final Pedro the Lion release, *Achilles Heel*, featured both a more pop-oriented sound and a shying from the "Christian rock" tag that was always attached to his work. It also contains what may be the most miserable song Bazan ever recorded: "The Poison," which features a broken-hearted alcoholic whose notion of Hell is a fire-free front-row seat "to watch your true love pack her things and drive away." From the start Bazan walked a line between the Christian and secular rock worlds. Though he never shied away from his faith, he did consistently use his material to question it, but by the time Pedro was put on the shelf he began moving to more secular material. He also began drinking heavily as he searched for his new voice. He joined T. W. Walsh and Frank Lenz of Seattle group Starflyer 59 in the short-lived synth-rock group Headphones, releasing a self-titled album that married Bazan's molasses vocals and pained lyrics to a bleeping closetful of vintage electronic bleeping—Postal Service references in reviews were many. The album also features in its final track, "Slow Car Crash," what Bazan holds as a true love song, stating in an interview from *Bazan: Alone at the Microphone* that "if I'm in a situation that there is peril I'm always looking for my phone and I'm thinking . . . If I know that I'm going to die how quickly can I dial Anne [his wife] so that she knows that the last thoughts I have are of her and Eleanor [their daughter]."

The ten-song *Fewer Moving Parts* EP appeared in 2006 under his own name and continued the autobiographical direction of his songwriting. Also in 2006 Bazan joined Mark Eitzel (American Music Club), Will Johnson (Centro-Matic), and Vic Chesnutt as the Undertow Orchestra to tour the US and UK together. What was implied by the name, but left off the official tour release, is the fact that these four artists are specifically *dour* "under the radar, yet prolific singer-songwriters," and *that*, more than any lack of popular acclaim or prolificacy, is the glue that bound them together. Bazan's first solo full-length, *Curse Your Branches*, appeared in 2009 and continued his pop exploration, a sound that carried through to 2011's *Strange Negotiations*.

THE MISERABLE LIST: PEDRO THE LION/DAVID BAZAN

1. "The Longest Winter"—*It's Hard to Find a Friend* (1998)
2. "Criticism as Inspiration"—*The Only Reason I Feel Secure* EP (1999)
3. "June 18, 1976"—*Progress* EP (2000)
4. "Options"—*Control* (2002)
5. "Second Best"—*Control* (2002)
6. "The Poison"—*Achilles Heel* (2004)
7. "Slow Car Crash"—*Headphones* (2005)
8. "Harmless Sparks"—*Curse Your Branches* (2009)
9. "In Stitches"—*Curse Your Branches* (2009)
10. "Strange Negotiations"–*Strange Negotiations* (2011)

ALLAN PETTERSSON

est known for the fifteen symphonies he completed during his lifetime, Allan Pettersson composed work that has been called "pessimistic," "downhearted," and "the musical equivalent of Ingmar Bergman's serious movies." He considered himself, he said, "a voice crying in the wilderness." Even as the most popular twentieth-century classical export from Sweden, he remains, wrote the *New York Times* in 1981, an "irascible outsider," little known beyond classical diehards. His unusual biography likely shaped his somber, melancholic compositional voice and his constant search for pinhole darts of light in the darkness. Born on September 19, 1911, in Västra Ryd, Uppland, Sweden, his family soon relocated to Södermalm, a working-class district of southern Stockholm, where his father was a blacksmith and his mother, a devout Catholic, would look after Pettersson and his siblings, often comforting them with song. Enamored of music's evocative power, Pettersson went on to study at the Royal Swedish Academy of Music, and eventually made his way to the Stockholm Philharmonic, playing viola with the

orchestra from 1939 to 1950. At that point he was granted leave to study under composers Arthur Honegger, Darius Milhaud, and René Leibowitz. Officially resigning from the Philharmonic in 1952, he devoted his life to composition. It was around this time that the first jolts of nagging pain began to radiate from his joints; he was later diagnosed with chronic rheumatoid arthritis, and the final composition he was able to write in his own hand—the fifth symphony—was completed in 1962. Though his work was often overshadowed by the modernism peddled by the likes of Karlheinz Stockhausen, Pettersson's breakthrough came with the performance of his Symphony No. 7, by the Stockholm Philharmonic, on October 13, 1968. The performance received a standing ovation and the composer was called to four curtain calls—unfortunately, due to his worsening health, this was the last public performance of his works that the composer would attend. Still Pettersson's most popular piece, the seventh is a prime example of the anxiety and sense of impending doom that pervades his work, the orchestra self-destructing in a fit of exhaustion at the climax, drifting to its conclusion on fumes. In 1970 the composer developed life-threatening kidney lesions that required a nine-month hospitalization. He left the hospital an invalid, confined to his noisy apartment—he believed he couldn't compose an opera due to the "acoustic irritation" of construction and blasting stereos—yet he continued to compose for more than a decade. In 1978 he completed his fourteenth and fifteenth symphonies—as well as his second violin concerto—despite his continued decline in health, which soon suffered another blow with a cancer diagnosis. In May 1980 ill health forced him back to Karolinska Hospital, where he died on June 20, 1980.

EDITH PIAF

La Môme Piaf, the Little Sparrow, is the most popular singer to come from the land of baguettes and bicycles—sorry, Johnny Hallyday—and in the grand *chanson* tradition was able to give her-

self fully to the melancholy material she preferred, a passion fueled in part by the now legendary tragic acts of her life. She was born Edith Giovanna Gassion on December 19, 1915, in Paris—in a hospital, not in a policeman's cape, as she preferred to relate it—to an acrobat father and an alcoholic mother who split her time between singing and prostitution. When her father was called to service in World War I, Edith became an afterthought and was sent to live with her father's mother in a brothel in Normandy, the prostitutes becoming her surrogate family. Piaf nearly lost her sight when she was five, and after she regained it, following a pilgrimage to the shrine of St. Thérèse of Lisieux (though Thérèse was not canonized until 1925), she forever after added a powerful belief in the saint alongside her vigorous superstitions and street smarts. (Her pre-show ritual included kissing or touching the floorboards, kissing her St. Thérèse medal, making the sign of the cross, and using the little finger and forefinger of her right hand to make what she referred to as her "little demon.") When her father returned from the war he incorporated the young Edith into his traveling street act. One evening, her father ill and the two out of money and food, Piaf took to the local square to sing the only song she knew, "La Marseillaise," and her career was born. Eventually she struck out on her own, teaming up with half-sister Simone Berteaut; the knockabout duo sang where they could and lived a life enveloped by pimps, petty criminals, and prostitutes. In 1932 Piaf fell in love—albeit briefly—with a delivery boy named Louis Dupont and became pregnant with their child. Her behavior toward her own daughter echoed her mother's disinterest in her, and Dupont eventually took to raising the child until she died from meningitis at the age of three. Piaf's next boyfriend, a pimp who took a cut of her singing tips in exchange for not forcing her into prostitution, attempted to shoot her when she ended the relationship. It was around this time that cabaret owner Louis Leplée happened upon the still-teenaged Piaf singing in the street. Impressed with the raw force of her voice, which sprang from a girl all of four feet ten inches, Leplée began to mold her into the star she would become, much of it coming from other successful singers of the day, like Marie-Louise Damien (oth-

erwise known as Damia, or "la Tragédienne de la Chanson"), who sang dressed all in black with a dramatic white orb from a spotlight illumining her face. Damien also favored bleak songs like "Sombre Dimanche" and "La Suppliante" (during which she actually sniffles back some tears in rhythm), a number of which Piaf would perform in her earliest days. Leplée billed her *La Môme Piaf*, the Little Sparrow, and her debut on Leplée's stage was a huge success. Piaf was soon cutting her first albums, *Les Mômes de la Clôche* and *L'Étranger,* for Polydor. Unfortunately, in April 1936 Leplée was shot to death and police suspicion fell over Piaf and her circle of criminal friends. The case became such a media sensation that the negative press nearly halted Piaf's professional singing before it had truly begun. In desperation she turned to Raymond Asso—a songwriter and Foreign Legion veteran—to rehabilitate her career. Asso set about educating Piaf, cut her off from her more disreputable friends, dubbed her Edith Piaf, and impressively began to craft songs—along with "L'Étranger" composer Marguerite Monnot—in the *chanson réaliste* style that took its subject matter from Piaf's own difficult life. Largely the opposite of the lovelorn figure she portrayed onstage, Piaf took Asso as her lover, the first in a long line of affairs that the diminutive but headstrong singer controlled. With the Nazi occupation of Paris she became involved in the French Resistance and composed (with Monnot) the protest song "Où Sont-Ils, Mes Petits Copains?" ("Where Are They, My Old Pals?"), which she refused to remove from her repertoire despite an order from the Reich to do so. After Asso, who was drafted at the start of the war, Piaf took up with a string of men that included journalist Henri Contet—who would write lyrics for a number of her songs, even after the affair had ended—and singer Yves Montand, who quickly became as big a star as she was. In 1946 she wrote (with Louis Guglielmi) and recorded what would become her signature song, "La Vie en Rose." The following year she toured the United States for the first time and, thanks to the intervention of respected critic (and composer) Virgil Thomson, became a success, performing at New York's Café Versailles for more than five months. It was around this time that she fell for French boxer

Marcel Cerdan, who shortly thereafter became the world middle-weight champion and a French national hero. Though married, Cerdan became the love of Piaf's life, and then tragedy struck like clockwork. In October 1949 Cerdan's plane, which was traveling from Paris to New York, crashed in the Azores. Devastated, Piaf sank into a cycle of self-abuse and dependency that included alcohol and morphine. Early the following year she would record a song she had cowritten (again with Monnot) to celebrate her love of Cerdan, a song that now stung with sadness. "Hymne à l'Amour" ("Hymn to Love"), with all her pain carrying it, became one of her biggest hits, certainly her most heartbreaking. She continued performing as her alcoholism deepened, and in 1951 she was involved in a serious accident, breaking her arm and two ribs. She was now depressed and injecting herself with cocktails of morphine and cortisone (for her progressively worsening rheumatism). She married singer Jacques Pills in 1952—*Life* magazine highlighting the wedding in an article titled "Mlle. Heartbreak: She Weds, But Still Sings Sad"—even though friends saw him as little more than an opportunist. Pills did force Piaf into what would be the first of three rounds of treatment for her addictions before the two divorced in 1957. Piaf continued to have hits and tour—Noël Coward writing in his diary after seeing her perform in 1956, "Piaf in her dusty black dress is still singing sad songs about bereft tarts longing for their lovers to come back and still, we must face it, singing them beautifully, but I do so wish she would pop in a couple of cheerful ones just for the hell of it." Finally kicking her drug abuse in the late fifties, she took up with young songwriter Georges Moustaki in 1958. Moustaki would write what would become her first UK hit, "Milord." Involved in yet another car accident (this one minor), Piaf collapsed early the next year while performing at New York's Waldorf-Astoria. After being rushed to the hospital, emergency surgery was performed, yet she insisted on continuing her tour, collapsing once again, in Stockholm. She returned to Paris for more surgery, but was back in the studio before long, recording another huge hit, 1960's "Non, Je Ne Regrette Rien." In late 1961, amid her performing schedule, she met and married Greek singer Théo

Sarapo, who was twenty years her junior. Frail, rheumatic, and agoraphobic, she took comfort in visits from longtime friend Jean Cocteau, who had written his 1940 play *Le Bel Indifférent* for Piaf and who now involved her in some measure in Rosicrucianism. Her final months were a trial of comas and lucidity, Berteaut and Sarapo doing their best to look after her. Piaf finally passed on October 11, 1963. Journalist Studs Terkel, in his book *Will the Circle Be Unbroken*, recalled quizzing Piaf on the subject of sad songs, with the Little Sparrow replying, "I feel happy when I sing a sad song and sad when I sing a happy song. When you sing a song that is up, where can you go but down? But if you sing a song that is down, where can you go but up?"

THE MISERABLE LIST: EDITH PIAF

1. "Tu Es Partout" (1941)
2. "Coup de Grisou" (1942)
3. "Les Trois Clôches" (1946)
4. "Hymne à l'Amour" (1950)
5. "Une Enfant" (1951)
6. "Miséricorde" (1955)
7. "Avant Nous" (1956)
8. "Je Sais Comment" (1958)
9. "Mon Dieu" (1960)
10. "Non, Je Ne Regrette Rien" (1960)

PORTISHEAD

Formed in the early nineties in Bristol, England, and stepping out of the same foggy scene that produced Massive Attack, Portishead would become synonymous with the trip-hop genre, crafting a hypnotic blend of dub beats, cool jazz, acid house, film scores, incidental music, and avant-garde inclinations into a supine, audio

narcotic few could resist. The group got its start after producer Geoff Barrow (Tricky, Neneh Cherry) met spidery pub singer Beth Gibbons and the pair began a writing partnership. Former Jazz Messenger guitarist Adrian Utley was soon brought into the fold and Portishead—named after Geoff Barrow's shipping-center hometown in the southwest of England—was complete. The group's first release was a short noir film, "To Kill a Dead Man," which featured the trio in starring roles and a dark soundtrack that recalled the work of Riz Ortolani, Ennio Morricone, and Angelo Badalamenti, and notably featured no vocals by Gibbons, who would soon become the retreating center of the group. Her torched vocals, at once naive and hypersexual, are a stark contrast to her performance identity, which always seemed to be collapsing in on itself, as her shoulders gathered forward around her matchstick frame and she clutched at the microphone for dear life. The group signed to Go! Records following the release of the short film, and in 1994 their quintessential debut, *Dummy*, appeared. From the beginning the group's atmospheric videos and Gibbons's shy nature—she flatly refused to do interviews—added to their shadowy allure. Journalist Simon Reynolds went so far as to imagine Gibbons's answer to a question about the mysterious source of her melancholia: "My sadness is the archaic expression of an unsymbolizable, unnameable narcissistic wound." *Dummy* topped album-of-the-year polls and the group won the prestigious Mercury Prize—besting the brightest stars of the Britpop invasion: Blur, Oasis, Suede, and Pulp. After *Dummy* debuted on MTV in America, the group took off stateside. Their self-titled second album appeared three years later, followed by 1998's live *PNYC*, which captured the band's meticulous live performance during a one-night stand with a thirty-five-piece orchestra at the Roseland Ballroom in New York City. Uncomfortable with the fact that their sound had become pillaged by the advertising industry and copycat acts, Portishead's attempts at recording a follow-up met with frustration—as Barrow described it in a 2008 interview, everything "sounded like a fucking ice cream advert"—and led to an extended hiatus beginning in 1999. Barrow started experimental record label Invada, and both he and Utley worked as producers—notably they

coproduced the Coral's 2005 album *The Invisible Invasion*. Meanwhile, Gibbons collaborated with former Talk Talk member Paul Webb, who assumed the pseudonym Rustin Man, on 2003's *Out of Season*, an organic album of softly scraping acoustic guitar strings that recalls Karen Dalton and Nina Simone's folksy side. Gibbons, in turn, appeared on a handful of tracks by Webb's ORang project. Following their lengthy silence the group returned in 2005, performing their first shows together in seven years and cobbling together material for what would become their third album, 2008's *Third*. The album—the creation of which Barrow described on the band's blog as "a never-ending journey with very few answers"—proved to be more unsettling and confrontational than their earlier work. "I don't think the fondue society will be happy," quipped Barrow upon its release. The first single, "Machine Gun," echoes with minimal industrial chic; "The Rip" marries a gentle acoustic melody with motorik Krautrock and a lyric boiling over with Gibbons's trademark self-doubt as she nearly weeps the words, "Through the glory of life / I will scatter on the floor / Disappointed and sore"; while "Magic Doors" features what may be the most foreboding use of the cowbell in music history.

THE MISERABLE LIST: PORTISHEAD

1. "Sour Times"—*Dummy* (1994)
2. "Biscuit"—*Dummy* (1994)
3. "Over"—*Portishead* (1997)
4. "Mourning Air"—*Portishead* (1997)
5. "Only You"—*Portishead* (1997)
6. "Cowboys"—*PNYC* (1998)
7. "Roads"—*PNYC* (1998)
8. "Plastic"—*Third* (2008)
9. "The Rip"—*Third* (2008)
10. "Magic Doors"—*Third* (2008)

RADIOHEAD

When Radiohead arrived in late 1992 heralded by "Creep"—an anthem of alienation so perfectly formed that, in retrospect, it almost feels like caricature—no one believed they had seen the future of rock 'n' roll. After all, the most inventive aspect of the single—the jagged guitar contusions before each chorus—was notable for being a happy accident, guitarist Jonny Greenwood's attempts to destroy something he deemed too earnest. The 1992 *Drill* EP gives us a picture of a Radiohead just beginning to shake off their spiky, power-pop roots, Thom Yorke repeatedly mumbling, "I'm better off dead," throughout lead track "Prove Yourself." When their debut album, *Pablo Honey*, arrived the following year, Yorke's glum persona continued to take shape; *Rolling Stone* noted that the singer's "narcissistic angst rivals Morrissey's." By the time *The Bends* followed, in 1995, they had quickly matured into one of the smartest, most pervasively melancholic rock bands on the planet, something the press were quick to jump on, *Melody Maker* calling the album "an integral part of this end of the century/culture of despair thing." With songs like "Black Star," "My Iron Lung," and "Sulk," the album was loaded with a detached sense of desire, Yorke's vocal during "Fake Plastic Trees" growling, soaring, and breaking apart into little more than an unformed whimper ("It wears me out"). It was theatrical, uneasy, existential pop brilliance. Following the success of *The Bends*, Yorke began to bristle at the band's doom-and-gloom public image; he hoped to change the conversation, noting as 1995 came to a close, "I am deliberately just writing down all the positive things that I hear or see. But I'm not able to put them into music yet." When two years later they did release their next album, *OK Computer*, Yorke, thankfully, still hadn't learned to write "happy." The album blended elements of prog, ambient music, arena-rock anthems, and techno with sci-fi themes of alienation and conspicuous consumerism. *OK Computer* suggested the sadness at the heart of life in an overly connected (and curiously disconnected) world. They even made a robot

sound depressed. "No Surprises," the downer gem glistening near the finale, is unapologetically grim; it opens with a "heart that's full up like a landfill" and suggests, just before the chorus, "a handshake [with] carbon monoxide." It was the sound of Generation X slogging to work and paying their bills: overworked, tired, paranoid, and ultimately alone. Filmmaker Grant Gee followed the band on their long *OK Computer* tour, in 1997, and the following year released the film *Meeting People Is Easy*, which captured the blurry exhaustion of the group's life on the road and, in particular, its deleterious effect on Yorke. Whatever melancholy stirred in the hearts of Yorke and company throughout their releases, up to and including *OK Computer*, it was all chalk compared to 2000's *Kid A*, a downbeat album of blue-eyed soul forced through a techno sieve and served superconductor cold. The album leaked early on the Internet—an act that wounded the group—yet it managed to debut at number one on both sides of the Atlantic. That was no small feat for such a difficult album, the centerpiece of which is the six-minute Futurism dirge "How to Disappear Completely," a song born of road weariness and the demands of celebrity that now seems prescient in a world of social networks and micromessaging. The following year the group released *Amnesiac*, an album comprised songs from the *Kid A* sessions that the group insisted were not outtakes but a properly composed release in its own right. *Hail to the Thief*, the group's post–War on Terror album, appeared in 2003 with less fanfare than *OK Computer* and less confusion than *Kid A* and *Amnesiac*, and focused on the ills of political maneuvering on mournful cuts like the disturbed "We Suck Young Blood (Your Time Is Up)," a track rooted by funereal piano and impossibly bleak handclaps. Following the release of *Hail to the Thief*, Yorke continued to experiment with electronic music, releasing his first solo album, *The Eraser*, in 2006, and Greenwood composed the unsettling score for Paul Thomas Anderson's 2007 film *There Will Be Blood*. Radiohead's seventh album, *In Rainbows*, was greeted as a return to form. The band crafted a unique way to sell the album, asking fans to pay what they wanted for the digital release, but also offering an expanded "discbox" that featured the album on vinyl and CD, lyrics, photos, and more. The distinctive marketing

garnered huge amounts of press and the album itself garnered the best reviews the band had seen since *Kid A*. It showcased the band's improving ability to craft precision art-pop and two of its standout tracks, the glitchy and dour neo-soul of "House of Cards" and the dire "All I Need" ("I'm an animal trapped in your hot car") also happen to be the most bleak.

In 2011 the group released the difficult, wiry, sputtering electro-clang album *King of Limbs* to comparably little fanfare—the Internet buzzing more about Yorke's Bob Fosse–meets–Ian Curtis turn in the video for lead single "Lotus Flower" than the music. The album failed to rank in many of the year-end lists the group so often dominates.

THE MISERABLE LIST: RADIOHEAD

1. "Creep"—*Pablo Honey* (1993)
2. "Fake Plastic Trees"—*The Bends* (1995)
3. "Street Spirit (Fade Out)"—*The Bends* (1995)
4. "No Surprises"—*OK Computer* (1997)
5. "How to Disappear Completely"—*Kid A* (2000)
6. "Fog"—*Knives Out* EP (2001)
7. "True Love Waits"—*I Might Be Wrong: Live Recordings* (2001)
8. "We Suck Young Blood (Your Time Is Up)"—*Hail to the Thief* (2003)
9. "All I Need"—*In Rainbows* (2007)
10. "Codex"—*The King of Limbs* (2011)

SONG ESSAY: "HOW TO DISAPPEAR COMPLETELY"

Following the release of Radiohead's 1997 post-prog behemoth *OK Computer* and the exhaustive tour that followed, Thom Yorke was fighting off a nervous breakdown, the result of the constant demands and pressures that come with fronting the biggest rock band in the world. His uncomfortable interactions with the press and the public were recorded for posterity as part of the tour documentary, *Meeting People Is Easy*, which features fragments of the song "How to

Disappear Completely" in two separate scenes: First, when Yorke scribbles the words "I'm not here and this is not really happening" on a hotel window (the scene set to the tune of Scott Walker's brooding "On Your Own Again"), and, later, when Yorke performs an early version of the song that accompanies a montage of sound checks and photo sessions—the singer sits at a desk while a stinging strobe light relentlessly slaps his exhausted face, which quickly drops into his hands.

Originally titled "How to Disappear Completely and Never Be Found," and performed live during the *OK Computer* tour, the song was the only one to be salvaged from those exhaustive days for inclusion on the group's 2000 release, *Kid A*. Perhaps the most pessimistic album by a band known for its bleak perspective, the album—named after Yorke's shorthand for the first cloned human—became the sound of the future's restless ennui.

Radiohead veered from expectations with *Kid A*, largely dispensing with the guitars that had heretofore figured so prominently in their sound—"How to Disappear Completely" is fourth in the album's running order, but is its first song to prominently feature any kind of guitar. It's a comparatively subtle song, with Greenwood's unsettling arrangement (he reportedly secluded himself for a month to create it) rarely rising beyond the vaguely present hum of a power line, which, along with the hypnotic largesse of its melancholy, emanates a gravity of its own, pulling the listener toward its core.

Musically, the song was inspired by Scott Walker and modern classical composers such as Krzysztof Penderecki and, specifically, Olivier Messiaen, an influence obvious in Jonny Greenwood's use of the ondes Martenot, an early electronic instrument that produces a quivering, spectral buzz that the guitarist explained as being like "a very accurate theremin." (The ondes Martenot was notably used by Jacques Brel in his recording of "Ne Me Quitte Pas.") Radiohead has been known to use six ondes Martenot during live performances of the song, the instrument's uniquely haunting tones helping to establish the out-of-body sensation Yorke's lyrics suggest—a theme that continues to ripple through his work with Radiohead and his solo work.

"That song is about the whole period of time that *OK Computer* was happening. We did the Glastonbury Festival and this thing in Ireland. Something snapped in me. I just said, 'That's it. I can't take it anymore.'" Despite the physical and mental toll the tour was taking, Yorke still found himself on the road promoting the album a year later.

During the height of the maelstrom Radiohead toured with alternative rock godfathers R.E.M., and Yorke struck up a friendship with singer Michael Stipe, also an introspective artist who had difficulties adjusting to the vagaries and demands of fronting a hugely popular rock band. Stipe detailed to Yorke how he learned to cope with the invasiveness of the spotlight: "I just go into a room on my own, close the door, turn off the lights, lie on the floor in the fetal position, and say to myself over and over: 'I'm not here, this isn't happening . . . I'm not here, this isn't happening . . . I'm not here, this isn't happening . . .'" The advice stuck with Yorke and he began to craft Stipe's words to the wise into lyrics.

Yorke's mumbled salvo in "How to Disappear Completely"—"Down there, that's not me"—echoes the belief of philosophers from Rousseau to Sartre that modern man, ever aware of his condition, is always outside of himself. It instantly places the song in a long line of self-conscious twentieth-century works such as René Magritte's infamous "*Ceci n'est pas une pipe*" ("This is not a pipe")—written beneath a painting of a pipe—and Alberto Giacometti's stark sculpture *Walking Man*, which French essayist Francis Ponge described as "Man—and man alone—reduced to a thread." Psychologist Viktor Frankl wrote of modern man's life in an "existential vacuum," due to the ancient loss of our instinctual natures and, in more recent history, the loss of our myths and traditions. Yorke struggles not only with these losses but also with the machinery of culture that has replaced some of those myths and traditions, and commands constant attention. He wallows in his celebrity. The speed at which the culture industry absorbs and dispenses with images and sounds creates an instability to time, as the waves and waves of data disappear into a colorless blanket of existential fog. Yorke explores this in the second verse when he ponders how quickly the slivers of genuine being can disappear: "The moment's already passed, yeah it's gone,"

an offhanded remark that in turn echoes the fickle nature of "the audience."

The strongest clue to the song's wracked tour-diary beginnings comes in the third and final verse, as Yorke rattles off a checklist of the sights and sounds he's witnessed on the road: "Strobe lights and blown speakers / Fireworks and hurricanes," all contribute to the sensory overload that he eludes to in the album's song "Idioteque," when he sings "Everything all the time."

This is the muffled yawp of postmodern weariness (we don't riot, we just sulk), Yorke a disembodied specter ("I walk through walls"), folded in cotton, floating "down the Liffey" and through his own life. Liffey, a river in Ireland, also comes from the Celtic "Liphe" or "Life," an interesting connection considering that the desire to vanish or disappear is a warning often expressed by individuals with suicidal thoughts.

The connection to Yorke's identity struggles and tug of war with his own self-consciousness runs through much of his work as an artist, connecting back to Radiohead's first hit, "Creep," which features the chorus "What the hell am I doing here? I don't belong here." In the distance between the two songs Yorke went from being an uncomfortable outsider looking in to the ghost of that outsider struggling to simply exist.

Kid A was praised universally upon its release and was at the top of dozens of best-of-the-year lists. Writing for *Uncut* at the time, Simon Reynolds singled out "How to Disappear Completely," calling it "the missing link between Scott Walker's desolate orchestral grandeur and the swoonily amorphous ballads on My Bloody Valentine's *Isn't Anything.*"

Over the years the album has been portrayed as the last gasp of the physical music industry—the final wide-screen, two-sided deep breath before MP3s swept over the landscape and the single reasserted its place at the top of the hill. Chuck Klosterman went so far as to paint the album as a prophesy of 9/11, with "How to Disappear Completely" positioned as the surreal, slow-motion microseconds following the attacks on the twin towers as everyone watching the events constantly recycled Yorke's chorus: "I'm not here / This isn't

happening." In Klosterman's take the song is "about being burned alive and jumping out of windows, and . . . about having to watch those things happen."

Kid A was rereleased in 2009 at its ten-year anniversary and was revisited by critics who largely defended the album's modern classic status—*Rolling Stone*, *Pitchfork*, and the *Times* of London all naming it the best album of the decade, with "How to Disappear Completely" remaining the album's devastating masterpiece. As Thrice drummer Riley Breckenridge—who sports a tattoo of the words "I'm not here, this isn't happening"—recalled for *Alternative Press* in 2010: "[The song] makes my eyes tear up just like it always has."

Just three years earlier, in 2006, while appearing on BBC Two's *The Culture Show*, Yorke was asked which moment he would like to be remembered for, and his response, without hesitation, was "How to Disappear Completely," saying, "It's the most beautiful thing we ever did, I think."ⓗ

Murder Ballads
and Death Discs

Early seventeenth-century English dramatist John Webster observed in his play *The Duchess of Malfi*, that "death hath ten thousand several doors for men to take their exits," and it would seem there are just as many songs dedicated to life's final chapter as there are passageways that lead to that last slumber. It's the immutable magnet that draws us along, as Sherwin B. Nuland writes in his book *How We Die*: "Moths and flames, mankind and death—there is little difference." From the earliest recorded works—Roosevelt Sykes's recording of "44 Blues" appeared in 1929 and insinuates murder if it doesn't exactly spell it out—through the "death disc" phenomenon of the early sixties, to gangster rap's heyday in the '90s, death has been a constant theme in music, touching every genre, high and low.

Even though the murder-ballad form—that is, any narrative song that describes a murder and often contains a final admonition for, or confession from, the guilty—may have originated in England, Scotland, and Ireland, it seems made for the violent psyche of America.

Many of the murder ballads that became early country and blues standards began their lives as European folk ballads. They were passed along through oral traditions before being printed on cheap broadsides and/or compiled in collections like the popular *Child Ballads*, a collection of hundreds of ballads first published by Francis

James Child in 1882. As an example, "Knoxville Girl," which was popularized by the Louvin Brothers on their classic 1956 album *Tragic Songs of Life* ("The most requested song we ever sang, maybe almost the first song we ever sang" Charlie Louvin once recalled), originated as an English ballad known interchangeably as "The Oxford Girl," "Waxweed Girl," or "The Lexington Girl," which were in turn derived from eighteenth-century broadsides "The Cruel Miller" or "The Bloody Miller."

In the song, which has been whittled down significantly from its earliest incarnations, a man and his future bride take a walk "about a mile from town." Everything seems perfectly pleasant until, well, the first verse ends. The man then coldly, inexplicably beats his fiancée to death with a stick as she begs for mercy. Perhaps the most haunting line—"I took her by her golden curls and I drug her round and around"—occurs just before he throws her in the river. He eventually ends up in jail "because I murdered that Knoxville girl, the girl I loved so well."

Despite their grisly nature, these songs have always found large audiences. When the Louvins' "Knoxville Girl" was released as a single in 1959 it climbed as high as seventeen and stayed on the charts for seven weeks. "Tom Dooley" was a huge hit for the Kingston Trio the previous year, and sixteen-year-old Tanya Tucker scored a number one on the strength of a murder ballad ("Blood Red and Going Down").

Many are pure fictions—spun from their balladic predecessors rather than emerging out of whole cloth from the imaginations of their composers. Others are loosely based on fact, as is the case with three popular songs that emerged from the red-light district of St. Louis at the end of the nineteenth century: "Stagger Lee," "Frankie and Johnnie," and "Duncan Brady." Still others, which number among the most chilling, are cobbled together from more credible sources such as newspaper accounts and court records, and play out as even more macabre and despairing for their reality roots.

A few days before Christmas 1929 a well-liked and respectable forty-three-year-old North Carolina tobacco farmer named Charlie Lawson traveled with his wife, Fannie, and seven children from their small Stokes County farm to Winston-Salem, where he bought them

all new clothes and purchased toys for the children; they even had a family portrait made. All were unusual extravagances for a modestly successful farmer. On Christmas Day, Fannie baked a cake and topped it with white frosting and a radiating pattern of raisins while the Lawsons' oldest son, Arthur (then sixteen years old), headed into nearby Germanton to buy ammunition for a brief rabbit hunt. It reads as an idyllic rural Christmas, which makes what follows all the more chilling. Lawson first shot his wife on the main floor of their small cabin, while she was holding their five-month-old daughter. He then shot the two younger boys and Marie, his seventeen-year-old daughter. Two other daughters, Carrie and Maybell, ran from the home, but Lawson caught up with them near the family tobacco barn. He dragged their bodies into the barn, crossed their arms on their chests, and laid a stone beneath their heads. He then returned to the cabin and laid out his wife, eldest daughter, and two sons, gently placing a pillow under their heads, and returned his youngest daughter to her crib. Lawson then wandered into the woods, where he eventually shot himself, the echo of the gun's report heard by the police who had already arrived at the cabin. In his pockets were found a number of bills of sale for his tobacco crop, two of which contained the scribbled notes, "Trouble will cause," and "Blame no one but I."

Some believe that an accident the previous year, when Charlie was hit in the head with a flying piece of mattock while digging a drainage ditch, must have been the cause of his rampage, but an autopsy conducted by the local doctor along with doctors at Johns Hopkins found no abnormalities. A 1990 book about the tragedies (with the sensational title *White Christmas, Bloody Christmas*, later updated and retitled *The Meaning of Our Tears*) questioned the sequence of events. It alleged that Marie, Charlie Lawson's teenage daughter, was pregnant with his child, and that this fact was the underlying cause of the slaughter. So far removed are we now from the occurence that allegations will likely remain speculative, and the truth lost to time.

The Carolina Buddies were the first to set the Lawson tragedy to song in Walter "Kid" Smith's "The Murder of the Lawson Family," but others, including J. E. Mainer ("The Story of Charlie Lawson"),

Doc and Merle Watson ("The Lawson Family Murder"), the Country Gentlemen ("The Story of Charlie Lawson"), the Stanley Brothers ("The Story of the Lawson Family"), Mac Wiseman ("The Ballad of the Lawson Family"), Bascom Lamar Lunsford ("Charlie Lawson"), and, more recently, Dave Alvin ("Murder of the Lawson Family"), eventually recorded versions of Smith's original, which remains the best rendition available.

"Tom Dooley," which was based on the 1866 murder of Laura Foster by Confederate army veteran Tom Dula, became a number one hit in 1958 for the Kingston Trio and is credited with kicking off the US folk revival that lasted roughly until the Beatles landed at JFK in 1964. Other notable murder ballads formed by fact include Harry Chapin's "Sniper" from the 1972 album *Sniper and Other Love Songs*—an epic, nearly ten-minute modern murder ballad about Charles Whitman, the troubled Vietnam veteran who killed sixteen people from a clock tower on the University of Texas at Austin campus on August 1, 1966—and Bruce Springsteen's "Nebraska," from the stark 1982 album of the same name, which is based on the 1957–1958 killing spree of nineteen-year-old Charles Starkweather and his fourteen-year-old girlfriend, Caril Ann Fugate.

Country and bluegrass artists more or less owned the murder ballad genre in the 1960s and 1970s. A young George Jones wrote "Life to Go," and Stonewall Jackson took it to the number two spot on the country charts in 1958. Jackson would have another sinister top-ten country hit with "Leona," in 1962—the same year Jones himself would hit the country charts with the dark narrative "Open Pit Mine." Other sterling examples of the form during this era include Doc Watson's take on "Omie Wise" that appeared on his 1964 self-titled debut; Johnny Paycheck's infamous weeper, "(Pardon Me) I've Got Someone to Kill" (1966); Porter Wagoner's "Cold Hard Facts of Life" (1967); and Tanya Tucker's countrypolitan classic "Blood Red and Going Down" (a country number one in 1973, recorded when Tucker was just sixteen years old). It was the Man in Black, Johnny Cash, however, who became most associated with the murder ballad as he toured prisons and recorded desperate and violent songs like "Cocaine Blues" and "Delia's Gone." He

also recorded "Don't Take Your Guns to Town," "Hardin Wouldn't Run," and "The Last Gunfighter Ballad," and a slew of other gunfighter ballads, a tributary of the murder-ballad form that gained popularity in C&W circles in the early sixties, reflecting the dusty drama of the era's most popular television programs such as *Wagon Train, Bonanza, Gunsmoke,* and *Rawhide,* and *Have Gun—Will Travel.* (The one-stop classic for the gunfighter ballad that reflected how swift the possibility of bloodshed could be in the early American West [the entire minigenre a progenitor of the urban violence of gangster rap], can be found concisely packaged as Marty Robbins's 1959 hit album *Gunfighter Ballads and Trail Songs.*) Cash's stark narratives and brimstone baritone became a touchstone for artists like Bruce Springsteen and Nick Cave, the latter exploring the tradition with his first group, the Birthday Party, in songs like the menacing "Deep in the Woods" off their 1983 *The Bad Seed* EP. Cave became the keeper of the flame, in a way, obsessing over the doorways of death in songs like "The Mercy Seat" (a killer's confessional from the electric chair) until he courted exhaustion crafting the 1996 concept album *Murder Ballads.* For the album Cave reinvented "Knoxville Girl" as "Where the Wild Roses Grow," a duet with Kylie Minogue about a riverbank murder that narrowly missed charting in the top ten in Britain. Cave told *Alternative Press,* "We had absolutely no idea 'Wild Roses' would be a hit, nobody did. We thought it would be one of the world's great flops." But if you really want to hear how the twenty-first century has updated the murder ballad, look no further than Eminem's 2000 release, *The Marshall Mathers LP.*

Already a multiplatinum-selling artist by Y2K, Eminem released the explosive *Marshall Mathers LP* in the spring of 2000 and with it pushed the boundaries of hip-hop, pressing the murder ballad into violent new ground. The album opens with "Kill You," a misogynistic track that not only prepares listeners for the grim listening to follow but also takes a swipe at his critics and his own popularity, nearly daring his listeners and the media to abandon him—"Oh, now he's raping his own mother, abusing a whore, snorting coke, and we gave him the *Rolling Stone* cover?" Later in the song he claims, "I

invented violence," before the chorus hits: "I said you don't wanna fuck with Shady / 'Cause Shady will fucking kill you." The song may lay the groundwork for what's to come, but it doesn't fit the mold of a murder ballad like the album's next track, "Stan." Featuring a delicate folk-pop sample from Dido's "Thank You" over a mid-tempo beat, the dry drag of a Sharpie marker, and an unceasing thunderstorm, the song is split into two acts. The first three verses are all individual agitated attempts by an overzealous fan (Stan) to contact the rapper, while the final verse is Eminem's calm, revelatory response. As the song builds, Stan becomes more unhinged at what he perceives as the rapper's neglect—"I just think it's fucked up, you don't answer fans." Stan's final message is a recording that captures him drunk ("Hey Slim, I drink a fifth of vodka") and drugged ("I'm on a thousand downers, now I'm drowsy"), driving toward a bridge, the never-ending storm still audible, bursts of his pregnant girlfriend's muffled screams coming from the trunk. Tires squeal, glass shatters, and thunder cracks as the car plummets into the water below the bridge. The final verse reveals Eminem's cautious, concerned response to the fan's initial mail—"I hope you get to read this letter / I just hope it reaches you in time / Before you hurt yourself"—prior to realizing that a news story from a few weeks back was about the fan he's writing to.

In its vivid portrait of tragic youth, its cinematic use of sound effects, and its bleak ultimate turn, "Stan" not only echoes and updates the murder ballad, but also breathes new life into the immensely popular death discs of the 1960s.

The birth of teen culture in the 1950s was spurred by a postwar economic boom that gave teenagers spending power for the first time in history and created a demand for products specifically designed for them. By the time James Dean's Porsche 550 Spyder crashed headlong into a 1950 Ford Custom Tudor coupe (driven by a twenty-three-year-old Cal Poly student), on September 30, 1955, Dean was already a cultural icon, despite having had leading roles in only two films at that point: *East of Eden* and *Rebel Without a Cause* (*Giant* was released posthumously in 1956). After death, Dean was forever young, forever misunderstood, his passing for teenagers of the 1950s

what Kurt Cobain's was for teens in the 1990s. It has since inspired a number of songs, including 1956's cautionary "Message from James Dean," by Bill Hayes; the Beach Boys' a cappella "A Young Man Is Gone," from 1963's *Little Deuce Coupe*; and "Daddy's Speeding," from Suede's majestic 1994 *Dog Man Star*. It was also one of three events in 1955 that laid the groundwork for the huge glut of teen-age tragedy records in the coming years. The second linchpin was the release of *Blackboard Jungle*, starring Glenn Ford and Sidney Poitier and the first film to use a rock 'n' roll song—Bill Haley and the Comets' "Rock Around the Clock"—in its soundtrack. And the third was the decidedly less-well-known release of the "Black Denim Trousers and Motorcycle Boots" by the Cheers.

Though the death disc is a catch-all that could technically include everything from Vernon Dalhart's "Wreck of the Old 97" to Eminem's "Stan," its heyday ran from the late fifties with the release of "Endless Sleep" in 1958 through 1965, which saw the release of two gems from the Shangri-Las, "Give Us Your Blessings" and "I Can Never Go Home Anymore." These tracks almost always included narratives revolving around the untimely death of a young man or woman and were often sweetened by producers with cinematic sound effects (singing birds, roaring motors, etc.). Though a handful of recordings, such as "Black Denim Trousers and Motorcycle Boots" and "Endless Sleep," trammeled down the path as predecessors, the death-disc phenomenon truly kicked off with the October 1959 release of Mark Dinning's "Teen Angel."

Written by Dinning's sister, Jean, and brother-in-law, Red Surrey, the song—about a young man who saves his nameless sixteen-year-old sweetheart from a car stuck on railroad tracks (a train rushing toward them), only to watch her tragically return to the car to retrieve his "high school ring"—faced a number of radio bans, none of which did much to stop it from reaching the top spot on the *Billboard* charts in February 1960. "Teen Angel" may have gotten things started for the golden age of the death disc, but it hasn't held up well—Dinning's wispy, quivering falsetto serves the material well enough, but the melody, lyrics, and production are anemic compared with the dramatic bite of the songs that followed quickly in its wake.

The other tragic hit that helped sound the starter pistol for the era was "Tell Laura I Love Her," which became a huge success for both Ray Peterson (US number seven) and Ricky Valance (UK number one) in 1960. It was one of the biggest of the vehicular tragedy songs, even if it was originally written about a rodeo rider being gored to death by a bull, a concept that was tweaked to catch some of the trailwind from the success of "Teen Angel" (listen for the nice addition of the organ as Laura visits the church in the final verse). It also sparked an early response song in 1961's "Tell Tommy I Miss Him" by Laura Lee. "Tell Laura I Love Her" also followed "Teen Angel" in being banned in the UK. In fact, Decca Records executives in the United Kingdom thought Peterson's recording was downright tasteless and destroyed twenty thousand copies of the single rather than release it, clearing the path for the Valance version to speed up the charts, his label somewhat less concerned with any moral degradation the song represented.

Most of the records dealt with automobile accidents: "Tell Laura I Love Her," J. Frank Wilson and the Cavaliers' "Last Kiss," Jan & Dean's "Dead Man's Curve," Ronnie Dante's "In the Rain," and others. But every stripe of vehicular tragedy made an appearance: the Shangri-Las' 1964 smash "Leader of the Pack," Twinkle's hit "Terry" (also 1964), and the Goodees' "Condition Red" from 1969, all revolved around speeding motorcycles; and the Everly Brothers' weeper "Ebony Eyes" as well as the Beverley Sisters' answer single, "Flight 1203," concerned themselves with the dangers of air travel.

Arguably no single group owned the death disc as the Shangri-Las did. Their "Leader of the Pack," a song about an alpha male greaser who suffers a brief, if mortally inconvenient, moment of road rage, the nadir of the era. The song opens with bare piano chords tolling at a funerary pace, punctuated by singer Mary Weiss's sheepish "uh-uh" when she's asked if her new boyfriend is going to pick her up from school that afternoon, foreshadowing the doom to come. In nursery rhymes (sad/bad, why/cry) interlaced with the recurring growl of a motorcycle, this unassuming epic builds to a tire-screeching climax before exiting on the grim chorus: "The leader of the pack and now he's gone." As perfect a gem as "Leader of the Pack" is, the "Shangs"

nearly matched it with other contenders for the death-disc crown: 1965's "Give Us Your Blessings"—about star-crossed lovers who can't see the road ahead for the rain (and their tears), notable because both young lovers die, leaving only their parents to mourn them— and the despairing "I Can Never Go Home Anymore."

The genre seemed to spawn as many parodies as it did source material, with some prime examples being Bob Luman's 1960 song "Let's Think About Living" ("In every other song that I've heard lately some fellow gets shot / And his baby and his best friend both die with him as likely as not"); Johnny Cymbal's "The Water Was Red" (trading in a speedy automobile for a man-eating shark), also from 1960; "(All I Have Left Is) My Johnny's Hubcap," by the Deltones, which features a forlorn teenager who wears a hubcap as a necklace (perhaps predating the bling era by three decades); and unparalleled in its ghoulish glory is Jimmy Cross's 1965, notably over-the-top "I Want My Baby Back," which offers a post-Beatles-concert car accident, is stuffed with sound effects, and ends with a twisted denouement that ensures the song's place on every necrophiliac's all-time top ten.

Though the death-disc heyday mostly petered out in the mid-sixties, it has continued to live on in songs like Bobby Goldsboro's "Honey," from 1968; "Johnny Don't Do It," from 10cc's 1973 debut; and David Geddes's "Run Joey Run," in 1975, which found a new lease on life in 2010 thanks to its inclusion in an episode of *Glee*. Two recent songs that flirt with the themes of the genre are M83's "Don't Save Us from the Flames" (2005) and the Flaming Lips' "Mr. Ambulance Driver" (2006), which isn't expressly about teen tragedy, although singer Wayne Coyne has described it as "a kind of Eddie Rabbitt at the roller rink, easy-listening teenager car-crash ballad."

THE MISERABLE LIST: BLOODRED AND GOING DOWN

1. "Stack O'Lee"—Mississippi John Hurt (1928)
2. "The Murder of the Lawson Family"—The Carolina Buddies (1930)
3. "Knoxville Girl"—The Louvin Brothers (1959)

4. "There Is Something On Your Mind, Part 2"— Bobby Marchan (1960)

5. "Pretty Polly"— Dock Boggs (1964)

6. "Sniper"— Harry Chapin (1972)

7. "Nebraska"— Bruce Springsteen (1982)

8. "Where the Wild Roses Grow"— Nick Cave with Kylie Minogue (1996)

9. "Stan"— Eminem (2000)

10. "Bass Song"— Hayden (2001)

THE MISERABLE LIST: I WAS A TEENAGE TRAGEDY

1. "Death of an Angel"— Donald Woods and the Vel-Aires (1955)

2. "Tell Laura I Love Her"— Ray Peterson (1960)

3. "Star-Crossed Lovers"—The Mystics (1961)

4. "Ebony Eyes"—The Everly Brothers (1961)

5. "Johnny Remember Me"—John Leyton (1961)

6. "I Can Never Go Home Anymore"—The Shangri-Las (1965)

7. "Requiem (For A Girl Born of the Wrong Times)"—Betty Barnes (1968)

8. "The Beginning of My End"—The Unifies (1969)

9. "Blasphemous Rumours"— Depeche Mode (1984)

10. "Daddy's Speeding"—Suede (1994)

JOHNNIE RAY

Tall and spindly, with big ears that actually captured little sound (he was largely deaf), Johnnie Ray looked a bit like a campestral Jacques Brel (he has been, not inaccurately, described as "Lincoln-esque"), but this unassuming farm boy from the Pacific Northwest possessed an emotive singing and performance style drawn from R&B that made him an unlikely but critical link between the expressive crooning of Frank Sinatra and the kinetic energy of Elvis Presley. John Alvin Ray was born on January 10, 1927, in Dallas, Oregon. He picked up music quickly and was pounding out tunes by ear on

a pump organ by three or four. But in the summer of 1940, while playing a game of blanket-toss at a Cub Scout Jamboree, he suffered a fall that would impair his hearing and dramatically alter his life, ultimately paving the way to his unconventional route to the top of the pop charts. No one reported his accident and Ray simply hoped his hearing would return. It didn't, and in the months that followed he began to feel more and more removed from his classmates (like "the loneliest boy in the world," he recalled), ultimately being outfitted with a bulky hearing aid. By the late 1940s he had made up his mind to become an actor and, like so many others with stars in their eyes, he traveled to Los Angeles only to face a litany of rejections. Miraculously he began to make his living as a singer—his hearing loss and the poor quality of hearing aids in the 1940s and 1950s meant that Ray couldn't pick up much bass and he had trouble keeping time with his backing bands. His struggles led to a unique style that looked and sounded like nothing the genteel white singers of the day were practicing—he slammed his fingers onto his piano keys (anticipating Jerry Lee Lewis), gnashed his teeth, and, rumor has it, shed tears while singing, which may have contributed to the illusion that his rhythmic singing imitated the sounds of sobbing. He claimed that more than one house manager dismissed him by saying, "Look kid, you're too weird for this room." His emotive style (deeply influenced by Billie Holiday) and ballad-heavy songbook eventually led to nicknames such as the Prince of Wails and the Nabob of Sob. It fit in perfectly, however, at all-black or mixed-race clubs, and in 1951 Ray found himself the lone white performer on a bill at the Flame Show Bar in Detroit, backed by future Motown Records wizard Maurice King and his twelve-piece orchestra. A local DJ (Bobby "Robin" Seymour) caught his act and passed the word on the idiosyncratic singer to Danny Kessler, the head of the newly revived Okeh Records. Before long, Ray found himself in the studio recording two of his own compositions ("Whiskey and Gin" and "Tell the Lady I Said Goodbye") under the Okeh banner. The tracks slowly picked up steam—*Billboard* called Ray "a cross between Kay Starr and Jimmy Scott"—and despite "Whiskey and Gin" being banned on the radio due to its suggestive nature, the record continued to sell

in urban centers like Boston, Buffalo, Philadelphia, and Cleveland. Taking Ray to the next level proved difficult as, minus evidence to the contrary, many believed he was a black woman—Kessler recalling record executives musing, "We don't think she's gonna make it!" Ray's fan base, however, was rabid—nearly tearing the clothes from his back at a tour stop in Cleveland—and it grew even more so following the release of his signature tune, 1951's delicate and somber "Cry." The song sold millions of copies and ruled the pop charts for eleven straight weeks, while the B-side, Ray's own "The Little White Cloud That Cried," found its way to number two, the duo of tearjerkers becoming the first two-sided chart-topping single and sparking an overnight demand for what became known as "sob ballads." But Ray's career was in danger of being derailed before "Cry" hit the radio: he had been arrested in Detroit for soliciting sex from an undercover vice officer targeting men in a burlesque-house restroom. The singer pled guilty, paid a fine, and the story disappeared, but the arrest would dog the singer on and off for years. He had another hit with "Please, Mr. Sun," in 1952, and married briefly the same year, his new wife, aware of the singer's homosexuality, stating that she would "straighten it out." They divorced two years later and Ray never remarried. The hits kept coming, though, including, "Walkin' My Baby Back Home," "All of Me," "Somebody Stole My Gal," and his own gospel composition "I'm Gonna Walk and Talk with My Lord." An attempt at a film career fizzled and he soon began an odd affair with Dorothy Kilgallen, an infamous journalist fifteen years his senior. (Kilgallen's mysterious death, in 1964, which conspiracy theorists tie to the JFK assassination, devastated Ray.) In 1956, returning from a two-month stay in England, Ray returned to a US pop landscape that had been forever altered by one Elvis Aaron Presley—suddenly even Ray's onstage histrionics seemed . . . square. He would still score a gigantic hit with "Just Walking in the Rain," an R&B song originally written and released in 1953 by the Prisonaires, but whereas the Prisonaires' version dropped out of site after release, Ray's dramatic rendition lingered on the US pop charts for twenty-eight weeks, peaking at number two (it hit number one in the UK), unable to knock off, among other chart toppers, Presley's

"Love Me Tender." In 1958 the singer underwent two radical operations to improve his hearing that turned out to be disastrous, compounding his hearing problems. And in 1959 he was arrested again for soliciting sex from an undercover officer in a Detroit gay bar, dredging up his first arrest at a time when his career was already teetering on the edge of the cultural dustbin. The arrest took a toll on his American audience, but the singer remained popular in Europe. Ray persevered, recording, performing, and remaining always keenly aware of the impact he had on popular music, saying, "I imagine that I paved the way for what was to come, which was to be called rock and roll." Ray, who battled alcoholism and self-destructive behavior for much of his later life, died in Los Angeles of liver failure on February 24, 1990. He was sixty-three years old. Though largely overlooked now, Mr. Cry has continually sneaked into the cultural forefront: He's the centerpiece of the first verse of "Come On Eileen" by Dexy's Midnight Runners ("Poor old Johnnie Ray sounded sad upon the radio"), he makes a flickering appearance in Billy Joel's "We Didn't Start the Fire," Edwyn Collins wrote "Johnny Teardrop" about the singer, and Portishead sampled his vocal (from "I'll Never Fall in Love Again") for the song "Biscuit" from their 1999 debut, *Dummy*.

THE MISERABLE LIST: JOHNNIE RAY

1. "Tell the Lady I Said Goodbye"—Single (1951)
2. "Cry"—Single (1951)
3. "The Little White Cloud That Cried"—B-side, *Cry* (1951)
4. "(Here Am I) Brokenhearted"—B-side, *Please, Mr. Sun* (1952)
5. "Coffee and Cigarettes (Think It Over)"—Single (1952)
6. "Please, Mr. Sun"—Single (1952)
7. "Oh, What a Sad, Sad Day"—Single (1953)
8. "Just Walking in the Rain"—Single (1956)
9. "I'm Confessin'"—*Til Morning* (1958)
10. "In the Heart of a Fool"—Single (1960)

RED HOUSE PAINTERS/MARK KOZELEK

Born on January 24, 1967, in Massillon, Ohio, Mark Kozelek began playing guitar before he was ten and made his way to Atlanta in is late teens. There he met drummer Anthony Koutsos and created the first incarnation of Red House Painters (RHP)—a name that came to the teenage Kozelek by way of a friend's painting crew that went by the name the International League of Revolutionary House Painters. After the duo traded in Atlanta for San Francisco they restaffed, with guitarist Gorden Mack and bassist Jerry Vessel joining the lineup. A Red House Painters demo eventually ended up in the hands of Ivo Watts-Russell at 4AD, who released the songs a few months later as 1992's *Down Colorful Hill*. Everything Kozelek has done is an expansion on what existed at the outset: The unforgiving pace, the reverb-soaked guitars, songs that scratch the ten-minute marker, the world weary vocal and blunt, introspective lyrics that fall across the songs like fragments of a shredded diary. Digging no deeper than the opening verse of "Medicine Bottle" reveals what's to come in Kozelek's career as he sings "Letting someone into my misery / I told it all step by step." By the time *Down Colorful Hill* hit the shelves, Kozelek's skill at conveying his deepest, sepia-toned turmoil had already improved greatly and the group had collected a clutch of material, which they split between two self-titled albums in 1993, unofficially, *Red House Painters I* (a.k.a. *Rollercoaster*) and, later that year, *Red House Painters II* (a.k.a. *Bridge*). He explored in painful detail the dissolution of his relationships ("Katy Song," "Bubble") and his struggle to comprehend his own darkest nature ("Uncle Joe"). But for all the emotional heft, Kozelek wasn't without a sense of humor, as evidenced by the 1994 *Shock Me* EP, which turned the 1977 Kiss song "Shock Me"—Ace Frehley's lead-vocal debut—into a groveling dirge ("Don't cut the power on me / I'm feeling low"). Long-running tensions between 4AD and Kozelek reached a head when the label suggested he cut the twelve-minute-plus running length of "Make Like Paper." Kozelek refused and the label

eventually released *Ocean Beach* in 1995 without the troublesome song, but when Kozelek later announced he was chipping away at a solo album, the relationship with 4AD evaporated. Gorden Mack exited the group and was replaced by Phil Carney while Kozelek quickly recorded the "solo" album, 1996's *Songs for a Blue Guitar*, which turned out to be more or less solo in all but name, and appeared as a Red House Painters' release. RHP recorded *Old Ramon* just in time for the messy label mergers of the late nineties to ensure it would do little more than collect dust for the rest of the decade. After appearing in Cameron Crowe's 2000 film *Almost Famous* and releasing his first solo EP—2000's *Rock 'n' Roll Singer,* which featured a clutch of AC/DC covers, a John Denver tune, and three new songs—Kozelek rescued *Old Ramon* and found it a home at former grunge palace Sub Pop, which would release it in 2001, just months after Kozelek released his first true solo long-player, *What's Next to the Moon.* By the following year, the singer/songwriter was itching to get back into a band setting, and formed Sun Kil Moon—an admitted continuation of Red House Painters in a new disguise—with Koutsos, bassist Geoff Stanfield, and American Music Club drummer Tim Mooney. Kozelek was still the center of the universe and his MO changed little with the 2003 release of *Ghosts of the Great Highway,* an album informed by post–9/11 dread, dead boxers, and broken hearts. By all accounts, 2005 was an odd year for Kozelek: He again appeared onscreen, this time in the adaptation of Steve Martin's *Shopgirl*; and joined fellow slowcore star Alan Sparhawk of Low for an EP of cover songs as the Retribution Gospel Choir. Sparhawk continued with the group, but Kozelek did not, instead founding the Caldo Verde label and released *Tiny Cities,* Sun Kil Moon's curious sophomore effort that was essentially a Modest Mouse tribute album. Kozelek explained his reasoning to *The Onion*'s *AV Club* by saying, "I think Isaac Brock is that good." Following the death of his ex-girlfriend and longtime muse, Katy, Kozelek disappeared for a time, resurfacing in 2008 with *April*—which featured vocal contributions from Will Oldham and Death Cab for Cutie's Ben Gibbard—and 2010's *Admiral Fell Promises.*

THE MISERABLE LIST: RED HOUSE PAINTERS/ MARK KOZELEK

1. "Medicine Bottle"—Red House Painters: *Down Colorful Hill* (1992)
2. "Katy Song"—Red House Painters: *Rollercoaster* (1993)
3. "Uncle Joe"—Red House Painters: *Bridge* (1993)
4. "Shock Me"—Red House Painters: *Shock Me* EP (1994)
5. "Song for a Blue Guitar"—Red House Painters: *Songs for a Blue Guitar* (1996)
6. "I'm Sorry"—Red House Painters: *Take Me Home: A Tribute to John Denver* (2000)
7. "Carry Me, Ohio"—Sun Kil Moon: *Ghosts of the Great Highway* (2003)
8. "Lost Verses"—Sun Kil Moon: *April* (2008)
9. "Heron Blue"—Sun Kil Moon: *April* (2008)
10. "Ålesund"—Sun Kil Moon: *Admiral Fell Promises* (2010)

LOU REED

After his father changed the family name from Rabinowitz, Lewis Allan Reed was born on March 2, 1942, in Brooklyn, New York. His youth was marked by rock 'n' roll dreams and a tumultuous family life; at one point he was subjected to painful shock therapy in an attempt to cure his "homosexual tendencies." He was playing guitar and writing songs by his teens, which—following his graduation from Syracuse University—led him to Pickwick Records. There he worked as a songwriter, churning out forgettable rock and novelty songs like "The Ostrich," the recording of which, under the working name the Primitives, led Reed and classically trained Welsh bohemian John Cale into the same studio. The two soon began working together under various names—the Warlocks, the Falling Spikes—and, once guitarist Sterling Morrison and drummer Angus MacLise were on board, the group finally settled on a name

taken from a book of aberrant sex acts: the Velvet Underground. MacLise was soon replaced by Maureen "Moe" Tucker, but it was when pop artist Andy Warhol became involved, adding them to his Exploding Plastic Inevitable show and embedding German model and singer Nico in the group's lineup, that sparks really began to fly. The Velvets' 1967 debut album, *The Velvet Underground and Nico*, and its follow-up, 1968's *White Light/White Heat*, didn't set the world ablaze when released, but the repercussions from them are still being felt in popular music. It was here that Reed laid out the blueprint for his solo career, writing songs that pushed the accepted barriers of the secular trinity, exploring kinky sex, hard drugs, and nervous, intelligent, vital rock 'n' roll delivered in intermittent blasts of confrontational noise and fragile beauty. It quickly became obvious to everyone that Cale and Reed couldn't coexist in the same musical universe—Cale driving the band toward drone and experimentation while Reed was more interested in subverting the pop form from within—and Cale exited the group in 1968, with most of the Velvets' more provocative musical aspirations disappearing with him. Reed, Morrison, Tucker, and Cale's replacement, Doug Yule, went on to release two more classic, if less abrasive, albums, 1969's *The Velvet Underground* and 1970's *Loaded*. Reed left the Velvets before the latter was released, and his return to the spotlight two years later with a self-titled solo album largely fell flat. Enter glam rock's wiry figurehead, David Bowie, and guitarist Mick Ronson (then in their gleaming Ziggy Stardust heyday), who helped Reed to craft 1972's glam-trash classic, *Transformer*, which was brimming with jewels like "Vicious" and the seedy shuffle of "Walk on the Wild Side," which became Reed's only top-twenty hit. Building on the song "Berlin," which first appeared on his debut solo album, Reed created what is arguably the greatest, and certainly the darkest and most ambitious, album of his career, 1973's bleak song cycle *Berlin*. The album tells the story of Caroline and Jim, two drug-addled lost souls who spend their days soldiering through depression and betrayal. The album was a hit in the UK, but flopped stateside, and Reed, after cutting the blistering live *Rock 'n' Roll Animal*, got lost in heroin addiction. He bleached his hair blond and cut 1974's

crisp, dull *Sally Can't Dance,* which, oddly, found an audience and slipped into the US top ten, but in retrospect is often considered one of his lesser efforts. Even more divisive is 1975's *Metal Machine Music,* an album composed of more than an hour's worth of feedback and distorted guitar that Lester Bangs called "some sort of ultimate antisocial act." Reed's own liner notes for the album admit, "No one I know has listened to it all the way through, including myself"; it enraged fans, record stores, and even some of his inner circle. If *Metal Machine Music* was an act of war, 1976's *Coney Island Baby*—a laid-back album filled with his best set of pop material since *Transformer*—was an olive branch. *Rock and Roll Heart* followed quickly that same year. As New York became ground zero for the US punk movement, Reed rightly became the scene's grumpy godfather, releasing the emotionally raw *Street Hassle* in 1978, which contained the distressing eleven-minute title-track mini-epic. Reed closed out the 1970s with 1979's *The Bells,* an album of sleek rock that ends on a high note with free-jazz artist Don Cherry adding melancholy sax over a thick fog of synthesizers. Reed bookended the 1980s with two of his greatest albums, 1982's *Blue Mask* and 1989's *New York.* He cleaned himself up for the former, writing mature, personal, and poetic songs about his struggles with addiction ("Underneath the Bottle" and "Waves of Fear") and the joys of his new, clean life ("My House" and "Average Guy"). Released the following year, *Legendary Hearts* was nearly as good, if more cynical, touched by chilly heartsick material like "Make Up My Mind" and "Betrayed." The surprising success of Suzanne Vega's "Luka," in 1987, may have allowed "Dirty Blvd."— his first single from *New York*—a brief flirtation with MTV and exists now as a gritty and vibrant snapshot of a New York City on the cusp of the cleanup Mayor Rudolph Giuliani would enact when he entered office in 1994. Following Andy Warhol's death on February 22, 1987, Cale and Reed—largely estranged since the former was squeezed out of the Velvets in 1968—cowrote an album of songs based on their lives with the iconic pop artist, resulting in the brilliant and heartfelt *Songs for Drella* in 1990. After losing

two other close friends within the space of a year, Reed devoted his 1992 album, *Magic and Loss*, to themes of sickness and mortality. Filled with drifting, largely mid-tempo material that fits the aggrieved nature of the songs, *Magic and Loss* is likely his last truly great album. Later efforts—1996's *Set the Twilight Reeling*, 2000's *Ecstasy*, and 2003's tribute to Edgar Allan Poe, *The Raven*—are all widely uneven sets. A devoted tai chi practitioner, Reed released the unambitious ambient set *Hudson River Wind Meditations* in 2007, which he composed for his own meditations. Also that year he took his haunting 1973 album *Berlin* on the road with his director and friend, artist and filmmaker Julian Schnabel, directing a concert film that was released in 2008 alongside the album *Berlin: Live at St. Ann's Warehouse*. In the summer of 2011 it was announced that Reed's next project would an album-length collaboration with stadium riffage barons Metallica. Based on the works of fin de siècle German playwright Frank Wedekind, *Lulu* was released later that year and proved a disastrous miscalculation that had some sniping that it was the worst record of all time—though *The Wire* noted it as one of the top ten albums of the year.

THE MISERABLE LIST: LOU REED

1. "The Kids"—*Berlin* (1973)
2. "The Bed"—*Berlin* (1973)
3. "Street Hassle"—*Street Hassle* (1978)
4. "The Bells"—*The Bells* (1979)
5. "The Day John Kennedy Died"—*Blue Mask* (1982)
6. "Betrayed"—*Legendary Hearts* (1983)
7. "Xmas in February"—*New York* (1989)
8. "Hello, It's Me"—Lou Reed and John Cale: *Songs for Drella* (1990)
9. "Cremation (Ashes to Ashes)"—*Magic and Loss* (1992)
10. "Vanishing Act"—*The Raven* (2003)

AMÁLIA RODRIGUES

The history of fado can be traced back to the early nineteenth century and the ports of Portugal (the genre features more than its share of widowed fishermen's wives), its roots coming from traditional Spanish and Portuguese songs as well as Afro-Brazilian dances. The form is philosophically aligned with the notion of *saudade*, a deep, painful longing colored by regret, and if a fadista (a fado singer) hasn't brought an audience to tears by the time they have finished their performance, they haven't done their job. Few controlled the taps like the Queen of Fado, Amália Rodrigues. In the song "Tudo Isto É Fado" ("All of This Is Fado") Rodrigues delivers an education in the genre, ticking off the defining attributes of the song form, singing, "Love, jealousy / Ashes and fire / Sorrow and sin / All of this exists / All of this is sad / All of this is fado." Born on July 23, 1920, in the Alfama district of Lisbon, Portugal, Amália da Piedade Rodrigues was one of ten children; she was abandoned by her mother while still an infant and raised by her maternal grandmother. When she was young she earned money selling produce, working as a seamstress, and dancing before she became an overnight success following her professional singing debut at nineteen alongside her younger sister, Celeste, at the Lisbon nightclub Retiro da Severa. Beyond simply becoming the most popular fadista in the world, Rodrigues pushed the boundaries of what fado meant. Beautiful and talented, she acted as muse for many poets and composers, beginning with classically trained composer Frederico Valério, who wrote material for her distinctly sad voice, and broke with fado tradition (a fadista is traditionally accompanied by the round, mandolin-like Portuguese guitar) by adding orchestral elements to songs like "Fado do Ciúme" and "Ai Mouraria." By the early 1950s poets great and small were providing lyrics for her work, and where traditional fado concerned itself solely with the pangs of lost love, Rodrigues dug even deeper into more metaphysical concerns such as the soul, God, and destiny, and she broke down the barriers that separated Lisbon's urban version of the song form and Coimbra's more rural expression. She starred in

films in Portugal—notably the 1946 film *Fado* and Henri Verneuil's 1954 French film *Les Amants du Tage* (*The Lovers of Lisbon*)—but later refused a number of offers to appear in American films. In 1953 she became the first Portuguese artist to appear on American television with a performance on Eddie Fisher's *Coke Time*, singing "Coimbra." It was already a fado classic, taking its name from the small university city of Coimbra, and Rodrigues reinterpreted the song as "April in Portugal," and its worldwide success made her a star. She receded from the public at the end of the 1950s and married engineer César Seabra in 1961, returning to fado the following year with an untitled album (known as either *O Busto* ["Bust"] or simply *Amália Rodrigues*) that would prove the first of her many collaborations with French composer Alain Oulman, who, like Valério before him, pushed the boundaries of fado by taking Rodrigues's voice into operatic territory. She toured the world, and her international fame was never greater. In 1965 she recorded standards in English for the album *American Songs* (subsequently retitled *Amália on Broadway*), and she collaborated with jazz saxophonist Don Byas for the 1968 album *Encontro*. During the 1970s her voice began to lose its power, though she still recorded frequently and continued to perform until 1995, when she was well into her seventies. Following heart surgery Rodrigues spent her final years as a semi-recluse. She died on October 6, 1999, at the age of seventy-nine. Upon hearing the news Portuguese prime minister António Guterres ordered three days of national mourning. "I have so much sadness in me," Rodrigues once said describing her attributes as an artist. "I am a pessimist, a nihilist; everything fado demands in a singer, I have in me."

JIMMY SCOTT

There is an otherworldly heartbreak woven into the voice of Jimmy Scott, a jazz balladeer whose unique vocal was shaped in large part by Kallmann's syndrome, what Scott referred to as "the Deficiency," a rare hereditary condition that arrests a body's development

before the onset of puberty. As a result, Scott's vocal was frozen as the castratolike soprano of his youth, and he never grew taller than four feet ten inches, but the emotive wellspring at his command belied his diminutive frame. Born James Victor Scott on July 17, 1925, the third of ten children, Scott was orphaned at thirteen after his mother was killed in an automobile accident. His first big break came with vibraphonist Lionel Hampton, who asked the twenty-three-year-old Scott to join his band in 1948, and soon rechristened the singer Little Jimmy Scott. Quincy Jones, also a member of Hampton's group, recalls that the band called him Crying Jimmy Scott, saying, "Night after night, I'd be sitting back there in the trumpet section listening to this man cry his heart out." Two years later his first recording session with Hampton produced the top-ten R&B hit "Everybody Is Somebody's Fool." Scott exited Hampton's ensemble not long after, and in the ensuing years recorded a number of singles and albums for the Regal, Roost, and Savoy labels. and then, notably, 1963's *Falling in Love Is Wonderful*, for Ray Charles's Tangerine label, and 1969's *The Source* for Atlantic. Unfortunately, the latter two albums, the best of the singer's career, fell under threat of legal action from Savoy label head Herman Lubinsky, who claimed ownership of Scott's contract. Both were pulled from the shelves within weeks of their release and Scott's vocals were erased from *Falling in Love Is Wonderful* and replaced by Wild Bill Davis's organ, the new tracks rereleased under Wild Bill's name as *Wonderful World of Love*. For much of the time between the disappointment of *Falling in Love Is Wonderful* and the late 1980s, Scott all but turned his back on music, caring for his ailing father and picking up menial employment as a dishwasher, elevator operator, and as a busboy and cook at a Bob's Big Boy. He sang sporadically until 1991, when performing at the funeral of his friend and supporter Doc Pomus, Sire Records boss Seymour Stein was so touched, he immediately moved to get Scott back in the studio. In quick succession director David Lynch cast Scott in the final episode of his groundbreaking cult hit *Twin Peaks*; Lou Reed asked him to lend vocals to his 1992 album *Magic and Loss*; and Scott released his comeback album, *All the Way*. Scott also contributed a menacing performance to the *Twin Peaks: Fire Walk with Me* soundtrack under the direction of composer

Angelo Badalamenti that may have been the singer's second-act high point: "Sycamore Trees" is as romantic as it is sinister, Scott's smoke-ring vocal rising slowly through a haunting accompaniment of upright bass and scuffling percussion. Scott continued to perform and record even as his voice began to break down (taking on a tone similar to that of Billie Holiday's late recordings), releasing a number of revelatory albums (including 1998's *Holding Back the Years* and 2002's *But Beautiful*) that contained more revealing moments of heartbreak than singers half his age could summon. As Marvin Gaye once said of him, he simply "had that tear in his voice."

THE MISERABLE LIST: JIMMY SCOTT

1. "Everybody's Somebody's Fool"—Single (1950)
2. "I'm Through With Love"—*If You Only Knew* (1956)
3. "Sometimes I Feel Like a Motherless Child"—*The Fabulous Songs of Jimmy Scott* (1959)
4. "Why Try to Change Me Now?"—*Falling in Love Is Wonderful* (1962)
5. "Day by Day"—*The Source* (1969)
6. "Unchained Melody"—*The Source* (1969)
7. "Every Time We Say Goodbye"—*All the Way* (1992)
8. "Sycamore Trees"—*Twin Peaks: Fire Walk with Me* (1992)
9. "Nothing Compares 2 U"—*Holding Back the Years* (1998)
10. "Darn That Dream"—*But Beautiful* (2002)

THE SHANGRI-LAS

Of all the girl groups that appeared in the 1960s, swooning with the turmoil of teenage love and loss, none hit quite as hard or cut quite as deep as the Shangri-Las. Identical twins Marge and Mary Ann Ganser and sisters Mary and Betty Weiss formed the group in 1963 at Andrew Jackson High School in Queens, New York, taking their name from a local restaurant. They released their oft-ignored

first single, "Wishing Well"/"Hate to Say I Told You So" in early 1964, on the Spokane label, but it wasn't until the girls were hired by producer George "Shadow" Morton to record his melodramatic "Remember (Walkin' in the Sand)," that the Shangri-Las really took off. After hearing the results, Jerry Leiber and Mike Stoller signed both Morton and the girls, who were still minors—Mary, fifteen; the twins, sixteen; and Betty, seventeen—to their Red Bird label. A re-recorded "Remember" became both a blueprint for the Shangri-Las' sound (Infinite heartbreak? Check. Spoken word? Check. Dramatic Mary Weiss lead? Check. Sound effects? Seagulls!) and the Shangs' first hit, as it cracked the top five in late 1964. A steady stream of top-notch material from Morton, Ellie Greenwich and Jeff Barry, and Leiber and Stoller, along with inventive production and Mary Weiss's intense performances ("I had enough pain in me at the time to pull off anything," she later recalled) led to more hits. These included Green-wich and Barry's "Leader of the Pack," which topped the pop charts in the US and became definitive of both the girl-group sound and the death-disc phenomenon of the early 1960s. The song overflows with judgmental parents, rebellion, dread, death, tears, and reverb: After an intrusive father demands that his daughter stop dating a tempestu-ous gearhead, "Jimmy," the young rebel rides off in a rage as Weiss screams "Look out! Look out! Look out! Look out!" to the cue of squealing tires and shattering glass. (If Brian Wilson crafted teen-age symphonies to God, then Shadow Morton and the Shangs made tragic opera for teens.) Once the Shangri-Las invaded the charts, their official lineup usually consisted of Mary Weiss on lead vocals, with the identical Ganser sisters acting as a Greek chorus in black leather pants, while Betty Weiss, preferring not to tour, would make only sporadic appearances. A manufactured tough image was crafted for the young performers as a contrast to the demure countenance of other girl groups, an image that was accentuated by controversies such as Mary's transportation of a firearm across state lines after a man put his hand through the plateglass window of her hotel room. Primarily a singles band, the Shangri-Las did release on the Red Bird label two LPs, *Leader of the Pack* and *Shangri-Las '65!* in 1965, that

focused on their hits. Between 1964 and 1966 the girls performed alongside the biggest acts in rock and R&B, including the Beatles, the Zombies, the Drifters, Dusty Springfield, and James Brown—the Godfather of Soul apparently booking the girls without realizing they were white. Red Bird would be the home to all their best material, beginning with "Remember" and "Leader of the Pack" and ending with 1966's "Past, Present and Future," a haunting spoken-word single that features a cut-and-paste melody from Beethoven's *Moonlight Sonata* and a mysterious admonition from Mary: "Don't touch me / Don't try to touch me / 'Cause that will never . . . happen . . . again." The lyrics hint at rape, though Weiss has since claimed it's simply "about being hurt and angsty and not wanting anyone near you." In between, the group released bleak pop treasures like "Give Us Your Blessings"—which opens with a forbidding crack of thunder and concludes with the death of a pair of eloping young lovers too overcome by tears to read road signs. Their final top-ten hit was "I Can Never Go Home Again"—a maudlin weeper that, to no one's surprise, ends in tragedy (Weiss admits the she was brought to tears performing the song in the studio). But for all their successes, the Shangri-Las' story is full of holes with unreleased material, including the final work the group recorded with Morton for Mercury in the late sixties and songs recorded for Sire Records by a reunited Shangs (Mary, Betty, and Marge), in 1977 (after the original recording of "Leader of the Pack" surprisingly shot to the top of the UK charts the previous year). Sire passed on the efforts of the reunited trio, and the group looked for other outlets, but with visions of CBGBs dancing in their heads and disco the only thing on the minds of record executives, the group split once again. Mary Ann Ganser died mysteriously in 1970 from what could have been a drug overdose or a seizure, and her twin sister, Marge, passed away in 1998 after losing a battle against breast cancer. After years of legal wrangling, which has kept her tight-lipped about much of the Shangri-Las' history, Mary Weiss returned to recording with the release of her first solo album, 2007's fantastic *Dangerous Game*, which offered a gritty, garage-rock take on the epic pop of her teenage years.

THE MISERABLE LIST: THE SHANGRI-LAS

1. "Remember (Walkin' in the Sand)"—Single (1964)
2. "Leader of the Pack"—Single (1964)
3. "Maybe"—B-side, *Shout* (1964)
4. "Out in the Streets"—Single (1965)
5. "Give Us Your Blessings"—Single (1965)
6. "I Can Never Go Home Anymore"—Single (1965)
7. "Long Live Our Love"—Single (1966)
8. "He Cried"—Single (1966)
9. "Dressed in Black"—B-side, *He Cried* (1966)
10. "Past, Present and Future"—Single (1966)

JEAN SIBELIUS

Born on December 8, 1865, in Hämeenlinna, Finland, Johann Julius Christian Sibelius was a daydreamer whose emotionally distant mother created in her son a sense of isolation from his earliest days. He took to music when he was young and was very likely a synesthete (someone who experiences two senses as one, such as tasting sound or hearing colors), recollecting years later that when he was a child, G major was his favorite chord because it was brown, like the piano. He composed small pieces, such as "Rain Drops," by age nine, and at age fifteen was introduced to the violin, and immediately set about fashioning himself into a virtuoso. Despite being a poor student, Jean, as he was now calling himself, entered the University of Helsinki in 1885 to study law and music. The restless young composer couldn't maintain the charade of a legal education for long, however, and music soon became his lone concern. He studied intensely, and in 1888 published his first piece of music, "Serenade," in a book of Finnish songs. The following year he first laid eyes on "the prettiest girl in Finland," his future wife, Aino Järnefelt, whom he claimed to have fallen in love with instantly. While studying in

Berlin, Sibelius was rocked by the works of Richard Strauss (who was then just one year the Finn's senior but far advanced as a composer), and turned to alcohol and a bohemian lifestyle for solace. He rapidly ran out of money and suffered from an attack of "nerves" that led to a brief hospitalization—this grandiose sweep from the heights of ostentation to ruinous fits of despair point to a likely manic-depressive personality, as his personal secretary in his later years would attest: "It took very little suddenly to change his cheerfulness into moroseness, which, in turn, was as quickly dispelled by a friendly word." Upon his return to Helsinki he proposed marriage to Aino in secrecy, and then left for further study in Vienna, where, as in Berlin, he encountered works of such magnitude by Johann Strauss and Richard Wagner that his enthusiasm again became overcast (and it didn't help that his nerves would fail him during an audition for the Vienna Philharmonic Orchestra). Despite these setbacks, Vienna provided the backdrop for the initial furtive scratches that would soon become his first major work, the *Kullervo* symphony, based on the *Kalevala*— the national epic of Finland; think King Arthur under a blanket of snow. With the premiere of the *Kullervo* in April 1893, Sibelius was marked as a cultural leader in the Finnish battle for independence and instantly regarded as the premier Finnish composer—a turn of events that allowed him to finally marry Aino. The premiere of the *Lemminkäinen Suite* (*Four Legends*) in April 1896 only solidified his standing in his home country, yet the following year he lost out on a prestigious teaching position; as compensation the Finnish Senate awarded the composer a stipend that he would continue to receive for the remainder of his life. He composed songs and incidental music, but it wasn't until the 1899 premiere of both his Symphony No. 1 and *Finlandia*—the one work that will always be attached to this most nationalistic composer—that his talent began to expand to continental Europe. His Symphony No. 2 premiered in 1903, and the following year he built the villa on the shore of Lake Tuusula, in Järvenpää near Helsinki, that he would call Ainola, after his beloved wife, and would reside in for the remainder of his life (the residence is now a museum). In 1908 Sibelius faced what he referred to as a "frightening warning from above," when doctors gave the composer a diagnosis

of cancer and removed a tumor from his throat; he was advised there-
after against partaking in two of his favorite pastimes, drinking and
smoking. The April 1911 Helsinki premiere of the despondent Fourth
Symphony was met with little more than polite disgust—its New
York premiere, despite a warning from the conductor, saw more and
more attendees crowding the exits with each successive movement.
Classical-music critic Alex Ross writes: "If the Fourth is a confession,
its composer might have been on the verge of suicide." Sibelius was
aware of the sublimely dark nature of the work, writing to a friend,
"It has nothing, absolutely nothing of the circus about it." The string
quartet *Voces Intimae* (1909), the Three Sonatinas for piano (1912),
and the tone poems *The Bard* and *Luonnotar* (both 1913), along with
the Fourth, are often grouped together as the darkest stretch in the Si-
belius catalog. Some note that the constant fear of a recurrence of the
cancer wore heavily on his mind, naturally worming its way into his
output, to say nothing of his continued abstinence from tobacco and
alcohol—"my most faithful companion"—which began to enter his
life once again in 1915. During the First World War, Sibelius stayed
at Ainola, completing his decidedly more joyful, and shockingly
original, Fifth Symphony. He wrote his Sixth Symphony in 1923,
the unique one-movement Seventh Symphony followed in 1924, and
he completed the dissonant and earthy tone poem *Tapiola*—his last
major work—in 1926. Though Sibelius lived another thirty years,
much of it was in frustrated silence. "Isolation and loneliness are
driving me to despair," he confessed to his diary in 1927. His per-
sonal secretary recounts the composer's shaken self-confidence, writ-
ing that while other composers were fortunate to have died younger,
at the height of their powers, "Sibelius had thirty years of inner strife,
the hopelessness of which he must have recognized early on." Out-
side Ainola his reputation had become split—battered and dismissed
in Eastern Europe and celebrated in England and America—while
inside his forested villa he remained his own worst critic. As news-
papers wrote of the "Silence of Järvenpää," Sibelius, crippled by self-
doubt and weak hands that made work difficult, took to burning his
scores. The notorious Eighth Symphony, a work that consumed much
of the old master's emotional energies in his final years, is thought

to be among the works that disappeared in a cloud of black smoke over Ainola during the mid-1940s. When Finland aligned itself with Germany and the Nazi Party in 1941, Sibelius remained quiet and allowed his works to be celebrated as the creation of an "Aryan" composer. He aged with little peace in his soul, telling his personal secretary, "I look back for the bright spots in vain," and he died in his home at age ninety-one on September 20, 1957, from a brain hemorrhage. His legacy as "the apparition from the woods" has waxed and waned in the ensuing years, but has lately been celebrated for its unique spirit—subtly modern and staunchly romantic—and the revelatory depths of its expressive emotion.

THE MISERABLE LIST: JEAN SIBELIUS

1. Sonata in F Major (1895)
2. Romance in D Minor (1898)
3. Elegy from *King Christian II* Suite, Op. 27, No. 2 (1898)
4. *Svarta Rosor* (*Black Roses*) (1899)
5. *Sav, Sav, Susa* (*Reed, Reed, Rustle*) (1900)
6. *The Swan of Tuonela* (1900)
7. Violin Concerto (1905)
8. *Im Feld ein Mädchen Singt* (*In the Field a Maid Sings*) (1906)
9. String Quartet in D Minor: *Voces Intimae* (1909)
10. Fourth Symphony (1911)

NINA SIMONE

A singular talent in the landscape of twentieth century music, the iconoclastic Nina Simone bridged blues, jazz, classical, folk, rock, and gospel music influences and performed with a spirit. Born Eunice Kathleen Waymon on February 21, 1933, in Tryon, North Carolina, the sixth of eight children, she took to music early as something of a prodigy, her sister noting that by the age

of three, "her fingers were protected" from the wear of regular chores. By four she was performing for church audiences under her minister mother's watchful gaze. Simone eventually made her way to New York's prestigious Juilliard School during her teens and supported herself by giving piano lessons and performing as an accompanist. After Juilliard she hoped to continue her studies at Philadelphia's Curtis Institute of Music. She believed her concurrent rejection to be veiled racism, and the sting of the event stayed with her throughout her life. After she was offered a good-paying gig at a nightclub in Atlantic City but told she would have to sing, she added what she would refer to as her "third layer" (her left and right hands being the first and second layers) and adopted the name Nina Simone—a creation that married the Spanish for "little girl" and the surname of French actress Simone Signoret—out of shame at performing what she called "dumb, stupid tunes," and so that her mother would not find out she was performing secular music in such questionable environs. She first recorded for the small jazz label Bethlehem, releasing her debut album, *Little Girl Blue* in 1957. Her version of George Gershwin's "I Loves You, Porgy" was released as a single in 1959 and cracked the top twenty—the first and last time she would do so—but the album also features definitive takes on a dusky lover's lament, "Don't Smoke in Bed," and the album's Rodgers and Hart title song, which was taken from the 1935 Broadway show *Jumbo* and came to color the conversation about the singer's melancholy side. Her eclectic repertoire and already considerable confidence as a performer grew as she signed to the Colpix label that year, still suggesting her recording career "was all to raise money for proper tuition." Her extraordinary range can be evidenced on her first album for Colpix, 1959's *The Amazing Nina Simone*, which featured an English folk ballad ("Tomorrow"), a movie theme ("Theme from *Middle of the Night*"), jazz standards ("Stompin' at the Savoy," "Willow Weep for Me"), and a spiritual ("Children Go Where I Send You"), among others. A series of classic live releases followed (*Nina Simone at Newport*, . . . *at the Village Gate*, and . . . *at Carnegie Hall*). The exquisite 1964 album *Folksy Nina*—recorded at the same date as

Nina Simone at Carnegie Hall—features heartbreaking reads of "Lass of the Low County" and "When I Was a Young Girl." When she made the jump to Philips, in 1964 she began to infuse her music with social consciousness via songs like the blazing "Mississippi Goddam" and the introspective narrative "Four Women," two of her finest compositional credits. By this point, Simone had become a powerful enigma, lashing out at audiences who dared to talk during her sets (and admonishing others for not applauding with proper enthusiasm), while simultaneously delivering plangent performances in what journalist Frank Brookhouser described as "an atmosphere of blue lights and sad memories," her mood swings channeled through her music. One critic, who witnessed her live show at a Philadelphia supper club in 1966, said it was "like a journey to a dark and uncharted nether region of the soul where hate has mated with love and given birth to searing, tortured anguish." After a handful of albums for Philips she jumped to RCA, inaugurating her stay with 1967's *Nina Simone Sings the Blues*, which features her thrilling "I Want a Little Sugar in My Bowl," a woeful take on Buddy Johnson's "Since I Fell for You," and she plunders *Porgy and Bess* once again for the tearful, "My Man's Gone Now." Her 1969 album, *To Love Somebody*, opens with an acoustic funk reading of Leonard Cohen's "Suzanne," and largely splits the remainder between covers of Bob Dylan and Bee Gees songs. The long downward spiral for Simone began when she left the country in 1970. Soon after, she divorced her husband and manager, Andy Stroud; faced tax-evasion charges ("I came to expect despair every time I set foot in my own country," she wrote in her autobiography); and the legendary mood swings that had been a constant in her life since childhood became more severe—it's possible that Simone suffered from schizophrenia—even as she attempted to control them with medication. Her recordings became more sporadic, but the decade was highlighted by 1973's strange and powerful Vietnam commentary, *Emergency Ward*, and 1978's *Baltimore*. In 1987 her early recording of "My Baby Just Cares for Me" became an unexpected chart hit in the UK after appearing in a Chanel No. 5 commercial, though she saw no money from this after having signed

away the rights to the recordings decades earlier. Her final years were bleak and she had little to show for her extraordinary career, a fact that forced her into performances when she should have been attending to her personal demons. She recorded her final album, *A Single Woman*, in 1993. She died of breast cancer ten years later on April 21, 2003, at her home in Carry-le-Rouet, France. Her music stands today as strikingly influential and more popular than ever.

THE MISERABLE LIST: NINA SIMONE

1. "Little Girl Blue"—*Little Girl Blue* (1957)
2. "When I Was a Young Girl"—*Folksy Nina* (1964)
3. "Don't Let Me Be Misunderstood"—*Broadway-Blues-Ballad* (1964)
4. "Strange Fruit"—*Pastel Blues* (1965)
5. "Images (Live)"—*Let It All Out* (1966)
6. "Wild Is the Wind (Live)"—*Wild Is the Wind* (1966)
7. "My Man's Gone Now"—*Nina Simone Sings the Blues* (1967)
8. "Why? (The King of Love Is Dead)"—*'Nuff Said* (1967)
9. "Who Knows Where the Time Goes"—*Black Gold* (1969)
10. "I Think It's Going to Rain Today"—*Nina Simone and Piano!* (1970)

Suicide, It's a Suicide
Self-Harm and Song

Interestingly, one of the songs marked as a forebear to the death disc phenomenon, Jody Reynolds's "Endless Sleep" (a top-ten hit in 1958), concerns a young woman who throws herself into the ocean after a fight with her boyfriend. The final version of the song features only her attempted suicide and no actual death—"Reached for my darlin' / Held her to me / Stole her away from the angry sea"—though the original ending went without the final-verse heroism. Record executives had thought twice about the market's ability to bear such morbid material, but while suicide is a theme missing from the tragic records of the death-disc heyday, the attempted self-destruction of Reynolds's darlin' is nothing new for popular music.

Blues pianist Richard M. Jones wrote about flirting with suicide in his classic "Trouble in Mind"—"I'm gonna lay my head on some lonesome railroad iron / Let that 219 train satisfy my mind"—which was first caught on record in 1924 with Jones accompanying vocalist Thelma La Vizzo. (As with many blues songs from the time, these words are as likely to be a covert nod to the prevalent racial violence of the times as they are about any actual death wish.)

It wasn't long before popular music's single greatest contribution to suicidology occurred, in the same year the United States entered World War II, when Billie Holiday released what would become one

of her signature songs and the fountainhead of multiple urban legends, "Gloomy Sunday." First recorded in English in 1936 by Hal Kemp and His Orchestra, it was marketed as "the Hungarian Suicide Song," having inspired a series of suicidal acts in its original Hungarian.

Written and recorded in 1937 by overlooked country legend Rex Griffin, "The Last Letter" is a powerful lost weeper written in the form of a suicide note, and represents one of the earliest examples of the bare, confessional country music that would make Hank Williams a legend. One persistent legend about the song places its origin in an actual suicide letter Griffin wrote following the dissolution of his first marriage. His measured adenoidal vocal and gentle strumming give the song a matured sense of despair that dovetails with the desperate lyrics, particularly in lines like "If you don't love me I wish you would leave me alone." The song proved so popular that in 1939 Griffin wrote what may be one of the first "answer songs" when he penned "Answer to the Last Letter," recycling the melody of the original but providing the point of view of the young woman who left him for "another man's gold." Of course, she didn't know what she had until it was gone: "Though I would love to be with you I know it's too late."

The Carter Family, the Blue Sky Boys, Gene Autry, Ernest Tubb, Don Gibson, Marty Robbins, Connie Smith, Ray Price, George Jones, Willie Nelson, and Waylon Jennings all covered "The Last Letter" during their careers. Bob Dylan lifted the melody for "To Ramona," and Nashville's Beach Boys–style pop group Ronny and the Daytonas (best known for their hot-rod hit "G.T.O.") turned it into a delicate, arpeggiated ballad—lines like "Will you be happy when you are withered and old" turn menacing when sung in such a dewy tone.

Pat Boone's final number one hit, 1961's "Moody River," was a brief, bouyant narrative about a young woman who drowns herself in the titular tributary and leaves a note on the bank addressed to her boyfriend. It reaches a ghastly peak when Boone looks into the muddy waters and "sees a lonely, lonely face just lookin' back." Mark

Dinning followed up "Teen Angel" in 1962 with a maudlin teen-suicide drama called "The Pickup," but it pales next to the comparatively gruesome "Patches" by Dickey Lee from the same year. Lee's song is like a much more disturbing *Pretty in Pink*, as Patches, a girl from an "old shantytown" on the wrong side of the tracks, and Dickey, daydream about a summer wedding until Dickey's folks shut the whole thing down, because "a girl from that place" just couldn't be good enough for their son. The next we hear of Patches she's been found "floating face down" in a river and Dickey swears, "It may not be right but I'll join you tonight."

Percy Mayfield may be best known for penning the Ray Charles classic "Hit the Road, Jack," but he also jotted down a number of terribly miserable tunes that he recorded himself, including two that specifically touched on suicide—"River's Invitation" and "Life Is Suicide" (echoing Charley Patton's "Down the Dirt Road Blues" observation that "every day seem like a murder here"). Neither song was a hit, but both are fantastic R&B sides heavy-laden with despair.

Bobbie Gentry's mysterious, Southern-gothic suicide ballad "Ode to Billie Joe" spent four weeks atop the charts following its release in 1967. The song's steady, languid rhythm is punctuated by moaning strings that were arranged to mirror the curious and conversational dinner-table lyrics and add to the song's steamy sense of secrecy. In her raspy vocal Gentry recounts a family's reaction to the suicide of Billie Joe McAllister, who they just learned has "jumped off the Tallahatchie Bridge"; it's all the more enthralling for what it doesn't say than what it does. As the song patiently unfolds, it turns devious with the revelation that a local preacher recently saw Billie Joe and someone who looks just like the singer "throwing somethin'" (a ring, a draft card, a baby?) off the bridge.

A myth persists that Gentry's original take on "Ode" ran more than seven minutes in length and included eleven verses that filled in the plot holes in the final version, but no evidence has ever come to light to support that tale. Jimmie Haskell, who wrote the string arrangement for the song, claims never to have heard a longer version, saying that no one ever mentioned such a thing when he was working

with Gentry and her label. For her part, Gentry has said that even *she* doesn't know what was thrown from the bridge (and in any case the point of the song is about the indifference of the family to Billie Joe's death and of how two women experience similar losses yet still fail to find a meaningful connection to each other).

The first three years of the 1970s saw a steady stream of songs that dealt with suicide, perhaps in small part due to the huge success of "Ode to Billie Joe," just a few years previous. But more likely it can be attributed to a pendulum swing away from the pollen-dust haze of the flower-power movement following the assassinations of Martin Luther King Jr. and Robert F. Kennedy, along with the exhaustion of continued escalations in Vietnam. The turbulent times also coincided with a wave of opportunities for introspective singer-songwriters.

"Fire and Rain" was the biggest hit from James Taylor's 1970 debut album, *Sweet Baby James,* and was inspired partly by the suicide of his friend Suzanne Schnerr ("Suzanne, the plans they made put an end to you"). Robert Altman's film version of *M*A*S*H,* which premiered in 1970, prominently featuring the song "Suicide Is Painless," which was written by composer Johnny Mandel and featured lyrics by the director's fourteen-year-old son, Mike Altman.

What is arguably the most depressive song in Leonard Cohen's large miserabilist catalog, "Dress Rehearsal Rag," appears on his 1971 album *Songs of Love and Hate.* (It was originally recorded by Judy Collins for her album *In My Life* in 1966—the same year Simon and Garfunkel released their second album, *Sounds of Silence,* which itself featured two songs that dealt with suicide as a major theme: "Richard Cory" and "A Most Peculiar Man.") Billy Joel's "Tomorrow Is Today," from his 1971 album *Cold Spring Harbor,* presented lyrics drawn from a suicide note he had written the previous year, when he attempted to end his life by drinking furniture polish. (Joel later wrote "You're Only Human [Second Wind]" in 1985 to aid in teenage suicide prevention.) Don McLean's ode to Vincent Van Gogh, "Vincent (Starry, Starry Night)," was a monster hit in the fall of 1971, reaching number one on the UK charts. It alluded to the post-impressionist's suicide in the chorus—"And when no hope was left in sight on that starry, starry night / You took your life as lovers

often do"—even as recent evidence suggests the mercurial painter was likely murdered. One of the highlights of Jackson Browne's self-titled 1972 debut album, "Song for Adam," was written about a close friend of the singer/songwriter who had taken his own life. (Also of note, "Here Come Those Tears Again," from Browne's 1976 album, *The Pretender*, was cowritten with Nancy Farnsworth, the mother of Browne's wife, Phyllis Major, who had committed suicide earlier that year, just months after their marriage.) The year also saw the release of perhaps the biggest chart hit that chose suicide as its backdrop during the early seventies, Gilbert O'Sullivan's massive "Alone Again (Naturally)," which spent six nonconsecutive weeks at the top of the charts between July and September in 1972—incidentally, the same year the Tallahatchie Bridge so prominently featured in "Ode to Billie Joe," collapsed.

As rock subdivided, the suicide song lived on in "The Ledge," by the Replacements and "Oh, Candy," by Cheap Trick; in S.O.D.'s "Kill Yourself" and Metallica's "Fade to Black"; in U2's "Stuck in a Moment You Can't Get Out Of" and Pearl Jam's "Jeremy"; in Bikini Kill's "R.I.P." and Blink-182's "Adam's Song"; and it continues as a constant in country in songs such as Rascal Flatts' "Why?" and the Brad Paisley and Alison Krauss duet "Whiskey Lullaby," which won the CMA Song of the Year award in 2005.

In 1992 researchers Steven Stack of Wayne State University and Jim Gundlach at Auburn University released a study entitled "The Effect of Country Music on Suicide," which found that the more radio airtime in a metropolitan region "was devoted to country music, the greater the white suicide rate." Stack and Gundlach discovered that "the themes found in country music foster a suicidal mood among people already at risk of suicide" and sprinkle their paper with warning-label-ready verbiage like, "country music may increase suicide risk" and curiously obvious phrases like, "country music per se probably will not drive people to suicide." (The study, which won an Ig Nobel prize—awarded for strange and esoteric scientific research—engendered its share of discussion and spawned what seems like a flood of responses from scholarly circles—"Comments on Stack and Gundlach's 'The Effect of Country Music on Suicide': An 'Achy Breaky Heart' May Not Kill

You"; "Music Preference, Depression, Suicidal Preoccupation, and Personality: Comment on Stack and Gundlach's Paper"; and "Country Music, Suicide, and Spuriousness.")

The researchers behind "The Effect of Country Music on Suicide" went on to release "The Heavy Metal Subculture and Suicide" two years later, finding that "the greater the strength of the metal subculture, the higher the youth suicide rate." "Heavy Metal Music and Adolescent Suicidality," a 1999 study by Karen R. Scheel and John S. Westfeld, found that US high school students who preferred heavy metal music to other genres scored lower on a reasons-for-living inventory and reported more frequent suicidal thoughts. It echoes similar studies conducted in Australia and Iceland, though, just like Nick Hornby's confused record store clark Rob Fleming's asked in *High Fidelity,* there's a question as to which came first, "the music or the misery?"

As country music grew from what some call low culture—the music of poor farmers and low-wage factory workers—opera is even more concretely considered high culture. So it's interesting that, ten years after first needling the "country subculture" for patterns that would suggest a predisposition toward suicidal behavior, Stack (think of him as the Dick Clark of suicidology) did exactly the same for the "opera subculture." It's referred to, with tongue firmly in cheek, as the Madame Butterfly effect, which originated in Stack's 2002 study "Opera Subculture and Suicide for Honor," which found that "opera fans are 2.37 times more accepting of suicide because of dishonor than non-fans" and that "only two variables, religiosity and education, are more closely related to suicide acceptability than opera fanship." Makes one wonder how many overprotective parents would view a teenager's opera habit as a bad influence in the way many view heavy metal or hip-hop?

Dozens of operas turn tragic with the suicide of a main character, notably Ponchielli's *La Gioconda,* Sassano's *Anna Karenina,* Bondeville's *Madame Bovary,* and Berg's *Lulu,* while Berlioz's *Les Troyens* and Mussorgsky's *Khovanshchina* both feature mass suicides. Two of the most popular and long-standing operas in the history of the tradition featuring dramatic twists of self-harm were both written by one

man, Giacomo Puccini. His masterpieces *Tosca* and *Madama Butterfly* contain dramatic exits by leading ladies: In *Tosca*, the titular character leaps to her death from a parapet at the Castel Sant'Angelo, while Butterfly commits seppuku—with the blade her father used to do the same—rather than live with the shame of having been abandoned by her husband, who has taken another bride.

Suicide has never been an easy theme for audiences to swallow. When *Tosca* premiered in New York in February 1901 the suicidal leap that ends the opera caused a scandal and the offending self-defenestration was altered temporarily to depict Tosca instead being shot by soldiers. Nearly a hundred years later, in a 1997 *Guitar World* interview with shock-rock singer Marilyn Manson, heavy metal godfather Ozzy Osbourne didn't shy from his feelings about the subject, saying "I've now been sued by about twenty-five people who claim their kids committed suicide from listening to my music. That's total crap." Besides, he summed up, "If everyone who buys the record is gonna fucking shoot themselves, then the follow-up wouldn't sell many records, would it?"

Osbourne's most notorious lawsuit occurred in 1985 after California teenager John McCollum took his life while listening to "Suicide Solution," a song found on the singer's 1980 album *Blizzard of Ozz*. McCollum's parents sued Osbourne and CBS Records, alleging that the song prompted and validated their son's actions. The song itself is about Osbourne's alcohol addiction, and the singer—as well as songwriter Bob Daisley, who cowrote the song with Osbourne—testified that the "solution" of the title was written to reference something dissolved in a liquid, and was, in fact, the opposite of an answer. The courts ruled in Osbourne's favor, as they did when he was sued again in 1991 for similar reasons.

But while Osbourne may have been sued twenty-five times, the most widely known case of a heavy metal group brought to trial for their suicidal suggestiveness was the 1986 lawsuit involving Judas Priest, taken to the courts by the grieving families of two Nevada teens (Raymond Belknap and James Vance) who shot themselves after listening to the 1978 Judas Priest album *Stained Class*. (Belknap died instantly, but Vance survived his horrifying wounds, only to die

in 1988 of a methadone overdose.) The prosecution's argument stated that the group had buried subliminal suicidal messages in their music (specifically calling out the *Stained Class* track "Better by You, Better Than Me," which allegedly contained the subliminal phrase "do it") that subsequently drove Belknap and Vance into a hypnotic suicidal trance. Vance suggested as much in a letter to Belknap's mother after the incident, writing, "We were mesmerized. There was no doubt, no second thought in my mind, that I was going to pull that trigger, even though I didn't want to die." The trial swirled with unique legal matters such as whether subliminal speech was protected under the First Amendment and whether subliminal messages could be powerful enough to drive someone to actually commit suicide. Judge Jerry Whitehead of Washoe County, Nevada, decided that subliminal speech was not protected by the First Amendment (stating that people have to the right to be free from unwanted speech), but ultimately declared the band and their label free of any wrongdoing.

Rap and hip-hop have since replaced heavy metal as the musical boogeyman responsible for drilling vice into the minds of teens. "Suicide, it's a suicide" was first uttered by KRS-One on the 1987 song "Moshitup," from the Just-Ice album *Kool & Deadly (Justicizms)*. It has since gone on to become one of hip-hop's most enduring memes, appearing in dozens of songs including Snoop Dogg's "Serial Killa" (1993), Gravediggaz's "1-800-Suicide" (1994), Geto Boys' "Retaliation" (1998), Scarface's "Suicide" (2001), Xzibit's "Criminal Set" (2004), Fat Joe's "Get It Poppin'" (2005), Redman's "Suicide" (2007), and Jedi Mind Tricks' "Suicide" (2007). Nas switched it up a bit—changing "suicide" to "genocide"—for the song "Nah Mean," in 2010, and Jay-Z brought the phrase into the rock realm when he employed it in his remix of the Coldplay song "Lost" (the remix is titled "Lost+") from the group's *Prospekt's March* EP.

For a phrase that sounds so menacing it's original use by KRS-One actually spotlights the dangers of pork. During "Moshitup" the long-time vegetarian asks, "Haven't you seen the way this animal lives?" and warns that when eating pork, you're taking your life in your hands. In other words: "Suicide, it's a suicide." Ice-T removed the phrase from its herbaceous roots for use in the 1991

song "Ricochet," and from there it was on its way. No matter the use or context, the extremely metatextual nature of hip-hop ensures that this shout-out to the legacy of KRS-One—a.k.a. Teacha—will remain in circulation.

For a more grim look at suicide in the world of hip-hop, look no further than the Notorious B.I.G. (a.k.a. Biggie Smalls), whose "Suicidal Thoughts" closes out his groundbreaking 1994 album, *Ready to Die*. The bleak and somewhat spacey track opens with Biggie calling up a sleeping Sean "Puffy" Combs—his initially groggy voice echoing throughout the conversation—as he lays out a stream of dark, self-immolating rhymes, including an opening couplet that will be familiar to anyone who has ever suffered through a true depressive episode: "When I die, fuck it, I want to go Hell / 'Cuz I'm a piece of shit it ain't hard to tell." Smalls continues to spill his stresses, making them hit that much harder when he briefly questions his line of thought, saying, "I can't believe suicide's on my fuckin' mind," but as the song closes, a single gunshot fires, the bell in the telephone gives off a muffled "ding" as it drops to the floor, a thick heartbeat slows and fades as the operator says, "Please hang up and try your call again." It's a grisly confessional and a haunting end to one of the most popular and influential albums in the history of hip-hop.

The list of musicians who have truly decided to end their lives prematurely is tragically long. Among the many: Joe Meek, Donny Hathaway, Pete Ham (of Badfinger), Phil Ochs, Del Shannon, Faron Young, Billy Mackenzie (of the Associates), Screaming Lord Sutch, Adrian Borland (of the Sound), country singer Gary Stewart, guitarist Robert Quine, Nick Drake, Ian Curtis, Vic Chesnutt, and Mark Linkous (Sparklehorse).

In Kurt Cobain's *In Utero* many see the singer's musical suicide note, but his actual suicide note contained a phrase from Neil Young's "My My, Hey Hey": "It's better to burn out than to fade away." Young was deeply disturbed by Cobain's final thoughts, and much of his 1994 album *Sleeps with Angels* is a lament in response. Young later told *NME,* reflecting on the lyrics and Cobain's appropriation, "Obviously his interpretation should not be taken to mean there's only two ways to go and one of them is death."

"If it bleeds it leads" is a journalistic cliché that gives a clear indication of our culture's morbid thirst for violence and death, whether packaged as news, a pop single, or a video game. It's a thirst unlikely to wane, and there's little doubt that murder ballads will continue to be reinvented, teen tragedies will continue to be reimagined, and the list of musicians who choose to dictate their own exits will continue to grow, just as the exploration of these dark, often unsettling emotional corners in the arts will continue to unlock an invaluable connection and catharsis for both artists and fans.

THE MISERABLE LIST: SUICIDE, IT'S A SUICIDE

1. "The Last Letter"—Rex Griffin (1937)
2. "Gloomy Sunday"—Billie Holiday (1941)
3. "Life Is Suicide"—Percy Mayfield (1951)
4. "Patches"—Dickey Lee (1962)
5. "Dress Rehearsal Rag"—Leonard Cohen (1971)
6. "Song for Adam"—Jackson Browne (1972)
7. "Fade to Black"—Metallica (1984)
8. "22"—Richard Buckner (1994)
9. "Suicidal Thoughts"—The Notorious B.I.G. (1994)
10. "Russian Roulette"—Rihanna (2009)

SONG ESSAY: "GLOOMY SUNDAY"

Written by Hungarian composer Rezső Seress in 1933, with lyrics by his friend and poet László Jávor, the first American recording of "Gloomy Sunday"—"Szomorú Vasárnap" in Hungarian—was rushed onto the market just three years later in a recording by Hal Kemp and His Orchestra. Released by the Brunswick Record Corp., the album was sold with a distinctly bleak publicity campaign that dubbed it the Famous Hungarian Suicide Song.

"Pennies from Heaven" it wasn't.

In March 1936 upon the release of the initial American record-ings of the song *Time* magazine noted that Budapest police, while investigating the suicide of shoemaker Joseph Keller, who had left a suicide note quoting passages of "Gloomy Sunday," were able to string together seventeen other suicides related to the song: "Two shot their brains out while hearing a gypsy band play the piece, others killed themselves listening to recorded versions, several leaped into the Danube, clutching the sheet music." In a glowing grasp of the obvious, *Time* put their short piece on the song to rest by noting that "few who listened to the Kemp recording for Bruns-wick or Paul Whiteman's for Victor or Henry King's for Decca failed to confess that the melody and lyrics had a profoundly de-pressing effect."

This unfortunate string of suicides reportedly led the Hungarian police to ban the song—though there is scant evidence to suggest the ban actually occurred. It did, however, face similar restrictions on the BBC and, briefly, on American radio.

The following month, *Time* ran a subsequent letter from Seress to his American record company, in which the composer, haunted by what he referred to as his "fatal fame," wrote, "I stand in the midst of this deathly success as an accused." Seress himself would eventually commit suicide in 1968, choking himself to death with wire while recuperating in a hospital from wounds he received after jumping out a window. Yet there is no indication that his most famous song was a contributing factor in his death, other than, perhaps, his distress over never having written anything else that was as popular.

The Hungarian origins of the "Gloomy Sunday" myth aren't sur-prising even if they are difficult or impossible to verify. Hungary is notorious for having one of the highest suicide rates in the world: Ac-cording to the Organization for Economic Cooperation and Develop-ment (OECD) statistics released in December 2009, 21 out of every 100,000 people ended their own lives in Hungary during 2006, plac-ing the small Eastern European nation second only to South Korea, which had the highest rate, at 21.5 per 100,000. It should be noted

that 21 suicides per 100,000 is a significant improvement over numbers that placed the country's suicide rate as high as 48 per 100,000 during the late 1980s. (For comparison, the 2006 OECD suicide statistics for the United States and the United Kingdom are significantly lower, at 10.1 and 6.1 per 100,000, respectively.)

There are two English versions of "Gloomy Sunday" that warrant record. The first translation is by Desmond Carter, which can be found on the early recordings by Hal Kemp, Paul Whiteman, Artie Shaw (and their orchestras), and Paul Robeson (who sounds a bit like he's testing for a role in a Dracula musical). Carter's interpretation of the song is too plainly straightforward and touches neither the apocalyptic grandeur of the Hungarian original nor the poetic darkness of the dominant English translation by singer and lyricist Sam Lewis (paradoxically, also responsible for the lyrics to "I'm Sitting On Top of the World"). Lewis's version veers dramatically from the original in style if not theme: Introduced is an entirely new third verse, which, though melodically fantastic, follows in the unfortunate show-biz tradition of hackneyed plot twists in service to happy endings, placing the troubling original verses in the relative safety of a dream ("Dreaming . . . I was only dreaming . . .").

In 1941 Billie Holiday, already a star, was just entering the phase of her career marked by melancholic realism, ushered in by songs like "Long Gone Blues," "God Bless the Child," and, most notably, the dramatic and dark "Strange Fruit." When Holiday took up the Lewis version of "Gloomy Sunday" and recorded it with Teddy Wilson and His Orchestra, the song, like many Lady Day encountered before and after, became her own, and in 1952 Holiday cited it, alongside "No More" and "Fine and Mellow," as one of her three favorite recordings. In a remembrance of Holiday, though, comedian James "Stump" Cross recalls that the singer "got tired of it; it was so real to her that as she sang it she would see it and it would get to her," adding, "with her vivid imagination, when she sings a song like that, the tears come down."

The song provided the inspiration for the 1999 Hungarian film *Gloomy Sunday* (*Ein Lied von Liebe und Tod*), which fictionalizes

its genesis within a love triangle. Its legend is also at the heart of the 2006 conspiracy film *The Kovak Box*, which stars Timothy Hutton as a science-fiction writer lured to a conference on the island of Mallorca, only to find that a series of unexplained suicides are mysteriously connected to Billie Holiday's recording.

No one would argue that Holiday's performance is the most popular version of the song, but it sways with a gentility that belies its tragic nature, and the use of Lewis's hopeful third verse taints the song's essential morbidity with the kind of lost-in-translation, gee-whiz American optimism that dilutes many European works on their journey across the Atlantic.

Though many artists have recorded "Gloomy Sunday," there are three versions following Holiday's take that are worth paying particular attention to. Ray Charles recorded one of the finest for his 1969 album *I'm All Yours, Baby!*, interestingly opening with the gentle sway of Lewis's daydream finale before the skies darken and the traditional slow-turning verses appear while the bottom drops out for the two-word chorus.

The two other remarkable versions present the song in its most elegiac and purely miserable form: Lewis's lyric without the hokum of the third verse. The first is from soul singer Ketty Lester, whose 1962 version crosses Holiday's rendition with the breathy melancholy of Julie London's "Cry Me a River." More recently, Icelandic curio Björk, dressed in a pair of wooden angel wings and a feral, over-feathered skirt, performed the song with doomful organ accompaniment at the funeral service for fashion designer Alexander McQueen, who took his life on February 11, 2010. That version can be found all over the Internet, but Björk's only official live version, featuring the Lewis lyric and cheat verse, featured full orchestral backing, and was recorded in 1998 for an AT&T promotional release, pulling double-duty as a fund-raiser for the Walden Woods Projects. Her otherworldly voice and overenunciated English, along with the noir orchestral setting, make for a gauzy and haunting rendition, but it falls short of the moodiness captured in her performance at McQueen's service.Ⓗ

FRANK SINATRA

Frank Sinatra once referred to himself as "an eighteen-carat manic-depressive," explaining that he lived "a life of violent emotional contradictions," which may explain, in part, how he so comfortably wafted between the worlds of carefree ring-a-ding-ding machismo and bruised barstool melancholy. Born Francis Albert Sinatra on December 12, 1915, in Hoboken, New Jersey, the young singer knew early in life what he wanted, and dropped out of high school in his senior year to get it. After a short stint as a singing waiter, he fronted big bands, first for Harry James and then Tommy Dorsey, with whom he scored sixteen top-ten hits. He recorded his first solo material in January 1942, four songs that included Cole Porter's "Night and Day," which became his first hit two months later. After a successful stint opening for Benny Goodman at New York's Paramount Theatre, Sinatra became the first legitimate teen idol, the press anointing his effect on teenage girls "Sinatrauma." Throughout the 1940s he racked up hit after hit, was more responsible than any other artist for creating the "Great American Songbook," helmed a handful of short-lived radio shows (*Songs by Sinatra*, *The Frank Sinatra Show*), and made regular film appearances. With the arrival of the 1950s, however, his career took its first bruises: His popularity waned and he lost his voice for a brief time, the press was castigating him after he left his wife for screen temptress Ava Gardner in 1951, and the following year Columbia Records refused to renew his contract. Whether Sinatra's Mob connections or Gardner's influence secured his role as the hapless Maggio in the 1953 WWII drama *From Here to Eternity*, it salvaged the singer's career, winning him the Academy Award for Best Supporting Actor. That same year, he signed with Capitol Records, where his tumultuous affair with Gardner—the two split in 1953, but weren't officially divorced until 1957—would fuel his darkest recordings. For his first release at Capitol, Sinatra worked with the gifted arranger and composer Nelson Riddle, the two nearly inventing the concept album with 1955's *Songs for Young Lovers* and, later that year, the duo

collaborated on the downbeat ballad collection *In the Wee Small Hours*. Where the former is gently swooning and romantic, the latter is cloudy with resignation and despair, filled with the anguish the singer felt at the collapse of his volatile marriage. With each new ballad collection Sinatra's material and performances grew bleaker. In 1957 he released *Where Are You?* (with arranger Gordon Jenkins), which features the operatic "I'm a Fool to Want You"—legend has it that after Sinatra deftly captured the song for posterity he ran from the studio in tears. That same year, again with Riddle, he recorded the truly cheerless *Frank Sinatra Sings for Only the Lonely*, which includes the mournful title track, the vacant melancholy of "Guess I'll Hang My Tears Out to Dry," and frayed favorite "One for My Baby." He returned to work with Jenkins for the final Capitol ballad collection, 1959's *No One Cares*, which featured brooding takes on "A Cottage for Sale" and "Here's That Rainy Day." In 1962 he released the grim waltz collection *All Alone*, and 1965's *September of My Years* captured Sinatra at fifty in gloomy renditions of the title track and "It Was a Very Good Year." As the 1960s came to a close, Sinatra took a left turn and recorded 1969's *A Man Alone: The Words and Music of McKuen* (McKuen was a popular poet and singer at the time and was among the first to translate moody Belgian singer Jacques Brel's work into English). Later that year he attempted his furthest leap toward a mainstream rock sound as he teamed with songwriters Bob Gaudio (one quarter of the Four Seasons and responsible for hits like "Big Girls Don't Cry" and "The Sun Ain't Gonna Shine Anymore") and folk-rocker Jake Holmes (mostly known for writing "Dazed and Confused") to create an ambitious and strikingly maudlin—even for Frank—concept album called *Watertown*, about a small-town single father whose wife has abandoned him. Holmes recalled Sinatra's respect for the material: "He wouldn't smile through a sad song, because he understood that at the heart of singing is storytelling." *Watertown* recalls the sullen cabaret pop of David Ackles, and writer Richard Meltzer referred to it as Frank's *Berlin*, a nod to Lou Reed's oppressively stark concept album from 1973. A commercial failure

upon release, and now largely forgotten save a cult of ardent supporters who insist it's an overlooked masterpiece, *Watertown* was arguably Sinatra's last great statement. *She Shot Me Down* from 1980 easily stands as the best of Ol' Blue Eyes from the 1980s—his voice had lost its voltage, but its disintegrating gloom holds a hypnotic power of its own.

Sinatra died on May 14, 1998, from a variety of accumulating problems including bladder cancer and heart disease. He was eighty-two. The following night, the lights on the Las Vegas Strip were dimmed for ten minutes. Sinatra's world contained incredible highs and uncanny lows—rumors of multiple suicide attempts have circled the singer's story for decades—and he was able to successfully channel those emotions into his work, leading some to dub him a "method singer." In 1957 he summed up his understanding of those peaks and valleys by saying, "I've known joy, unhappiness; success, failure; hope and despair. Good or bad, what's happened to me is my lot and I've never begrudged a thing that life has given, or taken, from me."

THE MISERABLE LIST: FRANK SINATRA

1. "I'll Never Smile Again"—Single with the Tommy Dorsey Orchestra (1940)
2. "I Get Along Without You Very Well"—*In the Wee Small Hours* (1955)
3. "I'm a Fool to Want You"—*Where Are You?* (1957)
4. "Only the Lonely"—*Frank Sinatra Sings for Only the Lonely* (1958)
5. "One More for My Baby"—*Frank Sinatra Sings for Only the Lonely* (1958)
6. "The September of My Years"—*September of My Years* (1965)
7. "Rain in My Heart"—*Cycles* (1968)
8. "Didn't We"—*My Way* (1969)
9. "Watertown"—*Watertown* (1969)
10. "A Long Night"—*She Shot Me Down* (1980)

ELLIOTT SMITH

From his first shy and clever basement recordings to his awkward moment in the spotlight at the 1998 Academy Awards, and ultimately to his mysterious death at age thirty-four, few artists have so enigmatically personified uncomfortable misery like Elliott Smith. Born Steven Paul Smith on August 6, 1969, in Omaha, Nebraska, he was still a baby when his parents divorced. He went with his mother when she relocated to the suburbs of South Texas, where she married a stern insurance salesman who would terrorize Smith throughout much of his childhood. At fourteen he left Texas to live with his biological father in Portland, Oregon, and began writing and recording his own material, quickly becoming a fixture on the burgeoning Portland indie-rock scene. His first success came as one-third of the band Heatmiser, but the group was largely overlooked during the post-Nirvana infatuation with all things Pacific Northwest. His first solo album, 1994's sparse and reflective *Roman Candle*, was recorded in a basement on a four-track, and featured Smith as his own backing band. The album's serene melancholy nudged the willowy ghost of Nick Drake into the grunge-battered 1990s, and provided a template for Smith's career. The following year he released a fragile self-titled album on Portland's Kill Rock Stars label, which featured his first undeniable classic, "Needle in the Hay." By the time Heatmiser released 1996's *Mic City Sons*, their best work, the trio was on the verge of dissolving—though Smith reported that the group had signed with Virgin Records, no record ever appeared. Smith's next album, 1997's essential *Either/Or*, was tricked out with dark characters hurting each other and themselves, and his way with a melody and song construction had distinctly improved. By this point, lots of people were paying attention to Smith's overcast genius, including director Gus Van Sant (*Drugstore Cowboy, Milk*), who used a number of songs from *Either/Or*, as well as commissioning a new song, "Miss Misery," for use in the film *Good Will Hunting*. It was an opportunity that led to Smith—his dark, greasy hair wicking at the shoulders of a marshmallow-white suit—performing live at the 1998 Academy Awards ceremony,

sandwiched between histrionic performances by Trisha Yearwood (performing "How Do I Live" from *Con Air*) and Celine Dion (performing "My Heart Will Go On" from *Titanic*). Smith was grounded about the experience, saying afterward, "It was fun to walk around on the moon for a day." Maybe, but he seemed anything but well-grounded otherwise, reportedly having jumped off a cliff in North Carolina while on tour, in an attempt to end his life, that was thwarted by a surprisingly sturdy tree. Smith soon signed to Dreamworks and released his major label debut, *XO,* in 1998. His later efforts to make "a happy-sounding record" resulted in what would sadly turn out to be the last album he would release in his lifetime, 2000's lush *Figure 8*. From all accounts, the years between the release of *Figure 8* and his death were a dark and confused period for the singer. He had struggled with heroin addiction for years and had recently switched to crack. When his friend and producer Jon Brion confronted him about his addiction, Smith abandoned both the album the pair were working on and their friendship. Then, in a fit of paranoia, his relationship with Dreamworks quickly corroded, with Smith threatening suicide if the label did not release him from his contract. At some point during the fall of 2002, however, he turned things around, reportedly kicking his addictions (even giving up red meat, caffeine, and sugar) and pouring himself into a proposed thirty-song double-album. Then, on October 21, 2003, his body was found with two fatal stab wounds to the chest. The mystery surrounding his death divided his friends, family, and fans, and the coroner's report provided more questions than it did answers. Though Smith's death remains clouded, the subtle majesty of his work remains a testament to the troubled time he spent with us.

THE MISERABLE LIST: ELLIOTT SMITH

1. "Roman Candle"—*Roman Candle* (1994)
2. "Needle in the Hay"—*Elliott Smith* (1995)
3. "The Biggest Lie"—*Elliott Smith* (1995)
4. "Between the Bars"—*Either/Or* (1997)

5. "2:45 AM"—*Either/Or* (1997)

6. "Sweet Adeline"—*XO* (1998)

7. "I Didn't Understand"—*XO* (1998)

8. "I Better Be Quiet Now"—*Figure 8* (2000)

9. "King's Crossing"—*From a Basement on the Hill* (2004)

10. "Twilight"—*From a Basement on the Hill* (2004)

THE SMITHS

Formed as a reaction to the dominance of synth-heavy popular music in the early eighties, the Smiths breathed new life into rock, returned the guitar to pop prominence, and left a legacy as potent as any group since the Beatles and the Stones. Guitarist John Maher (soon to be rechristened Johnny Marr) had been aggressively seeking success with numerous bands, primarily Paris Valentinos. Meanwhile, the young Steven Patrick Morrissey had sung briefly in the Nosebleeds and Slaughter and the Dogs—both with future Cult guitarist Billy Duffy—but spent most of his time writing lyrics, letters to the British music press, and brief books (his short biographies of James Dean and the New York Dolls were both completed before he joined the Smiths). Eventually Marr hunted down Morrissey and the pair quickly began writing together, recording some demos with drummer Simon Wolstencroft (then working with the Fall). They settled on the name the Smiths and recruited drummer Mike Joyce and Marr's former classmate Andy Rourke to take on bass duties. On October 4, 1982, the Smiths debuted at the Ritz in Manchester, and within months were fielding label offers. They turned down Factory Records and signed instead with Rough Trade for the release of their first single, "Hand in Glove"/"Handsome Devil." Released in early 1983, the single sparked the first of many controversies for the group, specifically for its suggestive lyrics and packaging, which featured a blue-tinted photo of a nude male model. Both Morrissey and Marr were devoted pop acolytes who cherished the idea of a perfect

single, and cultivated an instantly recognizable aesthetic for all of their releases, largely borrowing film stills that featured actors and cultural icons such as Terence Stamp ("What Difference Does It Make?"), Alain Delon (*The Queen Is Dead*), and even a young Elvis Presley ("Shoplifters of the World Unite"). Their pop adoration was also evident in their sound, notably Marr's crisp and concise guitar work, which had its roots in British Invasion revivalism and rockabilly. Marr's playing led Morrissey to remark, "Johnny can take the most basic, threadbare tune and you'll just cry for hours and hours and swim in the tears!" On the other hand, Morrissey's rich croon, hyperliterate lyrics, and affection for swinging gladiolas onstage seemed to come from another time and place altogether. The group played their first Peel Session in 1983—bringing about more controversy when the song "Reel Around the Fountain" was thought by some to tacitly condone child abuse. Annoyed by the perception that their Rough Trade labelmates Aztec Camera were getting more attention, Marr wrote the Smiths' bright second single with more mainstream success in mind, but "This Charming Man," which appeared in the fall of 1983, stalled at number twenty-five on the UK charts. During the second half of 1983 an attempt to record their debut album with producer Troy Tate (former guitarist with the Teardrop Explodes) was scrapped—resulting in the heavily bootlegged Tate Sessions—in favor of working with producer John Porter. Their third single, "What Difference Does It Make?," preceded their 1984 self-titled long player and climbed to number twelve on the charts while the album reached number two on the UK albums chart. The group, minus Morrissey, backed British singer Sandie Shaw on her cover of "Hand In Glove," and Morrissey made another Shaw connection, naming their fourth single, "Heaven Knows I'm Miserable Now," after her 1969 song "Heaven Knows I'm Missing Him Now." Their fourth single also courted more controversy, not for the A-side but for the dark, unsettling flip, "Suffer Little Children," which was based on the infamous "Moors Murders" of 1963 to 1965. By the end of the year the group had another hit with "William, It Was Really Nothing" and released *Hatful of Hollow*, which collected singles, B-sides, and BBC sessions. Their second album, 1985's *Meat Is Murder*, became the group's first number one album, introducing a more politically engaged

Morrissey alongside a band keen on expanding their sound. It's a phenomenon that can be heard on the massive "How Soon Is Now?," released as a single just weeks before *Meat Is Murder* and featuring a cluster of Marr's tremolo-doused guitars, Rourke's threatening and metallic bass line, and a massive beat from Joyce. Early the following year, Rourke was unceremoniously sacked via a Post-it note left on his car window—"Andy, you have left The Smiths. Goodbye. Good luck. Morrissey"—under the pretense he was suffering from a heroin addiction. Former Aztec Camera guitarist Craig Gannon boarded to replace Rourke, but when the bassist soon returned, Gannon very briefly became the fifth Smith on second guitar. Not long after, Marr's drinking caught up with him when he was seriously injured in a car crash that left him in braces and bandages for weeks, and it was during his recuperation that Gannon was cut from the band. *The Queen Is Dead* appeared later that year. Widely regarded as the Smiths' masterpiece, it became the first of the group's albums to crack the US top 100. They recorded their only official live album, *Rank*, in October 1986 at the National Ballroom in London, though it wouldn't see release until 1988, after the band had split. As 1987 had approached, tensions between Morrissey and Marr flared. The singer bristled at Marr's work with Bryan Ferry and Billy Bragg, and the guitarist became irritated with Morrissey's slavish devotion to sixties pop, saying later, "I didn't form a group to perform Cilla Black songs." Finally, just weeks before the autumn release of what would prove to be their final studio album, *Strangeways, Here We Come*, Marr announced his departure from the group. The remaining trio attempted to move forward with former Easterhouse guitarist Ivor Perry, but the magic had atomized. Morrissey disbanded the Smiths in short order, just five years after Marr had knocked on his door. Morrissey went on to a fruitful solo career, Joyce eventually became a member of the reunited Buzzcocks, and Rourke retired from the music industry, while Marr collaborated with a number of artists (notably The The and Talking Heads), was a member of Electronic with New Order's Bernard Sumner, started his own Johnny Marr and the Healers, and surprisingly joined Modest Mouse in 2007. Crisscrossing legal actions and rumors of the band's re-formation have continuously swirled, though Morrissey released a

statement in 2007 that read, in part, "One thing the future will not bring is a Smiths' reunion tour."

THE MISERABLE LIST: THE SMITHS

1. "Miserable Lie"—*The Smiths* (1984)
2. "Suffer Little Children"—*The Smiths* (1984)
3. "Heaven Knows I'm Miserable Now"—Single (1984)
4. "That Joke Isn't Funny Anymore"—*Meat Is Murder* (1985)
5. "Asleep"—B-side, *The Boy with a Thorn in His Side* (1985)
6. "Rubber Ring"—B-side, *The Boy with a Thorn in His Side* (1985)
7. "The Boy with the Thorn in His Side"—*The Queen Is Dead* (1987)
8. "There Is a Light That Never Goes Out"—*The Queen Is Dead* (1987)
9. "Last Night I Dreamt That Somebody Loved Me"—*Strangeways, Here We Come* (1987)
10. "I Know It's Over"—*Rank* (1988)

SMOG/BILL CALLAHAN

Bill Callahan (a.k.a. Smog) blends a black sense of humor and fragmented lyric poetry—mortality, domestic miseries, and birds, horses, and apples are his stock in trade, though he's quick to point out, "I'm not a biologist or nothin' "—with a stunningly artless deadpan baritone and a constant drive to investigate new directions for his lean, bewildering folk rock. Born in 1966 in Silver Spring, Maryland, Callahan spent his youth split between the Old Line State and Yorkshire, England. Inspired by reclusive and experimental man of mystery Jandek, he began recording his own songs, which hewed to no real structure and reveled in their unsteady naïveté. The first Smog material appeared in 1988 on the cassette-only *Macrame Gunplay*, released via Callahan's own Disaster label. Other tapes followed, including *Cow* in 1989, and *A Table Setting*, *Tired Tape Machine*, and *Sewn to the Sky*,

all in 1990. He signed to Chicago indie label Drag City and re-
leased the *Floating* EP in 1991 and his first full-length, *Forgotten
Foundation*, the following year, both of which showed a marked
improvement in his songwriting. He would slowly continue to
mature over the course of 1993's *Julius Caesar*, 1994's *Burning
Kingdom*, and 1995's innovative *Wild Love*, which had highlights
in the cracked pop of opener "Bathysphere" and the teetering
ballad "The Candle" ("I'm gathering these splinters to make a
raft someday"). Callahan hit a gloriously bleak peak in the late
1990s, beginning with the 1995 release of *The Doctor Came at
Dawn*, which laid a thick blanket of domestic despair over songs
like "You Moved In," "Lize" (a brutal duet with Cindy Dall), and
"All Your Women Things." Callahan has described his approach
to songwriting by saying it "boils down to two things moving
against each other . . . the voice and the instrument." The *Kicking
a Couple Around* EP, which also appeared in '95, gives insight
to that process—only four songs long, its stark minimalism and
claustrophobic sense of despair is hypnotic. Less aloof, 1997's
Red Apple Falls threaded forlorn pedal steel, organ, and brass
into a mélange of folk, country, and rock, a sound best heard on
the sinister pop of "I Was a Stranger" ("You should've seen what I
was in the last town") and mournful cuts like "Red Apples," "Red
Apple Falls," and "To Be of Use," which finds Callahan confess-
ing, "Most of my fantasies are of making someone else come."
Working with producer Jim O'Rourke for 1999's *Knock Knock*,
Callahan crafted songs marked by billowing strings ("Let's Move
to the Country"), industrial-informed percussion ("Held"), hand-
claps ("Cold Blooded Old Times," which, the following year, was
featured on the *High Fidelity* soundtrack), ambient landscapes
("Teenage Spaceship"), and a children's choir ("No Dancing"). It
didn't hurt that his songs were as good as they'd ever been. He
scaled back for 2000's *Dongs of Sevotion*, then subtly changed his
one-man band from Smog to (Smog) and played with the repeti-
tive song structures of Krautrock on 2001's *Rain on Lens*. The
comparatively sunny *Supper*, also released as (Smog), in 2003,
merged the sounds he had fostered on *Red Apple Falls* and *Knock*

Knock. The parenthetical was dropped for 2005's *A River Ain't Too Much to Love*, and Callahan carved out dark, wistful waltzes like "Say Valley Maker" and "Rock Bottom Riser"—even setting the traditional blues "In the Pines" in a three-quarter-time shuffle. *A River* turned out to be the final Smog album, though without missing a beat Callahan began to issue albums under his own name, beginning with 2007's *Diamond Dancer* EP and the *Woke on a Whaleheart* full-length, which found Callahan approaching his work like a Brill Building songwriter, leaving the arrangements up to Royal Trux member Neil Michael Hagerty. The faded gothic Americana that colored Callahan's works beginning in the mid-nineties found a home on 2009's foggy and warm *Sometimes I Wish We Were an Eagle*, while the 2010 live album *Rough Travel for a Rare Thing* surveyed his career from the stage. In 2011 he released *Apocalypse*, a sweeping account of America that is as bruising as it is pastoral, as much as outsider statement as it is a celebration of the union.

THE MISERABLE LIST: SMOG/BILL CALLAHAN

1. "The Candle"—*Wild Love* (1995)
2. "Your New Friend"—*Kicking a Couple Around* (1996)
3. "Lize"—*The Doctor Came at Dawn* (1996)
4. "To Be of Use"—*Red Apple Falls* (1997)
5. "River Guard"—*Knock, Knock* (1999)
6. "Nineteen"—*Dongs of Sevotion* (2000)
7. "Vessel in Vain"—*Supper* (2003)
8. "Night"—Bill Callahan: *Woke on a Whaleheart* (2007)
9. "The Wind and the Dove"—Bill Callahan: *Sometimes I Wish We Were an Eagle* (2009)
10. "Rock Bottom Riser"—Bill Callahan: *Rough Travel for a Rare Thing* (2010)

THE SOUND

Among the most criminally overlooked British guitar bands to record during the "Me" Decade, the Sound spent years exploring the same murky trenches of pop's vast ocean as Joy Division and Echo and the Bunnymen had, yet never nearing any portion of their successes. In 1979 in South London, from the ashes of the Outsiders—a group whose 1977 *Calling on Youth* was possibly the first self-released British punk album ever—guitarist/vocalist Adrian Borland and bassist Graham Bailey (later know as Graham Green) went on to form the Sound with drummer Michael Dudley, releasing the *Physical World* EP in December of that year on Raw Edge Records, a label run by Borland's parents. The group added keyboardist Bi Marshall, signed to WEA subsidiary Korova (incidentally, also home to Echo and the Bunnymen), and released their debut album, 1980's *Jeopardy*, to rave reviews in the British music press. The album's low-budget sound and the band's energetic performances led to a handful of amazing moments, particularly the nervy album opener "I Can't Escape Myself" and cold-war anthem "Missiles." Producer Hugh Jones helped accentuate the band's pop leanings on 1981's *From the Lions Mouth*, the best entry point for new fans and the album that should have made them post-punk royalty, but shockingly did nothing of the sort (the *Record Mirror* saying that the group "seem[s] set to take up where Joy Division left off and become the saviors of the adolescent grim brigade"). The album's gloomy atmospherics (shaped in part by new keyboardist Colvin "Max" Mayers) prop Borland's existential themes of man's anchorless drift in the universe, explored in songs such as "Skeletons" ("There's a gaping hole in the way we are / With nothing to fill it up anymore"), "Judgment" ("Can there really be someone up above me who judges me when my time is up?"), "Winning" ("I was drowning and then I started swimming"), and "Sense of Purpose" ("I'll take my life into my own hands"). Critics responded well to the refreshingly imageless group and their powerful chiaroscuro

pop, which Borland was quick to point out expressed a few emotional highs along with all those searching lows. Their label, however, wanted a hit. The group responded poorly to pressures and directives, recording 1982's *All Fall Down*, a difficult album short on hooks and dominated by wandering mid-tempo numbers. Their brazenness is potently observed on the twitchy "Party of the Mind," a song which defiantly devolves into a Lou Reed fever dream in its final act, trailing off into a squall of laughter and feedback, and the nearly seven-minute-long "Glass and Smoke," a plodding track terrorized by atonal stabs of overdriven synth. Bruised by their major-label experience, the band signed with independent Statik Records, releasing the optimistic *Shock of Daylight* EP in 1984 and the romantic fatalism of *Heads and Hearts* in 1985, the latter an album that opens in the uneasy depths of "Whirlpool" ("Night follows night here / Daylight just hurts eyes") and closes with the end-is-near pop of "Temperature Drop" ("The head is bowed, the neck is clear / But will the cut be clean?"). The live double-album *In the Hothouse* appeared in 1986, and by the time of 1987's uneven *Thunder Up*, the aggression evident on their earliest releases had largely calmed into a more polished guitar pop. As happened with so many other underrated and overlooked groups, the lack of financial success and tensions within the band eventually took a toll and the Sound called it quits in 1988. Borland and Green intermittently tended to their electro side-project, Second Layer, throughout the Sound years, and Borland—who had a devoted following in France, Germany, and the Netherlands—would go on to record under his own name, as well as Honolulu Mountain Daffodils, and form the White Rose Transmission with Carlo van Putten of the Convent. Borland would also work as a producer with the groups Into Paradise and the Servants, among others. Keyboardist Mayers died from AIDS-related illness in 1993, and Borland, whose lyrics had mined his very real despair in a dignified and thoughtful manner, took his own life on April 26, 1999, by jumping onto the tracks at London's Wimbledon Station. An energetic push by Renascent Records to rerelease The Sound's earliest albums (as well as their Peel Sessions and a series of five performances for Dutch radio) presaged the rise

of gloom-rock bands like Interpol and Editors in the new millenium and considerably raised the profile of the band's impressive work.

THE MISERABLE LIST: THE SOUND

1. "I Can't Escape Myself"—*Jeopardy* (1980)
2. "Missiles"—*Jeopardy* (1980)
3. "Skeletons"—*From the Lions Mouth* (1981)
4. "New Dark Age"—*From the Lions Mouth* (1981)
5. "All Fall Down"—*All Fall Down* (1982)
6. "Winter"—*Shock of Daylight* EP (1984)
7. "Whirlpool"—*Heads and Hearts* (1985)
8. "Shot Up and Shut Down"—*Thunder Up* (1987)
9. "No Salvation"—*Propaganda* (1999)
10. "Burning Part of Me"—*The BBC Recordings* (2004)

SPARKLEHORSE

Born on September 9, 1962, in Arlington, Virginia, Mark Linkous (a.k.a. Sparklehorse) spent the mid-eighties in New York and Los Angeles leading the Dancing Hoods, a group that found mild success with the song "Baby's Got Rockets," from their 1988 sophomore album *Hallelujah Anyway*. When major label success eluded them the group disbanded, and Linkous returned to Virginia, joined the Johnson Family (later rechristened Salt Chunk Mary), and took a series of odd jobs painting houses and sweeping chimneys. He cowrote "Sick of Goodbyes" with Cracker's David Lowery (it would first appear on Cracker's 1993 release, *Kerosene Hat*), and by the mid-nineties he was recording the wobbly and distinct southern gothic material that would secure him an avid following as Sparklehorse. Linkous soon signed to Capitol Records and released his 1996 debut, *Vivadixiesubmarinetransmissionplot*, which was recorded with members of Cracker and produced by

Lowery (under the name David Charles). The song "Someday I Will Treat You Good" ("Everything that is made is made to decay") became an alternative-radio hit, but the troubles hinted at in his damaged, personal songs surfaced following a London show, when he passed out and nearly died after mixing Valium and prescription antidepressants. Linkous spent fourteen hours on the tile floor of his hotel bathroom, his legs pinned beneath him, and was nearly paralyzed from the restricted blood flow to the lower half of his body. Getting him back on his feet required a twelve-week stay in London's St. Mary's Hospital, as well as multiple surgeries. The incident provided inspiration for his second album, 1999's *Good Morning Spider*, an album that stretched Linkous's weary folk-rock in a more oblique direction with the inclusion of otherworldly synths, ambient textures, and drum loops, as in his lyrics he explored the metaphysical distance between life and death. *It's a Wonderful Life* followed in 2001 and *Dreamt for Light Years in the Belly of a Mountain*, recorded in collaboration with producer Danger Mouse, appeared in 2006. Before long Danger Mouse and Linkous teamed up again, this time with filmmaker and avant-garde instigator David Lynch, for the multimedia project *Dark Night of the Soul*. The resulting songs—written by Linkous and Danger Mouse, with a revolving cast of collaborators (Linkous singing only the duet "Daddy's Gone" with the Cardigans' Nina Persson)—were set to be published with a book of Lynch's photographs but ended up collecting dust as EMI blocked the release of the album, citing only the need to "reserve our rights." Linkous turned his attention toward a one-off collaboration with laptop shoegaze artist Christian Fennesz for the *In the Fishtank* series, and then set to work on the next Sparklehorse album. In March 2010, with *Dark Night of the Soul* finally on the verge of an official release, and the next Sparklehorse album reportedly nearing completion, Linkous took his life by shooting himself in the chest with a rifle. He was forty-seven years old. In 2007 he told rock critic Jim DeRogatis that music was the only thing keeping him "from slipping down into the vortex" of depression; it's unfortunate that it wasn't strong enough to hold him here for longer.

THE MISERABLE LIST: SPARKLEHORSE

1. "Homecoming Queen"—*Vivadixiesubmarinetransmissionplot* (1996)
2. "Heart of Darkness"—*Vivadixiesubmarinetransmissionplot* (1996)
3. "Painbirds"—*Good Morning Spider* (1999)
4. "Saint Mary"—*Good Morning Spider* (1999)
5. "Maria's Little Elbows"—*Good Morning Spider* (1999)
6. "It's a Wonderful Life"—*It's a Wonderful Life* (2001)
7. "Apple Bed"—*It's a Wonderful Life* (2001)
8. "Shade and Honey"—*Dreamt for Light Years in the Belly of a Mountain* (2006)
9. "Goodnight Sweetheart"—*In the Fishtank 15* (2009)
10. "Daddy's Gone"—*Dark Night of the Soul* (2010)

DAVID SYLVIAN

As the lead singer of Japan, which he formed in 1974, David Sylvian—born David Batt in Kent, England, on February 23, 1958—led the ambitious glam act through a series of albums that saw the group evolve from new romantic progenitors to fashionable art rockers, becoming an uncomfortable sex symbol along the way. (He was called "the Most Beautiful Man in the World" in 1981 by a British newspaper—his feathery blond haircut was reportedly the inspiration for Princess Diana's famous look.) Japan's final comprehensive studio statement, 1981's masterpiece *Tin Drum*, featured the elegant and disconsolate left-field hit "Ghosts," which against all odds found its way to number five on the UK singles charts. The following year an *NME* reporter pressed Sylvian on the melancholy that seemed to anchor much of his work, to which he confided, "I enjoy my depressions." Japan dissolved shortly thereafter, while the restless Sylvian was already in the midst of collaborating with Japanese composer Ryuichi Sakamoto on the "Bamboo Houses" single, the first in a restless series of collaborations and solo projects.

Exhausted, Sylvian briefly turned to cocaine to stabilize his mood while readying his 1983 debut solo album, *Brilliant Trees*—which featured contributions from Sakamoto, Can's Holger Czukay, and trumpeter Jon Hassell. In 1987 he released *Secrets of the Beehive,* a breakthrough collection of songs that synthesized his arch melancholy leanings and led *NME* to write, "If Sylvian ever smiled the magic [of the album] would be broken." In the following years he crafted two ballet scores for modern dancer Gaby Abis, collaborated with Czukay on two instrumental albums (*Plight and Premonition* and *Flux + Mutability*), and collaborated with light artist Russell Mills (*Ember Glance: The Permanence of Memory*). In 1991 he reunited with three former Japan colleagues—his brother, percussionist Steve Jansen; bassist Mick Karn; and keyboardist Richard Barbieri—to record a self-titled album under the name *Rain Tree Crow.* Two efforts with King Crimson guitarist Robert Fripp emerged before a well-deserved silence during which the singer married singer and actress Ingrid Chavez, moved to Minneapolis, had two kids, and embraced Buddhism. These years of relative serenity are captured on his *Secrets of the Beehive*, which contains the bright "Let the Happiness In," which *Uncut* referred to as "an anthem for hopeful depressives." Following the fulfillment of his long-term contract with Virgin Records he founded the Samadhi Sound label and relocated to the wilds of southern New Hampshire with his now ex-wife Chavez and their children, literally dividing the home between them, and erecting a studio in an old barn. Having become a semirecluse in the process, Sylvian began collaborating with artists around the globe via the Internet—"I'm . . . a little antisocial," he says. In 2003 the sparse and devastating *Blemish* appeared as the first Samadhi Sound release. Driven by Sylvian's quiet vocal and minimal arrangements, with brittle contributions from sound artist Christian Fennesz and guitarist Derek Bailey, the album was primarily informed by his emotionally draining divorce. An album's worth of *Blemish* remixes, *The Good Son vs. The Only Daughter,* was released in early 2005, and later that year he released one of his most accessible albums in years with *Snow Borne Sorrow*, a stunning collection album of post–9/11 pop created in collaboration with Jansen and electronic

composer Burnt Friedman (a.k.a. Drone). Another bleak dream of a record, *Manafon* appeared in 2010. Like *Blemish*, it features a run of bare, fragile songs flecked with improvised contributions from Fennesz, Bailey, saxophonist Evan Parker, pianist John Tilbury, and turntablist Otomo Yoshihide, among others.

THE MISERABLE LIST: DAVID SYLVIAN

1. "Ghosts"—Japan: *Tin Drum* (1981)
2. "Weathered Wall"—*Brilliant Trees* (1984)
3. "Forbidden Colours"—*Secrets of the Beehive* (1987)
4. "Let the Happiness In"—*Secrets of the Beehive* (1987)
5. "Blackwater"—*Rain Tree Crow* (1991)
6. "Blemish"—*Blemish* (2003)
7. "Transit"—Fennesz: *Venice* (2004)
8. "How Little We Need to Be Happy"—*The Good Son vs. The Only Daughter* (2005)
9. "Wonderful World"—Nine Horses: *Snow Borne Sorrow* (2005)
10. "The Rabbit Skinner"—*Manafon* (2010)

Keep Me in Your Heart for a While

Laments, Sung Weeping, and Deathbed Songs

Just as there are many ways to skip from this mortal coil so, too, do we all give ourselves to grief in different ways. In Greek mythology, Linus (or Linos), the son of Apollo and one of the Muses (typically Calliope), was considered the personification of lament. He was killed when young, and in various versions of the myth his death was caused when he was torn apart by dogs or after having suffered a fatal blow from Hercules, one of his lyre pupils (Orpheus was another), who hit him with his own instrument. Thereafter, young women would sing laments in Linus's name. A long line of musical laments have been sparked from the loss of youth to acts of violence and terror, the suddenness of these deaths jolting us into the recognition of life's impermanence and cruelty.

In the *Iliad*, Homer wrote of the desire and satisfaction of lament—the passionate expression of grief in poetry or song. It's a belief echoed by traditions as varied as the *gisalo* as practiced by the Kaluli of Papua New Guinea, keening in Ireland and Scotland, fado in Portugal, and jazz funerals in New Orleans. There are many funereal songs that ring out from this side of the mortal divide in the works of those pondering their demise, the deathbed works of

artists struggling with their own final curtain, and there are even more songs from artists pondering death as the greatest mystery of life, which is another way of saying that there are *deathbed* songs and then there are deathbed songs. The former include "Barbara Allen," blues masterpieces like St. Louis Jimmy Oden's "Going Down Slow," and Mimì's final reminiscence with Rodolfo ("Oh Dio! Mimì!") in Puccini's *La Bohème*, while the latter counts Mozart's Requiem and Warren Zevon's "Keep Me in Your Heart."

The conversation with death so masterfully portrayed as a game of chess in Ingmar Bergman's *The Seventh Seal* has long been represented in music, from Appalachian folk songs like "O Death," which was recorded so wonderfully by Ralph Stanley in 2000 (the singer pleading with Death, "Won't you spare me over till another year") to Scott Walker's baroque-pop classic about Bergman's film, "The Seventh Seal." And then there is Cam'ron's "Death," from 1998's *Confessions of Fire*, in which the singer supplies a very literal exposition of the Biggie Smalls line from "Suicidal Thoughts": "I swear to God I feel like Death is fuckin' calling me."

In the case of many composers, this conversation is extremely real, as they work frantically to complete pieces even in their final moments. Bach is said to have composed via dictation in his last days. Beneath the seats of the '52 Cadillac that Hank Williams died in, a crumpled sheet of lyrics were found, thought to be a final plea to his estranged wife, Audrey. Schubert corrected proofs of his heart-rending *Winterreise* on his deathbed (it would be published posthumously), and was able to finish before he died. That can't be said for Mozart, who struggled in vain through illness to complete his Requiem Mass. Commissioned by Count von Walsegg, anonymously, with the intended purpose of passing it off as his own, the Requiem Mass in D Minor, though not entirely the work of "Wolfie"—a man ever aware of the fragility of life—was composed while he was stretched across his deathbed, and was completed, following the composer's demise, by his pupil Franz Xaver Süssmayr. The Requiem stands as a prime example of the work composers create while staring into the face of death.

Gustav Mahler completed one of his greatest works, *Das Lied von der Erde* (*The Song of the Earth*), in 1908, following the twin tragedies of his four-year-old daughter's death and the revelation of his own troublesome but not exactly fatal heart condition. The piece—which Jan Swafford in *The Vintage Guide to Classical Music* calls a "heartrending farewell to life"—was based on the translations of six Chinese poems, which Mahler set for solo voice and blanketed with a rich, expressive sound. He experienced the light of his own life flickering as well as the extinguished flame of a young life, realities reflected in refrains such as "Dark is life, is death," which hover like a fog over the first two pieces. This is followed by three more vibrant scherzos, and ends with "Der Abschied" ("The Farewell"), in which Mahler reckons with his demise: "Still is my heart; it is awaiting its hour." Though Mahler may have believed he was on his deathbed, he lived another two years before dying on May 18, 1911, at the age of fifty.

Deathbed spirituals and hymns such as "Watching by a Deathbed" ("How dark it is! How full of mystery! That I as chained hound should useless lie! Aching for death, but still I do not die.") were popular from the eighteenth century through the Civil War years, and one tradition that still survives from the period is to spell out the details of your own funeral arrangements. This likely comes from another great English folk ballad known as "The Unfortunate Lad" or "The Unfortunate Rake," which eventually morphed into "Streets of Laredo" and "St. James Infirmary Blues." "Streets of Laredo" is both a first-person (a young cowboy who "knows he done wrong," is about to die, and maps out his funeral) and a second-person lament, as it describes the burial and the marker left on his grave. In "St. James Infirmary Blues" a man learns of the death of his woman and prepares for his own demise, saying, "Put a twenty-dollar gold piece on my watch chain / So you can let all the boys know I died standing pat." The sentiment is echoed in other blues, such as Blind Lemon Jefferson's "See That My Grave Is Kept Clean," in rap's greatest funereal songs, like 2Pac's "Life Goes On" ("Bury me smilin' with G's in my pocket"), and the smothering groove of Smog's "Dress Sexy at My Funeral."

Gangsta rap's death obsession is filtered through both the bravado and tears of the blues. Just one month before his shooting death, 2Pac (Tupac Shakur)—as his Makaveli alter ego—recorded the song "Hail Mary," seemingly resigned to his fate as "a ghost in these killing fields." Many thought that the Notorious B.I.G. (Biggie Smalls) had a hand in Shakur's death, as the two had feuded openly for months and became the personifications of the East Coast/West Coast rap wars. On March 9, 1997, Smalls was also gunned down, and his sprawling album *Life After Death* (released just weeks after his murder) featured tracks like the ruminative urban laments, "Miss U" and "You're Nobody (Til Somebody Kills You)." Biggie himself would become the subject of one of the biggest hip-hop eulogies ever, in the Sean Combs (then Puff Daddy) hit "I'll Be Missing You," which debuted at number one on the *Billboard* charts upon its release in 1997 and stayed there for eleven weeks.

The deathbed scene cuts to the funeral home, where music is often a vital part of saying good-bye. Movies like *The Big Chill* and *Love Actually* feature funeral scenes bursting with pop music—the Rolling Stones' "You Can't Always Get What You Want" in the former and the Bay City Rollers' "Bye Bye Baby (Baby Goodbye)" in the latter. In 2008 funeral managers at Centennial Park, the largest cemetery and crematorium in Adelaide, Australia, reported that Sinatra's "My Way" and Louis Armstrong's "What a Wonderful World" topped their list of most requested funeral songs. They also released a list of "Most Unusual" requests, which featured "I'm Too Sexy," by Right Said Fred, and "Ding-Dong! The Witch Is Dead." A 2009 poll of more than thirty thousand funerals in the UK found that pop songs now account for more than half of all music chosen for funeral services—it also found "My Way" to be extremely popular—as well as theme songs for popular TV shows like *Top Gear* (a reworking of the Allman Brothers' instrumental hit "Jessica") and *The Benny Hill Show*. The publicity that Centennial Park received from the lists was widespread and was followed in 2010 by the release of another top-ten list, from UK cemetery and crematorium Co-operative Funeralcare that had Celine Dion's "My Heart Will Go On" in the top spot.

TOP TEN FUNERAL SONGS—AUSTRALIA (2008)

1. "My Way"—Frank Sinatra
2. "What a Wonderful World"—Louis Armstrong
3. "Time to Say Goodbye"—Andrea Bocelli and Sarah Brightman
4. "Unforgettable"—Nat King Cole
5. "The Wind Beneath My Wings"—Bette Midler
6. "Amazing Grace"—Various Artists
7. "We'll Meet Again"—Vera Lynn
8. "Over the Rainbow"—Judy Garland
9. "Abide with Me"—Harry Secombe
10. "Danny Boy"—Various Artists

TOP TEN FUNERAL SONGS—UNITED KINGDOM (2010)

1. "My Heart Will Go On"—Celine Dion
2. "Candle in the Wind"—Elton John
3. "Wind Beneath My Wings"—Bette Midler
4. "Search for the Hero"—M People
5. "My Way"—Frank Sinatra
6. "You'll Never Walk Alone"—Gerry and the Pacemakers
7. "Release Me"—Engelbert Humperdinck
8. "Memories"—Elaine Paige
9. "Bright Eyes"—Art Garfunkel
10. "Strangers in the Night"—Frank Sinatra

In January 2009 retired Church of Scotland minister Ron Ferguson deemed "unhealthy" the rise of cheesy funeral songs and the desire of some mourners to go so far as to hide the coffin during a funeral service. In responding to the Co-operative Funeralcare list of the most popular funeral songs in the UK, Ferguson said the songs "might seem a good idea down at the pub, but may not feel so appropriate at the actual ceremony."

Just as some funerals may be solemn occasions reflective of the grief of loved ones left behind, other traditions celebrate the life lived, as is the case with the New Orleans jazz-funeral tradition. Its origins in the unique mélange of the city itself—French, Spanish, and African—the jazz funeral is usually reserved for local musicians or members of city social clubs. It begins with the family of the deceased and the band marching from the family's home. This march is accompanied by more somber, traditional material such as "Nearer My God to Thee." Following the burial, the tenor of the funeral changes and becomes more upbeat and celebratory as attendees and other onlookers are invited to join the "second line," which follows the band. As saxophonist Sidney Bechet once said, "Music [in New Orleans] is as much a part of death as it is of life."

As a listening experience, though, there are likely no musical sounds you could subject yourself to that are as emotionally bruising as listening to the now disappeared death wails or sung-weeping laments once practiced by the Kaluli of Papua New Guinea.

An important Kaluli myth tells the story of a young boy's metamorphosis into a muni bird, his voice transmogrifying from a boy's cry to the wail of the bird, and finally into the sung weeping once such an integral part of the Kaluli culture. This simple myth, one of only a handful that exist for Kaluli people of the Bosavi region of Papua New Guinea, became a focal point for musician and anthropologist Steven Feld and his 1982 book *Sound and Sentiment: Birds, Weeping, Poetics, and Song in Kaluli Expression*. "The argument," writes Feld, "is that this myth is a crystallization of relations between Kaluli sentimentality and its expression in weeping, poetics, and song."

Weeping in Bosavi takes two general forms: as a response to sorrow and as a response to song. Both men and women weep in the brief three- or four-note descending melodic pattern of the muni bird—which echoes the descending bass pattern found in John Dowland's "Flow My Tears" and in sorrowful songs across numerous genres—but men will weep with little variation, while women practice the "most complete elaboration" of weeping by including lengthy improvised text built upon the melody. It is the "women's cried songs that are the most intricate and developed form of weeping," according to

Feld, who says that "while sadness moves both men and women to weeping, it is weeping that moves women to song." The improvised text will include the specific names of people, rivers, gardens, and so on, which, Feld says, "add up to a textual map of shared experiences" for the Kaluli.

To the Kaluli, birds are the spirits of their deceased relatives and are therefore held in reverence, their songs the mournful cries of the dead. One of five ceremonies once practiced in the Bosavi region is *gisalo*, which roughly translates to "song" or "melody." A song form that is performed only in darkness, with the deliberate intention of moving its listeners to tears, *gisalo* demands that the performer must become a bird. After the sun has set, dancers enter one of the Kaluli's longhouses and begin to dance up and down the narrow hall, singing and rattling simple percussive instruments. They sing about familiar places and people, using evocative texts that reflect on their loss and sense of abandonment. At points in the performance the hosts are overcome with grief and burst into tears and wails. Angry at the pain they are made to feel, they jump to their feet, grab a nearby torch, rush onto the floor, and jam the flaming torch into a dancer. According to Feld, the dancer "continues as if unaffected by the burn and may be burned repeatedly. Hosts either sit down again and cry or move to the rear veranda of the longhouse to weep alone."

To immerse yourself in listening to the field recordings of the sung weeping of the Kaluli is to have your heart pummeled in a way that Billie Holiday, Hank Williams, or Leonard Cohen couldn't touch. It's raw—Yoko Ono minus the artifice—and so removed from what we're familiar with that it fills the air with a mysterious toxicity. The sung weeping is like free jazz from another time, order barely hanging together; it distresses the listener looking for clarity in all the manipulated choking and shuddering.

Now, after decades of missionaries, oil producers, lumber concerns, and anthropologists have visited Papua New Guinea and brought with them the culture of the West—Feld himself speaks of playing blues and jazz tapes for them—the Kaluli have lost much of their traditional song forms in favor of what they refer to as *gito gisalo* (string bands), merging their word for guitar and their long-standing

musical form. The *gito gisalo* leaves behind the sung weeping of the traditional *gisalo* in favor of more Westernized melodies. Yet even removed from the raw beginnings of their sung-weeping traditions, the string bands still emit what longtime *Village Voice* music critic Robert Christgau called a "sour, mournful undertow." Though it does ring with a simple majesty it has lost the mysterious magic of the ceremonial singing that came before it. (Both field recordings of the sung weeping now lost to time, and the newer string bands of the Bosavi region, can be heard on 2001's Smithsonian Folkways three-disc collection *Bosavi: Rainforest Music from Papua New Guinea*.)

The Kaluli's sung weeping tradition is just one of a handful of varieties found in different cultures. The keening tradition of Ireland and Scotland features improvised and set patterns of wailing over the dead at burial. The Karelia of Northern Europe, a minority people who once lived along the borders of Finland and the former Soviet Republic, sing the *itkuvirsi* ("The Karelian Lament"), which once made up an integral part of their wedding and funerary ceremonies. The *itkuvirsi* lamenter worked as a guide to the afterlife, or *Tuonela* (the land of the dead), with her song acting as a bridge. As many as fifty laments were performed in a funeral ritual and, as musicologist Elizabeth Tolbert describes, "Each lament [was] 'a work of sorrow,' improvised anew for each particular occasion."

These death wails and acts of melodic weeping have largely been lost to time, held in fragile stasis by ethnomusicologists and cultural anthropologists in yearly celebrations like Finland's Ancient Culture Week—which features Karelian Laments. Lamenting the dead, however, will likely never cease to be a part of life.

Of all the English folk songs to have survived and flourished in the past century, few have found such fertile soil as "Barbara Allen"—also known as "The Cruelty of Barbara Allen," "Bonny Barbara Allen," "Barb'ry Ellen," and Child Ballad 84, among other titles. Diarist Samuel Pepys wrote of the song on January 2, 1666, after hearing it performed by actress Mary Knipp: "In perfect pleasure I was able to hear her sing, and especially her little Scotch song of 'Barbary Allen.'" Eighteenth-century author Oliver Goldsmith wrote that the "finest music of the finest singer is dissonance to what I felt

when our old dairy-maid sung me into tears with . . . 'The Cruelty of Barbara Allen,'" and folk singer and song collector John Jacob Niles collected two versions of the song including a text from a twelve-year-old girl who told him there was "no music to it, because it was too sad to sing."

The song is about a young man (often Jeremy Grove) who falls gravely ill and asks for Barbara Allen to come to his bedside to sit with him. She slowly makes her way to his deathbed and treats him curtly ("I cannot keep you from your death. So farewell."), but following his passing she is haunted by her actions and grieves over his end. The overwhelming sorrow eventually leads to her death and she is buried next to the young man she once so heartlessly spurned.

Renaissance composer Guillaume Dufay's will set monies aside for the performance of a Mass on the first anniversary of his death and for a large meal for the choristers after Mass. His will also reserved funds to pay musicians to perform his own *Ave Regina caelorum* while on his deathbed, a piece that features a surprising switch from major to minor and that has since proved to be influential to the development of mourning music.

Three decades later Josquin des Prez would compose what choral conductor and Renaissance music expert Edward Wickham has called "the first truly 'modern' piece of funeral music," "Nymphes des Bois," as a lament on the passing of Johannes Ockeghem, composer of the earliest extant version of a polyphonic Requiem Mass (though it's likely Dufay wrote an earlier one that has not survived). The Requiem is named after the Mass's first sung word and was originally meant to be sung in monophonic chant, but has grown to stand for any music written for the expressed purpose of mourning.

Seventeenth-century composer Henry Purcell drafted a handful of Funeral Sentences based on the Book of Common Prayer while in his teens, and one of the greatest laments of all time is "Dido's Lament," from his one-act opera *Dido and Aeneas*. And as organist at Westminster Abbey in 1694, when Queen Mary II died of smallpox at the age of thirty-two, Purcell was also responsible for producing the dignified and achingly beautiful *Funeral Music for Queen Mary II*.

During the twentieth century, Ralph Vaughan Williams added

poems from Walt Whitman to his *Dona Nobis Pacem* while Benjamin Britten added poems by Wilfred Owen to his 1962 *War Requiem*. Krzysztof Penderecki included the traditional Polish hymn, *Święty Bože,* in his *Polish Requiem.* His *Threnody to the Victims of Hiroshima* made him an instant success in the early 1960s—it's a horrific, cacophonous attack on the senses, the dissonant strings clawing their way through the score before receding into near silence, returning again, imitating air raid sirens, retreating, returning, sparks of confusion and dread flying like shrapnel. Morton Feldman's *Rothko Chapel* was written in 1971—in memory of the composer's friend and artist Mark Rothko, who had committed suicide the previous year—and shares the name of the Rothko Chapel in Houston, Texas, that holds an enveloping series of the artist's paintings. A stunningly gorgeous avant-garde lament with voices but no text, it contains a sweetly sad Jewish melody that Feldman had written during WWII that rises only in the song's final moments like a stoic heart finally giving in to grief.

In the world of jazz and pop, laments are equally as ubiquitous. The bombing of the Sixteenth Street Baptist Church on September 15, 1963, that killed four little black girls became a turning point in the civil rights movement and was marked by John Coltrane's grieving "Alabama" and a song Joan Baez made famous, "Birmingham Sunday." The assassination of Martin Luther King Jr. spurred Nina Simone to perform the haunting "Why? (The King of Love Is Dead)," just three days after the civil rights leader was gunned down. (The song was written by Simone's bass player, Gene Tayor.) And Dion had a hit in 1968 with "Abraham, Martin, and John," which was written to memorialize liberal leaders Martin Luther King Jr., Abraham Lincoln, and John F. Kennedy and, though not mentioned in the title, Robert F. Kennedy. The Beach Boys recorded "A Young Man Is Gone" after the passing of James Dean, Charles Mingus wrote "Goodbye Pork Pie Hat" following the death of saxophonist Lester Young, and Elton John's "Candle in the Wind" remembered Marilyn Monroe (and was later performed following the death of Princess Diana). Eric Clapton's "Tears in Heaven," about the passing of his four-year-old son, became a major hit and won Grammy awards for Song of the Year and Record of the Year; and John Adams composed

On the Transmigration of Souls as a eulogy for the victims of 9/11. Having corresponded with singer/songwriter Steve Earle for a decade, Texas death-row inmate Jonathan Nobles asked Earle to attend his execution, which Earle followed with the touching "Over Yonder." Immediately following the death of Michael Jackson on June 25, 2009, hip-hop and R&B stars the Game, Chris Brown, Usher, Sean Combs, Boyz II Men, and others recorded the tribute "Better on the Other Side," releasing it the very next day, June 26. And while laments usually focus on the remembrance of the departed, they sometimes well up in remembrance of other things or more amorphous ideas, suggested by the well-worn notion that "rock and roll is dead" (captured beautifully by Pacific Gas and Electric's "Rock and Roller's Lament") and, in the case of C. P. E. Bach (son of J. S. Bach), his melancholic "Abschieds Rondo," a lament for a Silbermann clavichord that was sold away from him.

They are all laments, for people young and old, rich and poor, school children and world leaders, for clavichords and movie stars, and they only begin to scratch the surface of a tradition of grieving that is as old as music itself.

THE MISERABLE LIST: LAMENTABLE

1. "Dido's Lament"—Henry Purcell (1689)
2. "Abschieds Rondo"—C.P.E. Bach (1781)
3. "Der Abschied" (From *Das Lied von der Erde*)—Gustav Mahler (1908–1909)
4. "St. James Infirmary Blues"—Louis Armstrong (1928)
5. "Going Home"—Paul Robeson (1958)
6. "Why? (The King of Love Is Dead)"—Nina Simone (1968)
7. "Rock and Roller's Lament"—Pacific Gas & Electric (1971)
8. *Rothko Chapel*—Morton Feldman (1971)
9. "Over Yonder (Jonathan's Song)"—Steve Earle (2000)
10. "Séance Gisalo Song"—Aiba (Recording date unknown, released 2001)

SONG ESSAY: "TAPS"

Sergeant Keith Clark may have performed the most widely heard and discussed rendition of "Taps" ever when he sounded the somber twenty-four-note bugle call during the November 25, 1963, funeral services for President John F. Kennedy. The services were broadcast on television and radio, and Clark's performance contained what can be called a historical hiccup, a single "broken note" that became a part of the brief song's long history. Soon after he began his performance, the sixth note simply vanished. He continued the song to perfection and later recalled that he simply "missed a note under pressure," but in his 2002 obituary the *New York Times* wrote that his performance "came to be seen as a perfect embodiment of national sorrow."

"Taps" is, like many rituals born of the military, exacting in its concision: composed of only three tones (E, C, and G) for a total of twenty-four notes, and not wholly dissimilar from Lincoln's Gettysburg Address in its brevity and power.

It is used in services and events by police departments across the country, the Boy Scouts of America, the Canadian Girl Guides, and even the French military adopted the deeply American song in 1937 as their "lights out" call. More significantly, it has played a central role in American mourning since Union General Daniel Butterfield composed it on a hot July night in 1826.

At an encampment at Harrison's Landing, on the grounds of Berkeley Plantation in Charles City, Virginia, soon before the call to extinguish lights was to ring out, Butterfield—who had previously composed other bugle calls and whose father, interestingly, was one of the founders of the American Express Company in 1850—called for a bugler. Private Oliver Willcox Norton arrived with his shining bugle in tow, and Butterfield asked him to sound the notes he had scratched onto the back of an envelope for a new "lights out" call. Norton later wrote: "I did this several times, playing the music as written. He changed it somewhat, lengthening some notes and shortening others, but retaining the melody as he first gave it to me. After getting it to his satisfaction, he directed me to sound that call for 'Taps' thereafter in place of the regulation call."

The new tune spread quickly throughout the Union army and became known as "Butterfield's Lullaby." It soon took on a more grievous aspect when, under battlefield conditions and concerned that the traditional three-gun salute given to honor a fallen soldier would spark renewed hostilities with a closely resting Confederate army, battery captain John C. Tidball determined that "Taps" should be sounded instead, marking its first funereal use. (The song's dual use in military life, as both a daily "lights out" call and a mourning song performed at funeral services, is a deeply ingrained example of the sleep/death metaphor.) Before long it had spread to the Confederate army and was reportedly sounded at the funeral for Southern General Stonewall Jackson—Richard H. Schneider, author of the book *Taps: Notes from a Nation's Heart*, believes the call "could well have been the first unguent in healing the wounds suffered by the bitterly opposing sides."

There are a handful of explanations for the origin of the name *taps*, most suggesting it comes from the Dutch term *tap toe*, which was a drum signal to tavern keepers, alerting them to close their taps so that soldiers could return to their barracks. It became *tattoo* somewhere along the line, and it's likely that *taps* is simply another derivation. Although a number of lyrics exist for "Taps," none are official; the most popular version consists of four verses and begins with yet another colloquial title that the piece has taken on over the years, "Day Is Done":

> *Day is done*
> *Gone the sun*
> *From the lakes, from the hills, from the sky*
> *All is well*
> *Safely rest*
> *God is nigh*

Though some scholars believe that Butterfield should not be given credit for penning the song, as it relates so closely to "Tattoo," most are happy to give him credit (especially when considering the small range of tonal options on a bugle). When Butterfield died, on July 17,

1901, he was buried at West Point (despite his never having attended the academy) by special order of the secretary of war and, as is only fitting, a lone bugler sounded "Taps" over his grave.🄻

THIS MORTAL COIL

On paper This Mortal Coil—a loosely knit collective headed by 4AD president and cofounder Ivo Watts-Russell, with contributions from members of Cocteau Twins, Wolfgang Press, Dead Can Dance, Colourbox, and other dreamy and dreary acts of the eighties and nineties—could have been a vanity-fueled train wreck. Instead, the three albums released under the name prove to be what *The Guardian* called Watts-Russell's "crowning glory," and continue to hold well their melancholy magic. The spark that lit Watts-Russell's imagination occurred after seeing then-4AD act Modern English mix together two cover songs ("Sixteen Days" and "Gathering Dust") to close a sold-out concert at the Ritz in New York. He encouraged the band to record the songs, and, though Modern English wasn't interested, Watts-Russell knew potential when he saw it. What started as the *Sixteen Days/Gathering Dust* EP quickly snowballed into 1984's *It'll End in Tears* and became surprisingly influential. Not only was it the greatest first step toward what would become known as "the 4AD sound" but it also reinvigorated the cult status of Memphis power-pop group Big Star—represented on the album by "Kanga-Roo" and "Holocaust," two of their most distressing songs, both from their monumental shambles of a recording, *Third/Sister Lovers*. Also included was Tim Buckley's "Song to the Siren," performed by Robin Guthrie and Elizabeth Fraser of the Cocteau Twins, which reaches an uncanny ethereal beauty; in Watts-Russell's words, "You'd have to be either deaf or dead not to be moved by that gorgeous song." Besides the focus on exquisite female vocals—Watts-Russell had approached dramatic male vocalists such as David Sylvian, Scott Walker, Robert

Wyatt, and Ian McCulloch, all of whom turned him down—and his desire to bridge the traditional silences between songs, the only criterion for the songs chosen was that they be "very introspective" and "melancholy." Watts-Russell kept the momentum and released the double-album *Filigree & Shadow* in 1986. Then, with what appeared to be a more core group of contributors—including Simon Raymonde of the Cocteau Twins, producer John Fryer, and arranger Martin McCarrick—by his side, he loaded half the running time with brief instrumentals, which, as beautifully dreary as they may be, always seem to float disruptively between the astonishing vocal cuts such as Pearls Before Swine's "The Jeweller" and Colourbox's "Tarantula." An extended silence occurred following *Filigree & Shadow*, and This Mortal Coil's final act wasn't released until 1991, with the appearance of another double-album's worth of material on *Blood*—a collection Watts-Russell began work on in 1986. This time he relied primarily on his go-to producer John Fryer. *Blood* once again called upon the Big Star legacy, with two Chris Bell works—"You and Your Sister" (with vocals by Kim Deal of the Pixies, and Tanya Donelly of Throwing Muses) and the song that has become synonymous with Bell, "I Am the Cosmos" (with vocals by Dominic Appleton, of Breathless, and Deirdre Rutkowski). Watts-Russell was adamant that *Blood* was the final chapter, saying in 1993 that This Mortal Coil "is very much over." Technically that promise may have held water, but by the late 1990s Watts-Russell wanted "to have a project to obsess over again" and returned to the studio. Working primarily with bassist Laurence O'Keefe, drummer/saxophonist Richard Thomas, and arranger Audrey Riley (erstwhile TMC producer Fryer became involved during the mixing process) under the name the Hope Blister, the result is 1998's . . . *smiles OK*, a more organic and ambient outing than any of the TMC releases. A comprehensive retrospective box set that included remastered versions of all three original albums as well as a bonus album, *Dust & Guitars*, was released in 2011, and listeners were more than happy to be thrown back in time into the gray embrace of TMC's ethereal works.

TINDERSTICKS

During the early nineties, Tindersticks trampled down a singular patch of the Brit Pop invasion, tailoring downcast pop stitched together from the threads of country rock, Stax-inspired soul, Ennio Morricone's Spaghetti Western soundtracks, and the Velvet Underground's taste for noisy experimentalism. At the heart of Tindersticks' unique sound was the deep-river baritone of Stuart A. Staples: a weighty anchor, equal parts Lee Hazlewood's cowboy mumble and the soulful croon of Isaac Hayes. Staples's lyrics—caddish country philosophy meets girl-group heartbreak—cast a sophisticated and seedy shadow over the soot-drawn breath of keyboardist David Boulter's organs and violinist Dickon Hinchliffe's dutifully gray string arrangements. The lion's share of the band came together in the early nineties to perform in Staples's group Asphalt Ribbons. When the lineup solidified, the group changed their name to Tindersticks and immediately began spitting out singles, beginning with 1992's "Patchwork." Their first eponymous album (known to those who know it as *Tindersticks I*) was released in 1993 and named Album of the Year by *Melody Maker*. They continued to refine their sound through 1995's *Tindersticks* (or *Tindersticks II*) and 1997's *Curtains*, before tightly embracing the hard-knock, string-sweetened soul of Curtis Mayfield and Isaac Hayes for 1999's *Simple Pleasure*. Their soul adoration remained on 2001's *Can Our Love . . .* but was largely dispensed on 2003's *Waiting for the Moon*, which many critics hailed as a return to form. Their output is also speckled with commanding live releases, including two limited "official bootleg" releases, *Live at the Botanique* and *Coliseu dos Recreios de Lisboa* (both recorded in 2001). The Tindersticks began an extended hiatus in 2005, with Staples performing under his own name—often in collaboration with 'sticks members David Boulter and Neil Fraser—and Hinchliffe scoring for television and film. The group returned to work in 2007 with Staples, Boulter, and Fraser at its core, releasing one of their finest albums, *The Hungry Saw*, the following year. More lineup changes preceded the 2010 release of *Falling Down a Mountain,* though the

trio of Staples, Boulter, and Fraser remained. In 2011 the *Claire Denis Film Scores* (1996–2009) box set was released, compiling the six soundtracks created by the group for the French director, and in 2012 *The Something Rain* was released, preceded by the springy rhythm machine beats and weeping strings of "Medicine."

THE MISERABLE LIST: TINDERSTICKS

1. "Patchwork"—Single (1992)
2. "City Sickness"—*Tindersticks* (I) (1993)
3. "Tiny Tears"—*Tindersticks* (II) (1995)
4. "No More Affairs"—*The Bloomsbury Theatre 12.3.95* (1995)
5. "Rented Rooms"—*Curtains* (1997)
6. "Can We Start Again?"—*Simple Pleasure* (1999)
7. "Can Our Love . . ."—*Can Our Love . . .* (2001)
8. "Trouble Every Day"—*Live at the Botanique* (2001)
9. "The Hungry Saw"—*The Hungry Saw* (2008)
10. "Medicine"—*The Something Rain* (2012)

TOWNES VAN ZANDT

Arguably the greatest singer/songwriter ever to come out of Texas and one of the most self-destructive to come out of anywhere, Townes Van Zandt wrote what his longtime friend Guy Clarke called "the kind of songs that everybody was afraid to write." Once asked why his songs were so sad, he responded, "Oh, they're not all so sad. Some of them are just hopeless. The other ones are sad." Born on March 7, 1944, in Fort Worth, into a prominent Texas family—Van Zandt County was named after his great-great-grandfather, Isaac Van Zandt—John Townes Van Zandt had wandering in his blood, as his father, an oilman, took his family through a series of homes in Colorado, Montana, Illinois, and elsewhere. "I had a nice childhood and all that," Van Zandt would note later in life. "I don't remember

it, but that's what I've been told." He started playing guitar at age nine after seeing Elvis Presley on TV, joking later that he didn't learn his second chord until he was twenty-one. He played a number of sports and had a high IQ; after finishing high school at the Shattuck Military Academy in Faribault, Minnesota, he was accepted into the University of Colorado at Boulder in 1962. At school he would spend days locked in his room, drinking, playing guitar, and listening to Bob Dylan albums, and by the spring of his sophomore year his parents—concerned about his binge drinking but primarily reacting to a forged letter in their names that granted Van Zandt permission to drop out—flew to Boulder to bring him home to Houston. Back in Texas he was diagnosed with manic depression and admitted to the University of Texas Medical Branch (UTMB) in Galveston for three months of insulin shock therapy, a harrowing process that played havoc with his long-term memory. He enrolled in the University of Houston as a pre-law student, married his first wife, Fran Petters, whom he had met as a sophomore in Boulder, and attempted to join the Air Force, though the doctors at UTMB wouldn't allow it, labeling him an "acute manic-depressive who has made minimal adjustments to life." It was at that point that Van Zandt began to take his playing more seriously and became a part of the Houston folk scene—where he met a group of like-minded souls, including lifelong friend Guy Clark, and one of his chief influences, legendary bluesman Lightnin' Hopkins. Simultaneously he maintained a dedication to the Van Zandt family tree, remaining a student at UH Law—a burden he abandoned following the death of his father in January 1966. "Waitin' Around to Die," one of his first songs, seemed to encapsulate all there was to know about Townes, with allusions to gambling, booze, the comfort of codeine ("a friend at last"), and "lots of ramblin'." Successes were few as he gigged through the folk circuit, spending nights on stages in empty rooms and being reduced to eating dog food on several occasions. Singer/songwriter Mickey Newbury (who had signed a deal with the prestigious Acuff-Rose publishing agency) saw Van Zandt performing in Houston and worked to solidify a recording opportunity for the singer. For better or for worse, Van Zandt signed a deal with industry player Kevin

Eggers, who was on the verge of launching Poppy Records—to many of those closest to Van Zandt, just the mention of Eggers's name in the years that followed would cause a spike in blood pressure—and the singer's debut album, *For the Sake of the Song*, became the label's flagship release in 1968. Producers "Cowboy" Jack Clement and Jim Malloy, unsure of what to do with Van Zandt's unusual songs, draped them with baroque, pseudo-psychedelic flourishes, which made the album difficult for Townes to listen to and a disaster to many of the singer's coffeehouse fans. His delicate playing and sad, softly bruised plainspoken voice, which worked so well for material like "Tecumseh Valley," "Quicksilver Daydreams of Maria," and "Waitin' Around to Die," suffered beneath the weight of stinging zithers, gothic organs, and disembodied choirs. He would rerecord many of the songs over the next few tremendously fruitful years, during which he released 1969's *Our Mother the Mountain*, 1970's *Townes Van Zandt*, 1971's *Delta Momma Blues*, and two 1972 masterpieces, *High, Low and In Between* and *The Late Great Townes Van Zandt*. His output slowed following this uncanny string of releases, and the remainder of his studio records came sparingly, with *Flyin' Shoes* in 1978, *At My Window* in 1987, and his final studio release, *No Deeper Blue*, appearing in 1994, his voice a more low-pitched, ravaged shadow of what it once was. He continued to tour during the lulls between studio albums, and many shows were recorded and subsequently released, though the performances became haphazard affairs as his health declined—he passed out on occasion or broke into helpless crying fits onstage. Even so, many of the recorded performances are sublime, capturing both the singer's world-weary pain and dry sense of humor. A recording session with Sonic Youth's Steve Shelley was scheduled to begin in December 1996, but a broken hip—which Van Zandt refused medical assistance for—and his drunken behavior at the studio, caused Shelley to cancel the session. Townes always assumed he would follow his hero Hank Williams to an early grave, and that he did, passing away unexpectedly on January 1, 1997, exactly forty-four years after the death of Williams. He was only fifty-two years old, and although the official cause of death was cardiac arrhythmia, there's no doubt that his hard

living was to blame. *Texas Monthly* eulogized him, saying he "wrote some of the saddest songs of the century." Guy Clark, reminiscing on a time when Van Zandt once performed a set of his saddest material, recalled a woman from the audience piping up and asking the singer if he couldn't play a happy song. Van Zandt responded in his typically tart manner, "Man, these are the happy songs. You don't want to hear the sad ones."

THE MISERABLE LIST: TOWNES VAN ZANDT

1. "Sixteen Summers, Fifteen Falls"—*For the Sake of the Song* (1968)
2. "Kathleen"—*Our Mother the Mountain* (1969)
3. "Waitin' Around to Die"—*Townes Van Zandt* (1970)
4. "Nothin'"—*Delta Momma Blues* (1971)
5. "You Are Not Needed Now"—*High, Low and In Between* (1972)
6. "Snow Don't Fall"—*The Late Great Townes Van Zandt* (1972)
7. "Tecumseh Valley"—*Live at the Old Quarter, Houston, Texas* (1977)
8. "Flyin' Shoes"—*Flyin' Shoes* (1978)
9. "A Song For"—*No Deeper Blue* (1995)
10. "Marie"—*Abnormal* (1998)

SCOTT WALKER

His influence can be heard rippling through the works of David Bowie, Thom Yorke, Jarvis Cocker, and Nick Cave, to name but a few devotees, and in the late 1960s he shared the peaks of the British charts with the Beatles and the Stones. Then rapidly changing tastes, a frustrated record company, and a challenging one-album statement saw his popularity slip away and his artistic resolve drift off into the fog of his reclusive nature (*Mojo* once called him "Pop's own Salinger") before his return with a string of complex avant-garde albums that defy categorization. Born Noel

Scott Engel on January 6, 1943, in Hamilton, Ohio, Walker moved with his parents to Los Angeles when he was five. In his early teens, and in contradiction to his future reclusivity, Walker sought the spotlight, recording a handful of foamy pop songs before eventually meeting John Maus and Gary Leeds, forming the Walker Brothers, and heading to swinging London to find fame, which the group did, inspiring a 1967 fan-club list larger than that of the Beatles. The group's hits, all spotlighting Scott's rich baritone, include Bacharach and David's "Make It Easy on Yourself" and their masterpiece of doomed romanticism, "The Sun Ain't Gonna Shine Anymore," which was released in February 1966 and ruled the British airwaves that spring, remaining at the top of the charts for weeks on end (it only reached number thirteen in the States). But later that year, when the group gathered to record their second album, *Portrait*, also from 1966, tensions were rising between the trio concerning Scott's perceived dominance of the group, and music journalists were beginning to ask just when the moody singer—who was experimenting with more difficult pop-chart allergens like "Orpheus" and "Genevieve"—would go solo. When Scott did finally break from the group, just after the 1967 release of *Images*, he immediately set to work on his debut, *Scott*, releasing it before the year was out. A clear continuation of the darker themes and styles Walker had begun experimenting with during his time with the Walkers, *Scott* was a spectacular hit. Though the direction didn't change on *Scott 2* (1968) or *Scott 3* (1969), Walker did feel free to explore more distressing material than he could have in the teen-idol trappings of the Walker Brothers. His outlook rarely brightened and the clinging schmaltz of the string arrangements rarely relented, though his thoughtful material (primarily his own compositions and English versions of songs by Belgian singer Jacques Brel) made for transportive listening. Greeted by cries of both genius and self-indulgence, and deleted within months of its release in September 1969, *Scott 4*, the first album featuring only material written by Walker, is now widely considered to be the masterpiece of Scott Walker's enigmatic and ambitious catalog. Before the release of

Scott 4, Walker prophetically said in an interview, "I don't think I could stand the taste of failure. I'd quit and go wandering off into obscurity forever." The album, which Walker insisted be released under his real name, tanked, and, true to his word, he began to recede from view, gave up songwriting, and retreated to facile, MOR balladry. Then, after two mostly forgettable soft-rock reunion albums with the Walker Brothers in 1975 and 1976, something stirred in the sleeping Scott. *Nite Flights* (1978), the final Walker Brothers album, begins with "Shutout," an unbelievable blast of futuristic noir funk ("Crouching and wailing on stones down here / We must freeze off the ratmosphere") and continues to career through three other Scott Walker songs ("Fat Mama Kick," "Nite Flights," and "The Electrician") that took a cue or two from David Bowie's Berlin-era work with Brian Eno (who raved in print about the tracks) and proved a tense denouement to a Lazarus act no one saw coming. Impressed, Virgin Records excitedly signed Walker and immediately set about waiting four years for the perplexing and wondrous *Climate of Hunter*, which opens with the lone clanking of a cowbell before Scott's "This is how you disappear." After an eleven-year hiatus, during which a record coproduced by Eno and Daniel Lanois (who had recently finished work on U2's *The Unforgettable Fire*) was scrapped, Walker returned with *Tilt* (1995), having followed his muse further down the rabbit hole. In 1999 he recorded the soundtrack to the film *Pola X*, and in 2006 released his most challenging statement, *The Drift*, on which he infamously used a full side of pork as a percussion instrument, telling *The Independent*, "I was looking for something to get across an undercurrent of violence." That same year, the pork slapping, as well as interviews with a number of Walker acolytes, appeared in the documentary film *Scott Walker: 30 Century Man*. Walker, in the midst of label squabbles during his pop heyday, acutely surmised the path that lay ahead, saying, "My music is not instantaneous, but in years to come the small number of people who have bothered to listen . . . should feel I have made some kinda effort which was worthwhile in retrospect."

THE MISERABLE LIST: SCOTT WALKER

1. "The Sun Ain't Gonna Shine Anymore"—The Walker Brothers: Single (1966)
2. "Orpheus"—The Walker Brothers: *Images* (1967)
3. "Montague Terrace (In Blue)"—*Scott* (1967)
4. "My Death"—*Scott* (1967)
5. "It's Raining Today"—*Scott 3* (1969)
6. "The Old Man's Back Again"—*Scott 4* (1969)
7. "The Electrician"—*Nite Flights* (1978)
8. "Track Three"—*Climate of Hunter* (1984)
9. "Farmer in the City"—*Tilt* (1995)
10. "Cossacks Are"—*The Drift* (2006)

SONG ESSAY: "THE ELECTRICIAN"

In 1978, the Walker Brothers were facing extinction. Again. The trio—not brothers, none named Walker—had been one of the biggest-selling groups of the mid-sixties in the UK, scoring major hits with wall-of-sound style ballads like "Make It Easy on Yourself" and "The Sun Ain't Gonna Shine Anymore." The brooding and restless Scott Walker, always the focal point of the group, slowly drew away from guitarist/singer John Maus and drummer/singer Gary Leeds during 1967 and 1968 and crooned his way through four massive and influential solo albums (followed by a fair amount of schlock) before rejoining Maus and Leeds in a full-fledged Walker Brothers reunion in 1975. Initally the reunion provided a glimmer of hope for the then struggling musicians, as the single "No Regrets" cracked the UK's top ten, but the 1975 album of the same name, and its follow-up, *Lines,* in 1976, proved artistically and commercially fruitless. The world had more or less written off the group and their crooning, sensitive center, Scott Walker.

Then news came that their label, GTO Records, was set to be acquired by CBS and the trio would likely be homeless when the smoke cleared. What must have been depressing news at first soon morphed into artistic license for Scott, who in a 1984 interview recalled the philosophy of the group leading up to their final recording: "I said to the other guys, this is going to be the last album so everybody just get as self-indulgent as you want." This freedom may have been fueled by a shot of inspiration coming from the general direction of Berlin, where David Bowie and Brian Eno had just completed what would become known as Bowie's groundbreaking Berlin trilogy: *Low* (1977), *"Heroes"* (also '77), and *Lodger* (1979). After the bloodless soft rock of *Lines,* the future-shock wallop of Scott's songs on 1978's *Nite Flights* seems to have come from nowhere. It did little to resurrect the Walker Brothers' commercial prospects, but Scott's tracks were undeniable heavyweights that instantly made the singer a big wheel in art-rock circles.

Nite Flights is usually dissected as three solo miniatures lashed together—Scott's four blazing tracks open the album, Gary's two contributions follow, and John's four songs round out the running order—but in the end it's all about Scott's. The album opens with "Shutout," an intense shot of protometal funk complete with a furious guitar lead; "Fat Mama Kick" is disco drowning in dread with a haywire saxophone solo; and "Nite Flights" is simply one of the coolest pop songs of the 1970s, and exhibits the most striking parallels to Bowie's Berlin work—for his part, Bowie, an avowed Walker disciple, covered the song on his 1993 album *Black Tie White Noise*—but it's Walker's fourth and final contribution to the album that's the real showstopper and became the blueprint for his subsequent career revitalization. A disturbing, organ-chilled torture drama, Walker's career unfurls into the past and the future from "The Electrician": the brooding romance of his early albums represented by an impossibly lush middle eight, while his career to come is represented in the song's haunting experimentalism and opaque poetry. While interviewed by a German DJ in 1984 Walker was less tight-lipped than usual about the song's origins,

revealing that it's about "the Americans sending in these people, trained torturers, in South America . . . I imagined these lovers in a conversation."

In November 1975—following a string of coups d'état across Latin America during the fifties, sixties, and seventies—the military governments of Argentina, Brazil, Bolivia, Chile, Paraguay, and Uruguay established Operation Condor as an antileftist plot to rid South American countries (primarily Argentina, whose Dirty War ran concurrent to Condor) of their political opponents. Though the stated objective was the eradication of guerilla activities, the civilian population, particularly trade unionists and students, also became targets, resulting in a wave of repression, torture, and murder. The full scope of the atrocities that occurred during Condor will likely never be known, but researchers estimate that as many as 50,000 people were murdered, another 30,000 forcibly "disappeared" (the tragic *desaparecidos*), and another 400,000 were incarcerated.

As Argentine dictator Jorge Rafael Videla consolidated his power, leftists and members of the People's Revolution Army were often tortured and disposed of without mercy. In an auto workshop, torturers used the sounds of roaring engines to mask the screams of their victims, who were beaten, shocked, and dunked headfirst into water using a pulley system—an act the torturers referred to as "The Submarine." Officials at the National Security Archives in Washington, DC, admit that the US had "general but very solid knowledge" of the crimes as they were occurring. Documents have revealed that the US funneled tens of millions of dollars to the military dictatorships of South American countries during this time, that then Secretary of Defense Henry Kissinger looked the other way regarding human rights violations, and that a shared intelligence program was created using American telecommunications networks that included specifics on torture programs, though suggestions that US torture specialists had their feet on the ground remain unfounded.

With the the backdrop of US involvement in Argentina's Dirty War

during the seventies—when many Argentineans were imprisoned, tortured, and killed—and Walker's "tortured lover" metaphor established, the oblique lyrics of "The Electrician" begin to reveal themselves, and when Walker sings the song's pivotal line, "He's drilling through the Spiritus Sanctus tonight," it can be read both figuratively and literally as a breaking of the spirit. "If I jerk the handle, you'll die in your dreams / If I jerk the handle, jerk the handle / You'll thrill me and thrill me and thrill me." Then, from nowhere, a gorgeous orchestral mirage blossoms, dotted with thrumming harp and Spanish guitar—like the kick of hallucinogenic endorphins that accompany brain death, or the sadistic joy of the torture artist, or, more likely, both—before quickly disintegrating again into the same darkness it erupted from moments earlier, Walker explaining one more time in his shrouded croon over a threatening pulse of synths, "When lights go low / There's no help, no."

"The Electrician" was released as a single and, despite its obvious artistic merits, it unsurprisingly failed to make a commercial impression. "Stayin' Alive," which ruled the charts for four weeks in early 1978, it was not. On the strength of "The Electrician" alone, Bowie—who was then finishing work on 1979's *Lodger*—contacted Walker's record company with a desire to collaborate in some way with the reclusive singer, but Walker turned him down through an intermediary. Impressed by his work on *Nite Flights*, Virgin Records signed Walker to a notoriously ridiculous-in-retrospect deal that was predicated on an eight-album deliverable. (Little did they know it would be more than four years before the world would hear another Scott Walker album—1984's *Climate of Hunter*—and that would notably be his only album of the 1980s.)

Roughly twenty-five years after praising the song upon its release in the pages of *Melody Maker*, Brian Eno, while listening to *Nite Flights* for the 2006 documentary *Scott Walker: 30 Century Man*, reflected on Walker's groundbreaking quad of songs and mourned the stasis of popular music as art, quipping, "We haven't got any further than this. It's a disgrace." Ⓗ

HANK WILLIAMS

When Leonard Cohen was building his "Tower of Song" he placed Hank Williams "one-hundred floors above" himself. Johnny Cash once told Bob Dylan that "I'm So Lonesome I Could Cry" was the saddest song he ever heard. In the five years between his first major hit, 1947's "Move It On Over," and his quiet death on New Year's Eve 1952 in the backseat of a Cadillac, Hank Williams's expressive voice and evocative lyrics combined blues, gospel, and "hillbilly music" to define modern country and leave an indelible mark on popular music as a whole. Hiram King Williams was born in Mount Olive, Alabama, on September 17, 1923. He was a frail child and was born with a congenital spinal defect (spina bifida occulta) that inflicted chronic back pain on him throughout his life. In 1930 his father, a WWI veteran, disappeared from his life for roughly a decade after being diagnosed with dementia and being admitted to a V.A. hospital. Williams's mother, Lillie, kept the family above water during the Great Depression by taking a number of odd jobs—people remembered Hank saying in later years, "There ain't nobody I'd rather have alongside me in a fight than my mama with a broken bottle in her hand." When he was around eight years old his mother bought him a second-hand guitar for $3.50, while his musical education was largely provided by local bluesman Rufus Payne, who went by the name Tee Tot. By his teens Williams was performing locally, and when the family moved to Montgomery he started his first and only band, the Drifting Cowboys. Williams and the group began performing on Montgomery's WSFA radio in 1941 and remained loyal to the station, which took to calling him the Singing Kid, throughout his career. In 1943 he met the pretty and ambitious Audrey Mae Sheppard while performing at a medicine show, and by the time the two were wed in 1944 she had become Hank's manager. Through his concert and radio appearances Williams had amassed a strong local following, but wider notice eluded him, which moved Audrey and Hank to travel to Nashville and meet with songwriter and publisher Fred Rose (of Acuff-Rose Publishing). The publisher liked what he heard and created opportunities for

Williams that led to the release of his first singles—"Never Again" in 1946 and "Honky Tonkin'" in 1947—and a contract with MGM Records. Williams's first single for MGM, 1947's "Move It on Over," became his first major hit and he followed it with songs like "I'm a Long Gone Daddy" and his first big crossover hit, "Lovesick Blues," which ruled the country charts and cracked the pop twenty-five. But Hank's drinking and violent outbursts were already a problem, and Audrey filed for divorce on May 26, 1948, specifying in her complaint, "I am afraid to live with him any longer." The two reconciled soon after, and the following year Audrey gave birth to their son, Randall Hank Williams (better known today as Hank Williams Jr.). That same year, Hank was hired by a reluctant Grand Ole Opry and relocated to Nashville as he continued to rack up hits including "You're Gonna Change (Or I'm Gonna Leave)" and "My Bucket's Got a Hole in It"—the latter timidly featured what would become his signature song, "I'm So Lonesome I Could Cry," as a B-side. His streak continued into 1950 with a mess of blue country classics including, "Long Gone Lonesome Blues," "Why Don't You Love Me," "Moanin' the Blues," "My Son Calls Another Man Daddy," and "Why Should We Try Anymore," while he also began cutting records under the name Luke the Drifter. Never as popular as the work released under his own name, his recitations as Luke are dark, cautionary, spiritual songs like "Pictures from Life's Other Side" and "Men with Broken Hearts" that count among his best work. Williams began 1951 with the two-sided hit "Dear John" b/w "Cold, Cold Heart"—a young Tony Bennett making the latter song a pop hit later in the year. He toured with Bob Hope and Jack Benny, appeared on *The Perry Como Show*, and continued to release hits like "Crazy Heart," "Hey, Good Lookin'," "Howlin' at the Moon," and "(I Heard That) Lonesome Whistle." Doing more than his share to establish a music industry trope, just as Williams's career was at its peak his personal life began disintegrating. Audrey's nascent recording career couldn't gather any steam—she didn't bring much natural talent to the table—while Hank's hectic performance schedule and increased drinking drove the two to intermittent separations. And after Williams hurt his back—already aggravated by sleeping in cramped quarters while touring—when he

fell during a hunting trip, he became addicted to painkillers. (Thanks to a bogus physician—an ex-convict who bought his medical license from a traveling salesman—Williams was kept in a ready supply of morphine shots and chloral hydrate tablets, an addictive sedative with possible side effects that included confusion, difficulty breathing, extreme tiredness, and a slowed heartbeat.) To help with his worsening back pain he often wore a steel-and-leather lumbosacral brace that likely constricted his breath, and some believe the brace may be responsible for his slightly clipped singing style heard in later recordings (though it's just as likely to have been caused by the painkillers). As his chart success continued ("Honky Tonk Blues," "Half as Much," "You Win Again," among others), his friends and family were deserting him. Audrey left Hank for the final time in January 1952. As a result he became unhinged, drinking uncontrollably and taking painkillers by the handful. If he could make it to his concerts he was often drunk, behavior that eventually led to his dismissal from the Grand Ole Opry. Audrey and Hank divorced for a second time in April 1952, and by October he was married to nineteen-year-old Billie Jean Jones Eshlimar, whom he had met just weeks earlier. (That same month he agreed to support his child from another woman.) The final single released during Williams's lifetime, "I'll Never Get Out of This World Alive," had an eerily prophetic title, even if the song itself, cowritten with Fred Rose, carries little of the doomed spirit it suggests. By the end of 1952, Williams was twenty-nine years old and running out of rope. He died while sleeping in the backseat of his 1952 powder-blue Cadillac convertible coupe, sometime between the last hours of December 31, 1952, and the early morning of January 1, 1953, somewhere between Bluefield and Mount Pleasant, West Virginia. He was traveling from his home in Montgomery, Alabama, to a scheduled performance in Canton, Ohio. "I'll Never Get Out of This World Alive" went to number one following his death and was followed by "Your Cheatin' Heart," "Take These Chains from My Heart," and the odd novelty song, "Kaw-Liga." Following his death songwriter Merle Kilgore recalled Williams telling him, "Everybody likes to feel sorry for themselves. . . . You write 'em, sing 'em, and they say that's the story of their lives."

THE MISERABLE LIST: HANK WILLIAMS

1. "Never Again (Will I Knock on Your Door)"—Single (1949)
2. "My Son Calls Another Man Daddy"—B-side, *Long Gone Lonesome Blues* (1950)
3. "Why Should We Try Anymore"—Single (1950)
4. "Men with Broken Hearts"—Luke the Drifter: Single (1951)
5. "(I Heard That) Lonesome Whistle"—B-side, *Crazy Heart* (1951)
6. "Pictures from Life's Other Side"—Luke the Drifter: Single (1951)
7. "Your Cheatin' Heart"—B-side, *Kaw-Liga* (1953)
8. "Alone and Forsaken"—B-side, *A Teardrop on a Rose* (1955)
9. "I'm So Lonesome I Could Cry"—*The Unreleased Recordings* (2008)
10. "Cold, Cold Heart"—*Hank Williams Revealed: The Unreleased Recordings* (2010)

ROBERT WYATT

A distinctive personality who has carved out a lengthy career existing (almost) exclusively below the radar, Robert Wyatt possesses a singular voice distinctly attuned to the fragile, magical, and melancholic—composer Ryuichi Sakamoto called it the "saddest voice in the world." Born on January 28, 1945, in Bristol, England, Robert Wyatt-Ellidge began his career as a drummer, graduating from university with little more than an obsessive love of jazz. He joined the influential group the Wilde Flowers, which would serve as a springboard for a number of musicians and bands, specifically Caravan and the Soft Machine (of which Wyatt was a member), two groups that became the heart of the loosely knit post-psych, avant-garde "Canterbury Scene"—a categorization that Wyatt has never exactly cottoned to. The Softies (as Wyatt took to calling his group) found success in a mixture of heavy rock, out-jazz improvisations, and noise experiments. Just as they achieved that success, however, Wyatt left the group, recording his first solo album, 1971's

wonderfully strange and exploratory *The End of an Ear,* during his final months with the band. Soon after the release he invested himself in the free-form workings of Matching Mole, a short-lived project that produced two albums but never hit the electric highs of his work with the Soft Machine. A third Matching Mole album was scheduled when Wyatt tragically fell from a fourth-story window and fractured his spine, permanently paralyzing him from the waist down. His wife-to-be, artist and poet Alfreda Benge—affectionately known to Wyatt and his fans as Alfie—stayed by his side and would become his muse and an integral part of his creative process, providing poetry and artwork for many of his releases. Through months of painful convalescence, and confined mostly to a hospital bed, Wyatt began daydreaming, whittling songs he had originally written for Matching Mole's third album into what would become his second solo release, 1974's majestically odd and melancholy *Rock Bottom*. Recorded with Mike Oldfield, Ivor Cutler, and Fred Frith, *Rock Bottom* went a long way to building what would become the trademarks of Wyatt's catalog: his woeful, iconic falsetto, disorienting synths, jazzy percussion, and an abstract lyricism that pointed to both a childlike sense of playfulness and a more serious desire for absurdist escapism. Now confined to a wheelchair, Wyatt concluded that he could no longer command a group, and in the years since has noted a strange sense of artistic liberation that unfurled from his paraplegia as he no longer worried about touring or a flurry of band-related housekeeping issues, and was left to focus primarily on the act of creation. It's with a strange twist, then, that his choice as the first post-accident single to be released was a relatively straight version of the Monkees hit "I'm a Believer." The song became his biggest popular success, finding its way into the UK top thirty— the BBC program *Top of the Pops* subsequently refused to allow the singer to perform the song in his wheelchair, sparking a firestorm of protest that eventually led the show's producers to back down. The follow-up single, a cover of Chris Andrews's "Yesterday Man," was shelved after Virgin chief Richard Branson deemed it "a bit too gloomy." His third release under his own name, 1975's *Ruth Is Stranger Than Richard,* was another ruminative exploration that

focused on a wobbly set of interconnected fables; it would prove to be his last release of the decade, with the exception that the "Yesterday Man" single finally saw the light of day in 1977. He returned in 1980 with a single featuring a dreamy take on the slow-burning Chic hit "At Last I Am Free" and the haunting Billie Holiday hit "Strange Fruit," which launched a string of other politically bent singles that would eventually be collected on 1982's *Nothing Can Stop Us*. The album also featured "Shipbuilding"—a maudlin exploration of the Falklands War penned for Wyatt by Elvis Costello—which took the idiosyncratic singer back to *Top of the Pops*. "I really was depressed to a point of serious disorientation by the conservative revival," Wyatt recalled of the early days of Thatcherism and the political frustrations he poured into his music during the ensuing years—primarily with 1985's *Old Rottenhat* and 1991's *Dondestan* (an album Wyatt referred to as "colonialism a-go-go"). With the decline of conservative England, Wyatt caged his political voice and crafted *Shleep*, a highly personal album that recalled *Rock Bottom* and featured contributions from rock royalty Brian Eno, Paul Weller, and Phil Manzanera, among others. He released *Cuckooland* in 2003; an official release of his 1974 concert, *Theatre Royal Drury Lane*, appeared in 2005; and *Comicopera* was unveiled in 2007. Wyatt has also collaborated with artists ranging from Björk—who recorded every note in Wyatt's impressive range and would go on to use what he jokingly refers to as the "Wyattron" for the song "Oceania" on her 2004 album *Medúlla*—to Steve Nieve and Muriel Teodori for the opera *Welcome to the Voice*. His influence even wormed its way into the neologistic explosion that accompanied the rise of blog culture when "Wyatting"—the practice of playing the most annoying songs on a public jukebox specifically to exasperate others—became significant enough to warrant mention by major newspapers on both sides of the Atlantic. When asked by *The Guardian* what he thought of the term, Wyatt politely replied, "I'm very honored at the idea of becoming a verb." In 2010 he teamed with saxophonist Gilad Atzmon and violinist Ros Stephen to record . . . *For the Ghosts Within*, a collection of Wyatt originals and standards including "Laura," "Lush Life," and "What a Wonderful World."

THE MISERABLE LIST: ROBERT WYATT

1. "Sea Song"—*Rock Bottom* (1974)
2. "Five Black Notes and One White Note"—*Ruth Is Stranger Than Richard* (1975)
3. "Strange Fruit"—B-side, *At Last I Am Free* (1980)
4. "Shipbuilding"—Single (1982)
5. "Te Recuerdo Amanda"—*Work in Progress* EP (1984)
6. "The Sight of the Wind"—*Dondestan* (1991)
7. "Free Will and Testament"—*Shleep* (1997)
8. "Lullaby for Hamza"—*Cuckooland* (2003)
9. "Just As You Are"—*Comicopera* (2008)
10. "Laura"— . . . *For the Ghosts Within* (2010)

Don't They Know It's the End of the World?

Songs from the Apocalypse

The father of the atomic bomb," J. Robert Oppenheimer, recalled that during the very first successful atomic explosion at Alamogordo, New Mexico, on July 16, 1945, a passage from the Bhagavad Gita came rushing unstoppably into his mind: "If the radiance of a thousand suns were to burst at once into the sky that would be like the splendor of the Mighty One. . . . I am become Death, the Shatterer of Worlds." Just as every culture invents its own creation myths—whether it be spun from the dreams of an omnipotent being or the eruption of a cosmic egg—so too do many cultures maintain myths of Armageddon, an example of which would be the Mayan prediction that the world as we know it will end on December 21, 2012. In the Western world the prevailing Armageddon myth can be found in the Bible's New Testament, in the book of Revelation, as the trumpets sound and the pale horse of death trods across the earth. Oppenheimer and his colleagues crafted a newer, more secular notion of the Apocalypse, which was birthed in the consciousness of the world on the morning of August 6, 1945, when the United States dropped the first atomic bomb on Hiroshima. Both have spawned

a catalog of songs that celebrate, parody, and fear the final tick of the Doomsday Clock and the first bleating trumpet on Judgment Day. And beyond these musical readings of "The End," a third song-book has risen from the absorbed apocalyptic language to express the mountain-crumbling, sea-boiling pain of lost loves and broken hearts.

Written by Thomas of Celano in the thirteenth century, the hymn "Dies Irae" ("Day of Wrath") is an unsettlingly beautiful work that became a part of the Roman Catholic Requiem Mass until liturgical reforms during 1969 and 1970, when it was removed. An archbishop for the church suggested that it "smacked of negative spirituality in-herited from the Middle Ages" that "overemphasized judgment, fear, and despair." The performance of "Dies Irae" as plainchant is con-templative and melancholic, but the words of the requiem have been set to music many times, notably by Mozart and Verdi.

When African slaves were brought to new, alien lands, they brought with them their song traditions, but, forbidden to use their own language or instruments, they created out of necessity a new, coded language using the English they learned and the Bible stories they were indoctrinated with, much of which revolved around the Rapture, or Judgment Day. Gabriel's trumpet blares to announce the Day of Wrath has come ("Where Shall I Be When the First Trumpet Sounds?"). Spirituals like "Judgment Day Is A-Rollin' Around," "My Lord, What a Mornin', " and "That Great Gettin' Up Morning" held multiple meanings for slaves—as both a release following judgment on the sinners (i.e., the plantation regime and, later, the Confederacy) and an escape to the North (as in "heaven," "the Promised Land," and "the land of Canaan"), conceived of the dream of a spiritual freedom when a corporeal freedom did not exist, while also spread-ing news about the road to freedom via the Underground Railroad.

Markedly more secular was the blues world, which largely preoc-cupied itself with the more trivial matters of everyday life and often left the larger issues of judgment and salvation to spiritual and gospel songs. Of course, there are plenty of exceptions to this rule, like Roy Brown with His Mighty-Mighty Men's "Judgment Day Blues" (1950), while Robert Johnson's popular "If I Had Possession over Judgment Day,"

from 1936, has more to do with the stray affections of his "biscuit roller" (a young woman who was good in bed) than any Armageddon.

Whites, particularly in what Flannery O'Connor dubbed the "Christ-haunted" South, also leaned heavily on the apocalyptic language of the book of Revelation, and long before schoolkids were learning to "duck and cover," "Battle Hymn of the Republic" served as a bridge between the religious vision of Armageddon ("His terrible swift sword") and a more secular, warrior notion of apocalypse. (That notion would eventually lead to Oppenheimer and company splitting the atom during WWII—a process captured in the powerful 2005 opera *Doctor Atomic* by composer John Adams and librettist Peter Sellars.) The tune spread under various names during the mid–nineteenth century, including "Canaan's Happy Shore," before Julia Ward Howe's lyrics were printed in *The Atlantic Monthly* in February 1862. Before country music's commercial breakthrough in the 1920s, most musical performances were held in relation to church gatherings. Shape-note songbooks featuring gospel songs old and new blew into towns under the arms of revivalist preachers and became extremely popular across the South. The songs eventually fed into the first successful country acts like the Carter Family, who regularly performed judgment songs like "When the World's on Fire" and "When Our Lord Shall Come Again." Religion was entwined with the rise of country music and pre- and post-WWII artists would often sing both secular and religious material. Hank Williams could record "Your Cheatin' Heart" and, as his alter ego Luke the Drifter, record "The Battle of Armageddon" (1949), which plainly calls out the Book of Revelation alongside prophecies that "the hearts of men shall fail them / There'll be gnashing of the teeth." One of Johnny Cash's final songs, "The Man Comes Around," from the 2002 album *American IV: The Man Comes Around,* is an Armageddon tale bookended by two spoken-word quotes from Revelation regarding the "four beasts" and the pale horse of death. But while some pop musicians such as Cash and Elvis Presley embraced religious songs, most do not. Bob Dylan's religious awakening as a born-again Christian during the late 1970s saw the release of albums like *Slow Train Coming* (1979) (a.k.a. the Second Coming) and *Saved* (1980), which featured tracks

like "When You Gonna Wake Up?" "When He Returns," and "Are You Ready?"—along with songs that didn't make these albums, like the chilling "Ye Shall Be Changed." All the songs boil with end-times language and, as Dylan himself later recalled, they frightened him: "I didn't plan to write them, but I wrote them anyway. I didn't like writing them, I didn't want to write them."

During WWII, French composer Olivier Messiaen was called to service as an infantryman in August 1939, just weeks before Britain and France declared war on Germany. Wounded three times, he was eventually captured by Germans the following summer. It was while in a prisoner-of-war camp that he wrote one of the most important pieces of classical music to come out of the war, *Quatuor pour la Fin du Temps* (*Quartet for the End of Time*), a striking work of political, historical, and musical import. Composed for the available musicians—violin, clarinet, cello, and piano—the quartet premiered January 14, 1941, in Stalag VIII A in Görlitz, Silesia, in the freezing cold and employing broken instruments. As Messiaen recalled, cellist Étienne Pasquier's "cello had only three strings; the keys of my upright piano remained lowered when depressed." Although the piece was inspired by the first six chapters of the book of Revelation, the composer focused not on the hellfire and brimstone usually associated with Armageddon artworks but on "its silences of adoration, its marvelous visions of peace." A devout Catholic, Messiaen prefaced his score with a vision of the Angel of Apocalypse standing on the sea, raising his hand to Heaven and proclaiming that "there should be time no longer." It's not difficult to bridge the celebration of Apocalypse as escapism (literal and figurative) of slaves in the eighteenth and nineteenth centuries, and poor, disenfranchised Southerners following the defeat of the Confederacy, with Messiaen's celebration of Apocalypse from within a German prisoner-of-war camp. Yet while Messiaen was premiering his apocalyptic chamber work in a stalag shrouded in snow, half a world away the seeds of the Manhattan Project had already been sown.

On the morning of August 7, 1945—the day after "the bomb" fell on Hiroshima—North Carolina country singer and radio host Fred Kirby began composing "Atomic Power," which David Janssen and Edward Whitelock, authors of *Apocalypse Jukebox*, called "the first

song dedicated to this new and awesome weapon." "Atomic Power" called for recognition of the touch of the Divine in the splitting of the atom, suggesting it was "given by the mighty hand of God." The most popular of the seven renditions of "Atomic Power" to be recorded between 1945 and 1948 was by the Buchanan Brothers, who scored well enough with the song in 1946 to follow it up with 1947's "There's a Power Greater Than Atomic," another of many songs that struggled to square the circle between the bomb's incomprehensible destructive force and the idea of God's last judgment. Others included Lowell Blanchard and the Valley Trio's "Jesus Hits Like an Atomic Bomb," the Louvin Brothers' "The Great Atomic Power," and "Atom and Evil," by smooth gospel group the Golden Gate Quartet, which posits the seduction of science by evil as a parallel to the story of Adam and Eve ("Brother atom has gone astray").

In the years immediately following the end of World War II perhaps the most inventive cultural merger of the religious notion of Judgment Day and the dread of whistling death from above may come from a curious place: the 1950 MGM musical *Summer Stock*. Written by Harold Arlen and Ted Koehler two decades earlier, and sung by Judy Garland in the film, the song "Get Happy" was a celebration of Judgment Day based on slave spirituals. But taken in tandem with the celebrated dance sequence in the film, choreographed by Charles Walters, it is presented as a secularized, "What, me worry?" commentary on postwar dread. Behind a whirl of tuxedo-clad dancers, one unmoving figure stands with his arms outstretched, working with a coral-and-cumulus backdrop to create the effect of a mushroom cloud. As the dancers crumble onto the floor, Garland appears dressed in a black leotard and rakishly tilted hat, stepping over the slumped bodies as she sings, "Shout hallelujah, come on get happy / Get ready for the judgment day." The dancers slowly spring back to life as if they've made it to "the other side" without a hitch, and go on to re-create the mushroom-cloud effect one more time with Garland as the radiant centerpiece.

This radically new concept of apocalypse brought new horrors to light, such as radioactivity and black rain, and, from the late 1940s into the 1960s, dozens and dozens of songs were recorded

about atomic bombs ("You Hit Me Baby Like an Atomic Bomb," by Fay Simmons), hydrogen bombs ("Hydrogen Bomb," by Al Rex), and radiation poisoning ("My Radiation Baby [My Teenage Fallout Queen]," by George McKelvey). Bill Haley and His Comets recorded two songs on August 12, 1954: One was "Rock Around the Clock" (the B-side), the other was the dystopia-meets-utopia A-side "Thirteen Women (And Only One Man in Town)"—"I had three gals dancin' the Mambo / Three gals ballin' the jack"—alas, it was all a dream. (Ann-Margret released a reversal of the song, "Thirteen Men," in 1962.) And Carl Perkins's 1956 song "Tennessee" gives the rock 'n' roll legend the opportunity to "brag some" about his home state's place in American musical history before oddly drifting off-topic to praise the volunteer state as home to "the first atomic bomb." Many of these early doomsday pop treasures have found new life thanks to the massively popular *Fallout* video game series.

Now, decades after the bombings of Hiroshima, two Japanese musicians are using objects that survived the blast to spread messages of hope. Flautist and instrument maker Kurotaro Kurosaka has crafted eight *kokarina* (wooden ocarinas) from an ancient hackberry tree that survived the explosion but was felled by a typhoon in 1984. To mark the sixtieth anniversary of the bombing, in 2005, Mitsunori Yagawa, a piano tuner who owns three blast-scarred pianos that survived the sweeping destruction of the bombs, began a tour with the instruments that included music, a reading of the pianos' histories, and an opportunity to touch the blemished instruments.

The Cuban Missile Crisis kept people carefully watching the skies, though a quick look at the *Billboard* charts during the fourteen days of the crisis (October 15 through October 28, 1962) makes one wonder if they weren't more concerned with Halloween that year—the bestselling single in the land was "Monster Mash," by Bobby "Boris" Pickett and the Crypt-Kickers. (The bestselling single during another near-miss nuclear annihilation, the Stanislav Petrov incident—in which an officer in the Soviet Air Defense Forces, Stanislav Petrov, deviated from protocol and correctly identified a possible US missile attack on the Soviet Union as a hardware malfunction—was Billy Joel's "Tell Her About It.")

Following the close-call of the Cuban Missile Crisis, US escalation of its commitment in Vietnam, continued missile testing, the rise of Dylan, and the maturation of the Beatles, the incongruous innocence of earlier novelty songs about whistling bombs and skies filled with flames subsided, replaced with more impassioned, politically aware records.

First recorded by Harry Belafonte in 1963, "Come Away, Melinda" told the story of the curious Melinda, a little girl who finds a "picture book" filled with images of children and cities, and her father explains, "It's just the way it used to be / Before they had the war." Judy Collins and the Weavers had both recorded it the same year, but it wasn't until Tim Rose—who had previously recorded it as one-third of the Cass Elliot pre–Mamas and Papas group the Big Three—recorded his solo take in 1967 that it received an appropriately sinister setting. Dylan's pre-salvation years were especially filled with apocalyptic paranoia and protest; his concern can be heard in generation-defining classics like "All Along the Watchtower," "Masters of War," and "A Hard Rain's Gonna Fall." The Searchers hit the charts in the US and the UK with "What Have They Done to the Rain?" and the Byrds covered Nâzim Hikmet's unflinchingly macabre song about a seven-year-old Hiroshima victim, "I Come and Stand at Every Door." The cover art for Jefferson Airplane's 1968 *Crown of Creation* featured the group superimposed into the white-hot cap of a mushroom cloud, and the album's finale, "The House at Pooneil Corners," is a six-minute psychedelic dirge about a nuclear holocaust where the "seas from clouds will wash off the ashes of violence." Meanwhile, in Germany, the group Wishful Thinking had a surprise hit with their 1969 song "Hiroshima," which was recorded by Sandra (Germany's answer to Madonna) in 1990, again to chart success in a number of countries.

By the 1970s the Cold War was already twenty-five years old and the alarm began to recede into complacency, leisure suits, arena rock, and disco, but following the 1979 Russian invasion of Afghanistan the paranoia seemed to return overnight. As the 1980s dawned the culture was awash in a fresh bout of cold-war angst.

Kate Bush recorded "Breathing," which imagines a nuclear holo-caust from an unborn child's perspective (Sting later hoped that the children really were the future in his 1985 hit, "Russians"); Frank Sinatra released his first album in six years—the ambitious *Trilogy*—which included the nuclear-protest song "World War None!"; Or-chestral Manoeuvres in the Dark (OMD) made the haunting shad-ows left behind by the flash-burnt victims of the first atomic bombs into the synth-pop hit "Enola Gay," which imagines an eternal kiss that is "never gonna fade away." (Postal Service leaned on the same disturbing imagery for their 2005 single "We Will Become Silhou-ettes.") Reggae-lite group UB40 had a UK hit with their third single, "The Earth Dies Screaming"—the video for which features the group gently swaying in front of black-and-white footage of bloom-ing mushroom clouds. It's interesting to compare the UB40 song to Tom Waits's "Earth Died Screaming," which introduced his 1992 album *Bone Machine*: Waits growls away in his trademark scabby drawl, while UB40 vocalist Ali Campbell delivers lyrics that would feel right at home on a Cannibal Corpse album ("Bodies hanging limp, no longer bleeding") in a voice as smooth and cool as a missile shell. UB40's song also points to the large number of surprisingly upbeat songs that have been written about nuclear apocalypse, the short list including classics like R.E.M.'s "It's the End of the World As We Know It (And I Feel Fine)" and Prince's "1999."

In 1982 Brothers Rob and Ferdi Bolland, a.k.a. Bolland & Bol-land, made the now forgotten but largely entertaining nuclear-war concept album *Domino Theory,* which featured a number-two UK single, "In the Army Now," along with other solid nuclear-wave tracks like "Cambodia Moon" and "To the Battleground." Roger Waters's infatuation with dystopian themes was already established by the time Pink Floyd's 1983 de facto Waters solo album *The Final Cut* saw release (his fascination would continue on his own solo albums *Radio K.A.O.S.* and *Amused to Death*). The album's finale, "Two Suns in the Sunset," paints a vivid image of a bright sun rising in the east even as another sun sets in the west. The somber pace of the song is interrupted by a scream and a child yelling "Daddy! Daddy!" before sinking back into its introspective measure and ending with

a lonely saxophone solo, as if suggesting that, like cockroaches and Keith Richards, a well-placed sax solo will be one of the few things to survive a nuclear holocaust. (Classic saxophone joke: Why did Adolphe Sax invent the saxophone? He hated mankind but couldn't build an atom bomb.)

Alphaville's "Forever Young" has 1984 written all over it, and despite its popularity now it failed to climb higher than 65 on the Hot 100 during its initial release, when prom couples awkwardly rocked back and forth to its quizzical lyrics ("Are they going to drop the bomb or not?"). Check out V/Vm's subversive take, which gives the song's cold-war message a more implicit menace. Speaking of menace, heavy metal loves the nuclear apocalypse as much as it does the religious one, as witnessed by songs like "Rust in Peace . . . Polaris," by Megadeth; Testament's *The New Order* album; and Iron Maiden's "Brighter Than a Thousand Suns" and "Two Minutes to Midnight" (the Doomsday Clock only hit two minutes to midnight once, in 1953, following thermonuclear tests by the United States and the Soviet Union).

By the time Mikhail Gorbachev's perestroika began to take root, resulting in the dissolution of the Soviet Union in 1991, popular culture had stopped worrying about when the bomb was going to drop and started concerning itself with what we would do once it did. MTV's schedule was brimming with dystopian videos like Scandal's "The Warrior," Billy Idol's "Dancing with Myself," and Duran Duran's "The Wild Boys." Johnny Cash provided vocals for the U2 song "The Wanderer," from their 1993 album *Zooropa,* which found the steely Man in Black "out walking" under an "atomic sky," wondering where God has gone. More recently, Radiohead, Godspeed You! Black Emperor, Vendetta Red, Linkin Park, and Nine Inch Nails have all explored dystopian scenarios for our future.

But what's the hypothetical notion of Rapture or nuclear annihilation compared to the very real pain of a broken heart? Many singers have turned to apocalyptic language as a metaphor for the wild hurt of love, a trope deftly addressed by Jens Lekman on his 2010 single, "The End of the World Is Bigger Than Love." There is perhaps no more pure example of the form than Skeeter Davis's 1963 hit, "The

End of the World." The then thirty-one-year-old singer culled from her honey-toned voice a teenaged tragedy of epic proportions, asking, "Why do the birds go on singing? Why do the stars glow above? Don't they know it's the end of the world?"

This devastating language is also used to express deep and abiding love in songs like Unit 4+2's samba-riffic hit "Concrete and Clay," Don Williams's "Til the Rivers All Run Dry," Ben E. King's "Stand by Me," and Miley Cyrus's "When I Look at You," all of which call out the crumbling mountains and tumbling stars not as the shattering consequence of heartbreak but as the impossible lengths of love. This is the approach mined in Barbara Lewis's aching "Baby, I'm Yours" (1965), during which the singer sweetly swears that her love will last until "the stars fall from the sky," "mountains crumble to the seas," and "the sun no longer shines," adding, in case anyone missed her meaning, "in other words, until the end of time." These songs speak to the idea of a soul that never dies and the rather innocent notion of a love that lasts, like a diamond, forever, but the darkness of the imagery almost betrays a doomed precognition. That seems eerily possible in the case of Edith Piaf's "Hymne à l'Amour" (1950), which was written for her lover, boxer Marcel Cerdan, and imagines the sky falling and the earth collapsing beneath her feet. She premiered the song in September 1949, and, as if she was tempting fate and lost, Cerdan died the following month when his plane went down in the Azores on his way to visit her in New York.

One of Willie Nelson's earliest hits was "This Cold War with You" ("The sun goes down and leaves me sad and blue / The iron curtain falls on this cold war with you"), which was successful for Floyd Tillman in 1949 and makes a parallel between love and the stalemate between the United States and the Soviets. (Janelle Monáe would call on a similar metaphor for her 2010 single "Cold War.")

Written by a then twenty-one-year-old Bobby Braddock— who would go on to write a number of hits in Nashville including "D-I-V-O-R-C-E"—and inspired by an episode of The Twilight Zone ("The Shelter") and the ingestion of lots and lots of speed, the obscure 1962 Billy Chambers B-side "Fallout Shelter" tells the tale of a young man who wants his girlfriend to share the family bomb

shelter when the bombs drop, only to have his father flatly refuse. Like a properly thoughtless young romantic he decides to weather the fallout with his TL4E, singing in the final verse, "You hold my hand, I understand the sickness has begun / And if we live or if we die, our hearts will beat as one." The little known "Fallout Shelter," by Dore Alpert, from the same year, presents the opposite premise, Alpert singing with a sneer, "I'm gonna lock myself in a fallout shelter / To get away from you."

The Cuff Links' minor 1956 hit "Guided Missiles" imagines Cupid with a somewhat more destructive payload ("Guided missiles bound to explode / Destroying my heart is your goal"), and while former Temptations singer David Ruffin's spectacular solo debut single, "My Whole World Ended (The Moment You Left Me)" (1969), doesn't get too specific about the destruction heartbreak has wrought, but if you can sing about a breakup like he could, maybe just knowing it feels like the end of the world is enough. (Hint: it is.) The French song "Et Maintenant," translated to English as "What Now, My Love," has been recorded by Elvis Presley, Frank Sinatra, Sonny and Cher, Shirley Bassey, and Mitch Ryder: Dreams "turned to ashes," the stars tumbling to Earth, and "the sky where the sea should be," the song builds slowly to a dramatic climax, proclaiming, "Now there is nothing / Only my last good-bye."

More recently, in 2009, Australian singer Kate Miller-Heidke had a hit in her home country with her song "The Last Day on Earth," which opens with the ground crumbling and stars exploding as the singer closes out the destruction around her and retreats to the interior fantasy world that sees the return of a former lover: "It's the end of the world and you've come back to me / In my dreams." In 2010 Eels' "End Times" married an unspecified world-stopping event to singer Mark "E" Everett's snuffed-out hope: "The world is ending and what do I care / End times are here."

Perhaps no artist embodies all three of these apocalyptic approaches to song like Nick Cave, a singer steeped in religious curiosity, who came of age during the Cold War and writes love songs that are gothically grandiose.

The singsong "(I'll Love You) Until the End of the World," from

the soundtrack to the Wim Wenders film *Until the End of the World*; "Tupelo, " with its prophecies of a "big black cloud" and an insatiable beast; and "Straight to You," a love song with seas that "swallow up the mountains" and skies that "throw thunderbolts and sparks," are great examples of Cave's adherence to end-times poetry. The three apocalyptic themes convene wonderfully on the sprawling two-disc masterpiece *Abattoir Blues / The Lyre of Orpheus*. "Abattoir Blues" seethes with a sky on fire and "the dead heaped across the land," but Cave hasn't lost his sense of humor about it: "Mass extinction, darling, hypocrisy / These things are not good for me." "Messiah Ward" imagines a frozen dystopia with the "stars torn down" and the moon "locked away," and on "Babe, You Turn Me On" he delicately witnesses "everything . . . collapsing" and "crimson snow . . . carpeting the ground" while he begs his lover to ignore the destruction and focus on his insistence that he's really turned on, "like an atom bomb," a notion punctuated by Cave with a soft, rumbling plosive of breath. In a 2009 interview with *Mojo* magazine Cave noted the metaphorical power of end times, saying, "I like the apocalyptic backdrop for a human story. Although I read the newspapers, I'm still not very interested in writing about that stuff."

THE MISERABLE LIST: WHEN THE MAN COMES AROUND

1. "Dies Irae"—Thomas of Celano (c. 1250)
2. "My Lord, What a Mornin'"—Marian Anderson (1924)
3. "The Battle of Armageddon"—Luke the Drifter (1955)
4. "Great Gettin' Up Morning"—Mahalia Jackson (1959)
5. "If I Had Possession Over Judgment Day"—Robert Johnson (1961)
6. "Steal Away"—Reverend Pearly Brown (1975)
7. "When He Returns"—Bob Dylan (1979)
8. "Ascension Day"—Talk Talk (1991)
9. "The Man Comes Around"—Johnny Cash (2002)
10. "Abattoir Blues"—Nick Cave and the Bad Seeds (2004)

THE MISERABLE LIST: MAN-MADE APOCALYPSE

1. "Fallout Shelter"—Billy Chambers (1962)
2. "What Have They Done to the Rain"—The Searchers (1964)
3. "I Come and Stand at Every Door"—The Byrds (1966)
4. "Hiroshima"—Wishful Thinking (1971)
5. "Here Comes the Flood"—Robert Fripp and Peter Gabriel (1979)
6. "Breathing"—Kate Bush (1980)
7. "Two Suns In the Sunset"—Pink Floyd (1983)
8. "Forever Young"—Alphaville (1984)
9. "The Wanderer"—U2 and Johnny Cash (1993)
10. "Batter My Heart (from *Doctor Atomic*)"—John Adams (2005)

THE MISERABLE LIST: MY WHOLE WORLD ENDED

1. "This Cold War with You"—Floyd Tillman (1979)
2. "I Watched My Dream World Crumble Like Clay"—Hank Williams (Recording date unknown, released 1986)
3. "Guided Missiles"—The Cuff Links (1956)
4. "Hymne à L'Amour"—Edith Piaf (1950)
5. "The End of the World"—Skeeter Davis (1962)
6. "Baby, I'm Yours"—Barbara Lewis (1965)
7. "My Whole World Ended (The Moment You Left Me)"—David Ruffin (1969)
8. "Straight to You"—Nick Cave and the Bad Seeds (1992)
9. "The Sun's Gone Dim and the Sky's Turned Black"—Johánn Jóhannsson (2006)
10. "End Times"—Eels (2010)

The 100 Saddest Songs

1. "ADAGIO FOR STRINGS"–SAMUEL BARBER

Written during a summer retreat in Venice in 1936, Samuel Barber's "Adagio for Strings" has become one of the most popular pieces of twentieth-century classical music (even as it stands apart from the more confrontational nature of most celebrated compositions of its time) and the reflexive sound of mourning. It was first performed by the NBC Symphony Orchestra under the direction of conductor Arturo Toscanini in New York in 1938, and was impulsively chosen by shocked radio broadcasters following the unexpected death of President Franklin D. Roosevelt, in April 1945. It has since been used in countless high-profile funerals (including those for Albert Einstein and Princess Grace of Monaco), was a pivotal aspect of Oliver Stone's 1986 film *Platoon*, and was the first choice of music programmers following the events of September 11, 2001. In 2004 it was named the saddest song ever by a BBC user poll. (For more about Barber's "Adagio for Strings" see pages 33–35.)

2. "STRANGE FRUIT"–BILLIE HOLIDAY

Written by Jewish high school teacher Abel Meeropol and definitively performed by Billie Holiday—though the song was not written for the singer as she liked to claim—there is no stronger condemnation in song of the sadness and horror of bigotry than "Strange Fruit." The

unforgiving imagery of "bulging eyes" and "twisted mouth" sets up the palpably unsettling dichotomy between fruit and flesh that plays out in the final verse as the crows descend, the rain falls, and the sun rots a "strange and bitter crop." It is staggering in its poetic power and leveling in its grievous allure. (For more about "Strange Fruit" see pages 164–68.)

3. "IN DARKNESS LET ME DWELL"—JOHN DOWLAND

One of Leonard Cohen's myriad nicknames may be the Godfather of Gloom, but that title rightly belongs to Elizabethan composer John Dowland, whose own motto—*Semper Dowland, semper dolans* (Always Dowland, always doleful)—highlights his deep connection to the dark stuff. Among the more modern of his compositions, "In Darkness Let Me Dwell" reads like a bitter note slipped from a prison of despair: Encased by a ground made of sorrow, "walls of marble black," and a roof that bars "all cheerful light," the composer pleads "O let me dying live / 'Til death come."

4. "MARIE"—TOWNES VAN ZANDT

Townes Van Zandt wrote more than his fair share of gentle heartbreakers, but the terrible and simple narrative of "Marie" is spun from so much tragedy that it is often in danger of toppling into farce. The story of a homeless rail worker who falls in love, the song follows attempts to find Marie food and clothing, a pregnancy ("In my heart I know it's a little boy / Hope he don't end up like me"), and the aftermath of a spring morning when he wakes to find she has passed away in the night ("my little boy safe inside"). It is performed by Van Zandt with such plainspoken despair that the unforgiving world he paints seems nearer and more real than most have ever imagined it could be.

5. "RANK STRANGER"—THE STANLEY BROTHERS

Written by the prolific and now oft-forgotten gospel songwriter Albert E. Brumley—unverifiably credited with composing some eight hundred songs in his lifetime—"Rank Stranger" was first published in 1942 under the title "Rank Stranger to Me." It may arguably be

the most mournfully evocative song ever cut, addressing the old adage "you can never go home again." First recorded by the Stanley Brothers in 1960, the simple bluegrass ballad is the story of a man returning to his "home in the mountains" after many years, only to find that everyone he knows—including his "mother and dad" and all his friends—have passed away and are waiting for him "by the bright crystal sea." The song remains one of the Stanley Brothers' most popular, and in 2008 their 1960 recording was added to the National Recording Register.

6. "I'M SO LONESOME I COULD CRY"—HANK WILLIAMS

Johnny Cash once told Bob Dylan that it was the saddest song he'd ever heard, and artists as diverse as Ray Charles, Dean Martin, Cassandra Wilson, Diamanda Galás, and the Mountain Goats, among many others, have recorded it. But "I'm So Lonesome I Could Cry" wasn't even originally intended to be a song, per se, rather it was earmarked by Williams to be a recitation by his more obscure alter ego, Luke the Drifter. Nervous that the imagery and metaphors of the lyric would be too pretentious for his audience, Williams tried the song out on his band, which enthusiastically suggested he record it. Williams would later note it as his personal favorite, though when it was released in 1949 it appeared as a B-side to the decidedly more prosaic "My Bucket's Got a Hole in It," suggesting Williams's concerns over its lyric use of language had not completely calmed. The original recording is a bona fide masterpiece, but it's the surprisingly slower live recording, captured during one of Williams's "Mother's Best" performances—officially released for the first time in 2008—that best serves the song's lugubrious sentiment.

7. "ONLY THE LONELY"—FRANK SINATRA

The Chairman of the Board devoted much of his mature career to plumbing the depths of loneliness and regret, and it's arguable that no song captures the torment of his late-hour emptiness quite like "Only the Lonely." Written by Sammy Cahn and Jimmy Van Heusen specifically for the singer, and given a consoling arrangement by

Nelson Riddle, Sinatra squeezes every bit of pathos from the lyrics. As he recalls "picnics at the beach when love was new" and philosophizes from his bar-side lectern that the "hopeless little dream" of love may only come but once, there's no doubt he believes every word.

8. "NOTHING COMPARES 2 U"—SINÉAD O'CONNOR

"Nothing Compares 2 U" was initially written by Prince for the Minneapolis band the Family, and first appeared in 1985 on their lone eponymous album. But when Sinéad O'Connor chose to include it on her 1990 album *I Do Not Want What I Haven't Got*, she took full possession of the song, infusing it with an inconsolable heartsickness born of her own emotional turmoil. A stark video that featured little more than a close-up of O'Connor's face as she sings—and a pair of unplanned tears shed in the final verse—helped the song reach number one in pretty much every country in the Western Hemisphere. *Pitchfork* has since placed it at number thirty-seven in their list of the Top 200 Tracks of the nineties, and *Rolling Stone* placed it at number sixty-five in their 2010 Greatest Songs of All Time list.

9. "CAROLINE, NO"—THE BEACH BOYS

Is there any more gorgeously rueful monument to lost innocence in all of pop music than "Caroline, No," or any line more heartbreakingly breathtaking than Brian Wilson's yielding "It's so sad to watch a sweet thing die"? Originally released as a Brian Wilson solo single in March 1966 (it stalled at number thirty-two), before appearing weeks later as the final addition to the Beach Boys' seminal *Pet Sounds* album, "Caroline, No" features only Brian Wilson on vocals. He had originally titled the song "Carol, I Know," but after lyricist Tony Asher—whose girlfriend had recently moved to New York and cut her hair, providing inspiration for the song's opening lines—misheard it as "Caroline, No" the pair decided to keep the new title. The song's coda—Brian's dogs, Banana and Louie, barking at a passing train—lends the song's sense of loss additional depth. In a 1989 interview Wilson said that the song reflects the feeling that "once you've fucked up, or once you've run the gamut with a chick, there's no way to get it back," concluding the sentiment by saying, "I just felt sad, so I wrote a sad song."

10. "D|P 1.1"—WILLIAM BASINSKI

A twenty-first-century lament born beneath the unfurling black clouds that drifted from lower Manhattan following the morning events of September 11, 2001, "d|p 1.1" blots itself into being in a slow cycle of destruction that takes just more than an hour. "d|p 1.1" is built from a brief synthesizer loop of ponderous melancholy that Basinski composed and captured on tape in the early 1980s. While transferring the tapes to digital sources in September 2001 (while the planes were hitting the towers) the composer found that the old analog ribbons were eroding, and he chose to create a new piece based on their deterioration. As the loop plays, the tape decays and the solemn, pastoral melody degrades into a mournful silence. (For more about the Disintegration Loops see pages 217–20.)

11. "TENNESSEE WALTZ"—PATTI PAGE

She was the sound of America's post–World War II glow, the sweet voice of suburban expansion ("[How Much Is That] Doggie in the Window?"), and her 1950 rendition of the Redd Stewart/Pee Wee King country standard "Tennessee Waltz"—first recorded in 1947 by Cowboy Copas and initially pegged as a B-side for Page's novelty song "Boogie Woogie Santa Claus"—has sold 10 million copies, making it both the biggest-selling single by a female artist and the bestselling country music song of all time. The simplicity of the song is not lost on Page: "Someone introduces their boyfriend to someone else, and now he's no longer her boyfriend. It's just a sad love song." Yet the simplicity is what makes it so heartbreaking, more than sixty years on, the singer seems to relive the pain in perpetuity, recalling clearly the waltz burned into her memory, reminding herself over and over of "just how much [she has] lost."

12. "LAST NIGHT I DREAMT THAT SOMEBODY LOVED ME"—THE SMITHS

Morrissey considered "I Know It's Over" (which topped a 2004 BBC poll of songs people listen to when they're sad) to be little more than a sketch for "Last Night I Dreamt That Somebody Loved Me." No surprise, then, that "LNIDTSLM" is also among the band's most bleak, opening with nearly two minutes of a stark piano figure

accompanied by the unsettling hysteria of a miners strike before sparking to life as a dazzlingly slow orchestral dirge, where love is found, as Roy Orbison put it, "only in dreams." It's a surprisingly laconic song for Morrissey, missing any hint of the sooty black comedy he liked to dust over his lyrics—but it allows him to stretch the notes for all they're worth, and when he sings "The story is old, I know, but it goes on" he could be winking to the long history of lovelorn pop. (As if it needed anything else to recommend its melancholic pedigree, "LNIDTSLM" also stands as the final Smiths single, released in December 1987, months after the group had already fallen apart.)

13. "DARK WAS THE NIGHT, COLD WAS THE GROUND"– BLIND WILLIE JOHNSON

When Ry Cooder referred to "Dark Was the Night, Cold Was the Ground" as "the most soulful, transcendent piece in all American music," his enthusiasm wasn't as hyperbolic as it may first appear. Deeply religious from his early youth, Blind Willie Johnson had, perhaps, a more clearly defined understanding of the soul than many of his peers. Adding to the song's metaphysical aura is the fact that it features no lyrics, only its foreboding title and Johnson's haunting falsetto cries, which seem to lift his playing from the merely sublime to the indisputaby profound. Facts at hand, it's not hard to understand why "Dark Was the Night . . ." was included on the golden records that accompanied *Voyager 1* and *2* into the vast emptiness of space as evidence of the intelligence and diversity of life on Earth.

14. "DIDO'S LAMENT"–HENRY PURCELL

Though Purcell composed with little acclaim in his lifetime, and missed the operatic fervor that swept through London just fifteen years following his death in 1695, "Dido's Lament," from his opera *Dido and Aeneas*, remains one of the greatest moments in the history of the genre. The devastating anguish captured in the brief composition punctuates the story of Dido, the queen of Carthage, and Aeneas, a prince of Troy, who fall in love before all manner of supernatural twists lead to their separation, whereupon Dido sings this famous lament and commits suicide. The aria features exemplary

chromatic texture and offers an early and impressive use of ground bass, or basso ostinato, a form in which a structurally pronounced bass pattern is repeated with shifting variations in the melodies above. "Dido's Lament" has been interpreted by contemporary performers such as Klaus Nomi (under the title "Death"), Alison Moyet, and Jeff Buckley, a testament to the lugubrious power of the lament over three hundred years since its composition.

15. "HOLOCAUST"–BIG STAR

When Alex Chilton and Jody Stephens entered the studio in 1975 to record Big Star's third album, *Third/Sister Lovers*, the band, as such, had ceased to exist. But what was caught on tape—the dark implosion of Chilton's dreams of rock 'n' roll glory—stands as one of the greatest achievements in rock history. It even topped a 2000 *NME* ranking of the most heartbreaking albums of all time, and "Holocaust" is the black hole at its disturbed center. Harrowing is almost too light a descriptor for this end-of-the-rope, edge-of-the-world piano dirge that finds Chilton—dejected, bitter, exhausted, and alone, propped up by a ghostly pedal steel and a muddy upright bass—exploring the fine line between unconscious life and conscious death: "You're a wasted face. You're a sad-eyed liar. You're a holocaust."

16. "AULD LANG SYNE"–GUY LOMBARDO

Born of a Scottish poem and folk melody that both took a long, circuitous route before being appropriated and combined by poet Robert Burns in the late eighteenth century, "Auld Lang Syne" became a widespread US tradition not long after Canadian bandleader Guy Lombardo arranged the song for his band, the Royal Canadians, and performed it during a 1929 New Year's Eve radio broadcast. Lombardo's popularity with the song was such that he wrote in his 1975 autobiography, *Auld Acquaintance*, that at times his band was "booked on NBC to play until a minute to midnight and on CBS on the stroke of the New Year." Despite its ubiquity, few can utter more than the first line—"Should auld acquaintance be forgot and never brought to mind?"—and fewer still know what "auld lang syne" stands for: roughly, "times gone by" or "times long past."

17. "WHO KNOWS WHERE THE TIME GOES"—NINA SIMONE

Though it was originally written and performed by English folk singer Sandy Denny (first with the Strawbs in 1967 and then with Fairport Convention in 1969), it's the version Nina Simone recorded for her 1970 live album *Black Gold*, complete with a pre-song speech that perfectly sets the mood—"Time is a dictator as we know it. Where does it go? What does it do? Most of all, is it alive?"—revealing the song's mysterious sadness. Not only do Simone's dusky vocals bring more depth to the philosophical lyric, revealing the song's mysterious sadness, but also her brief, sparkling piano solo is a gorgeous interlude that may exist as the greatest fusion of her classical training and her interest in contemporary folk.

18. "PAST, PRESENT AND FUTURE"—THE SHANGRI-LAS

Recited over a melodic line from Beethoven's *Moonlight* Sonata, "Past, Present and Future" is a bleak slice of conceptual spoken-word art from a girl group who thrived on heartache ("Leader of the Pack," "I Can Never Go Home Anymore," "It's Easier to Cry"). It suggests both the disillusionment of heartbreak and also implies the memory of a rape, as singer Mary Weiss emphatically asserts, "Don't try to touch me / 'Cause that will never . . . happen . . . again" before suggesting, "Shall we dance?" at the bridge. The song flowers for the briefest moment of baroque joy before dissolving into "the future," which brings about Weiss's weepy conjecture that "maybe someday I'll hold someone's hand" before shyly, helplessly concluding "I don't think it will ever happen again."

19. "THE LAST LETTER"—REX GRIFFIN

The flipside to jukebox hit "Over the River," Rex Griffin wrote and recorded this tuneful suicide note in 1937 after the breakup of his first marriage. One of the earliest examples of disarmingly intimate and confessional country music, the song's softhearted pace warmly carries the wearied resignation of the lyric: "To this world I will soon say my farewell, at last / I will be gone when you read this last letter from me." It was a hit again for Jimmie Davis in 1939, and that same year Griffin released "Answer to the Last Letter" to address the

postmortem regrets of those left behind. "The Last Letter" has since been covered by Ernest Tubb, the Carter Family, Gene Autry, George Jones, Willie Nelson, Waylon Jennings, and the Daytonas, and Bob Dylan even borrowed the melody for his "To Ramona."

20. "GLOOMY SUNDAY"–BJÖRK

Written in 1933 by Hungarian composer Rezső Seress, with lyrics by poet László Jávor, "Gloomy Sunday" was first marketed in America as "The Famous Hungarian Suicide Song." Though dozens have performed this bleak ballad, it has more or less belonged to Billie Holiday since she had a hit with it in 1941, but in recent years idiosyncratic Icelandic singer Björk has successfully claimed the song as her own, first recording it with big band accompaniment in 1998 for a Walden Woods Project fund-raiser, and more recently performing an otherworldly rendition at the 2010 funeral services for fashion designer Alexander McQueen. (For more about "Gloomy Sunday" see pages 286–89.)

21. "SOMETIMES I FEEL LIKE A MOTHERLESS CHILD"–PAUL ROBESON

In one of the most well-known recordings of this traditional song with roots in slave spirituals of the nineteenth century, there's a fascinating dichotomy at play between Robeson's measured, astonishingly strong baritone, and the fragility of the "motherless child" lyric. Some later performers toy with the lyrics, ditching the haunted "Sometimes I feel like I'm almost gone" second verse for attempts at reaching a more modern audience—Jimmy Scott's fantastic version replaces it with "This world out here is lonely and cold," while Van Morrison opts for the considerably more dippy "Sometimes I wish I could fly like a bird up in the sky." The dire metaphysical imagery conjures images of Robeson disappearing before our very eyes in a striking trick of sorrow's power to eviscerate the most vital among us.

22. "I WISH MY BABY WAS BORN"–DILLARD CHANDLER

A traditional ballad, the song was performed without accompaniment by keeper-of-the-Appalachian-holler Dillard Chandler. Born in 1907,

Chandler was a shy and illiterate logger who lived in the woods of North Carolina and learned a deep repertoire of songs in his youth. They were captured during the mid- to late 1960s by John Cohen—who also made the stunning 1973 short film *The End of an Old Song*, about the singer's life and struggle to define himself in a modern world. Chandler's take on "I Wish My Baby Was Born" is brief, running just more than a minute in length, but it takes just fifteen seconds for your heart to split as he sings the opening line, "I wish, I wish my baby was born / And sitting on its papa's knee." The song has been recorded by Uncle Tupelo (1992) and the Be Good Tanyas (2003), and came to popular attention after Tim Eriksen, Riley Baugus, and Tim O'Brien performed it on the *Cold Mountain* soundtrack (2003), but as wonderful as these renditions may be, it's difficult to supplant Chandler's richly aggrieved authenticity.

23. "NOT DARK YET"—BOB DYLAN

Teaming once again with producer Daniel Lanois—who produced 1989's exceptional *Oh Mercy*—Dylan explored the realities of a third act with dispirited resignation in "Not Dark Yet," the first single from 1991's *Time Out of Mind*. With the light narrowing, Dylan is scarred, jaded, tired, and insensate, ending each of the four verses that comprise the song with a grim reminder that "it's not dark yet, but it's getting there." Lanois—who preferred an unreleased demo version of the song to the final "Civil War ballad" that appeared on *TOOM*—envelops the song in atmospheric organ and layers of coruscating guitar, matching Dylan's "vacant and numb" lyrics. Likely to stand as his late-career summit, "Not Dark Yet" is as bleak as the inventive Mr. Zimmerman has ever been.

24. "ALABAMA"—JOHN COLTRANE

Opening with a sorrowful melody—that some have suggested, without attribution, is based on a Martin Luther King Jr. speech—drifting over a tremulous, rumbling piano, John Coltrane's "Alabama" takes all the pain of the September 15, 1963, bombing of Birmingham's Sixteenth Street Baptist Church, which killed four young black girls, and pours it out over five minutes of hurt and weary heartache. It can

be found on the 1963 album *Live at Birdland,* though it was actually recorded in the studio more than a month after the Birdland concert.

25. "YOU FORGOT TO ANSWER"—NICO

Over the course of two albums that helped lay the foundation for goth, former Velvet Underground chanteuse Nico—with a fair amount of help from another VU expatriate, John Cale—crafted a challenging sound that married her unemotional vocal to the haunted, distancing drone of the harmonium. "You Forgot to Answer," the third track on her stunningly desolate 1974 album *The End,* relates the very real heartbreak she felt after attempting to reach her former lover, the Doors' Jim Morrison, on the telephone, only to find out later that as she was calling, he lay dead in his Paris hotel bathtub. Her misery at this missed connection pours out in waves of howling, atonal anguish as she sings, "The high tide is taking everything and you forget to answer."

26. "DER ABSCHIED" ("THE FAREWELL")—GUSTAV MAHLER

Arranged for two solo voices and orchestra, Mahler's *Das Lied von der Erde* (*The Song of the Earth*) was inspired by the publication of *Die Chinesische Flöte* (*The Chinese Flute*), a book of German translations of ancient Chinese poetry. Conceived and written on the heels of three painful events in the composer's life, including the death of his daughter Maria, *Das Lied* was considered by Mahler to be his most personal artistic statement. "Der Abschied" ("The Farewell"), the final of six movements, runs almost as long as the other five combined, and draws on the intensity of the composer's loneliness and existential misery—"My heart is still and awaits its hour." *Das Lied* premiered after Mahler's death in 1911, and was conducted by his close friend Bruno Walter, who recalled first poring over the score that the frail composer had handed him, noting its funereal relevance as the "last confession of one upon whom rested the finger of death."

27. "TAPS"—DANIEL BUTTERFIELD

Written in July 1826 by Union General Daniel Butterfield as a revision to the infantry call to extinguish lights, "Taps" is achingly somber and terribly moving for every one of its twenty-four notes. It was

quickly picked up by other troops and later, on a tense evening with Confederate soldiers mere feet from his position, a battery captain overseeing a soldier's burial decided to sound "Taps" as an alternative to the traditional three-gun salute, which he worried would ignite a flurry of return fire. The mournful music quickly became a military standard and is noted as being played by both Union and Confederate armies within months, becoming an official part of military field manuals for "lights out" as early as 1863, and in a funereal capacity as early as 1891. (For more information about "Taps" see pages 320–322.)

28. "CRYING"–ROY ORBISON

The Big O specialized in operatic pop sorrow and "Crying," from 1961, which he claimed to be autobiographical, is one of the greatest and most grief-stricken moments in all pop history. Written by Orbison with Joe Melson, the entire song is an anguished inner monologue swirling around one brief moment, frozen in shellac, as the singer unexpectedly crosses paths with a former flame. The moment is excruciating, with even simple lines like "you wished me well" connecting with phenomenal force. As the brief song comes to a close, Orbison's trembling voice lifts off: "Now you're gone / And from this moment on / I'll be crying."

29. "HURT"–JOHNNY CASH

Cash hesitated to record "Hurt" when it was initially brought to him by producer Rick Rubin. The song, written by electro-goth kingpin Trent Reznor and originally appearing as the final cut on Nine Inch Nails' 1994 album *The Downward Spiral*, was dark stuff. Even Cash's son, John Carter Cash, was concerned that the "hopelessness of it seemed almost like a little too much." In the end Rubin won out and "Hurt" was on the lineup when *American IV: The Man Comes Around* was released in November 2002. The song became Cash's final single and was accompanied by a controversial video that featured a shaking, wet-eyed Cash that some viewed as exploitative of the singer's declining health. The song's ruminative qualities take on new meaning as the then seventy-year-old country rebel asks, "What have I become?" and painfully confesses, "I will let you down,

I will make you hurt." Cash so occupied the song that when Reznor finally absorbed this new version of his own deeply personal song, he "welled up with tears," saying "I knew it wasn't my song anymore."

30. "HALLELUJAH"—JEFF BUCKLEY

Buckley's version of Leonard Cohen's "Hallelujah" has become the de facto interpretation. Though John Cale gets the credit for plucking it from Leonard Cohen's songbook and breathing into it a place in pop culture, Buckley's version became a posthumous number one in 2008 for the singer-songwriter—who died mysteriously while swimming in Tennessee's Wolf River in 1997—and was named one of the 500 Greatest Songs of All Time by *Rolling Stone*. (For more about "Hallelujah" see pages 83–86.)

31. "ST. JAMES INFIRMARY BLUES"—LOUIS ARMSTRONG (1959 VERSION)

Based on an old anonymous English folk song called, among many other things, "The Unfortunate Rake," and freely tweaked by performers until songwriter Irving Mills (under the pseudonym Joe Primrose) won the rights to the title and his 1930 arrangement of the song, "St. James Infirmary Blues" has been recorded, under various titles ("St. Joe's Infirmary," "The Gambler's Blues," and on and on), by too many artists to name—Cab Calloway, Django Reinhardt, Billie Holiday, Andy Griffith, the Stray Cats, and the White Stripes among them. But it was Louis Armstrong's 1928 recording with his Hot Five (renamed the Savoy Ballroom Five for the session) that first brought the song to a wide audience. No matter what version you listen to, the first verse is usually about a young man who goes to visit his "baby," who is "stretched out on a long white table," dying in St. James Infirmary. After the first verse, though, it's a free-for-all. Most existing versions are lyrically clunky and filled with mixed messages, which may or may not concern themselves with any combination of alcoholism, prostitution, gambling, and/or venereal disease. Even Armstrong recorded multiple versions throughout his career, but the version Pops recorded with his All Stars for Decca in 1959 gives the song an unremittingly somber, stately pace—it crawls compared to his highly regarded 1928 version— that suits the material remarkably well.

32. "HE STOPPED LOVING HER TODAY"–GEORGE JONES

Thought by many to be the greatest country song of all time, "He Stopped Loving Her Today" was written by Bobby Braddock and Curly Putman and proved to be one of George Jones's biggest hits when it was released in 1980. The song's narrative uncovers how deep the well of pain at the heart of unrequited love can go ("He kept her picture on the wall / Went half crazy now and then"), and the late chorus that follows four consecutive verses provides a dark O. Henry–style twist as Jones reveals the chorus ("He stopped loving her today / They placed a wreath upon his door"). It's as solemn a take on "till death do us part" as exists anywhere in song.

33. "SONG TO THE SIREN"–THIS MORTAL COIL

Written by Tim Buckley and Larry Beckett, and chosen by 4AD cofounder Ivo Watts-Russell as the first single for his This Mortal Coil covers project, "Song to the Siren," performed by foils Elizabeth Fraser and Robin Guthrie (of the Cocteau Twins), is a breathtakingly gorgeous slice of dark, shimmering ambient pop that, in Watts-Russell's own words, "You'd have to be either deaf or dead not to be moved by."

34. "MILLE REGRETZ"–JOSQUIN DES PREZ

Josquin des Prez—often simply referred to as Josquin—was massively popular in his day (the sixteenth century) and was among the first composers to truly infuse his works with a holistic expression of emotion, "Mille Regretz" ("A Thousand Regrets") being a primary example. Written and gifted to Emperor Charles V in 1520, this sorrowful polyphonic chanson is said to have been the ruler's favorite, hence its colloquial handle, "The Emperor's Song," and it remains popular thanks to the simplicity and power of its touching melody and anguished text: "A thousand regrets to leave you / And to be far from your loving face. I suffer such deep sorrow and grievous anguish / That soon I will end my days."

35. "THE DARK END OF THE STREET"–JAMES CARR

Perhaps the best cheating song of all time, this maudlin soul ballad cuts to the guilty heart of running around without any pretense as the two

lovers who live "in darkness to hide alone" know they're doomed to "pay for the love" they've stolen, but can't help meeting in the shadows. Written by Muscle Shoals songwriters Dan Penn and Chips Moman during a break from a card game and released in 1967, the song unbelivably peaked at only seventy-seven on the pop charts. Carr's deep and sensitive performance is among his best and his rendition remains definitive despite numerous challengers, including Percy Sledge, Aretha Franklin, Bruce Springsteen, and Cat Power, to name just a few.

36. "NE ME QUITTE PAS"–JACQUES BREL

Tall, dark, and handsome Belgian chansonnier Jacques Brel swiped a fragment of Franz Liszt's *Hungarian Rhapsody* and painted over it with characteristically grand romantic overtures ("I'll give you pearls of rain from countries where it never rains"), but after all the poetic needling, he ends the song by resorting to a more simplistic plea, repeating over and over again, "Don't leave me, don't leave me, don't leave me . . ."— with each successive appeal more helpless than the one before.

37. "SHIPBUILDING"–ROBERT WYATT

When producer and composer Clive Langer heard Robert Wyatt's version of "Strange Fruit" he was so moved that he set to work fashioning a song for the idiosyncratic singer. But with a melody established, Langer struggled to find a lyrical foothold. A fortunate meeting with Elvis Costello led to the young singer penning a poignant response ("The best words I've ever written," he declared) to the short-lived 1982 Falkland Islands conflict between Argentina and the United Kingdom. Wyatt—a galvanic political creature— endowed Costello's words with staggering pathos as he sang of remorseful fathers preparing to build the ships that will take their sons to their deaths ("Within weeks they'll be reopening the shipyard and notifying the next of kin"), imagining that the young men will be "diving for dear life" when they should be "diving for pearls."

38. "HIGHWAY PATROLMAN"–BRUCE SPRINGSTEEN

Included on his stark 1982 masterpiece *Nebraska*, "Highway Patrolman" is among the greatest narrative songs ever written,

a testament to the unbreakable bonds and unavoidable torments that attend family. The plainspoken narrator, Joe Roberts, is a sergeant with the highway patrol, and when he ends the first verse by introducing his brother Franky by saying only that he "ain't no good," there's little doubt that a bad moon is rising. During the chorus, Joe's memory returns to earlier, better times spent with his brother, but their lives diverge at the next verse as Franky ships off to Vietnam and Joe marries and unsuccessfully attempts wheat farming. Joe winds up a highway patrolman and Franky returns from the war, the slow fuse already lit. In the final verse, Franky attacks a man in a bar and steals a car. Joe chases after him, but as he speeds by a sign saying they're only five miles from the Canadian border, he realizes he needs to let him go. Joe corrupts his integrity and says good-bye to his brother as he watches the taillights disappear. The power of the narrative was not lost on Hollywood, as Sean Penn loosely adapted the song into the screenplay for his 1991 directorial debut, *The Indian Runner.*

39. "MY MOM"—CHOCOLATE GENIUS

Few songwriters have tackled the slow devastation of Alzheimer's, but Marc Anthony Thompson—a.k.a. Chocolate Genius—does so with shattering results in this song from his 1998 album *Black Music.* A whorl of bleak organ, muffled drums, and delicate acoustic guitar circle Thompson's husky vocal as he narrates a visit to his parents' home. The tender details—"that tree was a goalpost," and it "smells just the same"—accumulate as the verses spiral downward, finally resting at a spare chorus, Thompson touchingly singing, "My mom, my sweet mom / She don't remember my name." Simply heartbreaking.

40. "LUSH LIFE"—JOHN COLTRANE AND JOHNNY HARTMAN

The complex emotional and intellectual bite of Billy Strayhorn's greatest composition is even more shocking for the fact that he began writing it when he was just sixteen. It took him five years to slowly piece the song together, and he never imagining he would actually publish it, but it has gone on to become something of the Great American Songbook's dark night of the soul. Strayhorn's faraway glance

witnesses a life outwardly successful (jazz, cocktails, trips to Paris) but filled with emptiness. The stoic protagonist desperately points out the silver linings of a life touched by unfulfilled desires, a theme that may point to Strayhorn's youthful struggles with his homosexuality. Originally titled "Life Is Lonely" and, in an arrangement for the Duke Ellington Band that the group never performed, "Lonely Again," "Lush Life" entered the popular consciousness with Nat King Cole's 1949 recording. However, it didn't find its true owners until John Coltrane and Johnny Hartman serendipitously added it to the studio sessions for their eponymous 1963 album, perfectly crystallizing the song's gentle, near-magical sadness. (For more about Billy Strayhorn's "Lush Life" see pages 19–22)

41. "THE SAME DEEP WATER AS YOU"—THE CURE

Robert Smith and company were never so drenched in miasmatic despair as they were on 1989's *Disintegration*, the bleakest beacon of which was the nearly ten minutes of floating darkness, "The Same Deep Water as You." All of the group's musical trademarks—long synth lines, echoing drums, forlorn leads—are represented, all loping over the ambient sound of a distant thunderstorm. This is radio dirge. Smith's fragmented lyrics leave a lot to the imagination, but the song seems to suggest the lengths one can go to when truly committed to a relationship, with lines like "kiss me good-bye" and "the strangest twist upon your lips" implying suicide and death. While recording the song even its creator was so overcome with emotion that he needed some time to recover from the its powerful undertow.

42. "HOPE THERE'S SOMEONE"—ANTONY AND THE JOHNSONS

Antony and the Johnsons became indie-rock darlings with the release of their second album, 2005's *I Am a Bird Now*, and the opening track, "Hope There's Someone"—a solemn plea for comfort and understanding—was named the best single of 2005 by *Pitchfork*. Transgender singer Antony Hegarty's haunting vocal imbues an otherworldly anguish to a song that recalls everything from madrigal laments and turn-of-the-century spirituals to the circular minimalism of Philip Glass and the most smoldering torch songs.

43. "REMEMBER MY FORGOTTEN MAN"—JOAN BLONDELL, ETTA MOTEN

A famous Busby Berkeley–choreographed musical sequence from the Mervyn LeRoy film *Gold Diggers of 1933*, "Remember My Forgotten Man" was written by Harry Warren and lyricist Al Dubin as a reaction to FDR's famous "Forgotten Man" speech of April 7, 1932. The pair even constructed the song's three verses to echo the speech's themes (WWI, the farmer, and the family). Joan Blondell performs the song in the film, but is actually lip-synching to vocals laid down by singer Etta Moten. The song summed up the feelings of many Americans following the Great Depression and is the foundation for one of the greatest musical numbers—despite its dark nature—in the history of film.

44. "HOW TO DISAPPEAR COMPLETELY"—RADIOHEAD

Inspired by the works of Scott Walker, Krzysztof Penderecki, and Olivier Messiaen, as well as a turn of advice from R.E.M.'s Michael Stipe regarding the slings and arrows of fame, "How to Disappear Completely" is an existential celebrity lament for self-preservation in an exhaustive world of spotlight and surveillance. Originally titled "How to Disappear Completely and Never Be Found," and released on Radiohead's consumptive *Kid A* from 2000, it's easily the most brittle and crushing ode to the "rigors of touring" anyone has ever produced, a mini genre that also includes Journey's "Faithfully" and Mötley Crüe's "Home Sweet Home." (For more about Radiohead's "How to Disappear Completely" see pages 239–243.)

45. "HOW CAN YOU MEND A BROKEN HEART"—AL GREEN

Written by the Bee Gees' Robin and Barry Gibb and released as a single in 1971, "How Can You Mend a Broken Heart" became the group's first US number one. But when Al Green got hold of the song for his 1972 album *Let's Stay Together*, he moved in and took full possession, unearthing the pure, beseeching sorrow at its roots. Though the song exits with a glimmer of hope shimmering from somewhere deep within ("I got a feeling that I want to live"), the question posed in the song's title is never addressed. So, how can you

mend a broken heart? Maybe the Gibb brothers are suggesting this is one question without any answer.

46. "DIES IRAE"—THOMAS OF CELANO

A thirteenth-century Roman Catholic chant ascribed to Italian friar Thomas of Celano, the solemn "Dies Irae" ("Day of Judgment" or "Day of Wrath"), is notable for its long run as part of the Requiem Mass. In the late 1960s, however, "Dies Irae," along with other liturgical songs, were removed from regular Mass due to their overemphasis on "judgment, fear, and despair." Yet its import remains greater than its current ceremonial standing, as it has been echoed and quoted time again for works including Berlioz's *Symphonie Fantastique*; Haydn's *Drumroll* Symphony (No. 103); Mahler's Symphony No. 2; and Mozart's Requiem Mass. It even pops up prominently in *It's a Wonderful Life*, *The Nightmare Before Christmas*, and *Star Wars*.

47. "DRESS REHEARSAL RAG"—LEONARD COHEN

While discussing the mythology behind "Gloomy Sunday" during a 1968 BBC performance—pointing out that a number of people had supposedly committed suicide under the spell of the music, leading to an eventual ban of the song—Leonard Cohen noted: "I have one of those songs that I have banned for myself. I sing it only on extremely joyous occasions when I know that the landscape can support the despair that I am about to project into it. It's called the 'Dress Rehearsal Rag.'" The song is one of Cohen's earliest and its first official recording came on Judy Collins's 1966 album *In My Life*. Cohen—who believes Collins's version is superior to his own—didn't get around to recording it until the 1968 sessions for his second album. It didn't make the cut for that album, but he rerecorded it for his third album, 1971's *Songs of Love and Hate*. "Dress Rehearsal Rag" is a predusk dirge full of bruising accusations, the singer standing in front of a mirror, lost in self-hatred, cruel memories of "a girl with chestnut hair," and blurry, half-mad hallucinations, like his transformation from a mundane depressive attempting a shave to a distorted Santa Claus with "a razor in his mitt," contemplating his end.

48. "THE BLIZZARD"—JIM REEVES

Novelist R. S. Surtees once wrote, "There is no secret closer than what passes between a man and his horse," and "The Blizzard" spins the uniqueness of that relationship into a weary tragedy. One of a string of crossover hits "Gentleman" Jim Reeves racked up in the decade between 1957 and 1967—he continued to chart years after his death in a plane crash, on July 31, 1964—"The Blizzard" was written by Harlan Howard, one of the most important country songwriters in history, with thousands of compositions to his credit including classics like "I Fall to Pieces" and "Heartaches by the Number." It's the bitter tale of a man and his lame pony, austerely named Dan, struggling through an unforgiving snowstorm. Reeves plies his horse with notions of warm hay, but Dan just doesn't have the legs beneath him to carry on. "Get up you ornery cuss or you'll be the death of us," warns Reeves, but he quickly gives in and the two stop for a rest just "one hundred yards" from home, which is where they're found at dawn the next day. The song performed well on the charts when it was released as a single in 1963, reaching number four on the country charts and breaking into the top 100, and it's since been recorded by Tex Ritter, Johnny Cash, Jim Croce, and twee Scottish act Camera Obscura, though none capture the straight-back pathos of Reeves's original.

49. "YOUR NEW FRIEND"—SMOG

Bill Callahan's brief 1996 EP *Kicking a Couple Around* begins with this minimal and claustrophobic nod to modern love (and his own "Goldfish Bowl," from the previous year's *Wild Love* album) as the singer splits with his live-in girlfriend and is banished to his "living-room bedroom" in their revealingly small apartment, found to listen to her excited conversation with her "new friend." His loss of privacy echoes his inability to mask his emotionally fragile state. He rebels by blasting his stereo, but the truth is that he would happily die in his chair. Is it delusion or just the complexity of relationships when he reminds her in the final verse, "Don't get me wrong / I know I'm still your boyfriend"?

50. "COCKTAILS"—DENNIS WILSON

By the time the Beach Boys drummer Dennis Wilson went solo with 1977's *Pacific Ocean Blue* he had grown dramatically from the group's beachcombing weak link into its secret weapon—writing and performing songs with a diarist's sincerity and tired, husky vocals. Though he had begun work on a second album, provisionally titled *Bambu,* heavy drug abuse, as well as the sale of the Beach Boys studio, kept him from completing it. One track he did get down is the pallid, high-proof heartbreaker "Cocktails." As a glowing synth washes over delicate piano, Wilson, exhausted, explains his truth: "If I was a waterfall I'd fall and flow into you," even though he knows with all his being that whatever he is, he's not a waterfall, and the song's refrain, "*¿Por qué no dice que me quieres?*" ("Why don't you say you love me?")—punched up with a proto-Eitzel yawp—only serves to underline his desperation and confusion.

51. "I SEE A DARKNESS"—BONNIE "PRINCE" BILLY

Will Oldham, recording for the first time as Bonnie "Prince" Billy—he previously recorded as Palace Brothers, Palace Songs, and Palace—released *I See a Darkness* in 1999. *Mojo* has since named it the twentieth greatest album of our lifetime, and the song that shares the album's title is its anguished centerpiece. "I See a Darkness" is both a plaintive recognition of depression's often-unstoppable hold ("Did you ever, ever notice the kind of thoughts I got") and a hopeful plea for understanding ("A hope that somehow you, you can save me from the darkness"). The song became a touchstone of Johnny Cash's late-career revival when it appeared on his *American III: Solitary Man* album, Oldham confidently backing up Cash's weathered vocal.

52. "I'VE BEEN LOVING YOU TOO LONG"—OTIS REDDING

A gut-wrenching, slow-burning soul standard written by Redding with Chicago soul singer Jerry Butler, "I've Been Loving You Too Long" peaked at number twenty-one on the pop charts and number two on the R&B charts when it was released as a single in 1965, and more recently narrowly missed the top 100 in *Rolling Stone's* 2010

list of the Greatest Songs of All Time (it came in at number 110). Full of gritty anguish, Redding declares how wonderful his life has been, struggling to imagine it without love, before falling to his knees and boiling over with more linear overtures ("Please, don't make me stop now").

53. "DRY YOUR EYES"—THE STREETS

Originally written for Coldplay before everyone realized it would make a better Streets song, this surprisingly effective heartbreaker is included on Mike Skinner's (a.k.a. the Streets) loopy 2004 concept album—and most striking picture of modern "English youth"—*A Grand Don't Come for Free,* about a missing bundle of cash (£1000) that forces him to reexamine his wayward life. Beneath gently strumming acoustic guitar, distant strings, and a crawling beat, Skinner sketches out the graceless details of getting dumped, his stream-of-consciousness lyrics detailing every awkward eye movement and every desperate measure, while the combination of his knockabout Cockney accent ("I've got nuffin', absolutely nuffin'") and the bittersweet vocals of singer Matt Sladen during the chorus keeps everything grounded.

54. "HYMNE À L'AMOUR" ("HYMN TO LOVE")—EDITH PIAF

On October 27, 1949, French boxer Marcel Cerdan—along with forty-seven others, including acclaimed violinist Ginette Neveu— died when his Air France flight from Paris to New York crashed into an Azores mountainside. He was traveling to the United States to see his lover, Edith Piaf, who collapsed when she heard the news of his death. Just weeks earlier she had premiered "Hymne à l'Amour"—"Hymn to Love" and later, "If You Love Me (Really Love Me)"—a song she had written (with Marguerite Monnot) as a testament to her love for Cerdan. Following his untimely death, the song took on a mythical air of modern tragedy as Piaf sings— presaging the melodramatic misery of groups like the Shangri-Las and the Smiths—"If one day life tears you away from me / If you die far away from me / It doesn't matter, if you love me / Because I will die as well."

55. "LORENA"—REV. HENRY D. L. WEBSTER, JOSEPH PHILBRICK WEBSTER

This incredibly popular antebellum ballad of the North was actually written in 1857, years before the Civil War broke out, and ironically became a favorite among homesick Southern soldiers who took to naming their settlements, ships, and children after the mythical "Lorena." The song's origins are foggy, but the most popular lineage presents that the music was written by Joseph Philbrick Webster and the lyrics were penned by Reverend Henry D. L. Webster—of no relation—in 1857, and based on the forced dissolution of his engagement to Ella Blocksom in 1849. In her final letter to the young preacher she wrote, "If we try, we may forget," which eventually found its way into the pining song. Reverend Webster initially changed Ella to Bertha, but the song's melody required an extra syllable, and "Lorena"—with inspiration from the lost Lenore in Edgar Allan Poe's "The Raven"—was writ into history. "Lorena" has been recorded by Willie Nelson, Johnny Cash, Slim Whitman, Norman Blake, Bobby Bare, and John Hartford (best known for writing "Gentle on My Mind"), but it was Waylon Jennings who found the most success with the song. Worth seeking out, though, is the brief instrumental version recorded for Ken Burns's 1990 documentary series *The Civil War*, the Mormon Tabernacle Choir's ethereal recording on the 1992 release *Songs of the Civil War*, and Tennessee Ernie Ford's reverent take from his 1961 album *Civil War Songs of the North*.

56. "THE END OF THE WORLD"—SKEETER DAVIS

The Shangri-Las may hold the corner on streetwise girl-group grief, but for sickly sweet alienation and the depths of young love's heartache there's none more delicately miserable than Skeeter Davis's December 1962 hit. The world impossibly, cruelly goes about its business—tides still flow, birds still sing—when it should, by rights, be turning to ash. It struck a chord, and Davis found herself simultaneously gracing the top ten of *Billboard*'s Pop, Adult Contemporary, Country, and R&B charts—no small feat in 1963.

57. "SADNESS"—ORNETTE COLEMAN

A wobbly free-jazz dirge, "Sadness" (recorded live and appearing on the album *Town Hall, 1962*) features Ornette Coleman's weeping saxophone—he constantly struggled to give a "human quality" to his performances—gravely swinging over a bed of uneasy, alien-bowed bass, shimmering cymbals, and brushed drums. Unreal blue.

58. "OUR SONG"—JOE HENRY

A tearful dirge about the post–9/11 state of the union ("this frightful and this angry land"), Joe Henry's "Our Song," from 2007's *Civilians*, finds the singer heaping all our collective hope and love on proud baseball legend Willie Mays, caught in the act of buying garage-door springs at a Home Depot. The strangeness of the metaphor is gripping in its slowly unfolding banality. The song's narrator ponders the safety of Scottsdale's distance from tall buildings and our continued desire to celebrate the Greatest Generation, keeping close the thought that "the worst of it might still make [him] a better man."

59. "FEEL LIKE GOING HOME"—CHARLIE RICH

The Silver Fox brought together his love of gospel and his love of country when he wrote what is arguably one his greatest songs, an aching piano ballad that finds the singer chastising himself for a life littered with mistakes. He finds himself at the end of a long road with the clouds gathering and "without a friend around." As the song reaches its climax a choir lifts him, "tired and weary," up toward the heavens. It's a gorgeous, honest, heartbreaking song from one of country's most talented—if often overlooked—artists.

60. "TE RECUERDO AMANDA" ("I REMEMBER YOU, AMANDA")
—VICTOR JARA

A deeply touching song by Chilean activist and singer Victor Jara, "Te Recuerdo Amanda"—first recorded for his 1969 album *Pongo en Tus Manos Abiertas (Into Your Open Hands)*—is a portrait of Jara's mother and father, Amanda and Manuel, and the power of their young love as Amanda runs, smiling, through the wet streets toward the factory where Manuel works. During his five-minute break the couple

gets to see each other, "all of your life in five minutes," Jara sings. But when Manuel goes to war he is killed: "In five minutes it was all wiped out." It's likely that Jara was simply remembering Amanda's innocence—tying it to the innocence of his daughter, whom he had just learned was diabetic—but as Pinochet came to power during a military coup on September 11, 1973, the song's significance changed. The morning following the coup, hundreds of citizens deemed enemies of the state were rounded up, taken to the national stadium, and, over the following days, were beaten and murdered, Jara among them. After an infamous string of political disappearances—estimates range from 9,000 to 30,000 students, journalists, sympathizers, and others disappeared over the following years—the fate of the song's "Amanda" became more ambiguous, as she stood in for *los desaparecidos* (the disappeared). "Te Recuerdo Amanda" has since become associated with both Jara and the plight of the Disappeared and was recorded by Joan Baez on her 1974 album *Gracias a la Vida* and by Robert Wyatt on his 1984 *Work in Progess* EP.

61. "DER LEIERMANN" ("THE HURDY-GURDY MAN")—FRANZ SCHUBERT

Slowly dying from syphilis and hopelessly depressed during the latter half of 1828 ("...each morning but recalls yesterday's grief"), the shabby and gifted Franz Schubert struggled to complete his last masterpiece, *Winterreise (Winter Journey)*, in the final weeks of his life. A twenty-four-song cycle for voice and piano based on the poems of Wilhelm Müller, it tells the story of a young man who leaves an adopted home after the woman he has given his heart to falls in love with another man. His tears freeze as he wanders the countryside, considering slight details of nature's melancholy beauty. In the finale, "Der Leiermann" ("The Hurdy-Gurdy Man"), he listens to the music from a scorned and forgotten organ grinder—the piano echoing the cyclical melody of his cheap instrument—and decides this will be his future, mournfully asking the broken man before him, "Will you play music for my songs?"

62. "I (WHO HAVE NOTHING)"—BEN E. KING

Best known for his monster hit "Stand by Me," Ben E. King shines in his take on "I (Who Have Nothing)," a bleak shot of melodramatic

pop based on the Italian song "Uno Dei Tanti," with lyrics translated into English by Jerry Leiber and Mike Stoller—the duo responsible for many of Elvis Presley's biggest hits. King plays the longing admirer watching helplessly as the woman he loves is showered in diamonds, clothes, and expensive dinners by other men. There is sheepish naïveté as he explains how true his love is, but never is there a sense that it will lead to anything other than abject misery as he continues to watch her thrive in her rarefied world with his "nose pressed up against the windowpane."

63. "BROTHER, CAN YOU SPARE A DIME?"–BING CROSBY

Written by composer Jay Gorney and lyricist E. Y. Harburg (*The Wizard of Oz,* "Lydia, the Tattooed Lady," et al.) for their Broadway musical revue *Americana,* "Brother, Can You Spare a Dime?" became an immediate hit when it premiered—sung by vaudeville ventriloquist Rex Weber—in October 1932. But it was Bing Crosby's recording, made just weeks after the song's stage premiere, that made it the galvanizing lament that defined the Depression era. Based on a Russian-Jewish lullaby that Gorney's mother had sung to him when he was a child, it features both a minor verse and a minor chorus, with only a fleeting leap when lyricist Harburg gives the protagonist a reminiscence of his days building the railroads that "raced against time" before the song plummets back into a minor key and the reality of the country's economic turmoil. Both Crosby's version and Rudy Vallee's somewhat more sprightly take climbed to number one before 1932 came to a close. (For more about "Brother, Can You Spare a Dime?" see pages 156–159.)

64. "TANK PARK SALUTE"–BILLY BRAGG

Written about the death of his father in 1976, when Bragg was eighteen, this touching song is a perennial among his fans and can be found on his 1991 abum *Don't Try This at Home.* The song's mournful, circular melody provides the foundation for a searching conversation with his father, asking, "What had become of all the things we planned?" and confessing, "There's some things I still don't understand." The song proved hugely difficult for Bragg to write, as

he had largely avoided the subject of his father's death until then, but he has noted that the song's power to move people supports his theory that in order to write deeply affecting material "you must first articulate your own deepest feelings, those that are the most difficult for you to confront." Though both the senior and (briefly) the junior Braggs spent time in military service, the "tank park salute" of the title seems to memorialize a private moment between a father and son that Bragg is rightfully keen to keep to himself.

65. "TROUBLE OF THE WORLD"–MAHALIA JACKSON
Featured in Douglas Sirk's 1959 Eastmancolor melodrama *Imitation of Life*, "Trouble of the World" represents one of finest moments from the Queen of Gospel. Jackson pours every ounce of her soul into this universal message of release without ever slipping into unnecessary histrionics: "Soon we will be done / Trouble of the world."

66. "THE ELECTRICIAN"–THE WALKER BROTHERS
This disturbing, organ-chilled torture drama is the perfect midpoint between Scott Walker's two careers as brooding romantic in fab swinging-sixties trio the Walker Brothers and his more recent work as an uncompromising experimental artist. The song's obtuse lyrics likely refer to the United States involvement in Argentina's Dirty War of the 1970s and early 1980s, when countless people were imprisoned, tortured, and killed, and contains the frightening refrain "If I jerk the handle, you'll die in your dreams." Then, from nowhere, the middle eight blossoms into a gorgeous orchestral mirage—like a kick of hallucinogenic endorphins—before quickly disintegrating into the same darkness it had erupted from moments earlier, Walker explaining one more time in his shrouded croon, "When lights go low / There's no help, no." (For more about "The Electrician" see pages 331–34.)

67. "CON ONOR MUORE" ("TO DIE WITH HONOR")–GIACOMO PUCCINI
The libretto of *Madama Butterfly*, one of the most performed and beloved operas in the world, tells the story of Butterfly, a young

Japanese bride who is abandoned in her homeland, pregnant by her American sailor husband, Pinkerton. She gives birth to Pinkerton's son and patiently awaits his return to Japan, but when he finally does return it's as the husband of an American woman. Pinkerton's new bride informs Butterfly of their plan to return to the United States and Butterfly implores them to take her son with them. During the heart-rending final number, "Con Onor Muore," Butterfly tells her son to remember her face, sets him in the corner with a small American flag, ties a blindfold around his eyes, and then disappears behind a screen, where she commits seppuku—ritual suicide—with her father's knife. As she lies dying, Pinkerton enters shouting her name: "Butterfly! Butterfly! Butterfly!"

68. "AND THE BAND PLAYED WALTZING MATILDA"—THE POGUES

Written by folk singer Eric Bogle in 1971, both to honor the Anzacs (veterans of the Australian and New Zealand Army Corps) and protest the war in Vietnam, "The Band Played Waltzing Matilda" is a vivid, bitter first-person account of the horrors of war told from the view of a maimed Gallipoli veteran. Its defining moment came when the Pogues recorded it for their 1985 album *Rum, Sodomy, and the Lash,* as Shane MacGowan's warbling vocal perfumes every line with whiskey, giving a hard-won patina to lines like "I looked at the place where me legs used to be and thanked Christ there was nobody waiting for me." The song famously blends Australian bush ballad "Waltzing Matilda" (a "matilda" being a backpack, not a woman) into its finale, and as time passes and the world spins, the sacrifices of the "crippled" and "blind and insane" soldiers who returned from the war are forgotten.

69. "LONESOME TOWN"—RICKY NELSON

Released in 1958, two years after Elvis Presley topped the charts for the first time with the conspicuously similar "Heartbreak Hotel," Ricky Nelson's ode to lost love is a lugubrious fantasy where teardrops are currency and everyone's in the one percent. Written by Baker Knight—who also penned Nelson's hits "Poor Little Fool" and the "Lonesome Town" flipside "I Got a Feeling"—this simple song is

composed of the teen idol's sugary voice, a delicately strummed guitar (which Nelson was proud to have played on the track), and what may be the most depressed Greek chorus in rock history, the sepulchral backing singers rising through the recording like disembodied voices from the bottom of a well. "Lonesome Town" climbed to number seven on the US charts when released and has since been recorded by Paul McCartney, Holly Golightly, Richard Hawley, the Four Preps, the Ventures, and Allen Clapp, among others, though the most notable reinterpretations have come from French chanteuse Françoise Hardy and shockabilly group the Cramps. If younger listeners know the song now, that's likely thanks to its inclusion on the soundtrack to Quentin Tarantino's *Pulp Fiction*.

70. "ON THE NATURE OF DAYLIGHT"—MAX RICHTER

Inspired by Franz Kafka's fragmentary *Blue Octavo Notebooks*, Richter's 2004 release, *The Blue Notebooks*, features ten tracks stained with the color of the journals that frames the writer's personal struggles with the composer's sparse, "postclassical" style. Actress Tilda Swinton reads selections from the notebooks while Richter folds all manner of organic and electronic sounds together to create a lush, subtly modern sense of sadness. Composed of ponderous, outstretched melodic lines, crying strings layer to create a rich sound that recalls Barber's bleak "Adagio" or the popular works of Philip Glass slowed by an overwhelming sorrow. Richter, though, tags late Beethoven as the model for "On the Nature of Daylight": "I'm looking for that incredible intensity and clarity, using the minimum amount of notes possible."

71. "GOODBYE PORK PIE HAT" ("THEME FOR LESTER YOUNG")— CHARLES MINGUS

A mournful, bluesy lament written by tempestuous bassist Charles Mingus after hearing of the death of his close friend tenor saxophonist Lester "Prez" Young, just two months before the recording sessions for his 1959 album *Mingus Ah Um*, "Goodbye Pork Pie Hat" (later renamed by Mingus "Theme for Lester Young" when he reworked it for his 1963 album *Mingus Mingus Mingus Mingus Mingus*) became and remains one his signature songs. In 1979 Joni Mitchell composed

words to the song in collaboration with the bassist for her album *Mingus,* opening the song with the touching line, "When Charlie speaks of Lester you know someone great has gone." Mingus himself passed away soon after Mitchell's album was released.

72. "BLUE IN GREEN"—MILES DAVIS

Pianist Bill Evans's liner notes regarding this achingly slow "minimalist-cool" ballad from 1959's landmark *Kind of Blue*—"a ten-measure circular form following a four-measure introduction, and played by soloists in various augmentation and diminution of time values"—belies the extraordinary emotional understanding on display in this recording. Of the legendary sextet aligned for *Kind of Blue*—Davis, Evans, John Coltrane, Cannonball Adderley, Paul Chambers, and Jimmy Cobb—all except Adderley perform: Davis's muted, introverted playing is heartbreaking, Coltrane provides a brief solo full of brooding beauty, Evans is pure magic and the cut closes with Chambers's bowed bass grieving just beneath the surface. Davis claimed to have authored the whole of *Kind of Blue,* but it seems clear that Evans was, at the very least, the song's cocreator, a fact the pianist always insisted to be the case.

73. "EVERYBODY HURTS"—R.E.M.

A maudlin hit spurred by an eerie video partly inspired by the opening of Federico Fellini's *8½*—"Everybody Hurts" was uncharacteristically direct for R.E.M. (they specifically targeted the song's lyrics to the mawkish teenage brain), which may have helped its popular appeal. It became a top-ten hit across Europe, while it petered out at thirteen in the States.

74. ADAGIO IN G MINOR—TOMASO ALBINONI

On April 5, 1992, the first shots of the siege of Sarajevo were fired. The following month a mortar shell tore through a breadline, killing twenty-two people, an act of destruction that motivated cellist local Vedran Smailović to don his tuxedo and perform a daring act of artistic protest, playing Albinoni's Adagio in G Minor every day for twenty-two days in the rubble of his besieged city, becoming known to the world

over as the Cellist of Sarajevo. Tomaso Albinoni's Adagio, overflowing with tearful remorse and lugubrious melody, an apt choice, though it's likely that the piece wasn't written by Albinoni, who composed in the early eighteenth century, but rather by Italian musicologist Remo Giazotto after he discovered a few threads of unattributed notation (a full bass line and a few bars of violin) in the ruins of the Dresden State Library following World War II. Whatever its origins, the Adagio in G Minor is an enduring part of the classical canon and rivals Barber's "Adagio for Strings" in its broad, heart-swelling despair.

75. "BORROWED TUNE"—NEIL YOUNG

Appearing on Young's caustic, strung-out 1978 album *Tonight's the Night,* which was largely an attempt by the singer to exorcise the demons that haunted him following the deaths of his friends guitarist Danny Whitten and roadie Bruce Berry, "Borrowed Tune" (which was actually written before Whitten and Berry overdosed) is a spare ballad built on a fraying rope bridge of piano and harmonica. In an apathetic conceptual trick, Young openly nicks a melody from the Rolling Stones' "Lady Jane" (the "Borrowed Tune" of the title), admitting in his tired, nasal rasp that he's "too wasted" to write his own melody—Young predating both the heavy apathy and cut-and-paste culture of the 1990s, when he would be proclaimed the godfather of grunge.

76. "RIVER"—JONI MITCHELL

Appearing on Joni Mitchell's 1971 masterpiece, *Blue,* "River" was never released as a single but has blossomed over the years into one of her signature songs. Opening with a brief melodic nod to "Jingle Bells," it explores the need for change following the end of an intense relationship (Mitchell and the Hollies' Graham Nash had split just prior to her recording of *Blue*), the singer punishing herself for ruining everything. She wants to hide from everything around her—the reindeer, the "songs of joy and peace"—and longs for a frozen river she can "skate away on," implying a chilled metaphor for suicide (which Mitchell reportedly attempted just a few years later following her breakup with singer Jackson Browne).

77. "TWILIGHT"—ELLIOTT SMITH

Originally titled "Somebody's Baby," recorded during Smith's final, unfinished session, and released posthumously on *From a Basement on the Hill* in 2004, "Twilight" is a song haunted by intimacy, fear, and the mystery of its creator. Distant clusters of crickets open and close the song, which is highlighted by Smith's chopping, scraping acoustic guitar, his superheated and self-loathing lyrics, and his weak, trembling voice, as if he's whispering into each listener's ear individually. Every good turn is an omen of impending despair. A five-note synth lead circles the song before giving way to Smith's withered voice that confesses, "I'm tired of being down," but the admonition fizzles into the dusky atmosphere as he returns to his truth, "If I went with you, I'd disappoint you, too."

78. "THE COLOUR OF SPRING"—MARK HOLLIS

Inspired by the exploratory minimalism of Miles Davis, Karlheinz Stockhausen, and Morton Feldman, former Talk Talk ringleader Mark Hollis labored over every nudge of ivory, every brush of percussion, and every buzz of breath rippling through every reed on his eponymous 1998 solo debut. The album is a bleak sui generis masterstroke and its opening track, "The Colour of Spring," is a leviathan of restraint. Featuring only dappled piano and Hollis's retreating voice—he pounces at each abstract lyric with a young romantic's urgency and dissipates just as quickly—it's hard to conjure anything except rain clouds as he sings of forgotten fates and bridges burned. These moments will never come again.

79. "CANTUS IN MEMORY OF BENJAMIN BRITTEN"—ARVO PÄRT

When English composer Benjamin Britten passed away on December 4, 1976, Estonian quietist, medieval-music aficionado, and radio technician Arvo Pärt—who had never met Britten and had discovered only recently "the unusual purity" of the elder composer's works— welled up with "inexplicable feelings of guilt," which he poured into his mournful composition "Cantus in Memory of Benjamin Britten." Edgar Allan Poe, in a poem dedicated to the myriad ringing bells he heard while living in New York, called, aptly, "The Bells," writes of

the pealing of funeral bells, saying, "What a world of solemn thought their monody compels!" That's exactly the tone Pärt achieves as a split string ensemble descends a minor scale timed to the slow, deep chiming of a single bell, ending with the final tolling note drifting into silence.

80. "BLUE AND GREY SHIRT"–AMERICAN MUSIC CLUB

"Blue and Grey Shirt," from AMC's 1988 album *California,* is a devastating song that pries singer Mark Eitzel free from the barstool only to find him reflecting upon the death of a close friend from complications resulting from AIDS. Eitzel's exhaustion comes through in the lyrics—"I'm tired of being a spokesman for every tired thing"—and in his gruff, laconic voice as he slowly works toward his conclusion: "Now I just sing my songs for people who are gone."

81. "STAY WITH ME"–LORRAINE ELLISON

Though the pleading soul ballad "Stay with Me" has been covered by dozens of artists over the years—notably Bette Midler, the Walker Brothers, and Duffy—it was Lorraine Ellison's agonizing soprano that got there first; her intense 1966 recording remains untouchable. The song peaked at number eleven on the R&B charts and proved to be Ellison's only major hit, but her three gospel-touched albums for Loma Records—Warner Brothers' R&B division—contain a number of stone-cold classics and remain a powerful testament of her astonishing talents.

82. "100,000 FIREFLIES"–THE MAGNETIC FIELDS

In the earliest days of Magnetic Fields, songwriter Stephin Merritt— now comfortably the barrel-voiced center of the group—relied on delicate singer Susan Anway to bring his forlorn arch-pop lyrics to life. Released as the penultimate track on the group's first album, 1991's *Distant Plastic Trees,* "100,000 Fireflies" is a twee gem that shines like a diamond amid the best lo-fi pop of the era. Over a cheap machine beat and sparkling ostinato bells, Anway spins a haunting miniature opera about the sorrows of stringed instruments, crippling isolation, doomed romance, catching fireflies, and suicidal notions. Lines like

the infamous opener, "I have a mandolin / I play it all night long / It makes me want to kill myself" are delivered with a crisp sincerity, and when she sings "this is the worst night I've ever had" you believe her. In a 1995 interview, Merritt intoned his philosophy that music has less to do with catharsis and more to do with "making pretty objects you can treasure forever." In this case he's managed both.

83. "DEATH LETTER"–SON HOUSE

In "Death Letter," a dark, ragged blues written and performed by Son House, love dies without drama, passion, or foul play; it's just here one moment and gone the next with the arrival of the eponymous "death letter." He travels to view the body "on the cooling board" and watches it being lowered into the grave, and, with the sun setting, the heavy cast of depression overcomes him ("Minutes seemed like hours, hours they seemed like days"). He believes for a moment that she is haunting him before reaching the sturdy conclusion that "Love's a hard ol' fall."

84. "THE KIDS"–LOU REED

Since its release in 1973, Lou Reed's *Berlin*, a loose song cycle about the doomed love of aggressively troubled couple Jim and Caroline, has gained a reputation as "the most depressing album ever." The distinction isn't unfounded and "the kids" can be viewed as the blackest of a dark lot. The song opens with Caroline's children being taken away from her and continues as a laundry list of her transgressions. Jim calls her a "miserable rotten slut" and finds that he's happier in their relationship "since they took her daughter," while Caroline has slipped from cuckolding to suffocating in a severe depression. And if the narrative weren't dark enough, the song also features a chorus of crying children screaming for their troubled mother who, by the next song, has committed suicide.

85. PRELUDE NO. 4 IN E MINOR–FRÉDÉRIC CHOPIN

A whirl of contradiction, dandy salon artist Chopin was responsible for changing the conversation about piano music, as he painstakingly crafted a breathtaking world of miniatures including nocturnes,

mazurkas, waltzes, ballades, impromptus, and, of course, the twenty-
six preludes, of which none is more celebrated than the Number 4 in
E Minor. Less than two minutes in length, it is an austere gem that
flows with a halting, fragile, and natural sorrow. Chopin disliked
the idea that his works should be infused with biography, but it's
hard not to hear the dour environment in which the fourth prelude
was written in the melancholy that exudes from it: Ill and alone,
Chopin composed the piece during a disastrous 1838–1839 winter
trip to visit his lover, author George Sand, and her children. In Sand's
words, Chopin's preludes, from the moment of their conception, were
"masterpieces" that "present to the mind visions of the dead and the
sounds of the funeral chants which beset his imagination." Fittingly,
the prelude was eventually played at Chopin's funeral in 1849.

86. "I WISH IT WOULD RAIN"—JOHNNY ADAMS

The melody was written by Barrett Strong on a forty-dollar piano
with only ten working keys, while the words were penned by
introverted lyricist Roger Penzabene as a last-ditch catharsis to heal
the betrayals of his cheating wife. Despite the desperate origin, "I
Wish It Would Rain" became a major hit for the Temptations upon
its release in December 1967, reaching number four on the pop charts
and topping the R&B charts. Unfortunately, Penzabene, unable to
deal with the pain of his relationship's demise, committed suicide on
New Year's Eve, just days after the song's release, giving new gravity
to lines like "With her went my future / My life is filled with gloom."
Though a number of artists have recorded the song, the release that
best captures the flattened heart at its core is Johnny Adams's 1972
version. The Tan Canary does away with the Temptations' jumpy
mid-tempo beat and replaces it with a slow-burning Black Moses
vibe that positively simmers with pain.

87. "WITHERED AND DIED"—RICHARD AND LINDA THOMPSON

I Want to See the Bright Lights Tonight (1974) was the first album
from husband-and-wife duo Richard and Linda Thompson and is a
tenebrous collection of brilliant English folk rock, the darkest cut
of which is the sorrowful ballad "Withered and Died." Richard's

restrained guitar on the languidly processional track leaves room for Linda's despondent vocal—she once described herself as having "the soul of Ingmar Bergman"—as she explores themes of loss and betrayal, ending each verse with the tearful avowal, "my dreams have withered and died."

88. "SAM STONE"—JOHN PRINE

Though songs like Lou Reed's grimy "Heroin" (1967), the First Edition's "Ruby, Don't Take Your Love to Town" (1969), and Scott Walker's "Hero of the War" (1969) predate John Prine's "Sam Stone" (1971) in laying out shocking drug imagery or close-to-the-bone, Vietnam-era tragedy, Prine's single line "There's a hole in Daddy's arm where all the money goes" places the song alongside the Doors' "Unknown Soldier" and Creedence Clearwater Revival's "Fortunate Son" as a defining statement of the era. In a thin, nasal wheeze over a plaintive organ and crisp acoustic picking, John Prine spins the caustic story of Sam Stone, a Vietnam veteran who comes home from the war with frayed nerves, "shrapnel in his knee," and an all-consuming addiction to morphine. To absolutely no one's surprise things snowball quickly, the foggy sense of an "overdose hovering in the air" long before Prine says it. It's not long before Stone pops "his last balloon" and OD's, leaving his family to sell their home in order to buy him a casket. The original can be found on Prine's 1971 self-titled debut, but echoes of the song can be heard in Pink Floyd's "The Post War Dream" (on 1983's *The Final Cut*) and is more directly quoted in Spiritualized's "Cop Shoot Cop . . ." (from 1997's *Ladies and Gentleman We Are Floating in Space*).

89. "BLEMISH"—DAVID SYLVIAN

Struggling for understanding in the midst of his crumbling marriage, David Sylvian created 2003's *Blemish*, a work he has referred to as his most "unguarded." On the troubled title track his velour tremble is mixed front and center as he spills lines like "I fall outside of her," "There's no talking to her," and "He who was first's coming in last," over a tenebrous rippling of guitar drone. The chill is palpable and one can nearly see the curlicues of fog forming on his breath as he

comes to the dejected conclusion, "Life's for the taking they say / Take it away."

90. "THE SHORTEST STORY"—HARRY CHAPIN

A passionate activist, singer/songwriter Harry Chapin dedicated a substantial portion of his earnings to fighting world hunger, and this brief coda to his bestselling 1976 album *Greatest Stories Live* is a pungent attack on the evils of food insecurity. It is such a heartbreakingly succinct indictment that it has been used in comments before Congress to illustrate the plight of the hungry. The song opens with a birth, but here the beginning of life is inextricably linked with the cruelties of the world as even the "promise" of the sun "burns." Just a brief twenty days into life, the unfortunate runt at the heart of the song is shunned by his mother as he watches a bird circle overhead and asks himself, "Why is there nothing more to do than die?"

91. "SUICIDE IS PAINLESS" (THEME FROM *M*A*S*H*)— JOHNNY MANDEL AND MIKE ALTMAN

"Suicide Is Painless" originally appeared in Robert Altman's 1970 film version of *M*A*S*H* before it became more widely known as the theme to the long-running television series. Cowritten by musician Johnny Mandel and Robert Altman's son, Mike, the song became a UK number one in 1980 and has been covered by a host of artists, prominent among them is a version released as a single by the Manic Street Preachers in 1992, which peaked at number seven on the UK charts. During a *Tonight Show* appearance in the 1980s, the elder Altman joked that his son made more than a million dollars in royalties from his part in writing the song, while he made only $70,000 directing the film that spawned it.

92. "FRUIT TREE"—NICK DRAKE

For all the myth and mystery surrounding Nick Drake's short life and premature death he does seem soundly prophetic on "Fruit Tree," the penultimate track of his debut, 1969's *Five Leaves Left*. His delicate, paper-thin vocal trembles over the lush strings as he ponders the fleeting warmth of fame ("Fame is but a fruit tree, so very unsound"),

the quicksilver brevity of life, and the comparable comfort of death ("Safe in the womb of an everlasting night"). It's his commentary on the power of posthumous celebrity, though, that really sends shivers down the spine: "Safe in your place deep in the earth / That's when they'll know what you were really worth."

93. "KATY SONG"–RED HOUSE PAINTERS

Found on Red House Painters' first self-titled release of 1993 (unofficially *Red House Painters I*, or *Rollercoaster*), "Katy Song" slams together two rock buzzwords of the 1990s—slowcore (glacial pacing, reverb-soaked guitars) and shoegaze (a dreamy whirl of effects)—into one gorgeous eight-minute-plus miserable epic about the end of singer/songwriter Mark Kozelek's relationship with his girlfriend and muse. Kozelek funnels his anguish into a sprawling ode to disintegration, singing with plaintive contemplation, "Can't go with my heart when I can't feel what's in it / I thought you'd come over but for some reason you didn't."

94. "WISH YOU WERE HERE"–PINK FLOYD

Between the stunning talents of Roger Waters and David Gilmour, Pink Floyd crafted a staggering number of melancholy prog classics through the seventies and eighties, including "Us and Them," "Comfortably Numb," and "The Final Cut." But "Wish You Were Here," from 1975's "very sad record" (according to Waters) of the same name, touches something more earthy, more human, and less political (not apolitical), which allows it to hit that much closer to home. Waters described the song as "schizophrenic," an accounting of "the battling elements within," sung by battling aspects of his personality. Bookended by an existential, signal-from-the-black intro and a postapocalyptic windstorm that blows the song away, Waters's raspy dualities interrogate each other before one wises up to the fact they're all just "running over the same ground," battling "the same old fears."

95. "SOUR TIMES" (LIVE)–PORTISHEAD

It can be difficult to untangle Portishead singer Beth Gibbons's bleak poetry (and her reluctance to discuss her work doesn't help),

but "Sour Times," which first appeared on the group's 1994 debut, *Dummy,* unravels with plenty of poisoned clues—the "hidden eyes," "buried lives," and "bitter taste"—that point to the corroded heart of the track. Nothing in Gibbons's collected works of detached despair hits like the crying refrain here: As she clings for dear life to her "memories of yesterday," she abuses herself with one constant and grim reminder, "Nobody loves me, it's true." As wrenching as the studio version is, the narcoleptic live take that shows up on 1998's *Roseland NYC* impossibly squeezes even more bitter pulp from the song's punishing mantra.

96. "WHEN I LOST YOU"–BING CROSBY

In 1912 songwriter Irving Berlin met and married twenty-year-old Dorothy Goetz. Unfortunately, the newlywed couple chose Cuba, which was in the midst of a typhoid outbreak, as their honeymoon destination and Goetz succumbed to the disease soon after. The story goes that the devastated Berlin poured his grief into this, his first true ballad, but among his unpublished papers a set of lyrics surfaced dating from the same period titled "That's Just Why I Love You," which fit conspicuously well into the melodic structure of "When I Lost You." It's possible his expression of courtship joy darkened and he filed the original lyrics, replacing them with a new set that more accurately expressed his grief, but some go so far as to suggest that Berlin wrote new lyrics to take advantage of the situation, as Dorothy's death was headline news. Though it isn't performed with the regularity of other Berlin classics like "Cheek to Cheek" or "Blue Skies," "When I Lost You" still thrums with all his heartbreak and is best captured by Bing Crosby, whose molasses baritone croon gives the song all the weight it requires.

97. "DEATH LETTER"–SON HOUSE

In "Death Letter," a dark, ragged blues written and performed by Son House, love dies without drama, passion, or foul play; it's just here one moment and gone the next with the arrival of the eponymous "death letter." He travels to view the body "on the cooling board" and watches it being lowered into the grave, and with the sun setting,

the heavy cast of depression overcomes him ("Minutes seemed like hours, hours they seemed like days"). He believes for a moment that she is haunting him before reaching the sturdy conclusion that "love's a hard ol' fall."

98. "MR. BLUE"—THE FLEETWOODS

"Mr. Blue" was a number one hit in 1959 for softspoken doo-wop trio the Fleetwoods. Written by DeWayne Blackwell, the song deals with decidedly risqué material for such a squeaky-clean group, as singer Gary Troxel assumes the anxious identity of "Mr. Blue" while he impotently watches his one true love "head for the lights of town" to prove her love "isn't true." Gretchen Christopher and Barbara Ellis delicately support Troxel's shy assumptions, and in the end this most genteel of heartbreakers cuts no less deeply for its Rockwellian simplicity.

99. "THE BALLAD OF LUCY JORDAN"—MARIANNE FAITHFULL

The high point of Marianne Faithfull's postaddiction comeback, "The Ballad of Lucy Jordan" is a country tune written by Shel Silverstein (yes, he of *The Giving Tree* and *A Light in the Attic*) that first appeared on Dr. Hook's 1975 album *Ballad of Lucy Jordan*. When Faithfull and producer Mark Miller Mundy got hold of the song for 1979's *Broken English*, they crafted a dark, percussionless, new-wave fantasy that ends in vague darkness with the song's protagonist either jumping from a rooftop or being whisked away to a mental hospital in a speeding ambulance.

100. "THE SUN'S GONE DIM AND THE SKY'S TURNED BLACK"— JÓHANN JÓHANNSSON

The final track on Jóhannsson's 2006 conceptual *IBM 1401, A User's Manual*—an album originally conceived as a modern-dance soundtrack and subsequently reinvented—"The Sun's Gone Dim and the Sky's Turned Black" is a keening lover's lament that pairs the final, fluttering good-byes of early computing workhorse the IBM 1401 with mournful strings and the rippling sadness of a cybernated voice that repeats in downward steps, "The sun's gone dim and the

sky's turned black / 'Cause I loved her and she didn't love back." Recorded in 1971, the music is a sort of funereal performance by the very first computer imported into Iceland (in 1964) where, perhaps unsurprisingly, Jóhannsson's father was its chief maintenance engineer. It's a sweeping glitch-ballad for the twenty-first century that touches on "ghost in the machine" themes as well as the same apocalyptic heartbreak found in Skeeter Davis's "The End of the World" and Edith Piaf's "Hymne à l'Amour."

Acknowledgments

I went into the process of writing this book foolishly assuming it would be little more than an exercise in self-discipline. Having come out the other side, I see now with more clarity than I could have imagined the emotional weight that accompanies something as often overlooked as the acknowledgments. And so, with true heartfelt gratitude . . .

I need to thank my agent, the patient and hugely popular PJ Mark at Janklow & Nesbit Associates; and the talented Carrie Kania, for seeing potential in my celebration of sad; and my editor, Michael Signorelli, for lending a sharp overseeing eye to my process.

A gigantic thank you to Nanette Maxim as well for her part in making this book a reality and her continued support.

One of the greatest assets this book had, before the first letter of the proposal was typed, was the kindness, intelligence, and support of Christy Harrison.

And, to S., thank you for being there and being you.

Beyond these very important people, I want to express thanks for the encouragement I received from my brothers, Chris and Justin, and my friends, including Andrew Bradick, Kevin Gibson, Rob Kleiner, Maha Shami and Matt Michel, Chris Bonner, Will Hereford, J.J. Goode, Lindsay Maas, Jay Paavonpera, Hamooda Shami, Domenic Venuto and Joe Cohen, Dave Park, and Andy Lin, all of whom have

been consistent sources of joy and reassurance throughout a process that began when I was invited to a Midtown lunch with Jane Lear, my former coworker at *Gourmet* magazine, and Dan Frank, from Pantheon. There are a number of people from the *Gourmet* family that I'd like to thank, chief among them Kevin Demaria and Richard Ferretti, for helping me to package a thoughtful proposal; Ruth Reichl for her insight and generous attempts to rein in my overexcited imagination with gentle admonitions that I just "finish the book"; and Larry Karol, John Haney, John Willoughby, Diane Abrams, Mark Rozzo, and Jackie Terrebone.

Finally, this book—a public metaphor for anything I've ever accomplished—certainly would not have been possible without the love and guidance of my parents, who have always been supportive of my interests and (most of my) decisions, even if they didn't always understand them. I love you and I thank you, for everything.